WOMEN

Dressing

WOMEN

A Lineage of Female Fashion Design

WOMEN Dressing WOMEN

A Lineage of Female Fashion Design

Mellissa Huber and Karen Van Godtsenhoven

with contributions by
Jessica Regan, Elizabeth Way, Amanda Garfinkel,
and Elizabeth Shaeffer

Preface by Andrew Bolton

Photographs by Anna-Marie Kellen
Dressed by Joyce Fung
Conserved by Melina Plottu

The Metropolitan Museum of Art, New York
Distributed by Yale University Press, New Haven and London

CONTENTS

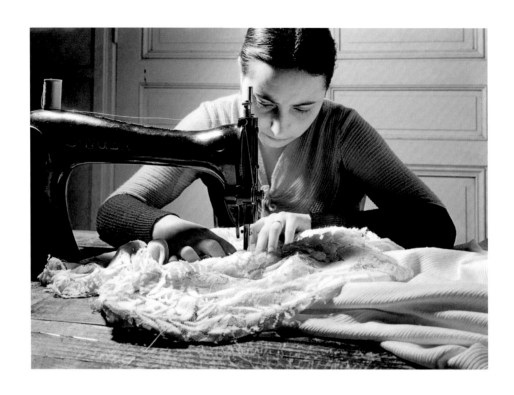

Seamstress at Callot Soeurs, 1931. Photograph by François Kollar (French, born Slovakia, 1904–1979)

SPONSOR'S STATEMENT

Morgan Stanley is honored to sponsor *Women Dressing Women* at The Metropolitan Museum of Art.

This long-awaited exhibition celebrates the artistic legacy of female fashion designers during a moment in which many couture houses are led by powerful women, such as Iris van Herpen at her eponymous label, Virginie Viard at Chanel, and Maria Grazia Chiuri at Dior. From Jeanne Lanvin and Elsa Schiaparelli to Miuccia Prada and Rei Kawakubo for Comme des Garçons, the exhibition incorporates iconic objects from The Costume Institute's tremendous collection, juxtaposing early female leaders of haute couture with their contemporary counterparts and tracing women's contributions to fashion through their corresponding historical narratives.

This juxtaposition and celebration echo the experience of Morgan Stanley. Our firm is proud to unite our history of leading expertise and hard work with our prowess as innovators who help discover untapped opportunities and create new legacies. Similarly, this exhibition draws a connective thread between designers across the last century to explore not only the power of shared artistic visions but also how women have collectively pushed the envelope of haute couture and contemporary ready-to-wear.

On behalf of Morgan Stanley and our employees worldwide, we truly hope you enjoy The Metropolitan Museum of Art's presentation of *Women Dressing Women*.

TED PICK
Co-President, Head of Institutional Securities Group
Morgan Stanley

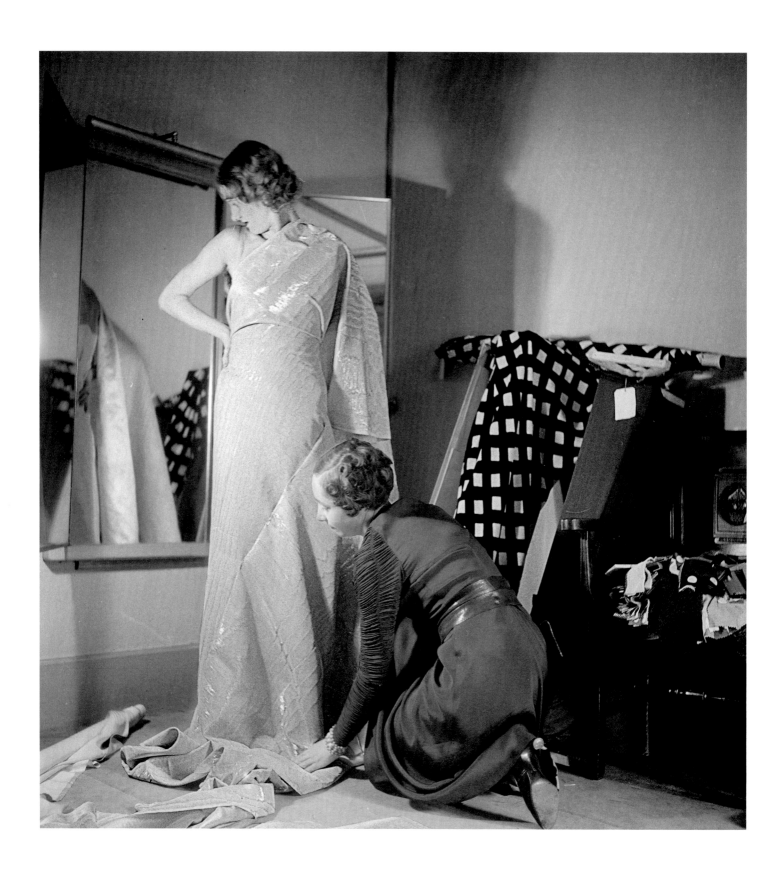

Alix, later known as Madame Grès (Germaine Émilie Krebs), draping on a model, 1933. Photograph by Boris Lipnitzki (French, born Russian Empire, 1887–1971)

DIRECTOR'S FOREWORD

Women Dressing Women celebrates the artistic legacy of female fashion designers by showcasing innovative and enduring garments created by well-known, anonymous, and overlooked women makers. Drawing primarily from the unrivaled collection of The Met's Costume Institute, and including many promised gifts as well as several recent acquisitions, this exhibition and its accompanying publication present a matrilineal genealogy that establishes chronological, conceptual, and commercial lineages between dressmakers of the past and pioneering female designers of the twentieth and twenty-first centuries. Some of their names—Gabrielle Chanel, Rei Kawakubo, Miuccia Prada—will be familiar, while others—Madeleine Maltezos, Marcelle Chaumont, Anifa Mvuemba—are less well known, which provided opportunities for research that uncovered new stories and fresh perspectives to share.

Throughout history, fashion has often functioned as a vehicle that offers women forms of financial, social, and creative autonomy. I am proud that this exhibition was conceived of and organized by two extraordinarily talented women: Mellissa Huber, Associate Curator in The Costume Institute, and guest co-curator Karen Van Godtsenhoven, previously an associate curator in The Costume Institute who currently works independently. Mellissa and Karen developed the catalogue with a group of creative women that included designer Laura Genninger of Studio 191 and photographer Anna-Marie Kellen, Associate Chief Photographer in The Met's Imaging Department. Like the makers of many of the garments featured here, the curators collaborated with their team, devising a concept for the publication that reflects each of the themes explored in the exhibition, illustrating women's progress in fashion—from anonymity to visibility to agency—while also acknowledging moments of absence or omission within fashion's canon and collections. Authors Jessica Regan and Elizabeth Way contributed informative and thoughtful essays that further underscore these important ideas and that appear alongside insightful text contributions from Costume Institute staff including Amanda Garfinkel, Assistant Curator, and Elizabeth Shaeffer, Assistant Conservator.

This project would not have been possible without the generous and enthusiastic support of our sponsor Morgan Stanley and the early endorsement of Met Trustee Ted Pick, whose understanding of the exhibition's goals and the Museum's needs is gratefully acknowledged. My appreciation goes to Andrew Bolton, Wendy Yu Curator in Charge of The Costume Institute, and to the staff in his department for their expertise and effort in helping realize this exhibition. Thanks also to The Met's Design Department, working under Alicia Cheng, Head of Design, for the beautiful exhibition design, installation, and graphics.

Originally, the run of this exhibition was to complement centennial commemorations of women's suffrage in the United States, but the COVID-19 pandemic altered that plan. Nevertheless, *Women Dressing Women* celebrates the important work of female creatives within an industry that has historically employed a largely female workforce and relied greatly on female consumers. My hope is that this thoughtful presentation will lead to further discovery, study, and recognition of the many talented women fashion designers whose contributions will be added to the canon, inspiring new generations of designers across the globe and broadening the opportunities for more visionary women.

MAX HOLLEIN
Marina Kellen French Director and CEO
The Metropolitan Museum of Art

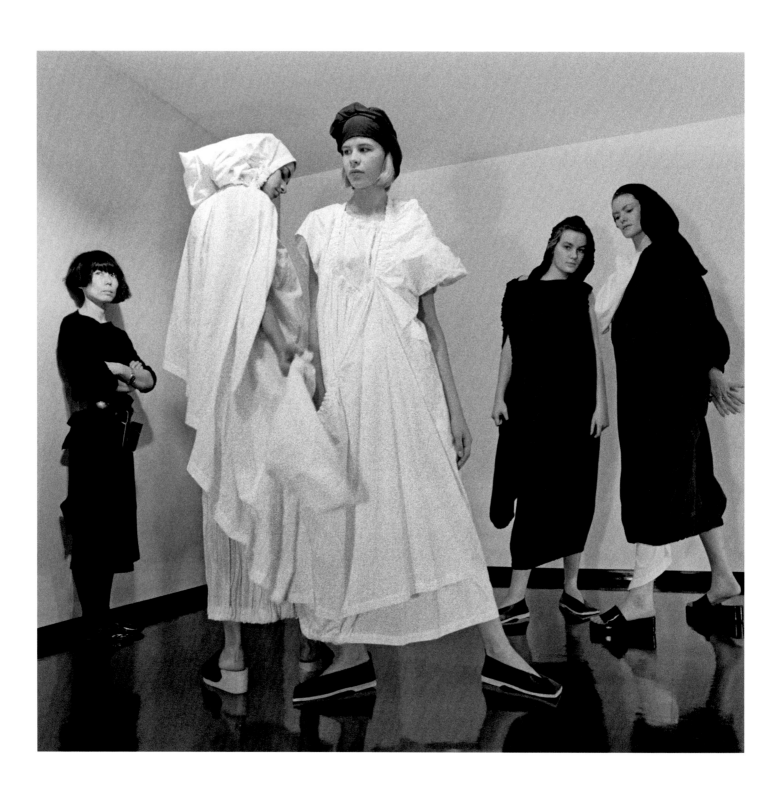

Rei Kawakubo with models wearing COMME des GARÇONS, December 26, 1983. Photograph by Takeyoshi Tanuma (Japanese, 1929–2022)

PREFACE

Andrew Bolton

The history of The Costume Institute is largely a story of women—of women's vision and foresight, of women's ingenuity and imagination, and of women's determination and resourcefulness. It was two women, the philanthropic sisters Irene and Alice Lewisohn, who originated The Costume Institute's collection. Daughters of a copper baron, the Lewisohns initially started collecting historical costumes to serve as a wardrobe for the theatrical productions of the Neighborhood Playhouse, founded by the sisters in 1915 and one of the first off-Broadway theaters located on Manhattan's Lower East Side. By the late 1920s, the Lewisohns had amassed an extensive collection of rare and important examples of historical as well as regional costumes, prompting them to establish the Museum of Costume Art with the assistance of another woman, the set and costume designer Aline Bernstein. The museum's original mission statement specified that it would include dress and accessories "of all epochs and all people, which may serve industrialists, artists, art historians, craftsmen, and students of all kind."

Another woman, the estimable Dorothy Shaver, spearheaded the merger of the Museum of Costume Art with The Metropolitan Museum of Art in 1944 to form The Costume Institute in 1946. Then vice president of Lord & Taylor—she would become president in 1945, the first woman to head a multimillion-dollar firm in the United States—Shaver implemented several campaigns for the department store promoting primarily relatively unknown American women designers including Tina Leser, Bonnie Cashin, Elizabeth Hawes, and Claire McCardell—all featured in this catalogue. The formation of The Costume Institute was predicated on the agreement that it remain financially independent from The Met, and it was Shaver, along with another woman, the legendary fashion publicist Eleanor Lambert, who conceived the annual benefit known as "The Party of the Year," which remains the main source of annual funding for The Costume Institute. Since the first Party of the Year in 1948, the gala has been chaired by a number of indomitable and indefatigable women, including Met trustees Pat Buckley and Anna Wintour. Wintour transformed the event into one of the most visible and successful fundraisers worldwide, drawing attendees associated with film, music, sports, politics, and business as well as fashion.

The first executive director of The Costume Institute was a woman—Polaire Weissman, who had previously served as the executive director of the Museum of Costume Art. It was also a woman who brought international recognition to The Costume Institute through her "blockbuster" exhibitions—the charismatic fashion editor Diana Vreeland. Her template of creating immersive experiences with abstract mannequins in dramatic poses lit with directional spotlighting significantly influenced the direction of fashion exhibitions internationally. Women continue to define the history of The Costume Institute, dominating all areas of the department—from curation, collections, conservation, and installation to the library, administration, and communications. (At the time of this catalogue's publication, 76 percent of the department, including interns, fellows, and volunteers, is comprised of self-identifying women.) One of the women featured in this volume interned in The Costume Institute—the late Isabel Toledo, who spent her time studying the work of many of the designers highlighted in this book. Of her experience in the department, she said, "The place . . . where it became clear to me that fashion is, indeed, an art form—was The Costume Institute." It is this art form created by women for women that this catalogue celebrates—a catalogue, incidentally, not only written, designed, and published by women but also featuring fashions conserved, dressed, styled, and photographed by women.

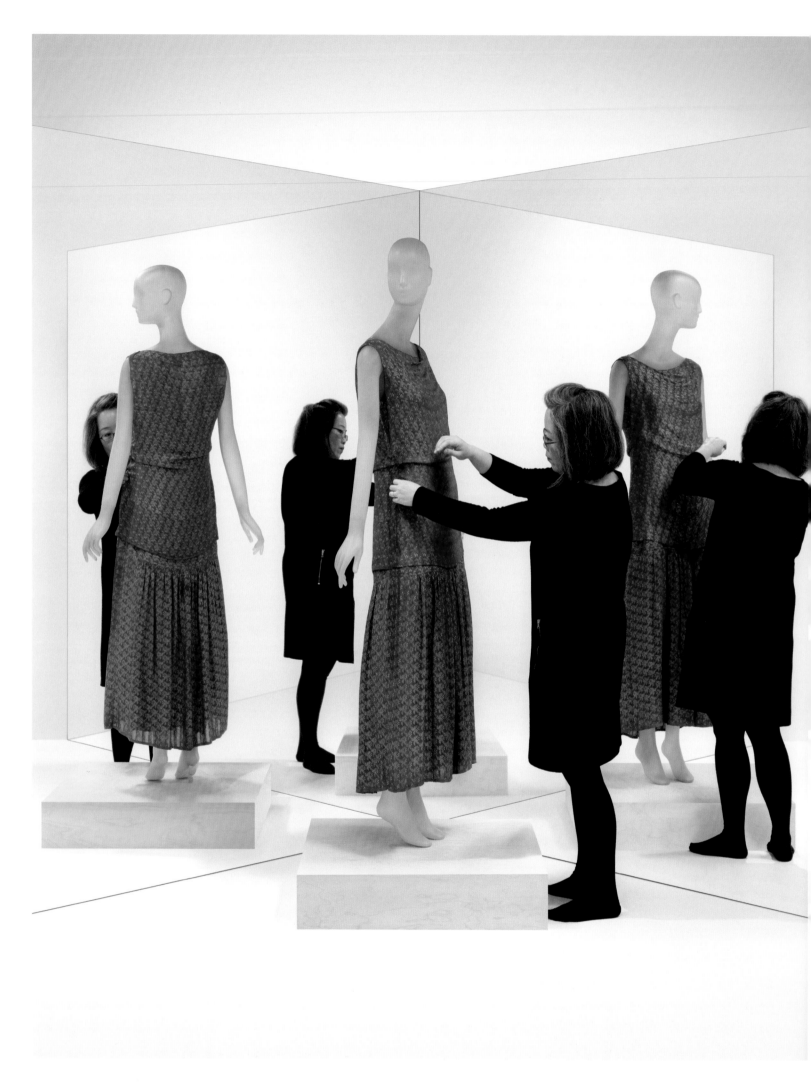

A Jessie Franklin Turner ensemble being dressed for photography by Costume Institute installation manager Joyce Fung, 2023

WOMEN DRESSING WOMEN
A Lineage of Female Fashion Design

Mellissa Huber and Karen Van Godtsenhoven

Women Dressing Women honors the contributions of female fashion designers represented in The Costume Institute collection, tracing a lineage of women makers from the eighteenth century to the present day by highlighting celebrated couturiers, new voices, and forgotten histories. Their diverse creative practices share a commonality in that they design garments for female-identifying bodies. As such, they are women who dress women, in the embodied and performative sense of the verb: their achievements are cultural as well as material, artistic as well as technical, discursive as well as practical.

Fashion has typically been regarded as a feminine purview, and although history demonstrates that this has not always been the case—the innovative designers creating gender-free clothing and menswear today continuously discredit this stereotype—the tendency to perceive womenswear as the standard bearer of fashion is a bias reflected within The Costume Institute collection, the majority of which contains clothing and accessories made for women, many of whom were also donors. While the artistic leadership of fashion houses has often been held by men, and this exhibition admittedly prioritizes the work of women who similarly attained the most visible and coveted creative roles, design by nature is most frequently a collective labor. Regardless of the name on a label, most of the garments preserved in the collection are likely the product of multiple hands: from textile-mill workers to patternmakers, designers, and seamstresses, to fitters and sales staff. For this reason, images of women working are included in the exhibition and throughout the book, demonstrating the physical, manual, intellectual, and embodied labor of crafting garments. Thus, highlighting the often overlooked female labor at the heart of the fashion industry—its diversity and plurality—opens up new perspectives when considering the canon of fashion history, which is often expressed in terms of the "fathers" or "masters" of haute couture.

Our intention with this show is celebration and acknowledgment, rather than essentialism, and one of the greatest challenges of the project was determining how to narrow the scope of a vast topic with many makers who merit recognition within a field heavily reliant on the contributions of women. To define our boundaries, we began by focusing on the permanent collection of The Costume Institute, which represents a rich time line of Western fashion history. The process of reviewing the Museum's holdings yielded interesting discoveries, and in addition to beloved garments that we might consider masterworks or exemplars of their makers or eras, we are thrilled to include in the exhibition several objects that have rarely been shown, if ever. While there are inevitable omissions from the designer and object lists that result from both spatial and material limitations, they only further attest to the breadth of women's meaningful contributions to fashion.

And just as the objects have involved many hands in their creation, their preservation within the museum's collection is the result of over eight decades of active collecting subject to the approach and priorities of multiple generations of curators. Like the encyclopedic Museum at large, the collection is a continuous work in progress, always relative and primed for further development, with each project providing us with an opportunity to reassess our holdings, address voids, and build upon new research. For this exhibition, over one dozen new acquisitions were made, including objects from designers not previously represented in the collection to clothing that accommodates a variety of body types—from adaptive fashion to sizeless garments that can be adjusted and configured to embrace nonbinary and transgender bodies under the most inclusive auspices of womanhood.

The catalogue is organized to trace a lineage of women makers across time, beginning with the concept of the anonymous eighteenth-century dressmaker and configuring a loose ancestry that leads to the present-day eponymous designer. Within this rubric, different types of connections are explored: from literal movements and mergers between fashion houses to more methodological or conceptual links across time. This ongoing examination builds upon the important research of other scholars, and many discoveries have only underscored how much more there is to learn about some of the most obscure fashion houses, which we hope this exhibition might inspire to continue. Because this is a collection-based show, a layer of the analysis considers the lives of the objects within The Costume Institute and their own distinct histories, addressed within the texts that introduce the plate sections. Both the exhibition and its accompanying publication follow a fourfold structure of chapters and sections that consider themes underlying the broader historical trajectory of women working in fashion. The book opens with notions of anonymity explored in an essay and section text by Jessica Regan, who discusses the previously gendered organization of the fashion

industry and the gradual development of opportunities for women through the role of the anonymous dressmaker as a type of collective ancestor. Although by the twentieth century the condition of anonymity becomes more exception than rule for the head designer, this arrangement never entirely disappears. The object entries in this section provide one example of a more contemporary practice in which designers working for department stores were uncredited following a standard strategy that remains common today for some businesses.

As fashion came to support increasingly larger enterprises, the industry provided ongoing opportunities for women seeking employment; the most successful of these mixed artistry with business acumen in one of the few professions where this was permitted for women. Fashion, often associated with female vanity, became a site for female empowerment and emancipation on the side of production as well as consumption. Yet recognition of the combined skill and labor required to achieve the reach of the influential early twentieth-century fashion houses underscores the collective nature of design—an interesting foil to the development of the star system that increasingly relied on the profile and identity of the head designer in shaping the salability and public identity of the couture house. These ideas are explored through the lens of increasing visibility, which impacts all genders but offers women particular opportunities with an emphasis on the stratified and interconnected French haute couture industry.

The newfound agency that erupts in the United States and Europe during the 1960s takes on several forms as women navigate a competitive system through a variety of means, forging spaces for themselves, with many makers imbuing their work with new forms of artistic, social, and political impetus. Within this section, we include contemporary fashion from the 1960s to the present, introducing a handful of recent acquisitions that highlight the way designers have applied their social and creative ethos to their work, ever contemplating the broader impact that our actions have in an increasingly globalized society. The final section of the book considers notions of absence or omission, whether the product of convention, circumstance, or, as Elizabeth Way thoughtfully acknowledges in her essay, systemic forms of oppression at the intersection of race, class, and gender. In a museum, omission can take many forms: from the missing maker or the lack of extant objects, histories that get lost at the time of record, or lack of recognition in favor of other narratives. While some of the clothing highlighted in this section represents these types of absences in fashion's historical canon, for these garments, as with those featured in the prior sections of the book, their stories are not singular

and they simultaneously hold the capacity to reflect notions of agency, visibility, and even anonymity, as these shifting states of empowerment exist in tandem throughout time.

We had the great pleasure of working with Laura Genninger of Studio 191 and her colleague Nick Thompson on the creative concept for this publication, which echoes the themes of the essays and treats the photographs for each section with a different technique. The combined and dedicated efforts of photographer Anna-Marie Kellen, photo retoucher Jessica Ng, conservator Melina Plottu, and installation manager Joyce Fung collectively served to bring these garments to life throughout the following pages. The resulting images metaphorically and literally place the garments and their (invisible) makers on a pedestal. Mirrors, light, and shadow make apparent notions of multiplicity and collaboration as well as the tangible and hidden sides of fashion's creative process. Although the studio space remained fixed, subtle shifts to the environment designate the progression of time as it occurs across objects and sections. These set changes draw dually on the history of fashion and photography, such as the use of the mirrored corner that was instituted in the early twentieth century to capture objects in the round for the purpose of copyright documentation, a practice notably adopted by the esteemed French couturier Madeleine Vionnet (p. 32). This blend of clarity and beauty birthed from practicality parallels the sensitivity and understanding that many of the women featured throughout this publication brought to every aspect of their design practices. Silhouettes in the agency section are foregrounded, confronting the viewer dynamically, and comprise more diverse interpretations of the body as seen through the eyes of women designers. The opaque gray scales and transparent composition of the mannequins serve to hide and reveal the women beneath the clothing—analogous to the dialectic process of women's reclamation of personal and historical agency.

As the unquantifiable contributions of women in fashion can be neither a comprehensive nor a fixed history, we see the sections focused on anonymity and absence/omission functioning as a prologue and epilogue of sorts that bookend the main plate sections. While a targeted selection of object entries invite multiple interpretations of the premises they introduce, similarly the shadows in these images can be seen from various perspectives: they function as a stand-in for those missing yet present, recalling histories of creation, production, consumption, and preservation. They are the invisible women workers of the ateliers, the craftspeople, and the mill workers, they are the implied presence of the bodies that shaped the empty couture dress, and they are the shadows that are cast when one steps into the spotlight.

ARTISTRY AND ANONYMITY

Defining WOMEN'S ROLE *in* WOMEN'S FASHION
(ca. 1675–1900)

Jessica Regan

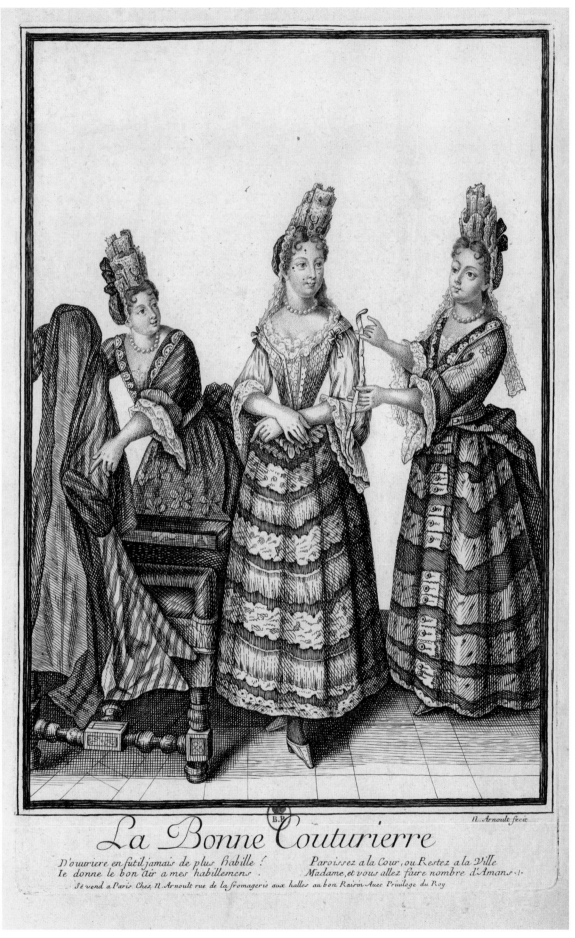

La Bonne Couturierre

D'ouuriere en futil jamais de plus habille ! Paroissez a la Cour, ou Restez a la Ville
Ie donne le bon air a mes habillemens . Madame, et vous allez faire nombre d'Amans .
 Se vend a Paris Chez N. Arnoult rue de la fromagerie aux halles au bon Raisin Auec Priuilege du Roy

Fig. 1. Nicolas Arnoult (French, active 17th century). *La Bonne Couturierre* (*The Good Dressmaker*),
from *Costumes du règne de Louis XIV par Bonnart et divers. Dames*, late 17th century

Writing in the early twentieth century on the status of women in American industry, economist and social reformer Edith Abbott stated that "sewing, needle-work of any kind except, perhaps, the making of men's garments, has always been regarded as within woman's 'peculiar sphere.'"[1] By this time, dressmaking had long been considered a "natural" occupation for American as well as European women. However, the creation of women's fashions was not always thought of as belonging to women's "peculiar sphere." The move toward this status began in European fashion centers in the late seventeenth century, when women gained professional standing in the clothing trades. Roles as dressmakers, milliners, and seamstresses also became critical for women, who at that time had access to a narrow set of professional opportunities.

Prior to the twentieth century, these women rarely gained widespread recognition. Despite the large number working in this field in the eighteenth and nineteenth centuries, few are known by name or identified with their bodies of work; most remain anonymous. This anonymity stems from a lack of documentation, a dearth of extant garments tied to identifiable makers, and, notably, the nature of the fashion industry itself. Few account books, personal writings, or other records survive to illuminate the working practices of small-scale, independent dressmakers. These individuals, who were essential to the creation of women's fashion in both Europe and the United States prior to the era of mass production, worked within limited regional areas, and their reputations were built largely by word of mouth. Additionally, the practice of labeling, which connects an individual maker to their work, did not become common until the late nineteenth century and, even then, was not universal. For women of color, these gaps in the historical record are even greater, and as Elizabeth Way discusses in her essay (see pp. 69–78), their roles have often intentionally been rendered invisible.

The long-standing obscurity of the majority of women who worked in this field prior to the twentieth century is not only the result of an incomplete historical record. It is also the product of a fashion system that generally did not elevate individual creators. Anonymity was inherent to the way most women worked, even as the idea of the designer-as-artist began to develop. Although the late nineteenth century saw the emergence of the named designer—that is, someone acknowledged for their individual artistic vision—this shift was gradual and uneven, offering recognition to a select few, most often those working on a larger scale or with an international reach. However, these changes laid the foundation for twentieth-century female designers to gain greater renown and acknowledgment as leaders of fashion.

Beginning with seventeenth-century France—an early pioneer in delineating women's roles in the fashion world—this essay considers women's move toward a central position in the creation of women's fashions and their path from the anonymity of this foundational period to the increased visibility of the modern era.

WOMEN DRESSING WOMEN?

The right for women to create female fashions was not always assumed. Rather, as historian Jennifer Jones has described, it was a "hard-won privilege" that emerged in the seventeenth and eighteenth centuries, when women's roles in the field were professionalized.[2] France, which arose in this era as Europe's fashion leader, made consequential changes within its highly regulated industry that enabled women's expanded participation; these developments were also echoed in other European centers of fashion in which the trade was not as rigidly structured.

Through the mid-seventeenth century, male tailors maintained their long-held monopoly on the production of fashionable clothing for men, women, and children in France, as was also the norm in Europe more broadly. As the century progressed, however, and as fashion grew in importance in France's economy, women would become integral to the industry. Louis XIV, who reigned from 1643 until his death in 1715, recognized the economic and cultural potential of fashion, using his court and its rich and ever-changing modes to establish France's ascendance in this domain. The king's finance minister, Jean-Baptiste Colbert, worked to place France at the heart of European fashion commerce, supporting the development of the textile industry and expanding the production of luxury goods that became in demand at home and abroad. Colbert also took steps to alter the guild system that governed the artisanal trades, including fashion. He drafted new rules for guild members and incorporated additional trades, changes that were intended to assure the excellence of goods across industries and to help secure France's international reputation.[3] The guilds, aside from regulating product quality, provided protections and support for their members. Guild rules established training requirements for new entrants and determined who could engage in a particular profession, effectively limiting access to the relatively privileged in French society, as the majority of guilds only accepted members who were male and Catholic.[4] At the start of Louis's reign, male tailors held the exclusive right to make women's fashionable dress. Although female seamstresses also worked within this sphere, they did so illegally and without the benefits afforded to incorporated workers.[5] Similarly, in England, where restrictions surrounding the clothing trades were less rigid, tailors were the primary producers, while women made a finite range of items of relatively simple construction, such as neckwear and chemises.[6]

Men and women who worked in—or aspired to work in—the French fashion trades recognized the financial potential of this growing industry as keenly as the king and his ministers. As Colbert moved to expand the guilds and incorporate new trades, seamstresses in Paris advocated for the right to produce women's fashions and for the establishment of their own guild. To support their case, they argued that these new privileges would also benefit their female clients by protecting their modesty. Creating custom garments required

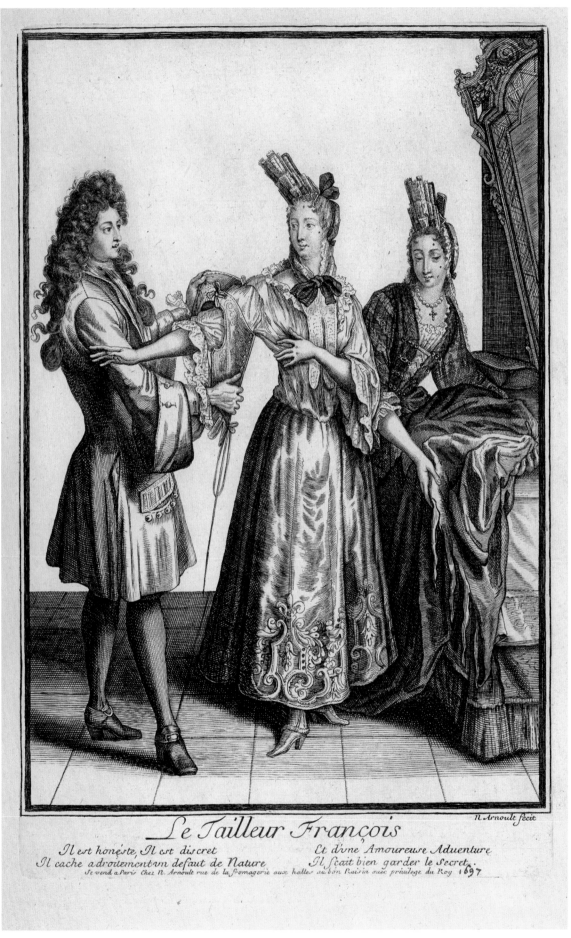

Il est honeste, Il est discret
Il cache adroitement un defaut de Nature

Et d'une Amoureuse Aduenture
Il sçait bien garder le Secret.

Se vend a Paris Chez N. Arnoult rue de la fromagerie aux halles au bon Raisin auec priuilege du Roy 1697

Le Tailleur François

N. Arnoult fecit

Fig. 2. Nicolas Arnoult (French, active 17th century). *Le Tailleur François* (*The French Tailor*),
from *Livre curieux des modes sous Louis XIV*, ca. 1695

the taking of measurements (fig. 1) or the draping of fabric on a woman in a state of undress; when fitting a pair of stays or a boned bodice, for example, a tailor would need his client to be dressed in only a chemise and petticoat (fig. 2). Given this intimacy, seamstresses contended that it was in the interest of women clients to have the option of being dressed by someone of their own gender.[7]

In 1675 their request was granted, and a guild of women dressmakers was formed. Along with permission to make children's dress, they were given the right to make women's garments, including dressing gowns, petticoats, informal bodices and jackets, *manteaux*, and chemises. They were explicitly prohibited, though, from producing the core components of elite women's formal dress: the heavily boned bodice and trained overskirt that were requisite for appearances at court.[8] This restriction might have seemed to perpetually safeguard the preeminence of the tailor, as he retained the exclusive right to produce the most costly and prestigious women's garments. However, court dress ultimately did not represent the future of fashion. By the early eighteenth century, these items were worn on an increasingly narrow set of occasions, Versailles was becoming less influential over new developments in dress, and the elegantes of Paris were ushering in a preference for looser, more informal styles.

An important precedent for these more relaxed garments was the mantua, or manteau, a gown that originated in the 1670s and that women dressmakers had the right to produce. The style was a significant development; as fashion curator Avril Hart has articulated, it was "the first major item of dress made by women for women."[9] The mantua evolved from negligee dress that was confined to more intimate or private contexts to a fashionable garment appropriate in public settings, worn over stays and a visible petticoat. Constructed similarly to the robe de chambre, the mantua had a simple, kimono-like cut. Its appeal lay in the fact that it was less cumbersome to wear than the boned bodice and overskirt (fig. 3). Additionally, despite its straightforward construction, the mantua could mimic the silhouette of the more formal ensemble once its skirt was draped gracefully around the hips and its waist tied with an elegant belt (fig. 4).

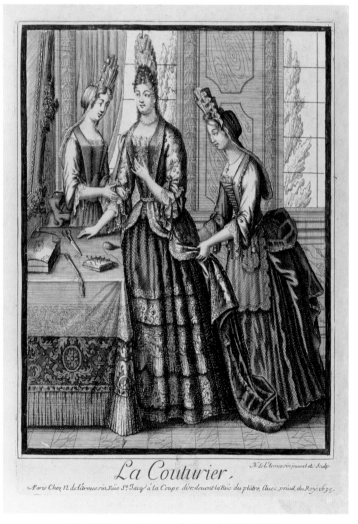

Fig. 4. Nicolas de Larmessin (French, 1684–1755). *La Couturier* (*The Dressmaker*), from volume 3 of *Recueil de modes*, 1695

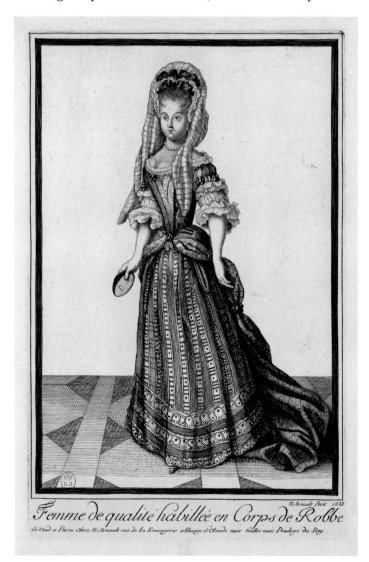

Fig. 3. Nicolas Arnoult (French, active 17th century). *Femme de qualité habillée en Corps de Robbe* (*Noblewoman Wearing a Dress Bodice*), from *Livre curieux des modes sous Louis XIV*, 1688. Etching, 11 ⅝ x 7 ⅝ in. (29.7 x 19.5 cm)

As historian Clare Crowston has demonstrated, although male tailors also had the legal right to create mantuas, women dressmakers quickly capitalized on the opportunity and became the principal makers of this popular item. The style did not require tailoring expertise to produce. Rather, it could be made based on dressmakers' existing knowledge of garments such as the robe de chambre. Since its use extended beyond aristocratic women, it also offered the advantage of a large customer base.[10] This crucial garment helped to set the stage for women to become the primary makers of female fashions, as the mantua was the precursor to the styles that defined fashionable dress in eighteenth-century Europe, including the *robe à la française* and the *robe à l'anglaise*, each of which was produced by women dressmakers.

Although dressmakers were gaining professional ground, they worked throughout this period in anonymity—that is, they neither enjoyed widespread acclaim as individuals nor attached their names and reputations to their work in a lasting way. Earning greater prestige were the *marchandes de modes*, or fashion merchants, who were responsible for the enlivening touches that could make an ensemble seem unique and at the cutting edge of fashion. They not only sold fashionable accessories and embellishments, such as lace, ribbon, feathers, and artificial flowers, but devised novel ways to apply these trimmings to women's garments, accessories, and headdresses. The most successful among them—notably, Rose Bertin, Marie Antoinette's "minister of fashion"—achieved a kind of celebrity status.

The attention given to the most renowned *marchandes de modes* was owed not only to their association with prominent patrons but also to their growing reputations as innovators of fashion. Louis-Sébastien Mercier, in his *Tableau de Paris*, placed them in a class above dressmakers, describing them as artists with inexhaustible imaginations. Mercier likened them to architects, whereas dressmakers, he said, were more akin to stonemasons building a basic structure.[11] Dressmakers responsible for the creation of complete garments, rather than just the decorative touches that were the focus of the *marchandes de modes*, would not begin to gain similarly celebrated status until the late nineteenth century, when they too emphasized the artistry and invention inherent in their work.

Through the eighteenth century, a period of shifting opportunities in fashion, women and men continued to compete for the privilege of creating specific items of women's dress, such as stays. Dressmakers in France articulated an expanded argument for the right to produce the full array of women's clothing. They emphasized that this work was especially important to women, as it was one of the few professions open to them and therefore one of their only means of earning a livelihood.[12] This assertion was taken a step further by contemporaries who argued that not only were women uniquely dependent on this profession as a means of earning a living but that it was a natural, inherent right for them. Jean-Jacques Rousseau described the making of clothing as "women's work" corresponding with an allegedly innate interest in dress and with women's supposedly more delicate nature. After all, he argued, a man's "large hands" were "made to blow the forge and strike the anvil," not wield the needle.[13]

Although women were granted the privilege of making female dress, they were awarded this right based on the assumption that their particular nature was weaker and that this was one of the only areas where they could thrive. The idea of dressmaking as a "natural" occupation for women continued to advance not only in France but more broadly in Europe and in the United States, furthering their fundamental role in fashion in the nineteenth century.

DRESSMAKER TO DESIGNER: DEFINING A PROFESSION

There is not an individual to be found in the several classes of society of greater importance than the "Dressmaker."
The Ladies' Pocket Magazine, 1828

The nineteenth century would advance varied perspectives on dressmaking, including the idea that it could be seen as an art and its practitioners as artists worthy of a more illustrious status. Remaining constant, though, was the centrality of the dressmaker in the creation of women's fashions. The role continued to be crucial for female consumers, for the fashion industry itself, and for women seeking professional employment. For clients, dressmakers played a vital function, helping to define their self-presentation and social standing. As the intricacy of women's fashion prevented most garments from being ready-made, the custom dressmaker was guaranteed a primary role in their design and production. The occupation also remained a critical opportunity for women, who had few comparable professional paths open to them.

The century opened with an understanding of dressmaking as "women's work." In France, where the guild system was abolished during the Revolution, women's ability to continue to work in the fashion professions was assured by the idea of its inherent appropriateness for them.[14] A similar outlook prevailed in the United States, where dressmaking was seen as aligning with a woman's conventional responsibilities in the home and, therefore, as a socially acceptable step outside the domestic sphere.[15]

The perception of dressmaking as a natural occupation for women gave them an advantage in the field but also limited their opportunities to this area. The notion that this work was an extension of domestic duties, such as simple household sewing, also belied the professional's hard-earned skills. While most women would indeed have had at least basic sewing abilities, expert knowledge of cutting, fitting, and finishing was built over many years, often beginning with an apprenticeship under an experienced dressmaker. The increasing complexity of women's fashions necessitated an ever more sophisticated set of skills to achieve the

superb fit and harmonious design that clients expected. Early nineteenth-century designs featured subtle but intricate embellishments, such as the delicate puffs popular in the 1820s, while retaining a relatively simple construction (fig. 5). By the late nineteenth century, however, fashions were characterized by layers of adornment including elaborate pleating, ruching, and trimming, as well as more emphatic silhouettes that required precise fitting (fig. 6). As one dressmaker—the author of a garment drafting system—described in the 1880s: "Dressmaking is not what it was ten years ago, for within the last few years the tendency of the times has called forth the most artistic skill. The close-skin-fitting busts and sleeves of to-day require scientific cutting and fitting. A fault at once shows itself, and disfigures the wearer; consequently, it is more essential to ladies to have perfect-fitting garments now than it has been at any previous time."[16]

Fig. 6. Dinner dresses, from *La Mode illustrée*, 1882

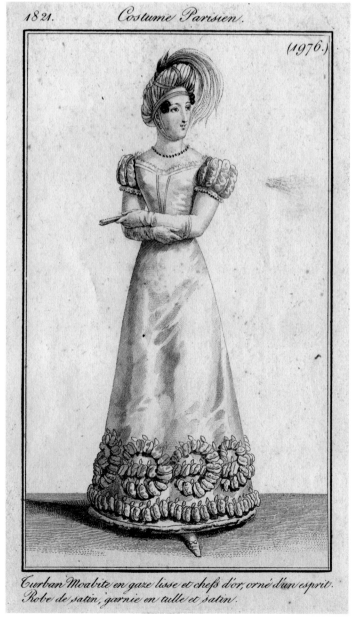

Fig. 5. Evening ensemble, 1821

The high level of expertise required to create women's fashions ensured that talented dressmakers remained in great demand. Given that dressmaking could offer steady work, it was a desirable occupation for women, one that offered the real possibility of economic and social advancement, along with the autonomy that came with managing one's own business and the satisfaction of engaging in creative work.[17] It was well paying in relation to wage work available to women in different industries and even in comparison to other employment within the needle trades; in contrast to seamstresses, for example, who executed sewing work for others, dressmakers could earn several times their wages.[18] Although it was difficult to achieve sustained success, for those able to maintain businesses over a number of years, there was the potential to gain economic independence—one of the few avenues to financial stability other than through marriage.

Although dressmaking was an attractive profession that offered economic and other advantages, one benefit it did not often provide was broad recognition for one's work. Unlike modern designers, whose names might become widely known and associated with certain artistic trademarks, dressmakers for much of the nineteenth century were rarely elevated as individual creators. Fashion journals concentrated on relaying the latest trends—favored colors, novel fabrics and trimmings, or preferred silhouettes—rather than focusing on named dressmakers.[19] The limited emphasis on specific makers was tied to the way in which their work was perceived: as a product of technical skill more than unique artistic vision, and as the result of design direction from both dressmaker and client.

Greater attention to individual dressmakers came in the late nineteenth century, as some were acknowledged for their artistic talents and personal ingenuity, a change that helped usher in the modern notion of the designer—someone recognized by name for their distinct creative concepts. An important catalyst for this shift was the couturier Charles Frederick Worth, who founded his Parisian couture house in 1858 and was one of a number of male dressmakers who gained prominence in the late nineteenth century. As these men were successful in a field considered conventionally female, their gender quickly became a point of discussion. "Would you believe," wrote Charles Dickens in the early 1860s, "that, in the latter half of the nineteenth century, there are bearded milliners—man-milliners, authentic men, men like Zouaves—who, with their solid fingers, take the exact dimensions of the highest titled women in Paris?"[20] Some French commentary similarly recalled Rousseau's proclamations about fashion one hundred years earlier. The Larousse dictionary published in the 1860s, for example, contained an entry for *dressmaker* that proclaimed, "Here, under the Second Empire we see the reappearance of those unspeakably peculiar men (are they really men?) presiding over the clothing of women. . . . This is a trend we sincerely hope will not become a general practice. . . . Let feminine hands have the privilege of constructing clothing for mothers, wives, sisters. To them leave the delicate tasks that require a skillful touch,

not an athlete's strength."[21] Although these remarks highlight ingrained views regarding dressmaking and gender, they did nothing to deter the rise of male dressmakers such as Worth, whose fame was only enhanced by the novelty of being a "man-milliner."[22]

Worth achieved preeminence as a leading arbiter of fashion in Europe and the United States, where his designs as well as his approach to fashion enjoyed far-reaching influence. The couturier styled himself as an artist, presented designs to his clients rather than rely on their direction, and was a pioneer in labeling garments with his name. The practice of labeling was, like an artist's signature, an assertion of creative ownership. As Worth reportedly said of his role, "My business is not only to execute but especially to invent."[23] Making a distinction between *executing* and *inventing*—between crafting garments and originating new ideas—Worth was setting himself apart from dressmakers whose output was more heavily shaped by the work of others or by direction from clients.

Worth's language of artistic genius was echoed in popular periodicals, where he was praised for his "genius for invention" and for raising dress to the status of "a fine art."[24] Dressmaking was increasingly spoken of as an artistic endeavor, acknowledging that, at its most successful, it required a combination of technical skill as well as creativity. In alignment with this perception, and as a means of building name recognition, "signing" one's work with a label became increasingly common. Many European and American dressmakers adopted this practice, stitching a waist tape bearing their names into their garments, thereby directly connecting themselves with their creations.

As the prevailing understanding of the profession continued to evolve, the criteria for achieving the elevated status of artist-creator were discussed in sources aimed at both consumers and professionals. The author of one late nineteenth-century handbook for American dressmakers opened her publication by stating, "There are dressmakers and [there are] dressmakers." Paralleling Worth's outlook, she delineated the differences between the "artisan dressmaker" and the "artist dressmaker," the former focusing solely on the mechanics of cutting and sewing, and the latter viewing each garment as a unique creation, an artistic whole. She went on to suggest that the industrious artist dressmaker could become highly successful, her "fame spread[ing] fast and far."[25]

The ability to create well-designed and well-constructed fashions was typically not enough to garner "fame"—that is, broad recognition and appreciation for one's work. Artist-designer status was reserved for those seen as creators—ones viewed as not only interpreting trends but directing them. Those who attained that level of acclaim, and who were the focus of contemporaneous fashion reporting, were primarily heads of the large Parisian couture houses that were considered leaders in originating new styles that would be widely copied or translated by others in Europe and the United States. In a typical example of the elevation of these entities as ultimate fashion authorities, *Harper's Bazaar* suggested

in the fall of 1893 that American modistes had taken in "the latest novelties from the *ateliers* of Worth, Rouff, Paquin, Félix, and Doucet," which "settle[d] beyond doubt the fashions of the winter."[26]

Most dressmakers—the majority of whom remained women—worked on a smaller scale, lacking the reach of the grand *maisons de couture*. Although the influence of these leading houses was widespread, skilled independent dressmakers were not simply copying these sources but interpreting them to create designs that best suited their own clients. However, as they were shaping fashion at an individual rather than universal level, they did not gain the loftier status of originators or the broader reputations of the most prominent houses.

If widespread name recognition remained elusive for most, criteria were being established for individuals to be acknowledged for their contributions to fashion. Although these developments created heightened expectations for fashion professionals, they also set the stage for more women to gain visibility in the twentieth century, when many female designers were recognized as leaders of fashion and appreciated for their distinctive bodies of work.

DRESSMAKER TO DESIGNER: A LINEAGE

For most dressmakers working in Europe and the United States prior to the twentieth century, anonymity was a condition of the profession. Their personal achievements were not amplified by the industry, nor were their names connected to their work in an enduring way. The eventual move toward greater visibility and lasting reputations was tied to the rising idea of fashion as an artistic endeavor and of the dressmaker as a creator—as a "designer." This change also shifted expectations. To achieve designer status, to gain widespread recognition by name, it was not sufficient to execute finely crafted garments conceived to meet the needs of particular clients. It was also necessary to be seen as guiding the direction of fashion. Those without the platform to exert such sweeping influence were not as readily recognized for their individual skill or ingenuity.

Fashion history has similarly been defined by this emphasis, privileging the work of those with the broadest reach and sway, with lesser attention given to makers working on a smaller scale, shaping fashion in more subtle ways. Recent and ongoing work by fashion historians, though, has uncovered and expanded on the narratives of lesser-known designers and their work in this period and later, some of whom are examined in the succeeding essays of this publication. Although few of the mostly female dressmakers working prior to the twentieth century can be identified by name or linked to their individual designs, they can collectively be acknowledged for their contributions to the development of fashion and credited as the "ancestors" to the modern women designers explored in the following essays and genealogy.

1 Edith Abbott, *Women in Industry: A Study in American Economic History* (New York: D. Appleton, 1910), 216. Cited in Marla R. Miller, "Dressmaking as a Trade for Women: Recovering a Lost Art(isanry)," in *A Separate Sphere: Dressmakers in Cincinnati's Golden Age, 1877–1922*, ed. Cynthia Amnéus, exh. cat. (Cincinnati, Ohio: Cincinnati Art Museum; Lubbock: Texas Tech University Press, 2003), 1.
2 Jennifer M. Jones, *Sexing La Mode: Gender, Fashion and Commercial Culture in Old Regime France* (Oxford: Berg, 2004), 77. Jones is specifically referring to events that took place in France, though a similar pattern is echoed in other European countries as well.
3 Pamela A. Parmal, "La Mode: Paris and the Development of the French Fashion Industry," in *Fashion Show: Paris Style* (Boston: MFA Publications, 2006), 19–20.
4 Clare Haru Crowston, *Fabricating Women: The Seamstresses of Old Regime France, 1675–1791* (Durham, N.C.: Duke University Press, 2001), 180. Crowston also discusses exceptions to this; see 180–82.
5 Crowston, *Fabricating Women*, 185–87.
6 Avril Hart, "The Mantua: Its Evolution and Fashionable Significance in the Seventeenth and Eighteenth Centuries," in *Defining Dress: Dress as Object, Meaning and Identity*, ed. Amy de la Haye and Elizabeth Wilson (Manchester, U.K.: Manchester University Press, 1999), 93.
7 Jones, *Sexing La Mode*, 82.
8 Crowston, *Fabricating Women*, 31. On the components of women's court dress, Pascale Gorguet Ballesteros, "Caratériser le costume de cour: propositions," in *Fastes de cour et cérémonies royales: Le Costume de cour en Europe, 1650–1800*, ed. Pierre Arizzoli-Clémentel and Pascale Gorguet Ballesteros (Paris: Réunion des musées nationaux, 2009), 58.
9 Hart, "Mantua," 93.
10 Crowston, *Fabricating Women*, 40–41.
11 Louis-Sébastien Mercier, *Tableau de Paris* (Amsterdam, 1789), 11:133.
12 Jones, *Sexing La Mode*, 84.
13 Jean-Jacques Rousseau, *Emile, ou de l'éducation* (Paris, 1762), 3:63, 65. Cited in Crowston, *Fabricating Women*, 65.
14 Crowston, *Fabricating Women*, 67.
15 Amnéus, *Separate Sphere*, 16.
16 Elizabeth Gartland, *The American Lady-Tailor Glove-Fitting System of Dress-Making, from Experience and Practice* (Philadelphia, 1884), 12. Cited in Claudia Brush Kidwell, *Cutting a Fashionable Fit: Dressmakers' Drafting Systems in the United States* (Washington, D.C.: Smithsonian Institution Press, 1979), 45.
17 On the advantages of dressmaking as an occupation for women, as well as the barriers to success, see Wendy Gamber, *The Female Economy: The Millinery and Dressmaking Trades, 1860–1930* (Urbana: University of Illinois Press, 1997), especially chap. 2, "A Precarious Independence: Female Proprietors in Gilded Age Boston," 25–54.
18 Gamber, *Female Economy*, 12.
19 As typical examples, see for instance *Le Moniteur de la mode*, May 1852, 66–76; *La Mode illustrée*, April 7, 1872, 105–10.
20 Charles Dickens, "Dress in Paris," *All the Year Round*, February 28, 1863, 9. Cited in Valerie Steele, *Paris Fashion: A Cultural History*, 2nd ed. (Oxford: Berg, 1998), 251.
21 Pierre Larousse, *Grand Dictionnaire universel du XIXᵉ siècle* (Paris: Administration du grand Dictionnaire universel, 1869), 5:417. Cited in Philippe Perrot, *Fashioning the Bourgeoisie: A History of Clothing in the Nineteenth Century*, trans. Richard Bienvenu (Princeton, N.J.: Princeton University Press, 1994), 187.
22 Steele, *Paris Fashion*, 251.
23 F. Adolphus, *Some Memories of Paris* (Edinburgh: William Blackwood and Sons, 1895), 190. Cited in Elizabeth Ann Coleman, *The Opulent Era: Fashions of Worth, Doucet, and Pingat* (London: Thames & Hudson, 1989), 33.
24 On Worth's "genius for invention," see "Worth, the Paris Dressmaker," *Harper's Bazaar*, February 14, 1874, 117. On the idea that "Dress, with Mr. Worth is a fine art," see "The King of Fashion," *San Francisco Chronicle*, November 3, 1880, 6.
25 Catherine Broughton, *Suggestions for Dressmakers* (New York: Morse-Broughton, ca. 1896), 1, 3.
26 "New York Fashions: French Dresses," *Harper's Bazaar*, October 28, 1893, 883.

A CONSTELLATION OF COMETS AND SHOOTING STARS

New VISIBILITY *for* WOMEN *in* FASHION
(ca. 1900–1968)

Mellissa Huber

A CONSTELLATION OF COMETS AND SHOOTING STARS

New Visibility for Women in Fashion
(ca. 1900–1968)

Melissa Huber

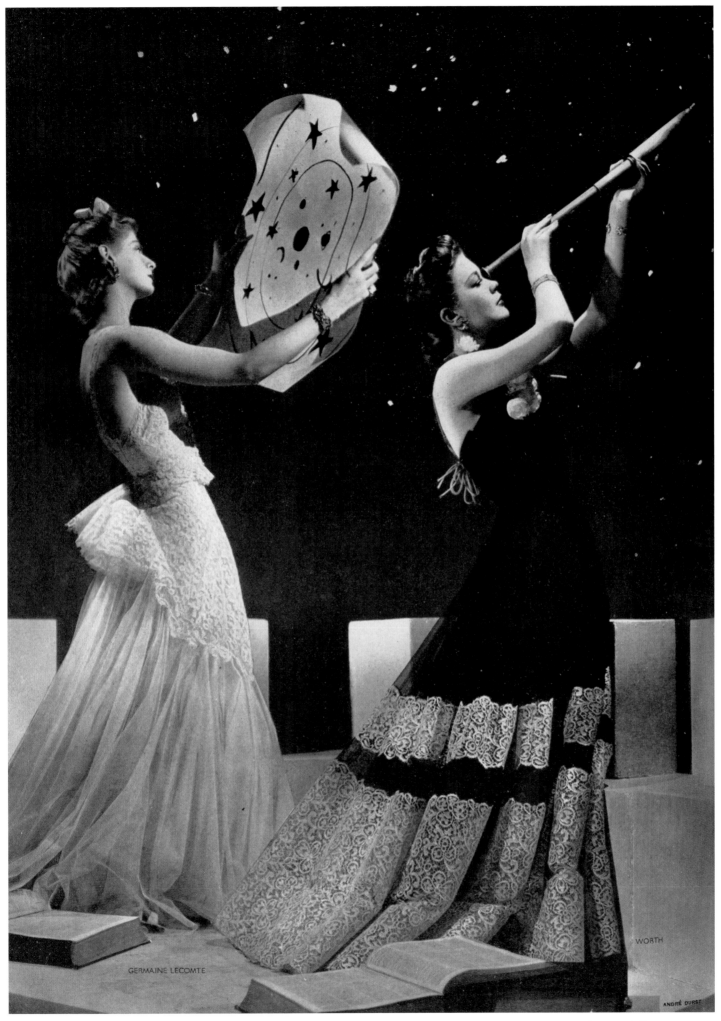

Fig. 1. Germaine Lecomte and Worth's "Paris Dream" dresses, *Vogue Paris*, April 1, 1940. Photograph by André Durst (French, 1907–1949)

Within the canon of fashion history, a trio of women loom especially large: Madeleine Vionnet, a couturier revered for her technical ingenuity; Elsa Schiaparelli, a creator of unrivaled imagination and wit; and Gabrielle Chanel, ostensibly the most famous fashion designer of all time. As Caroline Evans and Minna Thornton point out in their thoughtful account *Women & Fashion: A New Look*, "Vionnet, Chanel, and Schiaparelli feature in almost all the histories of twentieth-century fashion as established 'stars.'"[1] Assessments of their careers frequently classify them through design approach and personality in equal proportion, manifesting new roles as female creative archetypes. In the important work of Valerie Steele, they are characterized under the designations of technician or "professional dressmaker," "woman of style" or dandy, and artist or "socialite designer," respectively.[2] While these descriptions chart just a few of the ways in which women designers found entry and acclaim within a growing field, the indelible mark left by this triumvirate is particularly intriguing when considering the moment in which they emerged and the mythologies of their personas relative to their subsequent fame and success. This new degree of recognition, its force and potential, finds particular relevance in fashion and becomes especially amplified by the turn of the century, dramatically breaking with the relative obscurity that dressmakers worked in throughout prior periods in history.

While Vionnet, Chanel, and Schiaparelli stand out for their distinctive contributions to the industry, they were just three designers working within the complex, stratified, and deeply interconnected constellation of Parisian haute couture houses in existence by the early twentieth century. This was a moment of opportunity in which fashion companies rapidly ascended, often propelled by the stars of their creative leadership. The fates of these businesses—to shine, flourish, metamorphose, or disappear—became reliant on the designer in unprecedented ways as the industry expanded and mechanisms for promotion advanced, alongside challenges introduced through major events that included two world wars and the Great Depression. This essay considers the work of women in fashion during a period of growing visibility and recognition for the modern designer, a phenomenon that impacted men and women alike yet had particular significance for women makers and entrepreneurs. While the primary emphasis is on French haute couture—in response to the hegemony of France as a design locus during the era, and as reflected in the collection of The Costume Institute— this essay ends by considering female designers working in the United States during a moment of steadily increasing opportunity and including those who immigrated to Paris and New York to set up shops and spaces of their own prior to the full-fledged expansion of the ready-to-wear industry and the burgeoning boutique culture of the 1960s.

OBSCURE AND GREAT DRESSMAKERS

Brainerd's text is drawn from a 1905 article that describes a contemporary model for the "great dressmaker" who functioned as a type of design director, purchasing sketches from the equivalent of a freelance worker today. However, the implied barriers for the "obscure dressmaker," and their potential to garner the necessary capital and support to succeed independently, are equally illuminating.[3] Although men and women both actively participated in practices like selling sketches to more established houses, Wendy Gamber and others have acknowledged how opportunities during the nineteenth and early twentieth century were not defined by meritocracy but often linked to gender. Typically, "large-scale enterprise meant male enterprise. Women did not have vast amounts of capital at their disposal; rarely were they invited to join male partnerships."[4] This situation doesn't entirely change during an epoch in which the eponymous fashion house flourished, yet the profession of couturier, with its ranging methodological approaches and broadening business models, slowly became more accessible as this new role was continuously reconceived. Dominant forces like Charles Frederick Worth and Jacques Doucet emerged during the mid to late nineteenth century, as the profession came to be defined more closely by notions of taste, business acumen, and creative oversight—in opposition to the prior emphasis on technique and hand skill acquired through a dressmaker's training and apprenticeship. But closer examination reveals a variety of women-led houses that were also active and successful during this time.

Although they are rarely the origin of most fashion histories, highly influential women dressmakers were indeed working prior to the twentieth century—namely, Madame Germond, who dressed Empress Josephine, and Madame Palmyre, whom Empress Eugénie patronized.[5] Working on the rue Louis-le-Grand in Paris, Madame Roger can be considered a predecessor to Worth in that she combined material selection and garment production under one roof.[6] Couturiers

like Madeleine Laferrière and Henriette Favre or the house of Morin-Blossier created luxurious garments for an influential and aristocratic clientele. Despite obstacles, many women found ways to launch businesses or advance through the ranks of others, following one of the few career paths available to them that, propitiously, provided some of the greatest social, financial, and creative rewards on offer. Several of these women-led houses would reach their greatest success over the next decades during a period of considerable invention and change in fashion that led to a unique moment during the 1920s and 1930s in which women slightly outnumbered their male counterparts as creative leaders.

BUSINESS HEADS AND FIGUREHEADS

Madame Paquin rules, queen-like, today, in the light, as she did, queen-like, in other days, in the shadow.

Sloane Gordon, "The Czarina of Dress"

One of the earliest women-led fashion houses, Paquin exemplifies the common familial structure of nineteenth-century enterprise. The house was founded in 1891 by investor and business manager Isidore Jacob dit Paquin and his wife, Jeanne Marie Charlotte Beckers, a former mannequin and midinette who assumed responsibility as head designer.[7] Within just a few years, Paquin became regarded as among the most important Parisian houses, known for its fashionable and luxurious garments, the comfort and elegance of its salons, and, most especially, the charm of its leading couple.[8] Although much acclaim went to Isidore for his role as figurehead, Jeanne became equally recognized for her aptitude in creation as well as for modeling Paquin designs. If Isidore came to be seen as the embodiment of the young, male, modern designer who functioned as an art director, Jeanne came to personify the house of Paquin itself, demonstrating the promise of beauty and transformation that its clothing could bestow.

The year 1900 was a tipping point, as Paquin was instrumental in the collective presentation of Parisian haute couture at the Exposition Universelle, and Jeanne was selected by her peers to serve as president for this endeavor. Her creative influence was palpable in several elements of the fair, foremost through her design of the ensemble worn by Paul Moreau-Vauthier's towering sculpture that came to be known as *La Parisienne* (fig. 2).[9] Inside the pavilion, the Paquin booth displayed a wax figure of Jeanne seated at a dressing table that went even beyond the surrogacy of *La Parisienne* to capitalize on the designer's unique role, channeling her proximity to her customer base and explicitly linking the maker with the house. Although Charles Frederick Worth wasn't the first to use live models—which was an existing practice for mercers and became common for high-end dressmakers by the turn of the twentieth century[10]—the participation of his wife, Marie Augustine Vernet Worth, may have infused the act with new meaning. Through her modeling, she elevated the social

station of the couple through dress by symbolically placing them on similar grounding with their elite clientele. Jeanne Paquin's ability to do the same, in her more active role as designer, not only manifested the ideals of the house but simultaneously presented her as a new type of fashion authority.

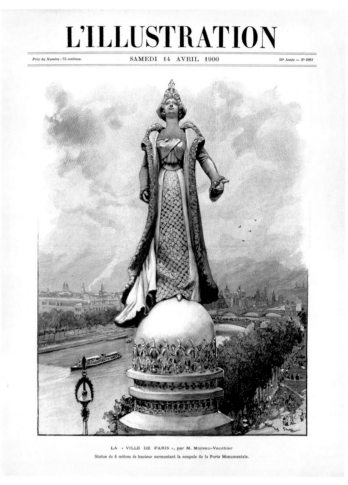

L'ILLUSTRATION

Prix du Numéro : 75 centimes. SAMEDI 14 AVRIL 1900 *58e Année — No 2981*

LA « VILLE DE PARIS », par M. Moreau-Vauthier.
Statue de 6 mètres de hauteur surmontant la coupole de la Porte Monumentale.

Fig. 2. Cover illustrating the main entrance to the 1900 Exposition Universelle, with a detail of *La Parisienne*, *L'Illustration*, April 14, 1900

When Isidore passed away in 1907, Jeanne assumed direction of Paquin.[11] By 1912 she was described as "a brilliant figure in the woman's movement of today," the author adding, "for it is seldom that such tremendous business success is coupled with so much youth and beauty and generosity."[12] While her aptitude for design was perceived as innate and feminine, her business success was consistently defined as a masculine attribute. As Anne Rittenhouse observed, "It was probably Mme. Paquin's taste in dress that put her at the head of the house after her husband's death, but it is her masculine knowledge of business that keeps her there."[13]

A similar dynamic occurred with Louise Lemaire Chéruit, who cofounded Huet et Chéruit with Marie Huet in 1898.[14] Although Chéruit did not sew, she was described as "a magnificent model and critic" with a perfectionist's approach to design who worked with her staff to drape directly on her own figure.[15] Similar to Paquin, Chéruit's hospitality within the cultivated atmosphere of her salon invested the commercial space with an element of comfort and privacy, akin to a domestic environment, while simultaneously positioning

the designer as a highly visible fashion leader (fig. 3).[16] Like Paquin, artists such as Paul César Helleu regularly painted Chéruit, which further served to burnish the reputation of the couture house by highlighting the renown and appeal of its creative figurehead.

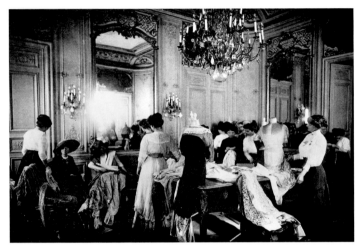

Fig. 3. Maison Chéruit, 1910. Photograph by G. Agié (Jacques-Gabriel François Agié) (French, 1871–1932)

In contrast to Paquin and Chéruit, the women who founded the formidable house of Callot Soeurs were almost never seen—though this seems to have only heightened their mythology. Four sisters—Marie Gerber, Marthe Bertrand, Joséphine Crimont, and Régina Tennyson-Chantrell—founded Callot Soeurs under their maiden name in 1879.[17] The familial nature of the business benefited from the financial support of their father and the artistic upbringing of both parents—notably, their mother, Eugénie, was a skilled embroiderer and lacemaker. Accordingly, their initial business was a shop that sold lingerie, blouses, passementerie, and antique lace. They established their couture house by November 1895 and quickly came to be admired for their opulent creations comprising luxurious textiles with rich details and embellishments that frequently incorporated hints of Eastern dress. Marie Gerber served as head designer, dressing many influential actresses of the period, including Ève Lavallière, Jane Renouardt, and Cécile Sorel, while the house's list of international clientele included similarly well-known women, such as the American socialite Rita de Acosta Lydig, for whom they would skillfully reincarnate antique lace into new confections (see p. 99). Gerber's granddaughter Lydie Chantrell and her former *première d'atelier* Madeleine Vionnet described how Gerber did not sew traditionally but, rather, approached the design process through draping to construct fashions that enfolded the body in new ways.[18]

In 1914 *Vogue* likened Callot Soeurs to "the three fates" (Joséphine Crimont passed away in 1897), remarking that "there are many in the world who give them the credit of controlling the destiny of fashion."[19] Although the sisters were outside the public eye, the prestige of the house became well documented, as recorded in the pages of Marcel Proust's acclaimed 1913 novel *À la recherche du temps perdu*, and as

depicted on the backs of their influential clientele by artists such as the painter Giovanni Boldini and the photographer Adolph de Meyer. This, along with the recognition that Vionnet would later grant them in shaping her own accomplished career, may be why Callot Soeurs is still remembered today while other houses from the period—such as Boué Soeurs—have been forgotten.

Another family-run enterprise, Boué Soeurs was primarily a partnership between sisters Sylvie Boué de Montegut and Jeanne d'Etreillis, who shared creative oversight of the house, while Sylvie's husband, Philippe Montegut, helped to manage the multiple locations of the international business. Founded in 1897 and active for an impressive sixty years, Boué Soeurs became known for its adoption of romantic, historically inspired garments that recalled eighteenth-century French culture, as echoed in its use of the painter Élisabeth Louise Vigée Le Brun's 1786 portrait of the actress Madame Molé-Reymond in their advertisements.[20] Boué Soeurs was especially celebrated for its delicate lingerie frocks, whitework and fine cotton textiles, and lingerie, with a particular affinity for filet lace. Montegut and d'Etreillis were among a group of designers who favored the full-skirted robe-de-style silhouette of the 1920s, frequently embellishing the garments with clusters of silk flowers that became a signature of the house's rococo sensibility (see pp. 102–3).

RISING STARS

*I shall never forget the wall of prejudice which I had
to storm. . . . Old family friends came and solemnly
warned me and my mother of the utter impossibility of
my going into "trade"[;] . . . the very word was spoken
with bated breath, as though it was only one shade
better than going in for crime. I was told that nobody
would know me if I "kept a shop"; it would be bad enough
for a man but for a woman it would mean social ruin.*

Lucy Duff-Gordon, *Discretions and Indiscretions*

Some women entered fashion by necessity, or against challenging odds, yet established businesses of incredible influence and longevity. Despite initial discouragement, the designer Lucy Christiana Duff-Gordon, who became known by the mononym Lucile, began her career in 1893 as a self-taught dressmaker in London after her husband abandoned her and their young daughter. Initially, Lucile oversaw every step of the process—sketching, cutting, sewing, and even delivering the garments to her clients—relying on word of mouth to promote her work with no capital to draw from. However, she quickly achieved a level of success that secured backing and allowed her to grow her business internationally. Her designs introduced a lightness to dress, prioritizing diaphanous fabrics like chiffon (see p. 104) that catalyzed her expansion into the production of accompanying underclothes she described as "delicate as cobwebs and as beautifully tinted as flowers."[21] Although her feminine

A CONSTELLATION OF COMETS AND SHOOTING STARS

garments, tinged with exoticism, were not revolutionary, Lucile was highly visionary and among the vanguard of those exploring the performative potential of fashion. She introduced a stage to her couture house, used amusing nomenclature for her designs, and embraced interdisciplinary elements of music, dance, and theater, working closely with her models to foster dynamic presentations. She also pursued alternate forms of visibility by regularly contributing to publications like *Harper's Bazaar*. Her writing was published internationally throughout her lifetime, and significantly, Lucile was one of the first designers to author an autobiography; *Discretions and Indiscretions* (1932) afforded her the empowering opportunity to document and shape the narrative of her life.[22]

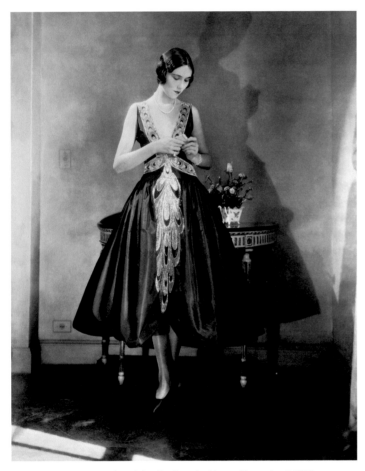

Fig. 4. Jeanne Lanvin's robe de style, *Vogue*, November 1, 1926. Photograph by Charles Sheeler (American, 1883–1965)

Jeanne Lanvin likewise sought financial stability through fashion. She lost her parents at a young age and, as the eldest sibling of eleven, began training in millinery at thirteen. By 1889 she had established a Parisian millinery label without any financial assistance.[23] Her first marriage resulted in a daughter, Marguerite di Pietro, around whom much of the house legend centers.[24] As she nurtured her millinery business, Lanvin began to design clothing for Marguerite.[25] These exquisite confections, rich with sophisticated detail, captured the eye of her customers. Growing commissions catalyzed the introduction of a children's department, and Lanvin expanded into women's dress, registering as a couturier in 1909.[26] Her fashions were widely published, and Lanvin became the designer perhaps most synonymous with a popular garment type known as the robe de style (fig. 4). Its full-skirted dress offered an expansive canvas for the intricate embellishments that the house excelled in, culled from Lanvin's careful study of global art, culture, and costume history.

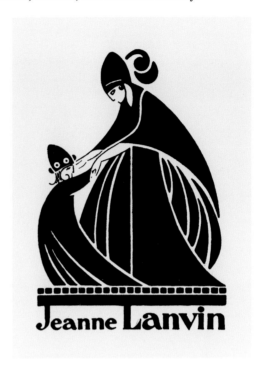

Fig. 5. Lanvin design house logo, 1921. Illustration by Paul Iribe (French, 1883–1935)

In 1921 the illustrator Paul Iribe created the logo after a photograph of Lanvin and her daughter in costume for a fancy dress ball (fig. 5).[27] While this image projects whimsy, imagination, and the range of the couture house offerings, it significantly underscores the familial connection, promoting an aspect of traditional femininity that was particularly palatable in France following World War I, when the pronatalist movement was underway.[28] Motherhood was a theme regularly illustrated within Lanvin advertisements, invitations, and fashion editorials. In addition to promoting products of the house, the motif positioned the designer's work as an expression of her motherly love. Although her devotion to her daughter is palpable—Lanvin continued to clothe Marguerite from childhood through adulthood, when she came to be known as Marie-Blanche de Polignac (see pp. 112–13)—to perceive Lanvin's dedication to her craft as solely rooted in maternal love risks obscuring the great ambition and scope of her accomplishments. As a mother and an older sibling who sought to provide for her family, Lanvin found ways to ingeniously and wholly intertwine her personal and professional lives. The longevity of the Lanvin brand and the scale of the house's activities are testaments to the dedication, innovation, and drive of this accomplished designer and businesswoman.[29]

Similar to Lanvin, Madeleine Vionnet entered fashion at a young age, starting her first apprenticeship at twelve. Her early career included tenures at Callot Soeurs—which

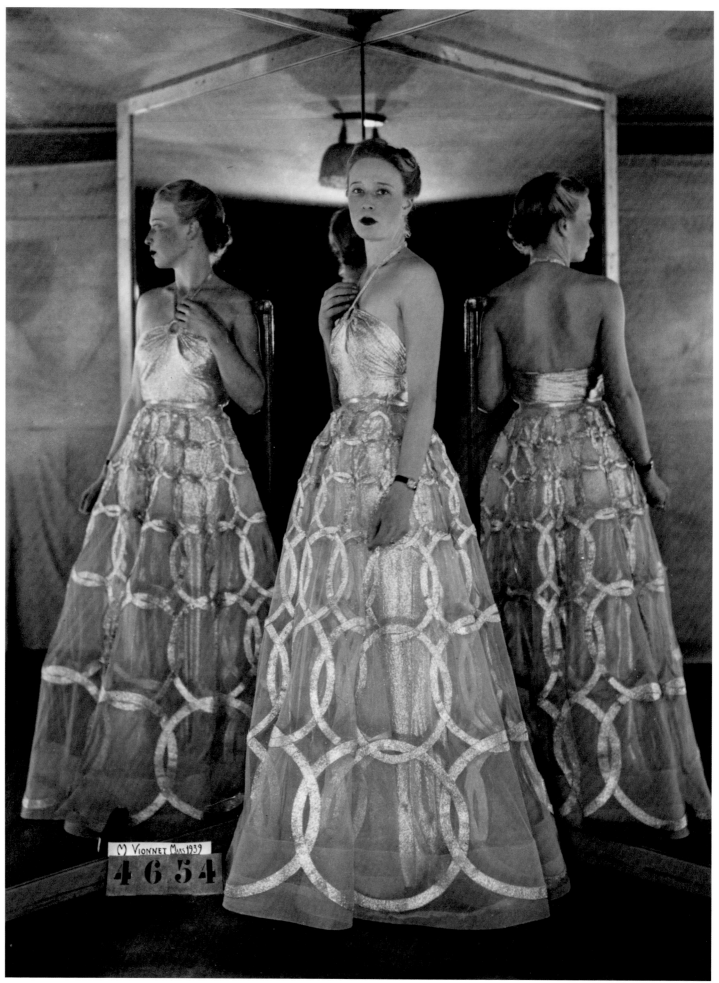

Fig. 6. Madeleine Vionnet registration photograph, summer 1939 collection

A CONSTELLATION OF COMETS AND SHOOTING STARS

Vionnet cited as instrumental to her evolution as a designer—and Doucet, before she opened her eponymous couture house in 1912.[30] Vionnet went on to establish herself as one of the most innovative and influential designers in fashion history. Her garments are marvels from a technical and artistic standpoint, renowned for their "architectural" cut and inventive forms that drew on complex conceptual ideas and introduced novel patternmaking techniques. Vionnet felt strongly that "a dress must never be unplanned; it must be sincere, genuine, have a starting point and develop the initial idea."[31] This ethos imbues all of her designs, which she worked through heuristically by draping directly on a reduced-scale figure. Her sophisticated taste resonated across every aspect of her business, from her elegant garments, to the design of her grand couture salon, to details like the logo for the house. Even the method of capturing registration photographs to protect her designs from being copied was thoughtful and refined, utilizing a V-shaped mirror to document the ensemble in the round (fig. 6).

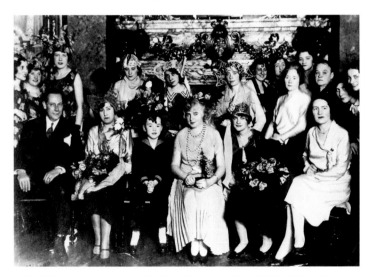

Fig. 7. Seamstresses dressed for Saint Catherine's Day with Madeleine Vionnet at center and Marcelle Chaumont at far right, 1930

Vionnet was deeply committed to advancing social conditions for her employees. Her modernized workrooms were well lit and ventilated and equipped with comfortable chairs. She provided onsite medical care and childcare, a cafeteria, paid vacation time, and funds to celebrate new births.[32] Vionnet had regretted her curtailed education, and she offered evening classes to her employees so that they might further develop their academic as well as dressmaking skills. Following couture traditions and to perpetuate camaraderie, the house observed holidays like Saint Catherine's Day on November 25, during which all of the single, twenty-five-year-old women would dress in costume for a celebratory feast and dance (fig. 7).[33] While the designer herself typically avoided taking center stage, the attention garnered from her highly successful fashion collections, the glamour of her international clientele, and the beauty and efficiency of her salon and workrooms served to keep a cultivated image of the house of Vionnet firmly within the spotlight throughout its activity.[34]

CONSIDERING THE BODY

The caricaturists of our grandmother's time made fun of the absurdities of the fashions of their day, and similarly the caricaturists of the present laugh at our modes. But if you compare Grévin and Guillaume with Sem and Caran d'Ache you will see that even our ridiculous fashions lean rather toward nature than away from it.

Jeanne Margaine-Lacroix

As the American historian Mary Louise Roberts has observed, fashion is often characterized as a "derivative expression of social changes already under way." In this sense, it is seen as an exclusively responsive medium that, as she describes, is "denied a historical dynamic of its own; it becomes a 'marker' but not a 'maker' of social change."[35] This notion is especially interesting relative to the shifts that occurred in dress throughout the first decades of the twentieth century, when women tried on new roles and clothes—namely uniforms—in response to events like war, while in the atelier many decisions resulted from the creative direction of women designers drawing on their own experience. Although it is tempting to trace events like Jeanne Paquin's introduction of Empire-waisted silhouettes around 1906 and Madeleine Vionnet's elimination of corsets and *fourreau* at Doucet in 1907 as defining moments,[36] the most dramatic changes in dress were already in the zeitgeist. As men and women collectively approached design from new perspectives during this period, the sheer quantity of voices, a new emphasis on youth, ranging methodological approaches, and the demands of female consumers all coalesced to impact developments in fashion.

While the lived experience and haptic aspect of wearing a garment cannot be discounted, neither can the relationship between the various layers of clothing and their tandem interaction with the body. These concerns inspired Jeanne Margaine-Lacroix, one of the earliest fashion designers to call for a renunciation of the corset. A talented artist and couturier, Margaine-Lacroix assumed direction of Maison Margaine following her mother's death in 1899.[37] Among her most notable innovations are her "Tanagréenne" dresses of 1889, followed by her robes "Sylphide," which advertised the replacement of stays with a built-in lining (fig. 8). Both styles drew on ancient source material and claimed an interest in seeking a natural line unconstrained by artificial corsetry. These designs were prescient in that they engaged with ideas related to dress reform yet applied them toward modifying contemporary fashions rather than presenting alternate versions of women's dress. Although collaborations with manufacturers such as Coronet Corset and H. W. Gossard Co. to produce and market "Sylphide" and "Sylphide-Fourreau" corsets undermined the conceit of entirely liberating the figure, Margaine-Lacroix's undergarments largely eliminated boning and incorporated front lacing and elastic knit textiles, allowing for greater movement and the "uncorseted effect" advertised by Gossard. Her clinging "Sylphide" gowns with built-in linings famously

caused a sensation for their slender, revealing silhouettes, and as Susie Ralph has pointed out, they relied on bias-draped textiles as early as 1907, foreshadowing the broader embrace of the technique by makers like Madeleine Vionnet, who became widely associated with this construction methodology.[38]

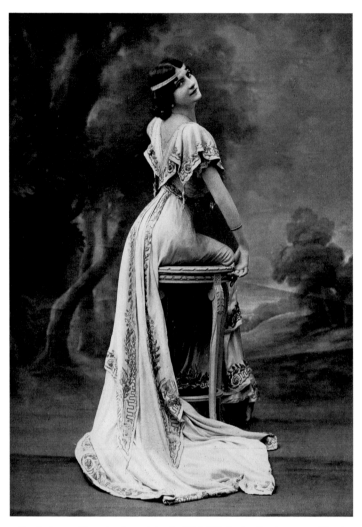

Fig. 8. Jeanne Margaine-Lacroix's robe "Sylphide," advertised as worn without a corset, *Les Modes*, May 1907. Photograph by Studio Felix

Although Vionnet championed the body-conscious designs of the 1930s, she had peers such as Germaine Émilie Krebs (known as Alix and, later, Madame Grès) (see pp. 8, 115) and Augusta Bernard (see p. 116) who were equally dedicated to achieving this symbiosis between figure and garment. Aside from their aesthetic affinities, what ultimately unites the work of these women is their skill as highly proficient seamstresses with a total mastery of their craft. Each worked in her own manner, but their techniques and innovations resulted from an intimate dual understanding of design and the body. Krebs preferred to work in seclusion, molding and draping her toiles directly on the form and tucking, pleating, and gathering to keep widths of fabric intact, reserving techniques like fluting for coordinated self-fabric details. Unlike Vionnet, Krebs draped her textiles somewhat freely, eschewing allegiance to proper bias or straight grain placement.[39] Augusta Bernard similarly liked to use straight grain cuts for her deceptively simple garments, though she would also drape on the bias, admitting that the weave of the textile was by necessity subservient to her design intent. Ultimately, her conception of the garment centered around an appreciation of the body and its needs. In 1933 she shared, "To me the dress is a living being. I wish it to breathe and move."[40] This dynamism is especially palpable in a George Hoyningen-Huene photograph from 1934 (fig. 9). The model Toto Koopman easefully makes her way down a set of stairs, her gown trailing and clinging, its sinuous curves rendering those of an adjacent statue static.

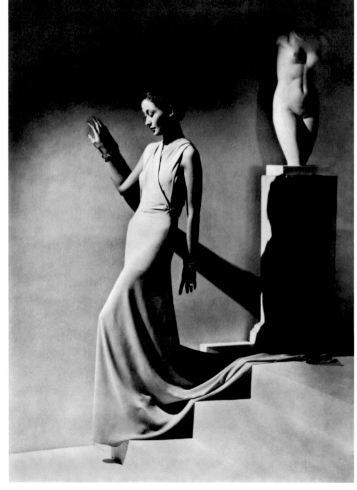

Fig. 9. Model Toto Koopman wearing an evening dress by Augustabernard, *Vogue*, September 1, 1934. Photograph by George Hoyningen-Huene (American, born Russian Empire, 1900–1968)

A CONSTELLATION OF COMETS AND SHOOTING STARS

Fig. 10. Design house logos for Germaine Lecomte, Louiseboulanger, and Madeleine Vionnet, 1919–26

THE DIGNITY OF THE BODY OR THE COSMOGRAPHY OF THE MICROCOSM

When a gown is perfect no one notices it;
one sees only the woman inside.

Marie-Louise Boulanger

Although they are careful to underscore that there is no universal way of designing or thinking when it comes to interpreting the work of women makers, Caroline Evans and Minna Thornton have described "a concern with the dignity of the body which is worked *with* rather than against."[41] Evans's later publication *The Mechanical Smile* expands upon this notion, contextualizing what she describes as a "rationalization of the body" in relation to the development of the fashion show, and the necessary "movement and modernity in a period of emancipation of women, at a time when modernity became particularly associated with speed and acceleration."[42]

While the female body has been a constant throughout art history, its appearance in the advertisements and logos of modern design houses reflects a new emphasis and comfort with the corporeal that aligns with changes in fashion from the period. Illustrations introduced between 1919 and 1926 for Madeleine Vionnet, Louiseboulanger, and Germaine Lecomte arguably advocate for the centrality of woman, elevating her literally, figuratively, and symbolically (fig. 10). The circular structure and foregrounding of the figure in these logos are in varying degrees reminiscent of Leonardo da Vinci's *Vitruvian Man*, a celebration of the proportions and ratios inherent to the beauty of the body. This "cosmography of the microcosm" can be interpreted as a subtle subversion or reclamation of sorts when appropriated by women designers in a dialectic response to the Art Deco use of the female body as a purely ornamental device.

Vionnet's logo was commissioned in 1919 from the Italian futurist artist Ernesto Michahelles, a regular collaborator who worked under the pseudonym Thayaht. Between 1918 and 1925, the artist illustrated house models for Vionnet, submitted ideas and studies of his own, and even seems to have participated in designing areas of the couture house.[43] According to Jacqueline Demornex and Betty Kirke, the designer and the artist shared several conceptual and philosophical approaches to creation. Thayaht introduced Vionnet to the work of artist Jay Hambidge and his premise of "dynamic symmetry," which identified "static" and "dynamic" forms of symmetry as critical nature-based tenets that could be applied to art and design. This type of analysis appealed to Vionnet, who seemed to appreciate a dogmatic approach and sought superior harmony throughout her designs, identifying the four critical bases of dressmaking to be "proportion, movement, balance, and precision."[44] These ideas are encapsulated in the Vionnet logo, which featured a woman perched atop an ionic column. The almost featureless figure grasps the sleeves of a circular-cut gown, in one gesture demonstrating the elasticity and ease of the garment, her arms graceful yet flexed. Aside from the ridges and volutes of the column, which are echoed around the vignette perimeter, the logo is absent of unnecessary adornment or decoration—though it was produced in a series of different colorways, providing an element of variation when desired.

Marie-Louise Boulanger was not only an incredibly artistic and influential designer but was also highly regarded for her knowledge and proficiency.[45] Bettina Bedwell described her as having "a genius as inexhaustible as that of Leonardo da Vinci."[46] This genius extended to her comprehensive understanding of her métier, as conveyed by Janet Flanner: "In a profession where many of its heads have elegantly learned to forget the use of a needle [Boulanger] still knows as much about basting as her littlest apprentice

and as much about everything else as everyone else in her employ. She knows her job from A to Z; she still practices the entire alphabet of its activities."[47] Her logo comprised a circular aperture holding a woman with bobbed hair, the face and limbs cropped into the frame, the figure wrapped tautly within a continuous length of fabric (fig. 10). Although the illustration is stylized, the proportions are more natural than idealized, with an elongated neck, sloping shoulders, and full, curving hips.[48] The image highlights focal points that Boulanger's designs tended to emphasize, including dramatic necklines and voluminous skirts (see p. 105). Illustrations of her work by Lee Creelman Erickson for *Vogue Paris* echo this interest, one bearing the caption "Louiseboulanger autorise la femme à avoir des hanches" (fig. 11). A style from the following year reflects the endurance of this fascination: while the front of the dress is cut narrow, the back explodes into a full tiered skirt (fig. 12).

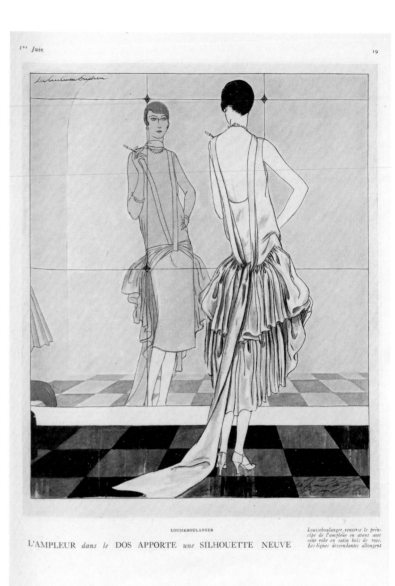

1ᵉʳ Juin 19

LOUISEBOULANGER

L'AMPLEUR *dans le* DOS APPORTE *une* SILHOUETTE NEUVE

Louiseboulanger renverse le principe de l'ampleur en avant avec cette robe en satin bois de rose. Les lignes descendantes allongent

Fig. 12. Louiseboulanger: The magnitude in the back brings a new silhouette, *Vogue Paris*, June 1, 1925. Illustration by Lee Creelman Erickson (American, 1895–1958)

18 VOGUE

LOUISEBOULANGER AUTORISE *la* FEMME *à* AVOIR *des* HANCHES

Très admirée, cette robe en velours panne noire est simplement ornée d'un groupe de feuilles en velours vert vif, posé sur l'épaule gauche

Une charmante façon d'accentuer les hanches, suivant la théorie chère à Louiseboulanger, nous est présentée en même temps qu'un nouveau drapé

Fig. 11. Louiseboulanger allows women to have hips, *Vogue Paris*, October 1, 1924. Illustration by Lee Creelman Erickson (American, 1895–1958)

Germaine Lecomte opened her Paris house in the early 1920s and became especially regarded for her "little black dresses," while later work from the 1930s and 1940s emphasized elegant and romantic eveningwear (fig. 1). Around 1926 she introduced a logo that frames a contemporary female figure at the center of a sphere (fig. 10). Although the model's legs remain demurely closed, her arms are outstretched, the field surrounding her body filled with contrasting geometric blocks. She is dressed in a sleeveless sheath, her hair bobbed in the fashion of the time, and, unlike da Vinci's *Vitruvian Man*, a perimeter square encompasses the circle entirely, avoiding overlap. This Art Deco illustration shows the additional influences of Cubism, Futurism, and, most especially, the Orphist, concentric circles of Sonia Delaunay. The latter's affinity for order and movement is palpable in this dynamic depiction of the modern woman.[49]

DRESSING THE MODERN WOMAN

In 1926 journalist Olga Drexel Dahlgren ruminated on the new freedoms of the modern woman and her ability to fill her life with activity and meaning. Dahlgren's description of emancipation starts with clothing: "Ever since the early days of suffrage, women have been plunging ahead . . . flinging away everything stuffy, confining, and cramping, first from their clothes, then from their lives, and, finally and most important of all, from their minds."[50] Throughout the 1920s, as the archetype of the independent *femme moderne* became increasingly ubiquitous, dress was one of her defining characteristics. Designers responded accordingly, creating clothing that considered the coexisting physical and psychological needs of women. Single, independent, successful, and fashionable, Gabrielle Chanel perfectly embodied this ideal. Her initial achievements resulted from her novel transposition of menswear and sportswear elements to women's dress, which she modeled herself to great effect. Her persona revolved entirely around the notion of effortless elegance—her youth, beauty, and social accomplishments feeding her spectacular rise as a media star. Although she wasn't the first couturier to bask in the spotlight, through the public performance of her cultivated lifestyle, Chanel introduced a model of celebrity that remains relevant today.

One of the most popular styles of the 1920s epitomizes this concept of the new woman, aesthetically, conceptually, and even by name. The relatively forgotten French house of Premet launched the "Garçonne" dress in 1923, following the buzz of Victor Margueritte's polarizing book of the same name (fig. 13). This popular model is an exemplar of the "little black dress," anticipating Chanel's later success by three years. The style was introduced by Madame Charlotte, perhaps the most famous designer among a succession who led the creative direction of Premet between its founding, around 1909, to its closure in 1932.[51] During its run, over a million copies of the "Garçonne" were alleged to have been produced.[52] The house

capitalized on this triumph, introducing variations on the style throughout the decade, each new version drawing upon the homogeneity and stability of the suit but enlivening it with more typically "feminine" elements such as lace, ribbons, or bows (p. 106). The achievement of the "Garçonne" was ultimately due to Charlotte's marketing acumen, ability to read the zeitgeist, and strong design sense, though her visibility as a fashionable and tasteful personality surely contributed to the house's prominence during her tenure. Similar to other women in the public eye, she was frequently discussed in relation to her appearance, and like many of her female colleagues, Charlotte was regularly captured by artists of the period.

Fig. 13. Premet advertisement featuring descendants of the "Garçonne" dress, *Vogue Paris*, April 1, 1926

The Italian designer Elsa Schiaparelli catapulted into the spotlight in 1927 with the instant acclaim of a witty trompe l'oeil sweater prototype commissioned from an Armenian knitter. Many have described Schiaparelli as having "a genius for publicity," and her public adoption and promotion of the design inspired great attention, immediately garnering a feature in *Vogue* (fig. 15). Schiap, as she was called, projected a distinctive identity for her fashion house from the outset; it was clever, slightly and intentionally outside of mainstream fashion, and conveyed a sense of confidence and awareness that was deeply and inextricably associated with the designer

herself (fig. 14). As former *Vogue* editor Bettina Ballard explained, "a Schiaparelli customer did not have to worry as to whether she was beautiful or not—she was a type. She was noticed wherever she went, protected by an armor of amusing, conversation-making smartness." Ballard also noted, however, that "her clothes belonged to Schiaparelli more than they belonged to her—it was like borrowing someone else's chic and, along with it, their assurance."[53]

Fig. 14. Elsa Schiaparelli wearing one of her earliest knitwear designs, 1928. Photograph by Thérèse Bonney (American, 1894–1978)

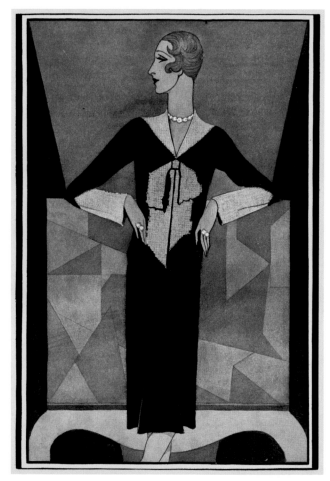

Fig. 15. Elsa Schiaparelli's trompe l'oeil bow sweater design, *Vogue*, December 15, 1927. Illustration by Douglas Pollard

Although women's fashions of the past may have contained aspects of the novelty found within Schiaparelli's work—with subtle incorporation of elements of trompe l'oeil, displacement, and the use of unsettling motifs like insects—what shifted in a meaningful and critical way with her designs was the intentionality behind how these garments were worn. While a woman might have been previously ridiculed as a fashion victim for wearing a camouflage evening dress (p. 123) or an extravagant millinery concoction, a Schiaparelli creation—and its projected confidence through humor—allowed the wearer to control the narrative and take ownership of the joke. Schiaparelli imbued her clothing, and thus the wearer, with intellectual and conceptual forms of empowerment in a manner that was paralleled but relatively unprecedented in fashion.

COMETS AND SHOOTING STARS/MERGERS AND RAPID CHANGE

In the fashion world the couturier ranks at the top and is the one that takes the limelight, but without the cooperation of these crafts[wo]men, nothing can be created.

Germaine Émilie Krebs (Alix, or Madame Grès)

Véronique Pouillard has documented the inherent vulnerability of a couture house model, with its reliance on seasonal sales, its general lack of liquidities, and the vast amounts of credit offered to its private clients.[54] This condition, in combination with the promise that a fashion business held, fed the rapid merger and dissolution of many houses throughout the early twentieth century. Particularly during the 1920s and 1930s, as women outnumbered men as creative directors, staff who had previously functioned as *modelistes*, *premières d'atelier*, and vendeuses utilized their experience—and their client lists—to nurture ambitions of forming their own businesses. Backing these women became an area of investment for entrepreneurs who wished to profit from the industry but often didn't have the technical or creative expertise to establish a fashion house independently.

The fashion press fed this sense of opportunity by reporting on the movements of key workroom staff. One such example is a 1916 article from *WWD* bearing the headline "Important Changes Occur in Couture Circles of Paris: Madeleine, Formerly Premiere of Chéruit, Goes to Paquin—Madeleine, Head Saleswoman with Poiret, Joins Monjaret."[55] These shifting alliances would have impacted the productivity of the couture house; they were documented and watched closely by the press and were of considerable interest to buyers and the American fashion industry. Although this phenomenon of visibility was new—and seems somewhat surprising when viewed through the lens of contemporary reporting practices—it was a logical development given the significance of employees' contributions and the collective

nature of design, which had only become more reliant on the talents of an atelier's staff. In her debut book, *Fashion Is Spinach*, the Paris-trained American fashion designer Elizabeth Hawes described the *première* as "a most important person in any dressmaking establishment," explaining that commonly the *première* is the actual designer. She cited Jean Patou as an example of this practice, wherein a recognized designer worked akin to an accomplished stylist;[56] this was a phenomenon that Hawes experienced firsthand during her own time at the house of Nicole Groult, where she worked on the winter 1928 collection.

Among the constellation of interconnected Parisian couture houses, one of the more interesting entanglements includes Maison Jeanne Hallée, which was established as a lingerie house in 1870 by its eponymous founder, Marie Jeanne Hallée. In 1891 Hallée sold the house to two staff members: Marie Angenard, who became known as Madame Madeleine[57] and, as Callie O'Connor has written, worked her way up from humble beginnings to second in command and then co-owner; and Blanche Diémert, who jointly assumed creative control of the establishment, serving as head designer until her death in 1911. Together, Angenard and Diémert expanded the business from a lingerie shop to a couture house under the name Jeanne Hallée Diémert et Cie.[58] The garments produced demonstrate a mastery of working with delicate materials and techniques that drew upon the heritage of the establishment while providing tasteful interpretations of the latest fashions, such as a feminine rendition of a jupe culotte ensemble in which the sheen of satin trousers is softly muted by swags of chiffon drapery (p. 101).

Around the time of Diémert's death, their *première d'atelier* Madame Lefranc left Jeanne Hallée to work as head designer at the relatively new house of Premet. *Vogue* reported on her move in April of 1912, confiding that "Madame was not known to the public in general, but to those 'in the knowing' she has long been considered one of the most promising designers in Paris."[59] Lefranc's work for Premet channels a similarly sensitive handling of materials, exemplified by the diaphanous tea gowns produced by the house (see p. 98). She continued to be celebrated until a promising career was cut short by her sudden death in 1914. Anne Rittenhouse lamented, "Had Mme. [Le]Franc lived . . . the world would have heard much of her personality. Within two years she came in and went out in a burst of meteoric glory."[60] The coverage surrounding her death is an interesting example of the collaborative atelier dynamic being acknowledged by the press. While they regretted that Lefranc passed within the "full vigor of her genius," her leadership abilities and the workplace environment that she fostered were equally highlighted.[61] As one writer reported, "one of her most noted characteristics was her ability to surround herself with . . . young and capable designers, who understood her admirably and aided her with their personal ideas." The author predicted that "because of the close association between Mme. Lefranc and the staff of premières, who

helped her so much to create the large number of successful models, the perfected organization of the Maison Premet will smoothly continue her work."[62]

Following the loss of Diémert and Lefranc, Angenard maintained creative direction of Jeanne Hallée, with Mademoiselle Madeleine, a vendeuse, serving as her second in command until 1918, when she sought to sell her interest in the business. This sale enacted a series of business permutations beginning with the new house of Madeleine & Madeleine. Its debut collection from August 1919 was described as a "revelation" and one of the "sensational events of the season." It comprised almost three hundred styles with a focus on long lines with trained skirts that drew from antique source material, featuring details such as blouson effects and low girdles that became signatures throughout later collections (see p. 100). The house was overseen by Mademoiselle Madeleine and Madame Madeleine Lepeyre, a talented designer who had previously worked at Paquin, Callot Soeurs, and Drecoll. The couture house was funded and overseen by a board called Société Madeleine & Madeleine that comprised a combination of French nobility and businessmen.[63] While Jeanne Hallée continued to cycle through ownership, in 1922 it was reported that Anne Rodillat, a former *première* at Worth, had purchased the house, which initially bore the names of both Anna and Jeanne Hallée. However, in 1924 it was announced that Maison Anna had acquired the house of Madeleine & Madeleine. While Madeleine Lepeyre chose to return to Drecoll, where she became co-directress with Madame de Wagner, Anna Couture, the progeny of the combined houses, remained active until 1926, when its owner passed away. Yet the house morphed once again when it was acquired by Brialix in 1927, reconfiguring into a new iteration of the establishment known as Paulette Couture by the following year.

Many of the movements that occurred represent the natural growth that charting a career path entails, such as with the charismatic Spanish-born designer Ana de Pombo, who founded a small dressmaking shop in Paris named Casa Elviana. Other opportunities beckoned: first at Chanel, where she worked as a brand ambassador, and then at Paquin (see p. 114), where she became head designer in 1936—the year of Jeanne Paquin's passing and the departure of Madeleine Wallis, who had guided the creative direction of the house from 1920 to 1936 following Paquin's retirement.[64] Elsa Schiaparelli's cousin Bianca Mosca, who worked alongside her relative for a period, also connected back to Paquin, assuming the role of head designer for the London branch the same year. Meanwhile, at Schiaparelli several Augustabernard fitters had migrated over, following the 1934 shuttering of the house on rue de Faubourg Saint-Honoré.[65]

Sometimes the closure of a house necessitated change, a challenge faced by the Italian-born designer Maria "Nina" Ricci. She began in haute couture when she was just thirteen years old and moved to the house of Raffin in 1908, where she worked for over two dozen years. Upon its closure, Ricci founded an eponymous house at the age of forty-nine. Robert,

her son, oversaw the business side, and Ricci was liberated to focus exclusively on design, creating understated, feminine, and infinitely wearable clothing for her largely French clientele (see p. 117).

Maison Agnès was founded in 1907 and creatively overseen by Jeanne Havet through its later merger in 1930. In parallel, the Viennese house of Drecoll was purchased in 1895 by a group of investors that included Pierre Besançon de Wagner and his wife, Marguerite van Speybrouck, who formed a Paris branch in 1903.[66] Their daughter, Maggy de Wagner, later Besançon de Wagner, would eventually help them run the house. By the time Drecoll had merged with Beer in 1929, Besançon de Wagner had departed to found a new house. The following year, in 1930, Agnès and Drecoll-Beer were combined to create Agnès-Drecoll, a house that remained active from 1931 to 1963. Although Havet gradually stepped away from design following the merger, her work from the early years of Agnès-Drecoll demonstrates her appreciation for refined details and exotic source material, with exquisite embroidery and color combinations (see p. 122).

Following her departure from Drecoll, Maggy Besançon de Wagner and her husband, Pierre Besançon, collaborated to run the house of Maggy Rouff. Somewhat unusually, while Maggy adopted the pseudonym Rouff, her husband became known as Monsieur Besançon de Wagner, combining the couple's last names. Unlike many of the women who rose through the ranks to become couturiers, Rouff admittedly did not sew. She viewed herself as an artist and oversaw the design process by directing others. During the 1930s, the house produced fitted evening gowns that often incorporated tiers, ruffles, or oversize bows, intermingling textiles of different weaves and weights. Rouff had a sensitive eye for color and favored fabrics with unusual tints (see pp. 120–21). She was also a published author, writing several books including *L'Amérique au microscope*, *Ce que j'ai vu en chiffonant la clientèle*, and *La philosophie de l'élégance*. The last included drawings by her daughter Anne-Marie, who assumed design responsibilities when Rouff retired in the late 1940s.

When the house of Vionnet closed on the precipice of World War II, it catalyzed a series of offshoots, including Mad Carpentier, a collaboration between Madeleine Maltezos, a former *première d'atelier*, and Suzie Carpentier, a vendeuse who had overseen the Vionnet salon.[67] Although Maltezos was the primary designer, the women worked together, drawing on Carpentier's vast knowledge of their clientele's needs. The house became particularly admired for its chic outerwear and day suits, along with its skillfully draped evening gowns (see p. 118). Mad Carpentier remained active until 1957, when a catastrophic fire consumed the workrooms. Maltezos and Carpentier initially aspired to resume activities but announced the house's cessation shortly thereafter. *WWD* mourned their decision, alongside a series of closures and the recent death of Christian Dior, reporting that "the Haute Couture is considered to have had its blackest decade on record."[68]

Marcelle Chapsal, creating under her maiden name Marcelle Chaumont, has been described as "the spiritual heir to the maison Vionnet."[69] She was among the earliest staff hired in 1912, working closely alongside Madeleine Vionnet until the house's closure in 1939 (fig. 7). Jacqueline Demornex has outlined how integral Chapsal became to the operation, describing that "she attended fitting sessions with [Vionnet's] clients, who were continually turning to her for assistance, knowing that her eye and cutting technique were infallible," and that Chapsal "brought a sense of the very latest trends to the collections, and her generosity with both her talent and her time was unlimited."[70] In 1940 Chapsal opened her house with the assistance of her sister Gaby Chaumont. Dominique Veillon has detailed some of the challenges that they initially faced during wartime, such as a lack of funding and publicity, material limitations, and a struggling workforce. However, the house prevailed and became admired for its sumptuous eveningwear, intricate pleating, and exquisite use of color (see p. 110), remaining active until Chapsal's retirement in 1953 due to health issues. Editorial images that document her work often have a haunting quality to them. In a photograph that was captured outside of Versailles in 1948, the Grecian-inspired pleats of a dress fall perfectly around the model's feet, evoking an aching familiarity in its contemporary grace (fig. 16).

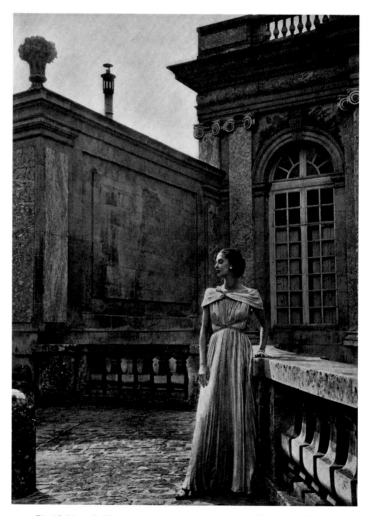

Fig. 16. Marcelle Chaumont gown captured outside of Versailles, *Vogue*, September 15, 1948. Photograph by Clifford Coffin (American, 1913–1972)

Although relatively forgotten today, Marie-Louise Bruyère was one of many designers working in France during the early twentieth century who rose to prominence by catering to an international clientele. The couturier had sewn from an early age and formally studied design at the École des Beaux-Arts. Upon graduation she was hired as a *modeliste* at Lanvin, where she worked for over six years before opening her own business, allegedly taking some of her former colleagues with her.[71] From the outset, the American press lauded her presentations as "creative and original," noting that each piece was "distinguished by its careful working."[72] Her designs became known for their elegance and seeming simplicity, subtle incorporation of intricate stitching and seaming, use of techniques like trapunto and shirring, and delicate color combinations (see pp. 126–27).

LIMINAL SPACES FOR FASHION

The haziness of the boundaries between the arts during the early twentieth century provided a variety of entry points, as many artists worked on set to design costumes for theater and dance or contributed illustrations and photography to periodicals. As fashion became an increasingly attractive pursuit for women to explore, others entered the field from the periphery, creating spaces for themselves that introduced vantages from analogous disciplines like fine art and craft. While the work of artists like Sonia Delaunay and her Atelier Simultané have been covered extensively, there were other successful makers from similar backgrounds less widely known today.[73] These early small-scale workshops, boutiques, or galleries cultivated sites of interdisciplinary collaboration that supported broader artistic networks, creating an environment that moved beyond the intimacy of the dressmaker's shop and rejected the congestion of the department store to provide an equally cultivated—but frequently more bohemian—take on the luxury and identity of the couture salon.

Living between France and Algeria, Marie Cuttoli launched her Parisian boutique and fashion house Myrbor in 1922. The name was a composite of Myriem, the Arabic interpretation of her given name, and her maiden name, Bordes.[74] This nomenclature, and the associated iconography of the house, drew strongly from the Slavic influences that were percolating in France due to the Russian Revolution of 1917, the resulting influx of immigrants, and the considerable impact of the Ballets Russes. Accordingly, one of the first artists that Cuttoli collaborated with on clothing was the Russian artist Natalia Goncharova.[75] The majority of published and extant Myrbor objects feature a combination of appliqué and embroidery techniques, comprising vibrant color blocks that have been patchworked into modernistic and abstract creations over solid textile grounds (see p. 132). Within the Myrbor boutique, and later Galerie Myrbor, Cuttoli displayed fine and decorative arts including textile-based products like rugs, which were woven in Algeria, and tapestries that were the product of collaborations with artists such as Jean Lurçat, Raoul Dufy, Georges Braque, Joan Miró, and Pablo Picasso. Cuttoli engaged others to design for Myrbor, most notably the Polish artist Sarah Lipska, who had also worked with Diaghilev and would go on to open her own shop in Montparnasse from the late 1920s through 1939. Although Cuttoli's degree of involvement in the production of clothing is unknown—and it can be difficult to attribute Myrbor designs to specific makers—there are some repositories of swatches and sketches that link certain objects to Lipska definitively. For example, a gouache drawing attributed to Lipska in the collection of the Musées de Poitiers captures the red and orange hues of abstract flowers that also adorn a slim two-piece dress of red silk crepe (p. 133).

Working in Rome, the artist Maria Monaci Gallenga began creating what would be categorized as artistic dress for herself around 1910. This clothing prioritized a value system that emphasized notions of craftsmanship and the pleasure of making, utilized production methods based on historical techniques, and referenced past modes of dress, such as medieval and Renaissance fashions. However, Gallenga felt adamantly that to simply copy styles from the past was masquerade and that her designs must also be wholly "modern in inspiration."[76] This approach resulted in a select group of silhouettes, comprising dramatic mantles and capes, sheath and tabard dresses, and tea gowns (see pp. 130–31). Her clothing was typically made in small quantities in close collaboration with the seamstress Signora Volero. Volero would take the fabric Gallenga supplied and cut pattern pieces that the designer would then print in her studio before returning the textiles for assembly and finishing.[77] Gallenga frequently printed on velvet and worked with carved wood blocks that were used to stamp adhesive onto the fabric ground. She then brushed metallic powder pigments atop the adhesive to produce motifs with a subtle ombré effect that one author likened to "water and moonlight."[78]

While Gallenga's Rome space functioned primarily as a salon, hosting colleagues from an artistic circle that included Giacomo Balla, Nicola d'Antino, Duilio Cambellotti, and Vittorio Zecchin, the designer made the decision to open a Paris boutique in June 1926. First named Gallenga France, the shop became Boutique Italienne in 1927 and sold fabric, clothing, linens, furniture, and decorative arts that, like those of Galerie Myrbor, were produced by a variety of makers. Gallenga exhibited her own textiles internationally and used her boutique to host exhibitions of her Italian colleagues' work, actively promoting the legacy of products made in Italy.[79] Fashion served as a connective thread between these women and their collaborators, despite their differences in approach and circumstance and their liminal status outside of both the stratified art world and fashion industries. As Jess Berry has pointed out, by combining fashion and modern art under one roof, the spaces enacted a form of visibility for their owners that could "enhance reputations among professional and social circles," thus further enabling forms of "social and cultural agency."[80]

AMERICAN DESIGNERS STEP INTO THE SPOTLIGHT

My clothes are not designed for women who think about nothing but clothes.

Bonnie Cashin

While the appeal of French fashion in the United States and the significance of this symbiotic consumer relationship cannot be overstated, the early twentieth century was also an incredibly important period in the development of fashion in the nation. Throughout the era, American designers sought varying paths to visibility beyond the glare of Paris. And as they emerged, many of these makers were women who had a substantial impact on shaping the direction of contemporary dress.

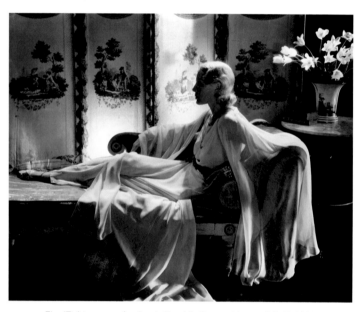

Fig. 17. A tea gown by Jessie Franklin Turner, *Vogue*, July 15, 1931. Photograph by Edward Steichen (American, 1879–1973)

Jessie Franklin Turner was one of the earliest American designers working in the custom salon model. Her design career was founded on her substantial knowledge of textiles and intimate apparel acquired over years of retail experience, including a lengthy tenure as a buyer at Bonwit Teller, where she had overseen the European and Asian markets for the lingerie department. Although her work had many notable characteristics, she became recognized for her ravishing draped tea gowns (fig. 17). These flowing, ethereal robes provided a wonderful outlet for Turner's aptitude as a colorist and drew on her knowledge of global dress—in part acquired during her prior travels as a buyer and visits to international museum collections. Jan Glier Reeder has detailed how this type of study would later become a defining inspiration for the designer, continuously cultivated through friendships with Morris De Camp Crawford, an anthropological fellow at the American Museum of Natural History, and Stewart Culin, curator of ethnology at the Brooklyn Museum.[81] Although she tended to shun the public eye, even avoiding interaction

with her customers, Turner regularly shared her work for exhibition as the display of fashion in the museum became more prevalent in the United States. These institutional relationships, and her commitment to creating independently outside of Parisian and industry dictates, were instrumental in the later identity and conceptualization of an American fashion aesthetic.[82]

Unlike Turner, who eschewed the spotlight, the former actress, dancer, and model Valentina Schlée, known publicly as Valentina, championed her creations by wearing them herself in fashion editorials (fig. 18). She always claimed, "I don't design dresses—I dress women,"[83] and it was the wardrobe that Valentina created for herself, and the elegant manner in which *she* carried it off, that especially captured attention. Valentina was known to work in monochrome fabrics, her work stripped of unnecessary surface decoration and frequently described as monastic—though there is a glamour and luxury to her garments that belies this description. Across three decades of changing trends, the drama of her clothing consistently relied on silhouette and its relationship to the figure, avoiding the padding and constrictions of contemporaneous fashion. This influence of simplicity in form is echoed in a dress that was created around the time an early partnership with Sonia Levienne dissolved (p. 108). After launching a short-lived business with her husband, George, in 1925, Valentina partnered briefly with Levienne to launch "Valentina and Sonia" before establishing Valentina Gowns, Inc., in 1928.[84]

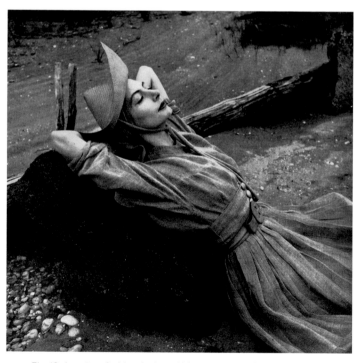

Fig. 18. American fashion designer Valentina wearing her own creation, *Harper's Bazaar*, July 1940. Photograph by George Hoyningen-Huene (American, born Russian Empire, 1900–1968)

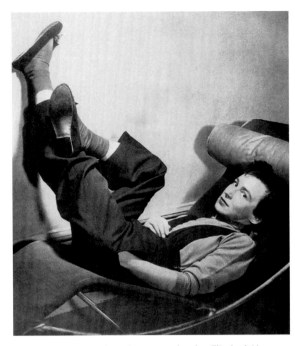

Fig. 19. American fashion designer and author Elizabeth Hawes, 1941. Photograph by Mary Morris Lawrence (American, 1914–2009)

Elizabeth Hawes is less known to the non-specialist yet remains an enduring favorite of historians, unsurpassed for her intellectual and irreverent approach to fashion. Following her college graduation, and after a short stint in the Bergdorf Goodman workrooms, Hawes set out for Paris to learn about the art of couture. She spent several years in the French capital exploring different facets of the industry as a copyist, freelance writer, stylist, and, finally, a member of the atelier staff at the house of Nicole Groult. When she returned to the United States, Hawes opened a custom salon that operated from 1928 to 1940.[85] She quickly became admired for elegant clothes that adhered to her rigorous design philosophies: avoiding superfluous ornament and utilizing integral construction techniques such as piecing and mitering; applying color theory to fabric selection and juxtapositions; and focusing on novel yet timeless styles that could exist outside of trends (see p. 119). In 1938 she published her first of nine books, *Fashion Is Spinach*. Hawes's candor and humor made this revealing critique of the French and American fashion industries a great success, while her independent spirit and innate talent for publicity regularly garnered attention, ensuring her status as one of the most famous American fashion designers of the period (fig. 19).[86] Hawes aimed to use her platform to her advantage. Deeply invested in social and economic welfare, she paid her employees generously, at one point creating a profit-sharing model of her business. After unsuccessfully attempting to apply her design theories to mass production, she turned her focus to writing and activism. Despite her lack of success in reforming the American garment industry at the time, her ingenious designs and prophetic writings remain highly influential and relevant today.

Hattie Carnegie began her career modestly, working as a milliner in 1909 in partnership with Rose Roth. By 1918 Carnegie had purchased the business and begun an expansion

that would result in an incredibly influential fashion empire comprising wholesale and retail divisions with a custom salon, fashion imports, millinery, and jewelry and cosmetics departments, as well as a sportswear line. Although Carnegie herself did not sew or design, she took on a leading role that inverted the typical gendered arrangement of labor in fashion, overseeing a thriving business that employed an oscillating series of men and women designers over the years, notably including talents such as Pauline Trigère, Claire McCardell, Norman Norell, and Pauline (Potter) de Rothschild (see pp. 128–29).[87] Carnegie exactingly oversaw the design process from a creative and production standpoint to ensure the quality and legacy of every piece that was produced. In addition to the rotating design team, the custom salon collaborated with a broad network of artisans, such as the premier embroider "Miss Anea" Tonegatti, who likely collaborated with Rothschild to create the delicate imbrication pattern that embellishes the bodice of a custom salon dress from around 1949 (p. 128).

Two designers with quite possibly the most enduring impact on contemporary fashion are Bonnie Cashin and Claire McCardell (fig. 20). Although their work and personalities are distinctive, they share commonalities in that both produced easeful garments that prioritized the comfort of the wearer, empowering them to modify the clothes to suit their own needs through wrapping, tying, or layering. Both women embraced materials that aesthetically and technically performed well, despite sometimes unconventional applications. They also shared an insistence on autonomy, finding ways to work within their own terms, ensuring that they received the credit and creative freedom that they had earned.

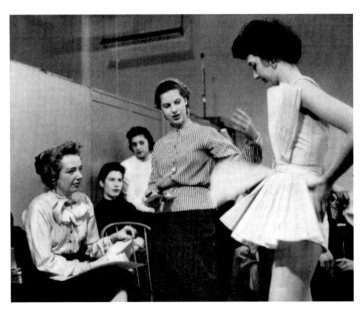

Fig. 20. Designer Claire McCardell and Parsons students, *Time*, May 2, 1955. Photograph by Martha Holmes (American, 1923–2006)

The notion of layering is one of Cashin's most resonating design legacies. She introduced her "double coat" in 1950 to much acclaim. The ensemble comprises a kimono-cut coat that slips over a sleeveless shell so the components can

be worn together or separately. Her more typically feminine takes on layering include elements like delicate aprons and an overcoat lauded in *Vogue* as a "smoke-screen of silk organdie" (fig. 21). Cashin also brought to her ready-to-wear garments heavy materials typically reserved for outerwear, namely, wool, mohair, and leather. She introduced oversize pockets and unusual findings. Her designs from the 1950s are especially striking in their embrace of simple shapes, like the square or rectangle, and their minimal use of darts during an era of especially structured design. Cashin embraced classic garments like the poncho (see p. 135) and the kimono and conceived of women's needs from head to toe, collaborating with outerwear and accessories manufacturers, including a lengthy and influential tenure at Coach, where she introduced innovations like the kiss lock and the bucket bag.

Working for the manufacturer Townley Frocks, McCardell had a similar interest in utilizing geometric pattern shapes. One of her more interesting designs comprises four triangles cut on the bias, each dissected into three parts that were reunited as a halter dress using her signature topstitching (p. 125). The simplicity and austerity of her "Future" dress lends an ease and timelessness that typifies McCardell's work. While many of her designs are admired for their ingenuity and contemporaneity—most notably, her playsuits and popover dress—perhaps her best-known style is the "Nada" frock or the "Monastic" dress. This latter prototype was launched in 1938. A simple, softly pleated shift dress of wool or rayon crepe, the long-sleeved garment was cut on the bias and had a free waistline and belt that allowed the wearer to customize it to her size. The "Monastic" was wildly popular and widely copied; Townley's costly pursuit of copyright infringement battles infamously led to the manufacturer's temporary closure.

When assessing McCardell's work, or when reading about her first incredible success with the "Monastic" dress, one could imagine that her fresh perspective and ingenuity had forged an easy path. Yet anecdotes have revealed her struggle to sometimes be heard or to see her ideas accepted with confidence. The "Monastic" was only sold because the designer took the initiative to wear it herself on the sales floor. Cashin encountered similar obstacles when she was first designing at Adler & Adler. If an important idea was rejected, she would return to the steadfast talent of her mother and trusted sample maker, Eunice Cashin, adopting the same strategy of publicly wearing a garment that didn't otherwise garner support. Far beyond simply designing for the self, these gestures became acts of subversion, a way of claiming space that wasn't initially granted, of making one's vision and potential apparent to the world.

In an ironic twist, some dress historians have remarked on how the overwhelming success and imitation of Cashin's and McCardell's fashion innovations have rendered them somewhat invisible—their contributions are so essential and ubiquitous that they are now taken for granted. As McCardell herself once wrote, "Most of my designs seem startlingly self-evident. I wonder why I didn't think of them before."[88]

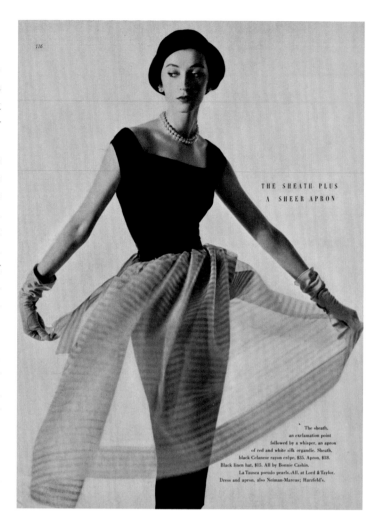

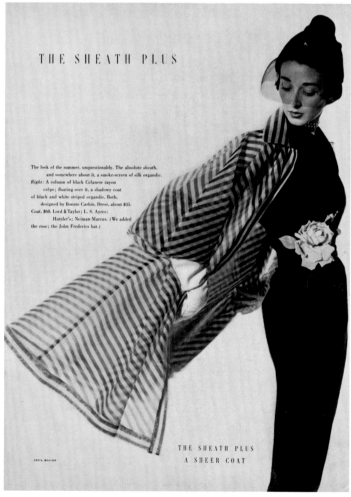

Fig. 21. Bonnie Cashin's sheath dresses layered with a sheer apron (top) and a coat (bottom), *Vogue*, April 1, 1950. Photographs by Cecil Beaton (British, 1904–1980)

1 Caroline Evans and Minna Thornton, *Women & Fashion: A New Look* (London: Quartet, 1989), 109.
2 Valerie Steele, *Women of Fashion: Twentieth-Century Designers* (New York: Rizzoli, 1991), 13–14.
3 The practice of selling sketches and design ideas to established couture houses became a widespread tradition that was equally embraced by men and women.
4 Wendy Gamber, *The Female Economy: The Millinery and Dressmaking Trades, 1860–1930* (Urbana: University of Illinois Press, Urbana, 1997), 193.
5 Steele, *Women of Fashion*, 22–23. See also Steele, *Paris Fashion: A Cultural History* (New York: Berg, 1999), 251, for mention of other early makers who merit further recognition, such as Clementine Bara, Eugénie Gaudry, and Rosalie Prost.
6 Véronique Pouillard, *Paris to New York: The Transatlantic Fashion Industry in the Twentieth Century* (Cambridge, Mass.: Harvard University Press, 2021), 12–14.
7 Jeanne Paquin had begun her career as a model, or mannequin, for the house of Maggy Rouff in 1885. Véronique Pouillard, "A Woman in International Entrepreneurship: The Case of Jeanne Paquin," in *Entreprenørskap: i næringsliv og politikk*, ed. Einar Lie, Knut Sogner, and Håvard Brede Aven (Oslo: Novus, 2016), 191, citing "Tête de Turc, Madame Paquin," *Fantasio*, March 1, 1913, 534.
8 Jan Glier Reeder "The Touch of Paquin, 1891–1920" (master's thesis, Fashion Institute of Technology, 1990).
9 Debra Silverman has explored how the statue came to emblematize what was being promoted as women's "inherent" skill in the decorative arts during a critical moment in France, as alarming notions of the "modern woman" were percolating. "The 'New Woman,' Feminism, and the Decorative Arts in Fin-de-Siècle France," in *Eroticism and the Body Politic*, ed. Lynn Hunt (Baltimore: Johns Hopkins University Press, 1991), 144–63. See also Anne Dymond, "Embodying the Nation: Art, Fashion, and Allegorical Women at the 1900 Exposition Universelle," *Canadian Art Review* 36, no. 2 (2011): 1–14.
10 When Worth first met Vernet, she was already employed as a model for the silk mercer Gagelin et Opige. Caroline Evans, *The Mechanical Smile: Modernism and the First Fashion Shows in France and America, 1900–1929* (New Haven, Conn.: Yale University Press, 2013), 13, citing Octave Uzanne, *The Modern Parisienne* (London: William Heinemann, 1912).
11 Initially, Jeanne oversaw the house independently and later brought on her brother Henry Joire to help with the management.
12 "A Matter of Millions," *Delineator,* December 1912.
13 Anne Rittenhouse, "The Women Who Create the Mode in Paris," *Vogue*, November 15, 1914, 52. Among many other accomplishments, Jeanne was awarded with the Legion of Honour in 1913 and in 1917 was elected as the first woman president of the Chambre Syndicale de la Couture Parisienne. This latter role from 1917 to 1920 was fraught with complex issues related to gender and workers' rights, as well detailed in Maude Bass-Krueger, "From the 'Union Parfaite' to the 'Union Brisée': The French Couture Industry and the Midinettes during the Great War," *Costume* 47 (2013): 28–44.
14 Chéruit and Huet purchased Raudnitz et Cie. to establish their business.
15 Mary Brooks Picken and Dora Loues Miller, *Dressmakers of France: The Who, How, and Why of the French Couture* (New York: Harper, 1956), 63.
16 For more on haute couture salons and the commercial spaces of fashion, see Jess Berry, *House of Fashion: Haute Couture and the Modern Interior* (London: Bloomsbury, 2018).
17 Camille Janbon, "The Importance of Callot Soeurs in the Emergence of Couture in Early C20" (PhD diss., Courtauld Institute of Art, 1999), 14.
18 Gerber was the only Callot sister with formal training in fashion, having previously worked as a *première d'atelier* at Raudnitz et Cie. Lydie Chantrell, *Les Moires 1895–1920: Mesdames Callot Soeurs* (Paris: France-Gutemberg, 1978), 36.
19 Rittenhouse, "The Women Who Create the Mode in Paris," 53.
20 Waleria Dorogova has established how this historical imagery was linked to nationalistic concerns during periods of wartime and positioned the house as an inherently French brand to appeal to its international clientele. Although Boué Soeurs was technically a British company between 1906 and 1928, their production and identity remained centralized in France. "Boué Soeurs: 'Compelled by the War,'" in *Fashion, Society, and the First World War: International Perspectives*, ed. Maude Bass-Krueger, Hayley Edwards-Dujardin, and Sophie Kurkdjian (London: Bloomsbury, 2021), 29–45.
21 Lucy Duff Gordon, *Discretions and Indiscretions* (New York: Frederick A. Stokes Company, 1932), 41–42.
22 According to Valerie D. Mendes and Amy de la Haye, Duff-Gordon wrote for *Harper's Bazaar* from 1913 to 1922 and contributed to *Good Housekeeping* in 1912, *The London Daily Sketch* from 1921 to 1928, *Weldon's Ladies' Journal* in 1930, and *The Saturday Review* until 1933.

Lucile Ltd.: London, Paris, New York and Chicago, 1890s–1930s (London: V&A Publishing, 2009), 216–21. For an early example of her presentation as an author in *Harper's Bazaar*, see Lady Duff Gordon (Lucile), "The Last Word in Fashions," *Harper's Bazaar*, August 1913, 12.
23 Dean L. Merceron, *Lanvin* (New York: Rizzoli, 2007), 2.
24 Lanvin's marriage to Henri Émile-Georges di Pietro lasted from 1896 to 1903.
25 Although some sources, such as Célia Bertin's *Paris à la Mode* (New York: Harper, 1957), mention that Lanvin first dressed her younger sister Marie-Alix Lanvin (later Marie-Alix Gaumont), the time line and details regarding this don't entirely align. She did dress her niece Marianne Gaumont who, along with Marguerite and Marie-Alix, was photographed for Lanvin advertisements.
26 During Lanvin's lifetime, the offerings of the house expanded to encompass millinery, children's wear, women's dress, fur, bridal, interior, dye factories, perfume, and lines for Lanvin Sport and Lanvin Homme. Throughout all of these endeavors, Lanvin oversaw a stable and flourishing business that provided employment to many of her younger siblings and extended family, while she also participated in numerous events to promote French fashion internationally.
27 The logo was designed in 1921 and patented in 1922. While it is unknown if the original photograph that inspired Iribe's illustration is still extant, many sources erroneously feature a reenactment photograph staged with models. My great thanks to Laure Harivel for this information and her ongoing research support.
28 While writers like Mary Lynn Stewart have pointed out the exclusion of the pregnant or maternal body in high-fashion publications, Dominique Veillon notes how women's magazines began to offer more space to expectant mothers. *Fashion under the Occupation* (Oxford: Berg, 2002), 128; Stewart, *Dressing Modern Frenchwomen: Marketing Haute Couture, 1919–1939* (Baltimore: Johns Hopkins University Press, 2008).
29 When Lanvin passed away in 1946, her daughter became president of the house and designed the collections until 1950.
30 World War I required Vionnet to close until 1918. During this time, the designer arranged for her seamstresses to continue to create clothing directly for clients, which served the dual purpose of supporting them financially during a difficult period while also securing her staff and clientele for the reopening of her salon. Pamela Golbin, ed., *Madeleine Vionnet* (New York: Rizzoli, 2009), 15, citing Madeleine Vionnet, interview by Madeleine Chapsal, ca. 1960, typescript, Madeleine Chapsal Archives, 15–16.
31 Vionnet quoted in André Beucler, "Chez Madeleine Vionnet," in Golbin, *Madeleine Vionnet*, 274–75.
32 Golbin, *Madeleine Vionnet*, 29.
33 Saint Catherine is the patron saint of haute couture.
34 Advertisements for the couture house that served to deter counterfeiting also promoted the environmental conditions, training, and, thus, expertise and excellence achieved by Vionnet's workroom staff. Documentary images of her workrooms were included and promoted the holistic conditions that contributed to the preeminence of her entire enterprise. For an example of this, see advertisement, *Harper's Bazaar*, April 1925, 54.
35 Mary Louise Roberts, "Samson and Delilah Revisited: The Politics of Fashion in 1920s France," in *The Modern Woman Revisited: Paris between the Wars*, ed. Whitney Chadwick and Tirza True Latimer (New Brunswick, N.J.: Rutgers University Press, 2003), 69.
36 *Fourreau* are the black, long-sleeved bodysuits that mannequins would wear beneath garments for modesty purposes. Evans, *The Mechanical Smile*, 19, citing Albert Barrière, *Argot and Slang: A New French and English Dictionary of the Cant Words, Quaint Expressions, Slang Terms and Flash Phrases Used in the High and Low Life of Old and New Paris* (London: Whittaker and Co., 1889), 162.
37 *La Ville lumière: anecdotes et documents* (Paris, 1909), 535.
38 Susie Ralph, "Margaine-Lacroix and the Dresses that Shocked Paris," RBKC Libraries, July 12, 2013, https://rbkclibraries.wordpress.com /2013/07/12/margaine-lacroix-and-the-dresses-that-shocked-paris/. See also Daniel Milford-Cottam, *Edwardian Fashion* (Oxford: Shire Publications, 2014), 34–37.
39 Patricia Mears, *Madame Grès: Sphinx of Fashion* (New Haven, Conn.: Yale University Press, 2007), 130.
40 "When Designers Meet and Talk About Clothes," *Vogue*, October 15, 1933, 73.
41 Evans and Thornton, *Women & Fashion*, 110.
42 Evans, *The Mechanical Smile*, 3.
43 Aurora Fiorentini, "The Collaboration between Thayaht and Madeleine Vionnet (1919–1925)," *Dress Study* 56 (Autumn 2009); Caterina Chiarelli, *Per il Sole e Contro il Sole:Thayaht & Ram, La Tuta, Modelli per Tessuti*, exh. cat. (Livorno, Italy: Sillabe, 2003).
44 Betty Kirke, *Madeleine Vionnet* (San Francisco: Chronicle Books, 2012), 115–16.

45 Boulanger began working in couture when she was thirteen years old and worked at the house of Chéruit, first for Louise Lemaire Chéruit and then leading the creative direction with Julie Wormser, before founding her own house, which was active from 1923 to 1933. When her house merged with Callot Soeurs, the joint venture was purchased by Calvet in 1938.

46 Bettina Bedwell, "Fashions of 1926," *Chicago Tribune* and *New York Daily News*, August 13, 1926.

47 Janet Flanner, "Behind the Seams: With the Women of Paris Who Dress the Women of the World," *Ladies Home Journal*, April 1929, 175.

48 This is only slightly reminiscent of the Art Deco approach to the female body that the historian Roland Marchand described as "grotesque modern."

49 Lecomte was actively involved in theatrical design, dressing many performers during the period that her couture house was active (ca. 1922–56). One photographic advertisement from 1926 depicts the Russian opera singer Maria Kousnezoff dressed by Lecomte for *La Bayadère*. She wears a dramatic cape with her arms outstretched, the sleeves trailing in a gesture similar to that in the house's logo.

50 Olga Drexel Dahlgren, "*Vogue*'s World as I See It," *Vogue*, May 15, 1926, 74.

51 Madame Lefranc of Jeanne Hallée was one of the earliest, highly successful female designers to oversee the creative direction of the house, from 1912 to 1914. Georgette Renal followed Charlotte's tenure from 1929 until the house's closure in 1932, opening her own eponymous house that year. Germaine Émilie Krebs (Alix, or Madame Grès) apprenticed at Premet at the start of her career.

52 "Business: Haute Couture," *Time*, August 13, 1928.

53 Bettina Ballard, *In My Fashion* (New York: David McKay, 1960), 55.

54 Pouillard, *Paris to New York*, 83.

55 "Important Changes Occur in Couture Circles of Paris: Madeleine, Formerly Premiere of Chéruit, Goes to Paquin—Madeleine, Head Saleswoman with Poiret, Joins Monjaret," *WWD*, June 26, 1916, 1.

56 Elizabeth Hawes, *Fashion Is Spinach* (Mineola, N.Y.: Dover Publications, 2015), 99.

57 It was common practice for women to use a variation of their name or adopt a different name when theirs overlapped with that of a senior employee within a couture house.

58 My thanks to Callie O'Connor for generously sharing her insights on Jeanne Hallée. See "Jeanne Hallée 1870–1924: 'One of the best of the early houses'" (master's thesis, Fashion Institute of Technology, 2020).

59 "The Designers Open Their Doors," *Vogue*, April 1, 1912, 108.

60 Rittenhouse, "The Women Who Create the Mode in Paris," 53, 100.

61 For more on the nationalistic and fascinating depiction of garment workers in France, see Patricia Tilburg, *Working Girls: Sex, Taste, and Reform in the Parisian Garment Trades, 1880–1919* (Oxford: Oxford University Press, 2019).

62 "Costumes," *WWD*, May 18, 1914, 5. This information was likely conveyed by the house to assure its customers. My thanks to former intern Emily Elizabeth Lance for her excellent research on the history of Premet.

63 Madame Madeleine, "The Defense of Madame Madeleine," unpublished letter, n.d., trans. Louise Vannier, Collection of Jean S. and Frederic A. Sharf, Museum of Fine Arts, Boston. See also Emily Banis Stoehrer, *Embroidered Dreams: Designs from the House of Madeleine & Madeleine* (Boston: Museum of Fine Arts, Boston, 2014); and O'Connor, "Jeanne Hallée 1870–1924," 89. My thanks to Emily Banis Stoehrer for her assistance with this ongoing research.

64 Very little has been published on Wallis, whose sobriquet was "Madeleine Manteau" due to her skill in outerwear. Her substantial tenure at Paquin merits more investigation.

65 G. Bruce Boyer and Patricia Mears, eds., *Elegance in an Age of Crisis: Fashions of the 1930s* (New Haven, Conn.: Yale University Press, 2014), 83.

66 See Birgit Haase and Adelheid Rasche, "Christoph Drecoll: Rediscovering the Viennese Worth," *Costume* 53 (2019): 186–206.

67 Pouillard, *Paris to New York*, 114. Suzie Carpentier was the professional name of Adèle Clerisse. Other offshoots of ex-Vionnet staff include the houses of Charles Montaigne (Charles Meuwese) and Jacques Griffe.

68 "10 Couturiers Shut in Decade," *WWD*, October 25, 1957, 1, 4.

69 Alice K. Perkins, *Paris Couturiers and Milliners* (New York: Fairchild Publications, 1949), 14.

70 Jacqueline Demornex, *Madeleine Vionnet* (New York: Rizzoli, 1991), 129.

71 "Dresses: Youthful Silhouette, Supple and Flowing, Developed in Black Satin by Bruyère," *WWD*, May 18, 1928, 6.

72 "Dresses: Youthful Silhouette," 6; "Carefully Worked Youthful Types in Bruyère Collection," *WWD*, July 31, 1928, 1.

73 For more on Delaunay's work, see Waleria Dorogova and Katia Baudin-Reneau, eds., *Maison Sonia Delaunay* (Berlin: Hatje Cantz, 2022); Marta Ruiz del Árbol, ed., *Sonia Delaunay: Art, Design, Fashion* (Madrid: Museo Thyssen-Bornemisza, 2017); and Sonia Delaunay and Tadeo Kohan, *Sonia Delaunay*, trans. Abigail Grater (London: Tate Modern, 2014).

74 Elizabeth Ann Coleman, "Myrbor and Other Mysteries: Questions of Art, Authorship and Émigrées," *Costume* 34 (2000): 100–4; Cindy Kang, *Marie Cuttoli: The Modern Thread from Miró to Man Ray* (New Haven, Conn.: Yale University Press, 2020), 11; Ewa Ziembińska, ed., *Sara Lipska: Dans l'ombre du maître* (Warsaw: Musée de la Sculpture Xawery Dunikowski, Palais Królikarnia, 2012).

75 Goncharova entered fashion via theatrical design in 1909, designed for Nadezhda Petrovna Lamanova's fashion house in 1912, and in 1913 began collaborating with Serge Diaghilev on costume and set design for the Ballets Russes. N. Z. Sidlina and Matthew Gale, eds., *Natalia Goncharova* (London: Tate Publishing, 2019).

76 Gallenga company brochure, ca. 1925, citing *Vogue*, October 15, 1916, Galleria Nazionale d'Arte Moderna e Contemporanea Archives.

77 Marianne Carlano, "Maria Monaci Gallenga: A Biography," *Costume* 27 (1993): 61–78; Rosanna Masiola Rosini and Sabrina Cittadini, *The Golden Dawn of Italian Fashion: A Cross-Cultural Perspective on Maria Monaci Gallenga* (Cambridge: Cambridge Scholars Publishing, 2020).

78 Gallenga company brochure, ca. 1925, citing *London Daily Express*, 1915, Galleria Nazionale d'Arte Moderna e Contemporanea Archives.

79 Rosini and Cittadini, *The Golden Dawn of Italian Fashion*, 5.

80 Berry, *House of Fashion*, 43.

81 Jan Glier Reeder, "Jessie Franklin Turner: An Intimate Affair," in *The Hidden History of American Fashion: Rediscovering 20th-Century Women Designers*, ed. Nancy Deihl (New York: Bloomsbury, 2018), 7–22.

82 For more on the promotion of Turner's work and American design during the early twentieth century, see Ann Marguerite Tartsinis, *An American Style: Global Sources for New York Textile and Fashion Design, 1915–1928* (New Haven, Conn.: Yale University Press, 2013).

83 Valentina quoted in Kohle Yohannan, *Valentina: American Couture and the Cult of Celebrity* (New York: Rizzoli, 2009), 98.

84 Yohannan, *Valentina*, 51–68.

85 Initially, Hawes partnered with her friend Rosemary Harden, and the enterprise was called Hawes-Harden before Hawes assumed full ownership in 1930. After closing the employee-owned iteration of Hawes Customers that was active from 1940 to 1941, Hawes primarily left fashion, outside of periodic projects and a brief reentry in 1948.

86 Aside from some select campaigns, the American press was substantially focused on French fashion during the early twentieth century until the start of World War II. This topic has been extensively and thoughtfully covered. For some further reading, see Rebecca Arnold, *The American Look: Fashion, Sportswear and the Image of Women in 1930s and 1940s New York* (New York: I. B. Tauris, 2009).

87 Steele, *Women of Fashion*, 101. Special thanks to Virginia Barbato intern Nathalie Silva for her excellent research on Hattie Carnegie.

88 Claire McCardell, *What Shall I Wear?: The What, Where, When, and How Much of Fashion*, rev. ed. (New York: Abrams, 2022), 20.

MOVING HORIZONS

AGENCY, IDENTITY, *and the* POETICS *of* WOMEN DESIGNERS
(ca. 1968–PRESENT)

Karen Van Godtsenhoven

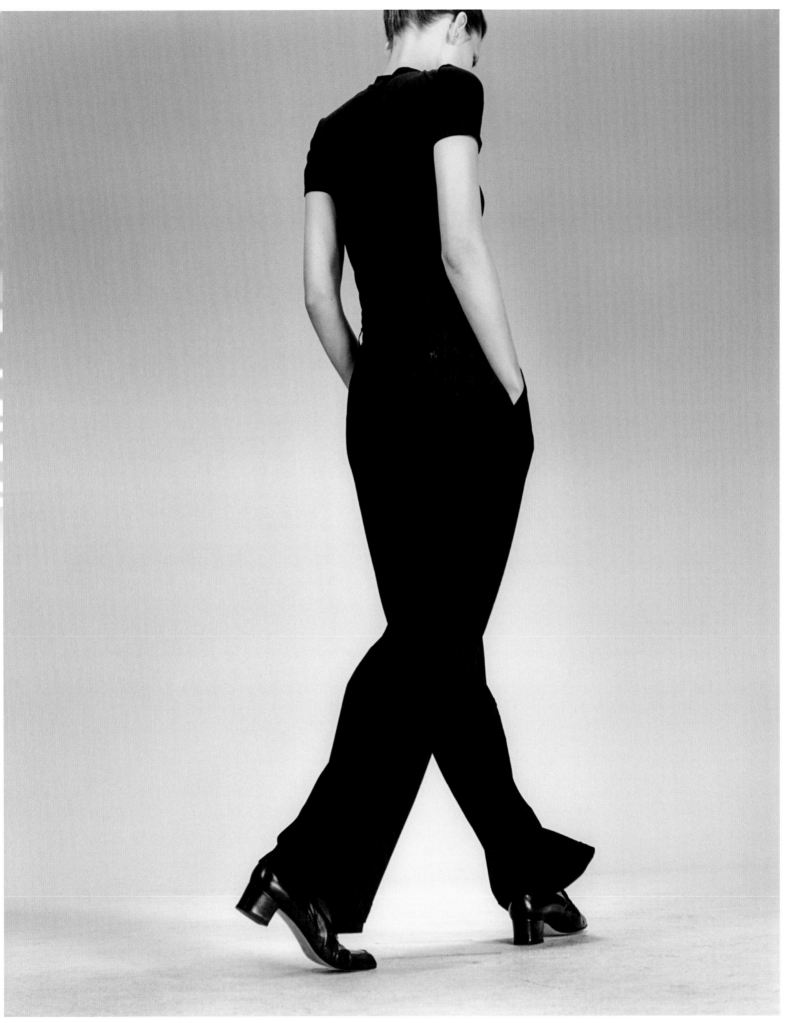

Advertising campaign for Jil Sander's spring/summer 1996 collection

DRESSING THE SELF:
A MATRILINEAL THREAD OF LIBERATION

She must write her self. . . . By writing her self,
woman will return to the body which has
been more than confiscated from her,
which has been turned into the uncanny
stranger on display—the ailing or dead figure,
which so often turns out to be the nasty
companion, the cause and location of
inhibitions. Censor the body and you censor
breath and speech at the same time.
Write yourself. Your body must be heard.

Hélène Cixous, "The Laugh of the Medusa"

In the 1960s and 1970s, the urge for women to write in a new language of their own experiences led to the concept of women's writing, or *écriture féminine*, a term coined by French feminist Hélène Cixous in her essay "The Laugh of the Medusa" in 1975 as a way for women to express themselves outside of patriarchal structures, language, and logic.[1] Fashions made by women designers can thus also evince this "writing of the self," since garments provide a way to write in an embodied, material language that can be read as well as worn by other women. Thus, dressing the self becomes a form of writing the self. This new language eludes concepts of "oneness" and, rather, presents subjective identities as multiplicities (always plural) by women for women.[2]

Women designers can create garments that bestow different types of agency on the wearer, such as professional, economic, artistic, or personal agency, and they can experience their own sense of sociocultural, financial, or artistic agency; their occupation has historically offered them opportunities for professional development and advancement, as Jessica Regan explains in her essay (see pp. 15–24).[3] In the historical context of the twentieth century, the affiliative, matrilineal thread running between different generations of professional women reveals how subsequent generations built and expanded upon the legacy of previous generations: one can hardly imagine the artistic and entrepreneurial autonomy of the designers of the boutique generation without the visibility and flourishing of female-led businesses in the interwar period (see Mellissa Huber's essay, pp. 25–46). For some women designers, creating fashion is a form of autopoiesis, or, in Sonia Rykiel's words: "Real direction occurred only later when I began making clothes for me—Sonia Rykiel— and not for other women. I wanted to be the only woman in the world to be dressed entirely in my own way. What this selfish idea did was to give my clothes a unique signature. My customers began to dress the way I wanted to dress and therefore "I made them unique in my own image."[4] This type of mimesis, or self-representation, in fashion makes it an autopoietic activity, whereby a designer's individual style and self-conscious approach produce new ideas, shapes, and garments for other women to wear.[5]

A BOUTIQUE OF ONE'S OWN:
AGENCY AND EMPOWERMENT FOR THE
BOUTIQUE GENERATION

I do not want women to disappear beneath
my clothing. The woman must be more than the
garment, for it is not the dress that makes
the woman, but the woman who makes herself.

Sonia Rykiel

The boutique generation came on the liberated heels of the midcentury American designers who sold their creations mostly through department stores. This new group of independent female designers included Sonia Rykiel, Betsey Johnson, Norma Kamali, Diane von Furstenberg, and Zandra Rhodes, among others. Most of them established their own ready-to-wear brands and boutiques in cities like London and New York as the male-dominated Parisian haute couture ateliers waned, with Cristóbal Balenciaga closing his house in 1968. These women launched their careers against the backdrop of the second wave of feminism and the cultural pop and youthquake movements.

The boutique functioned as a Woolfian "room of one's own" for these female designers and crystallized their newfound sense of control, not solely as creative thinkers and makers but also as the heads of their own businesses; the agency was sometimes artistic, sometimes socioeconomical, and often a combination of both.[6] Their arrival catalyzed the democratization of fashion, with five ready-to-wear designers being allowed entry into the Chambre syndicale de la couture in 1973, three of whom were women, including Rykiel, who served as vice president.[7] The boutique often conveyed a complete, youthful lifestyle and sold more than just clothes; as a spatial translation of the designer's identity, it became a gathering place where together designers and wearers could write a new communal language of embodied, sartorial freedom.

Fig. 1. Sonia Rykiel at the opening of her first boutique at 6, rue de Grenelle, Saint-Germain-des-Prés, Paris, 1968

Sonia Rykiel started to design during her pregnancy in 1955: unable to find maternity wear to fit her taste, she had dresses altered and later took her own designs to Italy, asking for snug jersey dresses with narrow shoulders that accentuated the form of the pregnant body, heretofore hidden beneath voluminous maternity wear. She designed under the flag of her husband's boutique, Laura, until 1965, when she started her namesake company, Sonia Rykiel. In 1968, after her divorce and in a move toward a life and business on her own terms, she opened her first eponymous boutique at 6, rue de Grenelle (fig. 1) and coined the term *Rykielism*, "a sociological and stylistic movement founded in 1968 by Sonia Rykiel in Saint-Germain-des-Prés. . . . Rykielism extols the libération [*sic*] of women through sensuality, intelligence[,] and irreverence. Rykielism is about having the freedom to be oneself. It's a way of life that's chic and offbeat."[8]

Her "Poor Boy" sweater,[9] with high-cut sleeves, narrow shoulders, and a shrunken fit, was featured in *Elle* magazine in December 1963, along with a striped dress ("like a long jersey sweater"[10]) worn by Françoise Hardy on the cover, introducing an emblematic design for years to come. For Rykiel, stripes were "the memory of the body, the between-the-lines, the inside which writes on the outside. It is the body with open eyes. It's a scar on a fabric, a cut in the drawing, one line following another."[11] The ensemble on page 147 features a sweater with a scooped neckline and stripes, of which the narrow bands of red are inside out, and a skirt that is finished with zigzag stitches instead of a hem at the bottom. The unfinished hem,[12] a sign of rebellion against bourgeois respectability, belongs to Rykiel's concept of the "démode," or being "out-of-fashion," underlining the independent spirit of the designer and her customers. Rykiel believed garments were not just a second skin but an extension of the body and soul, creating a continuity between the woman, the garment, and the world. Ideally, a woman would appear naked in her clothing, completely liberated, as her own creator.[13]

An American pioneer of the boutique generation, Betsey Johnson started her career designing youthquake garments for Paraphernalia, a Manhattan boutique that appealed to Warhol Superstars like Edie Sedgwick, Nico, and Jane Holzer, who was photographed in the designer's iconic striped mini ensemble in yellow and brown cotton, a bold, graphic leg-liberating garment worn with over-the-knee go-go boots as well as pants (p. 142). Johnson went on to open the boutique Betsey Bunky Nini in 1969 with two coworkers from Paraphernalia, Barbara Washburn (Bunky) and Anita Latorre (Nini),[14] and designed for the fashion label Alley Cat from 1970 to 1974. In 1978 she started a fashion line—one of the earliest lifestyle brands—in which her whimsical, high-femme, costume-like creations celebrated and exaggerated women's difference, playing into the performative aspect of gender. Johnson's creations were popular with a troupe of famous and creative women dubbed the "Betsey Girls," who lived their lives unapologetically and exemplified the youthquake spirit even after that era was over.

Norma Kamali's boutique on New York's East 53rd Street was the place to be for the art and fashion intelligentsia and club scene of the late 1960s and 1970s; fellow designers Diane von Furstenberg and Anna Sui as well as protopunk band New York Dolls frequented the store. Kamali designed gender-fluid garments, collaborating with people from the dance, wellness, and health worlds. Even though she sold womenswear, her boutique clientele was 50 percent male,[15] motivating her to think "beyond category/gender" and "force creativity in dressing, because it is creative dressing."[16] Kamali was always at the store, dressed in her own one-of-a-kind designs of snakeskin, tartan, or patchwork that often coordinated with the boutique's interior.[17] More than just a retail location, her store enabled her own personal and entrepreneurial independence: after divorcing Mohammed "Eddie" Kamali, with whom she had founded the brand in 1968, she relaunched her label in 1978 as OMO (On My Own), a personal venture without investors or external help. The store was a place where she could create meaningful connections with her customers and receive their feedback: "I'm bombarded with women's opinions in my shop. If I didn't listen to what they have to say, to what sells, I'd have to be stupid. We have to understand the needs . . . and give women what they want."[18]

Fig. 2. Diane von Furstenberg in her storeroom, May 1974

Diane von Furstenberg introduced her democratically priced wrap dress in 1973, selling it to women across the United States through department stores rather than a single boutique. A Belgian transplant to the United States, von Furstenberg merged the attitude of Anglo-Saxon equality feminism, where women focus on being men's peers in the boardroom, with European difference feminism, which concentrates on the strength of women being distinct from men. With the adaptable wrap dress, her goal was to prove that a woman can be in charge yet still clothe herself seductively, often in vibrant prints featuring natural motifs such as animal spots (p. 145) (fig. 2). Hence, the agency bestowed upon the wearer by the wrap dress is threefold: it is personal, professional, and sexual.

In the style of the American "labor aesthetic,"[19] with its focus on uniform and pragmatic work clothes, von Furstenberg

wanted to create a multipurpose dress—"a best friend" in a woman's closet—that allowed women to combine different social roles (executive, mother, lover, friend) into one garment that could go from day to night. She created the wrap together with patternmaker Bruna Sequalino, executing it in formfitting Italian-made soft stretch jersey in a wide variety of prints, explaining that "jersey is really a woman's material. If you look at fashion history, you will see that male designers choose more silks and women gravitate toward jerseys, because they care about wearability and how it feels on the body rather than how it looks."[20] Her motto "Feel like a woman, Wear a dress!"[21] exposes the artificial nature of gender: a garment is part of the gender performance that you can slip on and off; thus, femininity is a feeling, not an essential quality.

As her own muse and as a model for her customers, von Furstenberg was featured in her brand's advertisements and employed a mannequin made in her image. Her mission was for women to look and feel good. She traveled widely to American department stores to talk to women and literally adjust their wrap dresses in the changing room. She learned about women's insecurities and private struggles in front of fitting-room mirrors and recognized her own fears in them. In an intimate, embodied complicity with her customers, von Furstenberg dressed thousands of women in her own image—in the wrap dress.

Fig. 3. Zandra Rhodes in her London boutique, March 1978

Following the opening of her boutique in 1973, Zandra Rhodes (fig. 3) became part of a group of London-based designers who made the city the capital of cool in the international fashion scene of the 1970s. After running a collaborative label and store with designer Sylvia Ayton in 1967,[22] Rhodes launched her emblematic first solo collection, "The Knitted

Circle," for autumn/winter 1968–69, which established her as a successful designer in 1969. The collection evolved from her experiences of knitting as a child and with friends while on holiday in Wales, and from the knitted textiles that she had seen on exhibit at London's Victoria and Albert Museum. Looking through her mother's sewing books, she became enamored with the embroidery technique of chain stitch, which inspired the textile print design on page 143. The coat features a printed version of chain stitch that evokes a folk motif in bold colors, elements of Rhodes's signature aesthetic, which allowed women to appreciate and experiment with color, shape, and handcraft.

THE BOUTIQUE GENERATION'S PERSONAL IS POLITICAL

I just use fashion as an excuse to talk about politics. Because I'm a fashion designer, it gives me a voice, which is really good.
Vivienne Westwood

During the intellectual turbulence of the 1970s, different feminist ideas came to the fore, such as radical feminist Shulamith Firestone's statement that "the personal is political"[23] and the notion that women's suppression trumped class-based oppression. Ecofeminists like Françoise d'Eaubonne saw connections between patriarchal capitalism's exploitation of the earth and its mistreatment of women,[24] and Monique Wittig dreamt up the abolition of the sex class system, declaring in her essay "The Straight Mind" that there is no such thing as a "woman" outside of heterosexist thinking.[25]

Fig. 4. Vivienne Westwood wearing her "Buy Less" T-shirt, summer 2018

Similarly, several women designers used clothing to express political beliefs and to expand their personal and cultural sovereignty. Their boutiques in London, Milan, and New York operated not just as retail stores but as communal spaces promoting a more programmatic ethos reflected in the clothes—from rallying political messages to criticism of fashion's overconsumption. Most prominently, Vivienne Westwood's succession of London shops that she opened with partner Malcolm McLaren[26] were transgressive spaces that served as a meeting place for like-minded, anarchist youth (punks and, later, New Romantics) to confront social and sexual taboos. In her SEX boutique, for example, the walls were covered with graffiti lettering from Valerie Solanas's *SCUM Manifesto* and adorned with rubber curtains and chicken wire. Throughout her prolific career, Westwood employed fashion as an emancipatory tool: to lose the shackles of bourgeois respectability, to blur gendered binaries, or to denounce harmful overconsumption. Eschewing the word *feminist*, she nevertheless built her empire on her own terms. In recent years her political messaging focused on climate awareness and environmental activism, advanced by the slogan "Buy Less, Choose Well, Make It Last" (fig. 4).

Also in London, Katharine Hamnett expressed her political beliefs with silk-screened slogan T-shirts that she began selling in her boutiques in 1979,[27] branching out to four hundred international sales points in the 1980s. Her vision behind the slogan T-shirts was to appropriate the bold lettering of the British tabloid *The Sun*—"unmissable from 200 yards away"[28]—and to use it for critical anti-Thatcherite and anti-American messages. Most notably, she wore her "58% Don't Want Pershing" antinuclear T-shirt to a reception held by Prime Minister Margaret Thatcher at 10 Downing Street in 1984 (fig. 5). Hamnett's T-shirts are a form of direct political action: "Logo t-shirts [*sic*] are designed to put ideas in your brain. You can't not read them. They make you think, and hopefully do the right thing."[29]

The "Stay Alive in 85" T-shirt (p. 150) was inspired by the Greenham Common Women's Peace Camp, established in 1981 outside the Royal Air Force base in Berkshire, England. Hamnett's "US Go Home" T-shirts had been returned to her by London retailer Joseph, so she brought them to the women at the camp who were protesting against the placement of US nuclear weapons on British common land. Suspicious, the women refused the donation at first but then distributed the shirts before singing laments at the base's perimeter fence as soldiers looked on from the other side. The camp's antinuclear protest inspired Hamnett to make the "Stay Alive in 85" T-shirts. A few years later, in 1989, her political awareness expanded to a more self-critical perspective: she pioneered sustainability in fashion, inspired by Buddhist principles of doing no harm as well as preserving the earth for future generations, which led her to think, "You know, Aristotle asked, 'What is the good life?' You can live a good life but what good is that if you damage generations to come?"[30]

Fig. 5. Prime Minister Margaret Thatcher greets fashion designer Katharine Hamnett, wearing a T-shirt with a nuclear missile protest message, at 10 Downing Street, where she hosted a reception for British fashion week designers, March 1984

In Milan Miuccia Prada (fig. 6) received a doctorate in political science as a youth and joined the country's Communist Party and its women's movement, the Unione Donne Italiane. As a fervent campaigner for women's rights during feminism's second wave, she had an ambivalent relationship with fashion. Preferring to dress differently from her peers, she had to conquer her own feminist and theoretical dislike of the fashion industry in order to start designing and producing garments, which she started doing at the age of forty: "I always accepted my love for clothes, but I didn't want to enter into the fashion business. But I did it, I think, because I probably liked it."[31] Eventually, her sense of personal and creative agency prevailed over her political beliefs.

Prada's conceptual approach to design is based on an artistic and intellectual sensibility that is underlined by her resistance to the classical notion of female beauty propagated by mainstream fashion: "First of all it's because there is the political side, which is rejecting that idea, because simply, it is wrong, it's not dignified for women, so you have to be a doll to be beautiful, always the same. That's why I hate the bias cut, everything that people think make[s] women beautiful. I'm against that, in principle, from a personal and human point of view. The other reason I am against it is because it is banal. I want to be more clever, or more difficult, or more complicated, or more interesting, or more new."[32] Her ensemble for autumn/winter 2007–8 (p. 159), a chimeric encounter between synthetic embellishments and more

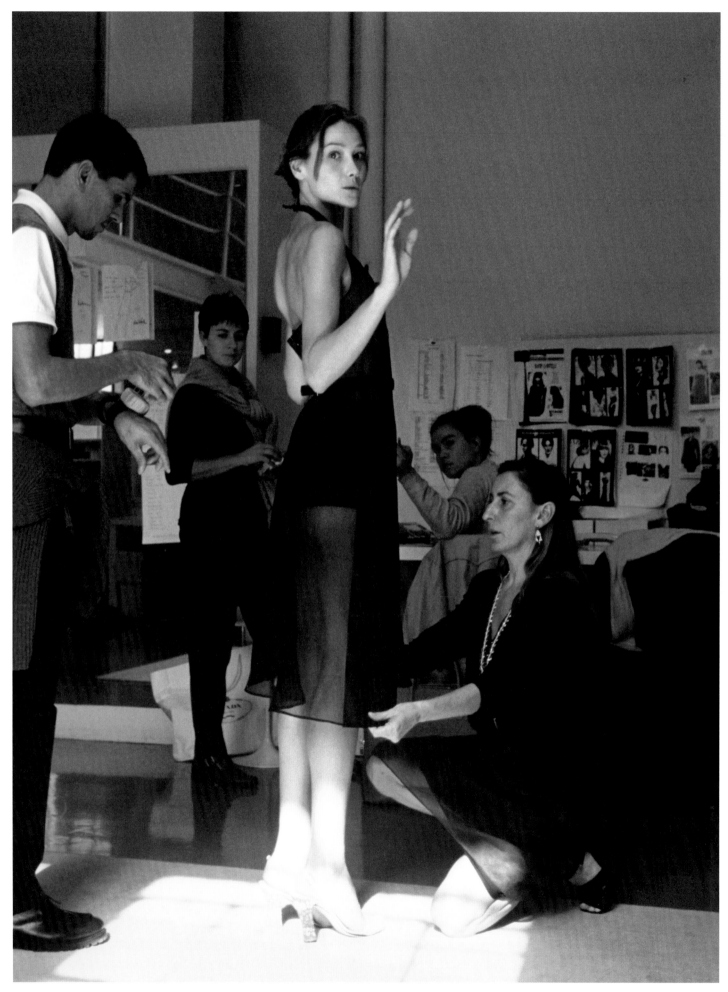

Fig. 6. Miuccia Prada adjusting clothes on Italian French top model Carla Bruni, October 13, 1994

primitive materials, goes against the rules of good taste and conventional beauty; it is "[s]omething simple but strange," as the designer told *Vogue*.[33]

In New York City, designers from various cultural backgrounds forged new styles that fused Eastern and Western approaches to dress in a climate optimistic about the position of women in society. One such designer is the Chinese American Vivienne Tam, who escaped the People's Republic of China in 1960 with her family when she was three years old and grew up in Hong Kong. Tam studied fashion design at Hong Kong Polytechnic University, moving to New York in 1983 to start her fashion career. During the 1990s, Tam collaborated with the Chinese artist Zhang Hongtu on her seminal 1995 "Mao" collection, which embraced the tradition of New York artists using images of political figures as a form of satire. Hongtu employed humor to manipulate the Chinese Communist leader's portrait to debunk his godlike status and as "a kind of mental therapy" following protests in China in 1989. Some of the colorful and playful dresses in the collection depict the leader wearing pigtails and sunglasses. However, the image featured in Tam's ensemble on page 153 is "more serious, symbolizing the positive and negative effects [he] had on Chinese culture."[36]

Fig. 7. Hanae Mori opened her first atelier as a dressmaker in Tokyo's Shinjuku district in 1951 at the age of twenty-five

Hanae Mori, who started out as a film costume designer, was the torchbearer of the generation of postwar Japanese designers who conquered the international fashion scene in a phenomenon that has been dubbed "Neo-Japonism"[37] after the time in the nineteenth century when Japanese aesthetics influenced Western art. A transitional figure, Mori searched for a balance between Eastern (*wafuku*) and Western (*yofuku*) modes of dress as well as between couture and ready-to-wear. She broke several gender and cultural boundaries as the first Japanese entrepreneur in a typically male-dominated world (fig. 7) and the first Asian woman to be allowed entry into the French Chambre syndicale de la couture, in 1976. She

sold Western-looking garments in her Tokyo boutique in the renowned Ginza shopping district beginning in 1954, yet she presented luxurious eveningwear based on the kimono and traditional Edo fashions at New York fashion week in 1965 before opening a store inside the Waldorf Astoria in 1973.

Fashion journalist Suzy Menkes claims that "no one has bridged the culture divide with more skill and subtlety than Hanae Mori."[38] Mori's cross-cultural fashions challenged traditional Orientalist attitudes: her signature butterfly logo symbolizes how, in Ayaka Sano's words, she overcame the Oriental past.[39] During her career, Mori sought to reestablish the notion of craftsmanship and elegant sophistication previously associated with the label "Made in Japan" by blending Japanese textiles, motifs, and the kimono method of garment construction with Western-looking silhouettes.[40] Mori adopted this approach after seeing a performance of Giacomo Puccini's opera *Madame Butterfly* on a trip to New York in 1965 and being shocked by how weak, Orientalist, and vulnerable the geisha was portrayed, "dressed in a 'Chinese-style' costume."[41] She also noticed that Japanese goods were often sold at low prices or in the basements of department stores, which upset her.[42] Her dismay at the incorrect representation of Japanese dress and culture prompted her to reclaim the motif of the butterfly both literally and metaphorically: she incorporated it into her brand's logo as a symbol of her business "spreading its wings"; she illustrated her lightweight garments with refined and stylized butterflies in bright colors; and she designed dresses with A-line kimono sleeves in diaphanous silks "born to flutter about the body" like butterfly wings.[43] Finally, in 1985, twenty years after seeing the opera in New York, she designed a theater costume herself for the *Madame Butterfly* protagonist, "a light pink kimono-style wedding dress with a large butterfly print and a Western-style veil, along with a violet kimono embellished with small, airy butterflies."[44]

One example of Mori's intentional design practice that attempts to overcome cultural stereotypes is her autumn/winter 1974–75 evening dress (p. 149) modeled after a series of woodblock prints by ukiyo-e artist Utagawa Hiroshige. The print series, titled Meisho Edo Hyakkei (One Hundred Famous Views of Edo) (1856–58), exemplifies the sophisticated Japanese aesthetic of Miyabiyaka, which draws inspiration from *miyabi* (refined courtly beauty and elegant femininity).

Donna Karan's philosophy of professional female empowerment and agency has been present in her work since her solo debut in 1985, when she introduced her "Seven Easy Pieces" collection, a seasonless, predominantly black, and modular wardrobe consisting of seven items that replaced the power suit with a more body-hugging, sensual, and minimal aesthetic and could accompany the working woman from day to night. Karan's beliefs found their most overt expression in her 1992 "In Women We Trust" advertising campaign that portrayed model Rosemary McGrotha as the first female American president (fig. 8). McGrotha wears Karan's "Cold-Shoulder" dress, a tight, black, long turtleneck dress with

fabric cutouts at the shoulders (p. 152). In an era when women's shoulders were often padded to project a masculine, powerful physique, Karan created the dress with cutouts, revealing the woman's bare shoulders. In 1993 Hillary Rodham Clinton wore the dress to her first state dinner as First Lady, saying, "I love the way it feels. And when you feel good, you look good."[45] For Clinton, wearing the dress prefigured her own ambition of becoming the first female president of the United States.

Fig. 8. Donna Karan's "In Women We Trust" advertising campaign featuring model Rosemary McGrotha as the first female president of the United States wearing the "Cold-Shoulder" dress, 1992. Karan's mission statement for her clothing line was, "You'll look chic, sophisticated, and as authoritative as any man in the room. Only you'll look like a woman."

WEARING THE TROUSERS: WOMEN DESIGNERS APPROPRIATING MENSWEAR

If gender attributes and acts, the various ways in which a body shows or produces its cultural signification, are performative, then there is no preexisting identity by which an act or attribute might be measured; there would be no true or false, real or distorted acts of gender, and the postulation of a true gender identity would be revealed as a regulatory fiction.

Judith Butler, *Gender Trouble: Feminism and the Subversion of Identity*

For women wearers, trousers and the tailored suit carry with them a highly symbolic status that acts as a fashionable indicator of women's liberation and agency. From the Bloomerite and the dress reform movement that politicized garments in order to catalyze female emancipation (both physically and politically), to Gabrielle Chanel's appropriation of English tailoring techniques for women's garments, to Elizabeth Hawes's "Uphill" cycling trousers (1939), to Yves Saint Laurent's tuxedo for women (1966) and contemporary queer and nonbinary versions, the suit has become an emblem of liberatory transformation and a signifier of gender performativity for some women. For women designers, the practice of tailoring, a technique and skill historically gendered as male (see Regan's essay, pp. 15–24), is a way to expand their professional as well as their artistic control.

German designer Jil Sander (fig. 9), known for the purist aesthetic she paired with luxurious fabric experimentation, aimed to create work outfits for women that would be taken seriously but that also pampered the body.[46] Gifted with both business acumen and artistic genius, she started her own company in 1968, originally working from her mother's sewing machine, and went on to list the enterprise publicly on the Frankfurt Stock Exchange just eleven years later, in 1979. Her autumn/winter 1998–99 suit mixes sharp tailoring with padded shapes (p. 154). The woolen ensemble has structured peepholes and armorlike conical shoulders, fusing harder features with more porous characteristics. The discreet, dandiacal silhouette exudes a modern attitude. As Sander once said, "Of course, I always have a sort of woman in mind when I design clothes. I like women cool, never over-decorated."[47] Her statements echo the functional aesthetic of the Bauhaus movement and reclaim the words of Austrian architect Adolf Loos, who crusaded against ornament in his 1913 essay "Ornament and Crime."[48] From his perspective, ornamentation is a loss of power, an othering of sorts, a feminization. Conquering this othering of women by borrowing from the male wardrobe, Sander provided professional women with monochromatic, unembellished, yet opulent workwear, equivalent to the business suit for men: "[A]ll I wanted was to enable women to have the same window of opportunity via their clothing that men have had for a long time. It was about confirming them in their self-assurance, lending flexibility and charm to their movements, underlining their natural attractiveness."[49] Dubbed the "Queen of Less," Sander established a minimalist aesthetic that reflected the sober mood of the last decade of the twentieth century.

Fig. 9. Jil Sander in her studio, 1983

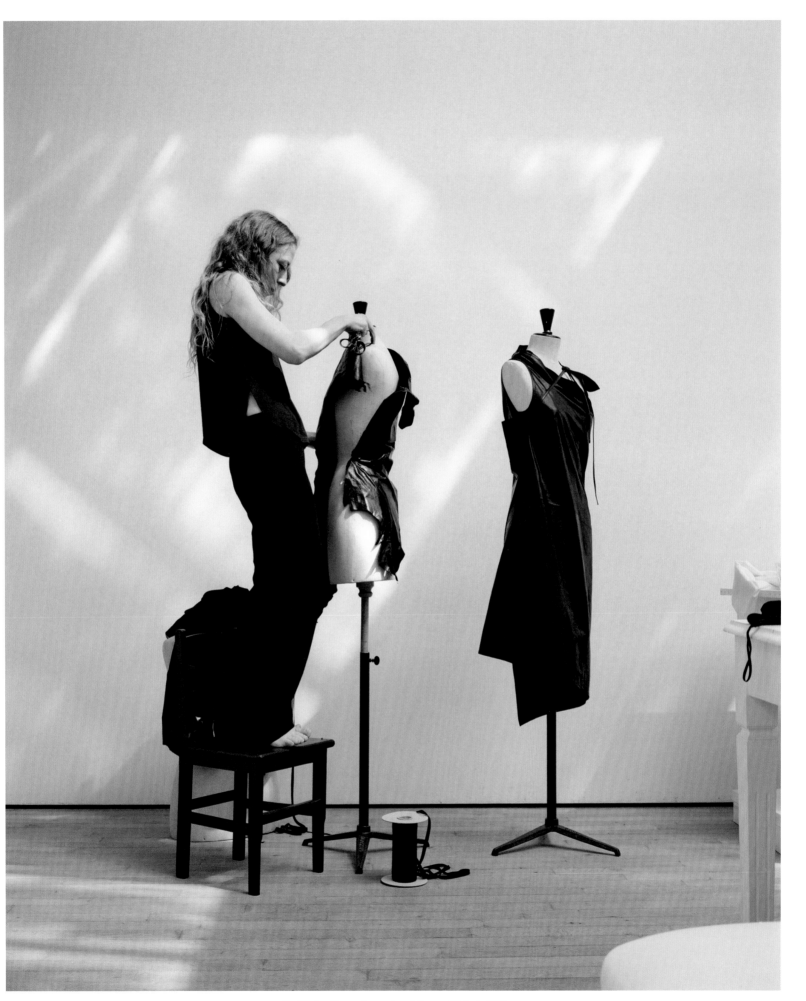

Fig. 10. Ann Demeulemeester, Antwerp, Belgium, 1999

Ann Demeulemeester (fig. 10) started designing clothes because "the Ann Demeulemeester woman was not around before I started."[50] In one of her first creations, she converted a man's black leather boot into a woman's shoe by incorporating a heel, which added height without the posture of stilettos. Her motivation came from within herself: "I believe that women design from within themselves, whilst a man is more likely to clothe a body."[51] The suit has been present in her work from the beginning, in both her collections for women as well as men: "It's been my challenge to keep reinventing 'the suit.' I have always worked toward designing an attitude through shapes by adjusting the balance, accentuating movement, imbuing the garment with a poetic nonchalance."[52] The suit on page 155—worn with an asymmetric blouse featuring an off-the-shoulder longer side that is adjustable using a strap—epitomizes Demeulemeester's play with proportion and mobility. The silhouette dates from her spring/summer 1997 collection, which "combined classicism with asymmetry and nonchalance with elegance . . . because she was so tired of seeing all these women in close-to-the-body clothes."[53] The androgynous suit with its off-the-shoulder white shirt recalls Patti Smith's self-styling on the cover of her 1975 album *Horses*. Smith is both an inspiration for and a close friend of the designer, for whom the word *androgyny* is not quite appropriate, as it suggests a certain gender neutrality; instead, Demeulemeester contends that "[w]hat is interesting for us in a man and a woman—the male and female elements—is how they relate to each other."[54] Following her spring/summer 1997 collection, she introduced male models into her 1998 womenswear collection and has included both genders ever since: "I want to be a woman, a man and a child altogether. I do believe in spirit, not in gender."[55] To her, femininity is not found in the usual "erogenous zones"[56] of the body or silhouette but in a movement or a drape that adds mystery and allure to a strong, confident woman.

Claiming their own agency in a manner not unlike the female designers who appropriated menswear's methodologies and silhouettes, Maria Grazia Chiuri, of Christian Dior, and Sarah Burton, of Alexander McQueen, have each taken the helm at heritage fashion houses established by male designers. Their successful tenancy indicates a larger positive evolution of women becoming the heads of traditionally male-led houses in the twenty-first century.[57] For her inaugural spring/summer 2017 ready-to-wear collection, Chiuri punctuated her position as the first female artistic director in Dior's seventy-year history and redefined the house's focus on femininity with an outspoken and self-conscious feminist message that included T-shirts printed with the title of Chimamanda Ngozi Adichie's essay "We Should All Be Feminists." The first silhouette Chiuri showed (p. 166) consisted of a white turtleneck and cotton jeans that she paired with a gender-neutral, white fencing vest embroidered with the customary red heart, as "the art of fencing 'involves mind and heart at the same time, which women always need if they are to realize themselves.'"[58] Chiuri's creative and feminist stance rebalances the house's

traditional notion of hourglass femininity by moving toward the more sportswear-influenced, ready-to-wear allure of a separates silhouette as an expression of freedom and means: "We have to understand that it's possible to use the past in a modern way for modern women."[59]

PHYSICAL AGENCY AND ADAPTABILITY

It's important to think of, who are we not designing for? Design is an enormous privilege but also a responsibility.
Sinéad Burke, "Why Design Should Include Everyone"

When garments are adaptable to the body's movement, capacity, size, mood, and gestures, they are the perfect tools for endowing the wearer with a sense of physical agency— that is, of being able to direct their body in the world freely. Historically, women designers such as Madeleine Vionnet (known for her draping, wrapping, and the bias cut), Elsa Schiaparelli (zippers), Claire McCardell (tying), and Gabrielle Chanel (pockets), among others, have bestowed autonomy on the wearer by designing unfettered garments that allow space for movement and that can accommodate and adapt to the wearer's circumstances. During the second half of the twentieth century and into the twenty-first, new developments in fabric technology and sportswear have offered designers even more options to expand the wearer's autonomy and to create adaptive fashions, including those for trans, nonbinary, agender, and disabled bodies.

Norma Kamali is best known for her innovative, stretchy, versatile, user-friendly garments, namely, sporty separates (sweats) and swimwear. For her original "Parachute" dress (p. 161), constructed with adjustable straps and drawcords that allow the wearer to adapt the dress's length and fit, she used parachute silk given to her by Victor Hugo, Halston's collaborator and window dresser.[60] Kamali applied the parachute principle to dresses, jumpsuits, and separates, but, as her colleague Vera Wang muses, "more than just clothes, it was about a vision of women."[61] The parachute endows her customers with a mobile and creative sense of choice: they are free to move their bodies in any direction and can dress themselves up or down for any occasion.

Cuban American designer Isabel Toledo's (fig. 11) work has been described by fashion scholar Patricia Mears as "liquid architecture, soft sculpture, organic geometry" and by the designer herself as a form of "romantic mathematics,"[62] formulations that, together, point toward the collusion of binaries in her work. Toledo took an autodidactic approach to fashion by interning and volunteering at the conservation department of The Metropolitan Museum of Art's Costume Institute between 1980 and 1984. There, she gleaned construction principles from gowns by couturiers such as Vionnet, Cristóbal Balenciaga, and Jeanne Lanvin that she later applied to her own designs, which combine the *tailleur* approach of tailoring with the *flou* technique of draping.

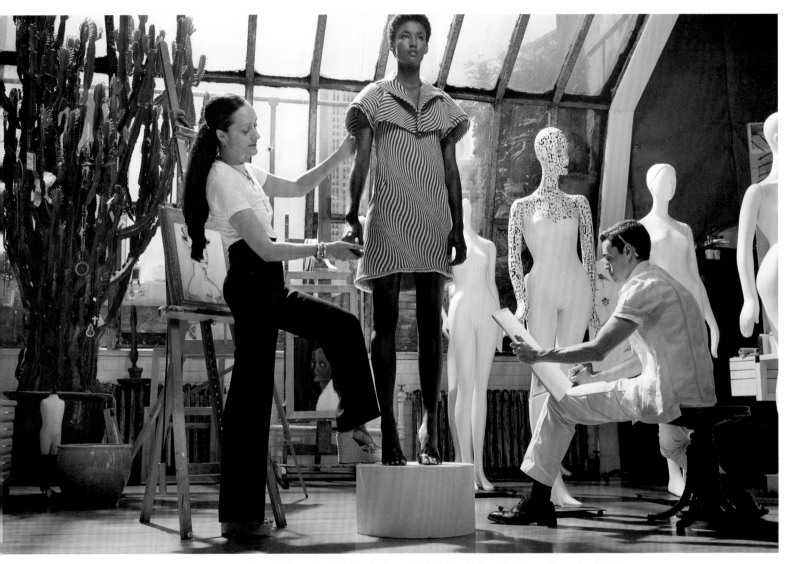

Fig. 11. Isabel and Ruben Toledo, with model Sessilee Lopez, in their New York studio, *Vogue*, November 2005

Toledo also had a penchant for gender-bending, whimsical garments with sexual allusions—items like man bras, a collection featuring pubic hair, and a hermaphrodite dress with custom pouches and phallic or mammary forms—that allow wearers to play with differently gendered components. Her "Kangaroo" dress (p. 162) consists of a panel of jersey looped around the upper back and lower abdomen, creating a volume at the stomach. As designer Cathy Maguire explains, Toledo's dress is "draped so that there's a kangaroo pouch across the woman's stomach, which most women would have a problem with, having so much fullness around the stomach. But this dress is one of the most sophisticated dresses I've ever seen."[63]

Fig. 12. Autumn Randolph and Pia Davis for the No Sesso x Levi's advertising campaign, spring 2022

No Sesso (Italian for "no sex or gender") is an American agender fashion label founded in 2015 by Pia Davis and Arin Hayes and now run together with Autumn Randolph (fig. 12). As a "brand for everybody," the community-based label blends utility and sensuality in collections that intersect art, fashion, and design. The first transgender woman designer to be featured officially on the New York fashion week calendar,[64] Davis showed a mainly handmade collection created from reconstructed materials for autumn/winter 2019–20. For autumn/winter 2022–23, Davis and Randolph translated their experience as Black American women into garments made of denim and nylon. The asymmetric dress with cutouts and cargo pockets (p. 163) has drawcords that "[help] to control how much skin is shown on the cutout,"[65] thus giving the wearer the option either to cover or reveal certain body parts.

Founded by Danish designer Jasmin Søe in 2021, the adaptive and inclusive brand Customiety—meaning "custom-made clothing for our society"—offers people with achondroplasia (the most common type of short-limbed dwarfism) a wardrobe of clothing that stems from a simple premise: "Something soft, something basic and something shiny."[66] The idea to create fashionable and functional garments for a body type that represents 700,000 people globally was long overdue and came to the designer when she was seventeen years old. Søe saw an adult with achondroplasia wearing children's clothes on a train platform. Their apparent lack of choice inspired her to establish a brand that considered the sartorial needs and daily lives of people born with the genetic condition. Every item in the collection is designed with cords via which the wearer can adjust the fit on the body. For example, the "Going Out" dress (p. 160) has cords in the front and back for an ideal fit and, in the words of Søe, is meant to "make the wearer feel beautiful right away—no need to send it to the tailor and wait to get it back—or to pay even more for a tailor to do any tailoring on it. You can buy it, . . . and wear it right away on a Friday night when you go out to have fun with your friends."[67]

AFFECTIVE FASHION, OR BECOMING-OTHERWISE

Perhaps, ironically, we can learn from our fusions with animals and machines how not to be Man, the embodiment of Western logos.

Donna Haraway, "A Cyborg Manifesto: Science, Technology, and Socialist-Feminism in the Late Twentieth Century"

At the turn of the twenty-first century, a few female designers, including Georgina Godley, Vivienne Westwood, and Rei Kawakubo, introduced the body to new ways of becoming. This type of affective fashion activates energies present in both the garment and the wearer, and their continuous interaction and exchange of matter, substances, durations, and flows engage them in a process of mutual becoming: the garments impact the wearer at an affective and physical level, and they both transform each other so that they can "become-otherwise."[68] In this instance, there is no ontological separation between a garment and the body wearing it, and the focus is on what it does for the wearer—namely, how it affects the wearer emotionally, how it impedes or encourages movement, how it transforms the wearer's body, self-awareness, etc.—rather than on the visual or the intellectual meaning of the garment. Dress is no longer "the frontier between self and not-self,"[69] as Elizabeth Wilson claims, but is entangled with the body or, as Kawakubo states, "Body meets dress, dress meets body and they become one."[70]

Furthermore, affective fashion bridges the Platonic divide that separates the body and the mind, which is the basis for the binary view that women are linked to the body and nature and men are associated with the mind and reason.

Affective fashion thus distorts the idea of the body as a coherent unit and, as an assemblage, opens it up to radical new ways of becoming-other: becoming-woman, becoming-queer, becoming-animal, becoming-matter, and so on. Rather than shifting the focus to different erogenous zones, affective fashion destratifies the body and liberates the agency contained within its core.

In 1986 Godley created three fluid, bulbous dresses in a collection titled "Body and Soul." Her "body" dress, "soul" dress, and "muscle" dress celebrated and exaggerated the female silhouette. For her seminal autumn/winter 1986–87 "Lumps and Bumps" collection, she stretched Lycra dresses over padded underwear, amplifying women's curves in a surreal manner. The collection was inspired by a study of African fertility dress, taking the female form as an expression of fecundity and power. The impetus for the garment on page 156 was Godley's deconstruction (or reconstruction) of Barbie dolls, a distorted rendering of the ideal Western female silhouette. She modeled clay onto the dolls until they "felt right,"[71] an exercise that evolved into padded shapes being sewn onto a jersey underdress, over which a Lycra dress with a hooped hem is worn. The dress features asymmetric padding from the upper left hip to the lower right at the back. Godley's autopoietic approach offers a third option, ignoring the sartorial dilemma between sexy dress and shapelessness, which was a prevalent issue for women in the 1980s. Her prosthetic garments function as a way for the wearer to imagine new selves and embodied, affective assemblages every time the garment is worn.

Kawakubo also deconstructs and reconstructs the female form and creates new ways of becoming-woman,[72] urging us to read the body differently by sculpting it into new shapes that do not adhere to classical ideals. Instead of playing a game of hide and seek with the male gaze, her swaddled, wrapped, and prosthetic body is completely obscured from his eyes. In a symbiosis of skin and fabric, the notion of the fold emerges, which philosopher Gilles Deleuze describes as a "continuous dialogue between inside and outside"[73] so the dressed body "touches herself . . . all the time,"[74] as explained by Luce Irigaray. The inside and outside of the garment (p. 157) and the skin are in a state of constant flux, exchanging gravitational and physical forces, as the body and dress are impacted by prosthetic shapes that are slipped like cushions inside the pockets of a gauze, worn between the garment and the body. These shapes are not alien appendages but integrate daily reality into the process of becoming-woman: they "are familiar shapes we can see every day, a bike messenger with a bag over the shoulder, a tourist with fanny pack, a baby on a mother's arm."[75] In a creative and dynamic process, wearers of affective fashion thus create their own processes of becoming-otherwise or becoming-woman, in order to give rise to new affirmative values, sharing agency between mind and matter.

Westwood focused on the hourglass silhouette—especially in the mid-1990s—mainly by looking at historicist ways of padding the female body and then subverting these tendencies in a postmodern pastiche of appendages and panniers.[76] Her iconic "On Liberty" collection for autumn/winter 1994–95 included a red tartan ensemble featuring a padded, bustle-like shape tied around the waist with a belt as an external appendage and cushion for the behind (p. 151), asserting the wearer's sexual freedom. Westwood's predilection for the work of eighteenth-century artists like François Boucher and the theatrical sartorial concoctions for women of that time results in a celebration of artifice, deconstructing the Western idea of the "natural" female silhouette.

Fig. 13. Phoebe Philo walks the runway during Céline's ready-to-wear show, Paris fashion week, autumn/winter 2012–13

British designer Phoebe Philo (fig. 13) offers her fashions as "a proposal" to women, basing the overture on her own experience navigating her private life amid the demands of the fashion world.[77] The affective qualities of her garments provide a sense of shelter, of sureness and ease. As artist Cindy Sherman muses, "When I wear [Philo's designs], I feel like I've got my act together without trying too hard."[78] In 2001 Philo took over as the artistic director at Chloé, where she had worked with Stella McCartney since 1997, staying until 2006. Later, she worked as the artistic director at Céline, from 2008 to 2018. For her Céline spring/summer 2017 collection, her proposal focused on the beauty of the everyday. The runway show was held in an open space, in the middle of which stood a two-way mirrored pavilion created by artist Dan Graham. The pavilion served as an instrument to unveil the power of the gaze: "My pavilions derive their meaning from the people who look at themselves and others, and who are being looked at themselves."[79] Images of the viewer and the objects were superimposed onto the glass, creating an intersubjective, reflective, and ever-changing view that brings to life Philo's idea of a sort of entwined agency between body and world: "I just want to show that our bodies are bound to the world, whether we like it or not."[80] Graham's glass structure echoes Philo's philosophy of striving toward becoming-otherwise: "I've always liked very diverse and different things. I am curious about 'the other.' I'm very interested in including that—the offness,

the chink."[81] Her white shift dress featuring an image from Yves Klein's Anthropométrie series of paintings (1960) (p. 164) reappropriates the gaze from this monument of postwar performance art. Philo places onto fabric a blue imprint of the naked female body Klein used as a "human paintbrush." As the dress with the imprint is worn by a moving, living body, Philo reflects the frozen image back at us, making room for new perspectives and becomings.

MOVING HORIZONS: EMPOWERMENT THROUGH PRACTICE

The feminine is redefined as a moving horizon, a fluctuating path, a recipe for transformation, motion, becoming.

Rosi Braidotti, *Nomadic Subjects: Embodiment and Sexual Difference in Contemporary Feminist Theory*

The personal agency assumed as a given by some women designers who came of age in the twenty-first century becomes disseminated in an atmosphere of communion, as these designers' practices move away from the traditional studio-based "genius designer" system toward a virtual, decentralized chain of collaborations across the globe. Power is shared between all the actors—textile workers, designers, seamstresses, saleswomen. The fashion designers' processes and sometimes self-taught approaches to dressing the body become more disruptive, and the cocreative aspect of designing, making, and wearing blurs traditional hierarchies. The intersection with other disciplines can hybridize the designer's role, and the introduction of intelligent technology contributes to an expanding horizon of new possibilities that can be used to address issues of environmentalism, gender, race, class, and adaptive modalities. Garments—their cocreative design and sustainable production process as well as their impact on the wearer and the material and virtual worlds—carry the communal agency shared between different generations of women, illustrating how fashion design can be an empowering practice for women and new posthuman, nonbinary figures such as the cyborg and the avatar.[82]

Dutch designer Iris van Herpen (fig. 14) engineers posthuman forms, harmoniously blending command of the body with technology. Her work is a continuous poetic collision of craftsmanship, technology, and design that integrates influences and techniques from various fields—from sculpture to mathematics, poetry to astronomy, dance to architecture, nature to philosophy. It is often a cocreative act between the designer and her team as well as partners from the science, arts, architecture, design, and engineering worlds, multiplying the creative agency manifested in the garment. For example, her "Skeleton" dress (p. 165) is a 3D-printed collaboration with architect Isaie Bloch that was executed in plastic polyamide, made using a laser sintering process. The ensemble mimics a skeletal structure that stands away from the body, and its silhouette resembles that of a ballerina's bodice and tutu. It comprises two parts—a stylized rib cage and a pelvis—with a peplum at the back. Featured in Van Herpen's autumn/winter 2011–12 haute couture "Capriole" collection, the baroque shape symbolizes the moment of free fall in skydiving, "when every fiber of the body feels as though it is growing in all directions,"[83] as if the body is turned inside out. Van Herpen muses, "I'm not only looking at the body, I also look at the space around the body, like a dancer would. It's like translating a piece of dance into a garment, evoking kinesthetic sensations through dressing. Honoring the nature of the body in process, the designs express femininity, volume, lightness and movement into wondrous experiences of reality."[84]

Another example of a designer who takes an engineered and architectural approach toward cut and materials, Malaysian-born designer Yeohlee Teng states: "I believe in the magic of numbers, and when your numbers are right, the proportion looks perfect. It is synchronized with the body."[85] Growing up with multicultural influences, Teng studied with a Javanese patternmaker. The experience resulted in her notion of clothing as the first shelter that you build around yourself as protection. It also instilled in her a deeply felt ecology of materials: "I grew up on an island, and when you grow up on an island you know that all resources are limited. . . . So being aware of that, it makes conservation a very instinctual thing to do."[86] Her ensemble consisting of a cape and dress constructed with geometric black-and-white pattern pieces (p. 168) is functional in its structure, but its visual appeal lies in the shifting constellation of building blocks and the possibility of hiding different elements of the body. The cape and dress together form a structure that envelops the body in movement, comparable to that offered by the sarong, the ultimate zero-waste and genderless garment from which Teng drew inspiration.

Similarly, visual artist and fashion designer Jamie Okuma draws upon her Shoshone-Bannock, Wailaki, Luiseño, and Okinawan heritage, modernizing Native American concepts of dress to produce her one-of-a-kind "Art to Wear" collection. Her autodidactic practice consists of a combination of handcrafted unique pieces and ready-to-wear fashions. Having started beading at the age of five, she is known for her beadwork as well as her mixed-media soft sculpture and her fashion design, which she dubs "contemporary native fashion design."[87] Her "Parfleche" dress (p. 169) is a nod to the folded rawhide bags that were produced by the Plains Indians of North America, who could not tan their buffalo hides using conventional methods because they were nomadic. Thus, the hide was prepared by cleaning and dehairing the skin and then stretching it, allowing it to dry in the sun. The process created a stiff leather (parfleche) that was often decorated with abstract diamond-shaped motifs—echoed in the structure of Okuma's silk and stretch tulle dress, transmuting the toughness into a fluid line.

French designer Marine Serre's self-described "ecofuturist" practice resonates with the values espoused by ecofeminism

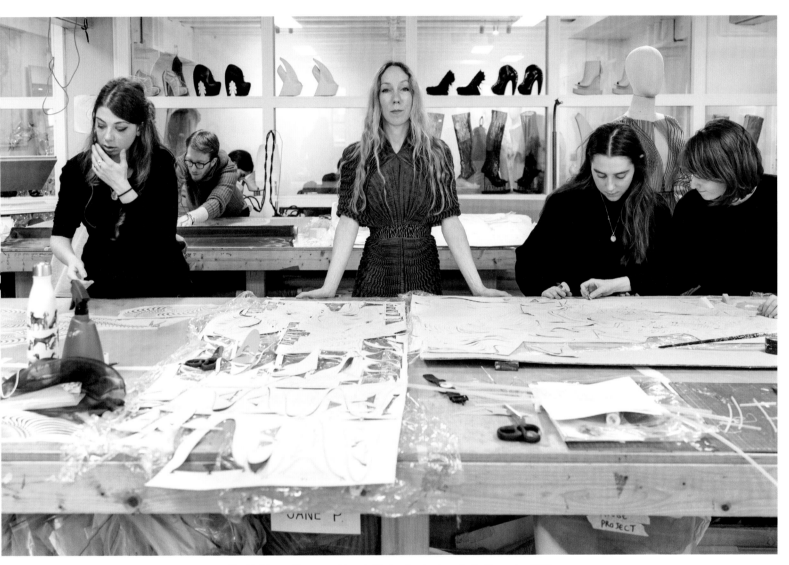

Fig. 14. Iris van Herpen and her staff in her Amsterdam studio, November 2019

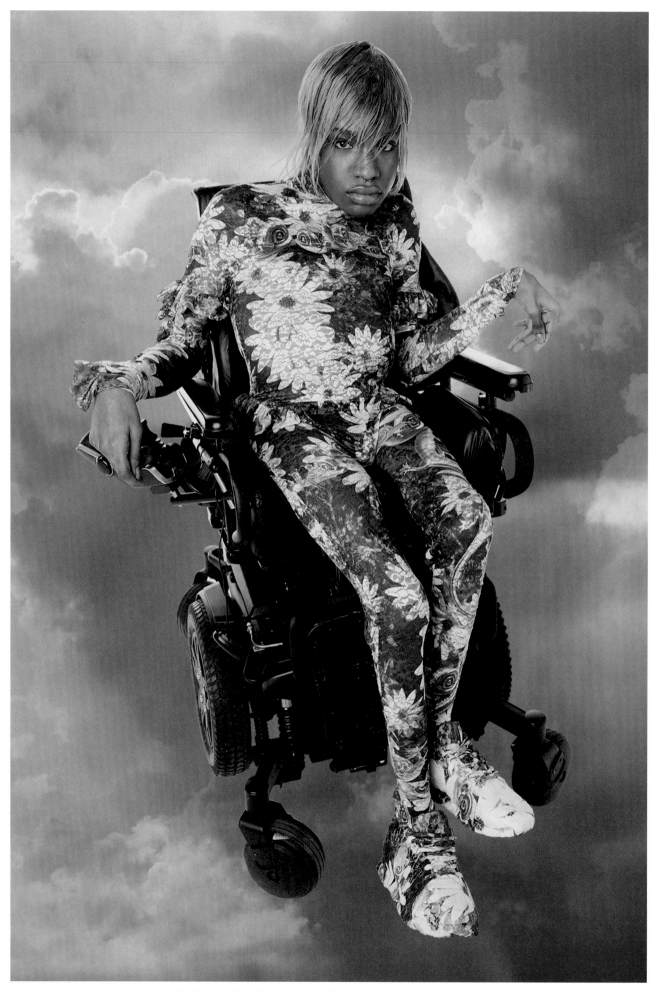

Fig. 15. Aaron Rose Philip wearing Collina Strada, autumn/winter 2021–22

and translates into her sustainable approach to the design and creation of her collections, which she shows on a wide variety of body types and models of all ages. For her spring/summer 2022 collection, "Fichu pour Fichu," 45 percent of her materials were regenerated and another 45 percent were recycled, supporting her conviction that garments can be loved, repeatedly mended, and remain a part of one's everyday life to the point that there is no further need to produce new garments. For Serre, responsible design is crucial, since "every choice you make as a company will influence the world: what you make, how you make it, how you speak about what you've made—for me, everything is political."[88]

The collection features garments made from billowing patchworks of synthetic "popcorn" fabrics, referencing the aesthetic of the free-spirited eclecticism of the 1990s. The hooded, floral, patchworked dress (p. 173) features a bodysuit printed with crescent moons, the moon being the fashion house's logo and expressive of Serre's brand values: "'The moon for us is like an icon, an emblem, an image, a representation, a flag, a language, a metaphor, an object of what we believe in: crossing boundaries, hybridity and freedom,' Serre reveals. . . . 'It . . . keeps evolving with us. . . . It is never stable and timeless at the same time,' she says, noting its 'thoroughly feminine' nature."[89] As a symbol of cross-cultural iconography—from lunar rituals to ancient goddesses to the Islamic religion—the moon fits Serre's inclusive ethos. She introduced the emblem at her graduation show in 2017 at La Cambre arts school in Brussels with a collection titled "Radical Call for Love," her response to the 2015 and 2016 terrorist attacks in Paris and Brussels, respectively. Later that year she became the first designer to win the LVMH Prize for Young Fashion Designers based solely on her graduation collection, without yet having her own company, bolstering her creative and sustainable approach with corporate financial support.

American designer Hillary Taymour founded her "post-hippie" brand Collina Strada[90] based on values such as climate awareness, social awareness, and self-expression. Exuberant and bright, Taymour's designs do not evoke apocalyptic undertones but are instead romantic, utopian, and inspired by the relaxed and layered way she herself dresses. Her sustainable approach runs through her work: she incorporates natural rose sylk (a cellulose fiber made from rose stems) into her designs, she recycles cotton and uses deadstock fabrics, and she asks audience members at her runway shows to suggest skills or offer expertise that may help her in becoming more eco-conscious. During and after the COVID-19 health crisis, especially, she became more aware of the task ahead regarding sustainability due to the interconnectedness of humans, animals, and viruses and her role as a fashion designer. She sewed colorful masks, sending them to healthcare workers as a way of nurturing her community. She also raised funds for twenty-two charities from the sales of her "Quarantine" loungewear collection, borrowing a quote from Martin Luther King Jr. to explain in her lookbook that the "time is always right to do what is right."[91]

Taymour creates her collections of patchwork dresses and stretch knits often in collaboration with others, thus building her cocreative network and sharing the artistic agency. For her autumn/winter 2021–22 collection, she presented her imaginative vision of a posthuman world with virtual GIFs in which the models turn into animals, such as a poison frog or a lemur. These human-animal metamorphoses were inspired by David Burroughs Mattingly's Animorphs book series. Her bodysuit of stretch synthetic lace (p. 172) from the collection was modeled by Aaron Rose Philip, a New York–based, Black, transgender femme model who lives with cerebral palsy and uses a wheelchair (fig. 15). Taymour's design for the bodysuit, though not strictly adaptive, is meant to be inclusive for all types of bodies and users, a philosophy underlying all her collections. The garments were made from leftover fabrics from previous seasons and from repurposed T-shirts from the Kantamanto market in Accra, Ghana, where 25 million garments find a new purpose every month. For Taymour, working sustainably is inextricably linked to working in solidarity with communities that have been cleaning up fashion's waste for decades.

Fig. 16. Mary Margaret Pettway, quilter from the Gee's Bend Quilting Collective, a collaborator on Gabriela Hearst's Chloé ready-to-wear autumn/winter 2022–23 collection

Uruguayan-born American designer Gabriela Hearst started her own sustainable ready-to-wear brand for climate-conscious women in 2015 and in 2020 became artistic director at Chloé, the house founded by Gaby Aghion in 1953 and recently led by, among others, Stella McCartney (1997–2001), Phoebe Philo (2001–6), Hannah MacGibbon (2008–11), Claire Waight Keller (2011–17), and Natacha Ramsay-Levi (2017–20). Hearst's vision for considered, tailored, and luxurious womenswear aligns with the ideology

of her predecessors, who also designed collections based on their ideal wardrobes. Hearst shares her creative and functional agency with the wearers, as well as with the makers of her collections. For autumn/winter 2022–23, Hearst's concept advanced the principle of "re-wilding" nature as a solution to the climate crisis. She commissioned quilters from the women artists community in Gee's Bend, Alabama (fig. 16), to transform Chloé deadstock fabrics into blankets and coats in a color palette inspired by Franco Zeffirelli's film *Brother Sun, Sister Moon* (1972), which chronicles the life of Saint Francis of Assisi, the patron saint of animals and the environment. The Gee's Bend Quilting Collective is renowned for its exceptional artisanal quilting skills that have been passed down through generations over the past two centuries. The women are direct descendants of the enslaved people who worked on a cotton plantation established by Joseph Gee in 1816. Remaining in Alabama after the Civil War, most Gee's Bend residents were not afforded the opportunity to become participants in the burgeoning American middle class (see Elizabeth Way's essay, pp. 69–78). Thus, projects like these empower the community and provide a sustainable income for the makers. The ensemble on page 171 represents a special collaboration between Chloé and the collective; they have remade the final silhouette from the autumn/winter 2022–23 collection specifically for The Costume Institute.

Fig. 17. Grace Wales Bonner adjusts the trim on her Dior "Bar" jacket, 2019

At Christian Dior, artistic director Maria Grazia Chiuri has been a vocal feminist since her appointment in 2016 as the first female creative director of the house. For Chiuri, fashion is the first space in which you define yourself as a woman,

and thus a site for personal independence. Her feminist position comes through in both her designs—elegant and sophisticated but always meant to empower, not constrain, the wearer—as well as in her collaborative practices with her studio staff. Amalgamating different cultures and crafts in a respectful, responsible manner while focusing on women's narratives is central to Chiuri's process. For her 2020 cruise collection, she invited several external collaborators, including British Jamaican menswear designer Grace Wales Bonner, to participate in a cross-cultural dialogue and exchange. Bonner's astute skills in tailoring and craftsmanship and mystical sensibility evoke Christian Dior himself and his proclivity for talismans and tarot. Wales Bonner reinterpreted the classic Dior "Bar" suit, the epitome of the 1947 New Look silhouette, with its cinched waist, padded hips, and flared skirt. Her "Bar" suit in black wool maintains the original hourglass shape but in a leaner, more relaxed profile, with pockets and sleeves edged in hand-crocheted raffia in Caribbean and Rastafarian colors including navy blue, coral, mustard green, and white (p. 170) (fig. 17). The skirt and jacket are embroidered with undulating bands of posies. Wales Bonner looked at Afro-Cuban tailoring from the 1940s and 1950s to connect with the Dior universe but from her own perspective: "I feel like with Wales Bonner, I'm trying to create a brand that can have a dialogue with these established brands, but is coming from a Black cultural perspective," she declared in *Vogue*.[92] By sharing the Dior studio staff and introducing a different cultural perspective, Chiuri and Wales Bonner's collaboration transforms the storied French house and forges the designers' own matrilineal genealogy.

FROM AUTOPOIETIC TO COPOIETIC APPROACHES

Since the 1960s, female fashion designers have developed a poetics of creating and designing garments for other women that have attributed and shared different types of agency—personal, economic, political, artistic, interpersonal, affective, ecological, and collaborative—anchoring women's agency both in the macrocosm of the historical record as well as in the deeper microcosm of one's own identity. Many at first dressed their wearers in an autopoietic way, as reflections of themselves, but they then transformed their practices and adopted copoietic processes to include customers and other makers, exploring new horizons of mutual becoming in a global and decentralized world. It is there, in these shared processes of creation and intimacy between women, as described by feminist philosopher and artist Bracha Ettinger, where new horizons for fashion might occur: "Co-poietic transformational potentiality evolves along aesthetic and ethical unconscious paths: strings and threads, and produces a particular kind of knowledge. . . . [T]he artist can't not-share with an-other, she can't not witness the other. . . . The artist doesn't build a defense against this fragility but freely embraces it."[93]

1 Rosi Braidotti, *Nomadic Subjects: Embodiment and Sexual Difference in Contemporary Feminist Theory* (New York: Columbia University Press, 1994), 144.

2 Hélène Cixous explains this plurality thus: "There always remains in woman that force which produces/is produced by the other—in particular, the other woman. *In* her, matrix, cradler; herself giver as her mother and child; she is her own sister-daughter." "The Laugh of the Medusa," trans. Keith Cohen and Paula Cohen, *Signs* 1, no. 4 (Summer 1976): 881.

3 In regard to the concept of agency, feminist scholar Rosi Braidotti offers a definition of feminism as "the movement that struggles to change the values attributed to and the representation made of women in the longer historical time of patriarchal history (Woman) as well as in the deeper time of one's own identity. In other words, the feminist project encompasses both the level of subjectivity, in the sense of historical agency, political and social entitlement, and the level of identity, which is linked to consciousness, desire and the politics of the personal: it covers both the conscious and unconscious levels." *Nomadic Subjects*, 155. She thus links feminism to agency, sociopolitical entitlement, and identity, both on the personal/individual as well as the historical/general levels.

4 Richard Actis-Grance, "A Talk with Sonia Rykiel," *Dépêche mode*, 1968.

5 Barbara Vinken writes that "to analyze fashion as a poetological activity that, like any poetological discourse, thematizes itself and has performative power." *Fashion Zeitgeist: Trends and Cycles in the Fashion System* (Oxford: Berg, 2005), 4.

6 It has to be noted, however, that several women designers founded their businesses in collaboration with their spouses, taking their husbands' names and keeping them even after separating from their partners. Rykiel, von Furstenberg, and Kamali all retained their married names.

7 The five designers were Sonia Rykiel, Emmanuelle Khanh, Kenzo, Jacqueline Jacobson, and Karl Lagerfeld. The federation was then renamed Chambre syndicale du prêt-à-porter des couturiers et des créateurs de mode. Maude Bass-Krueger, "Sonia Rykiel, a Fashion Revolutionary 1930–2016," *Hypotheses* (blog), August 25, 2016, https://histoiredemode.hypotheses.org/3722.

8 "Rykielisme," La Maison, Sonia Rykiel (website), accessed January 10, 2023, https://www.soniarykiel.com/eu/en/la-maison.

9 Sonia Rykiel would later say, "La fémininité pour moi, c'est être comme un garçon." (To me, femininity means being like the boys.) Interview with Rykiel in *Des femmes en mouvement*, July 1978, 82–83.

10 Cover credit, *Elle*, December 13, 1963.

11 "Rayure: c'est la mémoire du corps, l'entre-les-lignes, le dedans qui écrit sur le dessus. C'est le corps les yeux ouverts. C'est une balafre sur un tissu, une entaille dans le dessin, un trait qui poursuit un autre trait." Sonia Rykiel, *Dictionnaire déglingué* (Paris: Flammarion, 2011), 74.

12 About these unfinished hems, Hélène Cixous writes, "That the seams [of Rykiel's work] should remain apparent is the immodesty of writing." "Sonia Rykiel in Translation," in *On Fashion*, ed. Shari Benstock and Suzanne Ferriss (New Brunswick, N.J.: Rutgers University Press, 1994), 96.

13 Sonia Rykiel, *Et je la voudrais nue* (Paris: Grasset, 2001).

14 Betsey Johnson and Mark Vitulano, *Betsey: A Memoir* (New York: Viking, 2020), 102.

15 "Thinking back even to the '70s, I always thought I had been designing a women's collection. Then one day, we realized that at least 50 percent of the clothes we were selling were being worn on male bodies. It wasn't a reflection of the gender or sexuality of our customers, either. It was that kind of feminine-masculine style coming to the forefront. And the same blend applies to people who identify as women, too (both in the clothes they wear and beyond)—and I live that every day." Norma Kamali, "How Norma Kamali, Fashion Designer of More Than 50 Years, Embraces the 'Masculine-Feminine' in Style and Life," *Well + Good*, March 21, 2022, https://www.wellandgood.com/norma-kamali-feminism/.

16 Norma Kamali in Laird Borrelli-Persson, "That '70s Something: Norma Kamali on Why the Me Decade Still Matters Today," *Vogue*, September 14, 2018, https://www.vogue.com/article/norma-kamali-importance-of-1970s-fashion-on-gen-z.

17 "[Norma] was always there, and she was always head to toe in her [designs]. She would change the shop interiors along with the collections. At one point there were snakeskin walls and a lot of snakeskin clothes, and then another time it was all velvet patchwork, and she patchworked all the walls. Then another time it was all tartans, and she did these beautiful tailored tartan suits, and the walls were all covered in tartan." Anna Sui in Kristin Anderson, "Bette Midler, Vera Wang, and More Tell the Story of the Iconic Norma Kamali," *Vogue*, June 1, 2016, https://www.vogue.com/article/norma-kamali-history-cfda-award-2016-bette-midler.

18 Norma Kamali in "Is Fashion Working for Women? A Vogue Symposium," *Vogue*, January 1985, 205.

19 Michael Denning, *The Cultural Front: The Laboring of American Culture in the Twentieth Century* (London: Verso Press, 1997), 146.

20 Diane von Furstenberg, conversation with author, December 16, 2022.

21 Around 1973 the designer scribbled this phrase on a promotional image of herself wearing a wrap dress.

22 The Fulham Road Clothes Shop allowed Rhodes to transpose her textile designs onto garments designed by Ayton.

23 The phrase was coined by editors Shulamith Firestone and Anne Koedt for an essay written by Carole Hanisch that was published in *Notes from the Second Year, Women's Liberation: Major Writings of the Radical Feminists* (New York: Radical Feminism, 1970).

24 Françoise d'Eaubonne, *Le Féminisme ou la mort* (Paris: Les Éditions Horay, 1974).

25 Monique Wittig, *The Straight Mind and Other Essays* (Boston: Beacon Press, 1992).

26 The shops included Let It Rock (1971), Too Fast to Live, Too Young to Die (1973), SEX (1974), Seditionaries (1976), and World's End (1980).

27 Hamnett had previously created the label Tuttabankem together with Anne Buck in 1969.

28 Tom Rasmussen, "Katharine Hamnett Talks Sex, Politics, and Returning to Fashion," *Dazed*, February 5, 2018, https://www.dazeddigital.com/fashion/article/38895/1/katharine-hamnett-talks-sex-politics-and-returning-to-fashion.

29 Katharine Hamnett in *Passion for Fashion*, sale cat., Kerry Taylor Auctions, London, December 8, 2020, https://www.kerrytaylorauctions.com/auction/lot/200-a-rare-katharine-hamnett-stay-alive-in-85-printed-silk-t-shirt-1985/?lot=28620&sd=1.

30 Katharine Hamnett in Sarah Mower, "Katharine Hamnett, London's Activist Fashion Warrior, Is Back with a Sustainable Buy-Now Collection," *Vogue*, September 1, 2017.

31 Miuccia Prada in Alexander Fury, "Miuccia Prada Likes to Disturb," *Document*, November 15, 2015, https://www.documentjournal.com/2015/11/miuccia-prada-discusses-why-she-likes-to-disturb/.

32 Prada in Fury, "Miuccia Prada Likes to Disturb."

33 Sarah Mower, "Prada Fall 2007 Ready-to-Wear," *Vogue*, February 19, 2007, https://www.vogue.com/fashion-shows/fall-2007-ready-to-wear/prada.

34 About her collaboration, Vivienne Tam says, "His art was political, but I thought I could loosen it up a bit with fashion, to represent the openness of China. This would show its humor and warmth, and the growing freedom of its people from Mao's image." *China Chic* (New York: HarperCollins, 2006), 88.

35 Tam, *China Chic*, 92.

36 Tam, *China Chic*, 88.

37 Akiko Fukai, "Japonism in Fashion," in *Japonism in Fashion*, exh. cat. (Kyoto: Kyoto Costume Institute, 1994), 9.

38 Suzy Menkes, "Hanae Mori: The Iron Butterfly," in *Hanae Mori Style*, ed. Yasuko Suita (Tokyo: Kodansha International, 2001), 12–13.

39 As posited by Ayaka Sano, "Overcoming the Oriental Past: Hanae Mori's American Dream, 1965–1976" (master's thesis, New York University, 2020).

40 Hanae Mori, *Goodbye Butterfly* (Tokyo: Bungei Shunjū, 2010), 112.

41 Hanae Mori, *Fasshon: Chō wa Kokkyō o Koeru* (Tokyo: Iwanami Shoten, 1993), 125.

42 Sano, "Hanae Mori," 9.

43 Sano, "Hanae Mori," 40.

44 Mori designed the costume for *Madama Butterfly*, directed by Keita Asari. Sano, "Hanae Mori," 45.

45 Hal Rubenstein, "THING; The Cold-Shoulder," *New York Times*, February 7, 1993, https://www.nytimes.com/1993/02/07/style/thing-the-cold-shoulder.html.

46 Jil Sander, conversation with author, November 2019.
47 Laura Bradley, "Jil Sander's Swan Song," *AnOther*, October 24, 2013, https://www.anothermag.com /fashion-beauty/3129/jil-sanders-swan-song.
48 Adolf Loos, "Ornement et crime," *Les Cahiers d'aujourd'hui* (1913).
49 Jil Sander in *Jil Sander: Present Tense*, ed. Matthias Wagner K (Munich: Prestel, 2018), 259.
50 Ann Demeulemeester in *Femmes Fatales: Sterke Vrouwen in de Mode*, ed. Madelief Hohé (Zwolle, Netherlands: Waanders Uitgevers, 2018), 185.
51 Demeulemeester in Hohé, *Femmes Fatales*, 185.
52 Ann Demeulemeester, email message to author, November 2022.
53 "Ann Demeulemeester Spring 1997 Ready-to-Wear," *Vogue*, October 9, 1996, https://www.vogue.com/fashion-shows /spring-1997-ready-to-wear/ann-demeulemeester.
54 Hohé, *Femmes Fatales*, 185.
55 Demeulemeester in Hohé, *Femmes Fatales*, 185.
56 James Laver writes that fashions tend to shift with the interest for different erogenous zones of the body, such as the breasts, the hips, and the buttocks. *Costume and Fashion: A Concise History* (London: Thames & Hudson, 1969).
57 Vanessa Friedman, "Women Are Defining Paris Couture," *New York Times*, July 2, 2019, https://www.nytimes.com/2019/07/02/fashion /dior-chanel-van-herpen-couture-paris.html. Sarah Mower, "The Present Is Female: The Designers behind a Fashion Revolution," *Vogue*, July 11, 2019, https://www.vogue.com /article/female-designers-fashion-revolution-vogue-august -2019-issue.
58 Sarah Mower, "Christian Dior Spring 2017 Ready-to-Wear," *Vogue*, September 30, 2016, https://www.vogue.com /fashion-shows/spring-2017-ready-to-wear/christian-dior.
59 Maria Grazia Chiuri in Hamish Bowles, "This Is Not Your Mother's Dior," *Vogue*, November 15, 2016, https://www .vogue.com/article/christian-dior-creative-artistic-director -maria-grazia-chiuri-interview.
60 Marc Karimzadeh, "Norma Kamali on Her Most Iconic Looks," CFDA, May 26, 2016, https://cfda.com/news/norma-kamali -on-her-most-iconic-looks.
61 Anderson, "Bette Midler, Vera Wang, and More."
62 All formulations are used as chapter headings in Valerie Steele and Patricia Mears, *Isabel Toledo: Fashion from the Inside Out* (New Haven, Conn.: Yale University Press, 2009).
63 "FIT Museum Explores Latin American Designers— 2002-03-15," VOA, October 30, 2009, https://www.voanews .com/a/a-13-a-2002-03-15-33-fit/392090.html.
64 Gogo Graham, a transgender designer, has also participated in the event since 2016 but was not featured on the official New York fashion week calendar.
65 Email message from the brand, August 2022.
66 "Customiety World," Customiety (website), accessed January 13, 2023, https://www.customiety.com.
67 Email message from the brand, March 31, 2023.
68 Stephen D. Seely, "How Do You Dress a Body without Organs? Affective Fashion and Nonhuman Becoming," *WSQ: Women's Studies Quarterly* 41, no. 1/2 (Spring/Summer 2012): 248.
69 Elizabeth Wilson, *Adorned in Dreams: Fashion and Modernity* (London: Virago Press, 1985), 3.
70 Comme des Garçons press statement, spring/summer 1997 collection.
71 Georgina Godley, conversation with author, 2015.
72 "Such a project is what Deleuze and Guattari (1987) would refer to as 'becoming-woman,' which is not a progression *toward* the dominant constructions of womanhood but is, instead, the process of deterritorializing one's body, mind, and desire from its capture and organization by a phallocentric economy that dictates the terms of femininity in advance." Seely, "How Do You Dress a Body without Organs," 252.
73 Gilles Deleuze, *The Fold: Leibniz and the Baroque*, trans. Tom Conley (Minneapolis: University of Minnesota Press, 1993), 35.

74 Luce Irigaray, *This Sex which Is Not One*, trans. Catherine Porter with Carolyn Burke (Ithaca, N.Y.: Cornell University Press, 1985), 24.
75 Harold Koda, "Rei Kawakubo and the Art of Fashion," in *ReFusing Fashion: Rei Kawakubo*, ed. Linda Dresner, Susanne Hilberry, and Marsha Miro (Detroit, Mich.: Museum of Contemporary Art Detroit, 2008), 34. Choreographer Merce Cunningham on his collaboration with Kawakubo for his dance *Scenario*.
76 See also Westwood's "bum cage" underpants from her "Vive La Cocotte" autumn/winter 1995–96 collection in holdings of The Costume Institute (2020.54a, b).
77 "'Comfort and feeling good in clothes is something I think about a lot,' says Philo, who intends her designs to offer 'a proposal' to women negotiating the chaos, complexity, and contradictions of contemporary life." Eve MacSweeney, "15 Iconic Female Designers on Where Fashion—and the World—Are Going," *Vogue*, February 13, 2017, https://www .vogue.com/article/designers-tory-burch-victoria-beckham -on-future-of-fashion-womens-rights-feminism.
78 MacSweeney, "15 Iconic Female Designers."
79 Dan Graham in "What Is It about Dan Graham's Pavilions?," *Phaidon*, January 14, 2014, https://www.phaidon.com /agenda/art/articles/2014/january/14/what-is-it-about-dan -grahams-pavilions/.
80 Céline show notes, spring/summer 2017 collection.
81 MacSweeney, "15 Iconic Female Designers."
82 "As a hybrid, body-machine, the cyborg . . . is a connection-making entity; a figure of interrelationality, receptivity and global communication that deliberately blurs categorical distinctions (human/machine; nature/culture; male/female; oedipal/non-oedipal)." Donna Haraway, "A Cyborg Manifesto: Science, Technology, and Socialist-Feminism in the Late Twentieth Century," in *Simians, Cyborgs, and Women: The Reinvention of Nature* (New York: Routledge, 1991), 208.
83 "Collections," Iris van Herpen (website), accessed May 24, 2023, https://www.irisvanherpen.com/collections/capriole /backstage-6.
84 "Bespoke & Bridal," Iris van Herpen (website), accessed January 15, 2023, https://www.irisvanherpen.com /bespoke-bridal.
85 Yeohlee Teng in Liana Satenstein, "Yeohlee: Fall 2022 Ready-to-Wear," *Vogue*, February 22, 2022, https://www.vogue.com /fashion-shows/fall-2022-ready-to-wear/yeohlee. Since her debut in 1981, Teng creates garments with a zero-waste and genderless philosophy.
86 Yeohlee Teng in Laird Borrelli-Persson, "Yeohlee Teng, Soon to Be Honored by the CFDA, Talks Fashion and Figures," *Vogue*, November 5, 2021, https://www.vogue.com/article /in-advance-of-her-2021-cfda-award-an-intreview-with -yeohlee-teng.
87 Lee Allen, "Jamie Okuma Wins Third Best of Show Award at Santa Fe Indian Market," *Indian Country Media Network*, August 18, 2012, https://indiancountrymedianetwork.com /news/jamie-okuma-wins-third-best-of-show-award-at -santa-fe-indian-market/.
88 Maya Singer, "Can Fashion Be Political?," *Vogue*, October 2020, 87.
89 Emma Hope Allwood, "Why Marine Serre's Moon Prints Are Taking Over the World," *Dazed*, June 23, 2020, https://www.dazeddigital.com/fashion/article/49581/1 /marine-serre-moon-print-jersey-trend-style.
90 The name comes from the Italian words *collina* for "hill" and *strada* for "street," after a nickname an Italian college friend gave the designer.
91 Brooke Bobb, "This Designer Crafted a 'Quarantine Collection' from Fabric Scraps to Raise Funds for 22 Charities," *Vogue*, May 15, 2020, https://www.vogue.com /slideshow/collina-strada-quarantine-collection-charity.
92 Steff Yotka, "Grace Wales Bonner Takes on the Bar Jacket and the New Look Skirt at Dior's Marrakech Resort Show," *Vogue*, April 30, 2019, https://www.vogue.com/article /grace-wales-bonner-dior-resort-2020-collaboration.
93 Bracha L. Ettinger, "Copoiesis," *Ephemera* 5(X), no. 4 (December 2005): 703–4.

ABSENCE/OMISSION

BLACK AMERICAN WOMEN FASHION MAKERS

Elizabeth Way

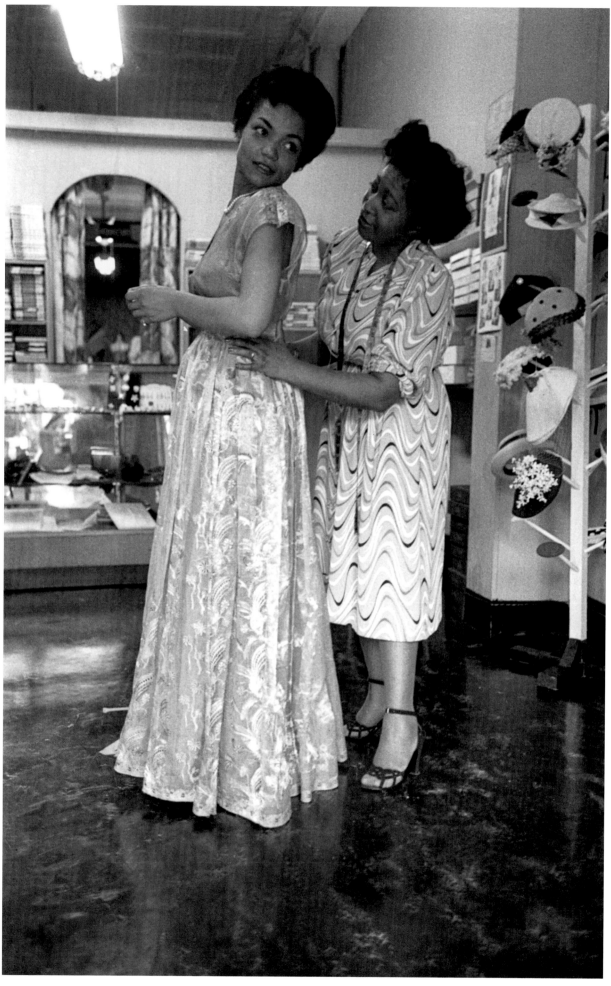

Fig. 1. Eartha Kitt (with Zelda Wynn Valdes), June 1952. Photograph by Gordon Parks (American, 1912–2006)

ZELDA WYNN VALDES:
VISIBLE AND YET OMITTED

On May 28, 1953, photographer Carl Van Vechten captured images of jazz singer and actress Joyce Bryant (figs. 2, 3). As much as Bryant's expressive face, distinctive silver curls, flawless, luminous skin, and elongated, curvaceous silhouette draw the eye in this series of photographs, her dress rivals her beauty for attention. The white sequin gown molds to her figure. The heavily constructed bodice hugs Bryant's torso as it also inexplicably drops to her waist in the back. A long single strap, in contrast with her body, snakes its way from the center of her sweetheart neckline, over her left shoulder, and down the right side of her back to her waist. The sheath clings to her thighs and gently gives way to skim around her lower legs and puddle at the floor. Two pleated swaths of bright red, transparent fabric sweep down from points at Bryant's hips, adding a shock of color and drama. This detail seems like it should be too much, but it is just enough—as uniquely glamorous as Bryant herself. The dress creates a searing image of sexuality and feminine power that winks at the more saccharine conceptualizations of women during the mid-twentieth century. That Bryant, as a Black figure, wears the dress shatters the stereotype that Black women are unfeminine and unattractive. The gown pointedly confronts the respectability politics that urge Black women to be demure, unobtrusive, and inconspicuous, thus counteracting centuries of negative caricatures portraying them as immoral seducers and flamboyant dressers.[1] Bryant is both unapologetically seductive and flamboyant, and her dress is spectacular.

The collection of Carl Van Vechten papers, which includes these images, notes that the dress was made by Zelda Wynn Valdes.[2] With this dress—likely surviving only in these photographs—and with many other striking gowns for celebrities such as Dorothy Dandridge, Mae West, and Eartha Kitt (fig. 1), Wynn Valdes shaped American fashion. She turned couture construction and New Look silhouettes up to a higher volume to create images of women, especially Black women, that resonated in popular and fashion culture. Much of her work—and certainly Bryant's 1953 dress—walks the line between performance costume and fashion, but it is a thin and blurry line. Wynn Valdes crafted garments with an irresistible appeal that remains evident decades later. Her dresses clearly show technical skill: her silhouettes seem to defy both gravity and bodily movement, yet they allowed her clients to sing, dance, and vamp for the camera, enlivening the gowns with more flesh and blood than could the austere white couture mannequins featured on magazine pages. With such memorable designs for such notable women one might expect Wynn Valdes's creations to crown the collections of fashion and costume departments throughout American museums. Yet here is a striking absence: few of her works survive in institutions. The Smithsonian National Museum of African American History and Culture holds just two. In fact, few fashion enthusiasts and even fewer fashion scholars know of Wynn Valdes. Fashion historians Nancy Deihl and Tanisha C. Ford have written on her life and career, and both emphasize her well-publicized clients as well as her role in supporting other Black fashion designers through organizational leadership and education.[3] Wynn Valdes

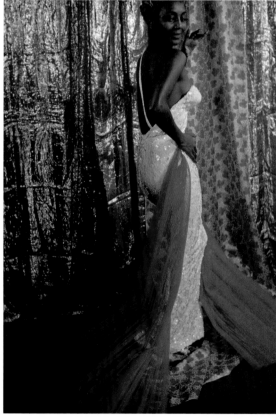

Figs. 2, 3. Joyce Bryant, May 28, 1953. Photographs by Carl Van Vechten (American, 1880–1964)

designed fashion and stage costumes in New York for an astounding eight decades, from the 1920s to the 1990s.[4] These looks were *seen*—at live performances, in the press, and, more recently, in countless online photography collections (some designs attributed, many more not)—and they have spread, inspiring imitators and changing the course of American style. Yet, tellingly, Deihl's chapter on Wynn Valdes appears in her book *The Hidden History of American Fashion*, and Ford's article in the *New York Times* is part of the Overlooked series of revisionist obituaries, tributes to figures who *should* have been commemorated by the newspaper upon their deaths. Black women like Wynn Valdes have been designing and making clothing for American women for centuries, but they are hidden and overlooked, omitted and absent. Who were these women and where is their material culture?

LOOKING FOR THE BLACK WOMEN FASHION MAKERS

Public historian Tiffany Momon has helped respond to the first question through the Black Craftspeople Digital Archive (BCDA), established in 2019.[5] The archive documents Black American artisans of the eighteenth century to the mid-nineteenth century using a variety of resources, from "runaway slave ads" seeking self-emancipated people to estate papers and federal censuses. Through Momon's platform, South Carolinian artisans such as Hanna, a "good Seamstress" who liberated herself in 1734, and Charlotte, an "extraordinary Seamstress" who emancipated herself in 1771, are made visible in the historical record, even if that record sought to re-enslave them.[6] Momon's methodology draws from what Marisa J. Fuentes calls "reading along the bias grain" to "stretch archival fragments . . . to eke out extinguished and invisible but no less historically important lives."[7] By examining these records for new information and actively combating omissions and absences, we can begin to build a narrative of Black women's fashion labor. Although many women in colonial America—Black and white—could sew, the superlative descriptions of Hanna's and Charlotte's skills make it likely that their work exceeded basic mending and plain sewing. Assembling eighteenth- and nineteenth-century clothing required knowing the most appropriate stitches for different types of fabrics in order to execute the perfect fit—a distinction that set fashionable elites apart from those who procured their clothing secondhand. Therefore, even competent plain sewing was a valued skill.[8] Yet Hanna and Charlotte may have been dressmakers, which required even greater technical knowledge and more creative effort. That they are not identified as modistes is not surprising; their forced labor likely encompassed a myriad of tasks—agricultural and domestic.

Momon has reflected on the difficulties of including women in the BCDA, as they were less likely to be documented than male craftspeople.[9] Hanna and Charlotte were among the thousands of Black women constructing clothing for both Black and white Americans during the colonial and antebellum periods, helping form an American fashion culture. This culture lived in the shadow of European style until well into the twentieth century, but it also formed its own distinctions that varied across the permeable barriers of geography, gender, race, and class. Historian and curator Katie Knowles argues that enslaved wearers of workwear are as much fashion makers as those who cut and sewed because they transformed clothing specifically designed to dehumanize, objectify, and degrade into expressions of the self.[10] Imagining all of these Black male and female fashion producers makes it irresistible to speculate that their material culture does in fact survive—not just hidden in attics and lost trunks, waiting to be rediscovered, but already within cultural institutions. Momon notes the tendency of institutions to impose the burden of proof of origin on the Black makers, who, like many historical artisans, did not sign their work. She explains, "The truth of the matter is that museums and historic[al] sites severely undercount the presence of enslaved craftspeople in the objects that we all love."[11] Scholars Alison Moloney and Erica de Greef and artist Wanda Lephoto write of the "violence of absence" in costume collections and the mix of beauty and trauma that exists for Black people in these spaces that overwhelmingly capture and exalt white histories and makers and, through absence, reflect the erasure of Black histories and makers. "How is it possible that in all this history that is collected and preserved, how is it possible that once again, the archive of my people is absent?" Lephoto asks.[12] Yet, as Momon suggests, it is not absent: the fashion design of Black American women makers is indeed archived in costume and textile collections within American institutions, but it is undocumented and uncredited. How do we uncover these narratives?

Anthropologist Michel-Rolph Trouillot has examined the silences created around archival objects and how tracing them can reveal the power structures that create both absence and omission. He identifies four distinct points at which silence can enter the archive: "The moment of fact creation (the making of *sources*); the moment of fact assembly (the making of *archives*); the moment of fact retrieval (the making of *narratives*); and the moment of retrospective significance (the making of *history* in the final instance)."[13] Trouillot notes that silences in history are inevitable—every detail simply cannot be recorded; however, unequal influence among history's chroniclers, archivists, narrative makers, historians, and others shows how power allows and encourages exclusions.[14] That Black women designers are among the most obscured American fashion makers is no surprise. Black feminist theory dating to the nineteenth century has articulated what anyone willing to acknowledge it clearly knows: women of color suffer from a combination of sexism and racism that white women and men of color have tended to ignore in their struggles for equality.[15] Black women

have been erased throughout historical narratives, and in fashion, silences, absences, and omissions abound. These deletions were created when garments were unlabeled by their makers or undocumented by their wearers or the family members who inherited the items. This anonymousness followed countless garments into museum collections—or it is at this point that objects lost their identification—creating silences at the moments of creation and assembly, as defined by Trouillot. Black women likely made hundreds of historical garments housed in museum collections, as suggested by the rare exceptions of documentation. For example, Cumber, a dressmaker enslaved in North Carolina during the Civil War, made a dress for her enslaver in 1864. The dress miraculously contains text on the hem identifying Cumber as the creator.[16]

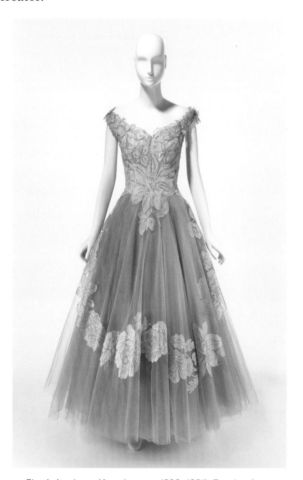

Fig. 4. Ann Lowe (American, ca. 1898–1981). *Evening dress*, ca. 1960. Nylon, metallic thread, and silk

Absence and omission may also occur when Black designers go unrecognized by the press or other important stakeholders, even for designing well-publicized garments. Ann Lowe designed the future First Lady Jacqueline Kennedy's 1953 wedding dress, but this detail was not conveyed to the press or to the public at the time, denying Lowe valuable publicity and creating a silence at the moment of fact retrieval. Although Lowe made couture-quality gowns for elite American women from the 1910s through the 1960s (figs. 4–6), until recently she was completely absent from fashion history narratives in scholarly texts, classroom

curricula, and mainstream fashion exhibitions, inducing a silence at the moment of retrospective significance that is only now being rectified in the twenty-first century.[17] That scores of Lowe dresses are held in costume collections across the country makes her reinsertion into the American fashion canon easier but her omission more baffling. Trouillot notes that "these moments [of silence] are conceptual tools, second-level abstractions of processes that feed on each other. As such, they are not meant to provide a realistic description of the making of any individual narrative."[18] However, when used as discursive tools, these moments are useful for tracking the power dynamics that shaped the narratives of Black women contributors to American fashion culture. For example, Lowe's dresses survive because she created the kind of gowns elite women treasured—debutante and wedding dresses and highly embellished, beautifully constructed eveningwear. Her wealthy white clients were also much more likely to operate in networks that encouraged the donation of their fashion objects to museums. Yet, like Wynn Valdes, Lowe designed custom, couture-quality garments in New York in a period that historical narratives characterize as dominated by ready-to-wear. The formal fashion industry shut out Black women, creating a limited space for them as designers. Those who fought for success attained it by working one-on-one with clients in independent ateliers, thereby making these Black contributors invisible to New York's fashion industry gatekeepers and, later, fashion historians. But when we start to *look* for Black women in American fashion, they begin to emerge.

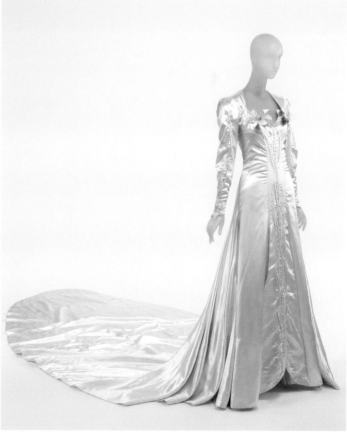

Fig. 5. Ann Lowe (American, ca. 1898–1981). *Wedding dress*, 1941. Cellulose acetate

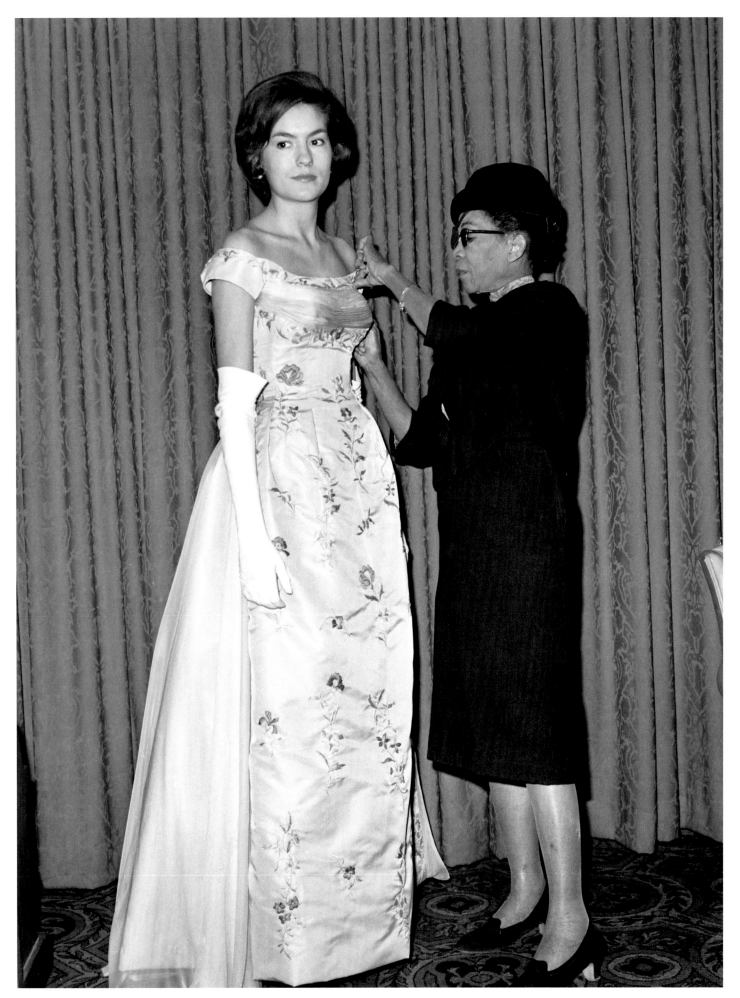

Fig. 6. Ann Lowe fitting a dress of her design on model Alice Baker at a fashion show, December 10, 1962

WOMEN DRESSING WOMEN

REVISING THE NARRATIVE

As scholars seek to unveil Black women as significant fashion makers, they form connections that change the narrative of American style.[19] Over the course of this effort, dominating facts come to displace others to create a more holistic picture of fashion history. For example, dresses collected by museums because they belonged to First Lady Mary Todd Lincoln are now drawing interest because of their maker, Elizabeth Keckley (fig. 7). In the exhibition *In America: An Anthology of Fashion* (May 7–September 5, 2022), The Costume Institute at The Metropolitan Museum of Art showed a dress attributed to Keckley from the early 1860s, a gown now in the collection of the Smithsonian National Museum of American History (fig. 8). The didactic label noted Lincoln as the wearer and Keckley as the maker, acknowledging that few nineteenth-century garments were branded with their designer's name and that Keckley was an important contributor to the public image of an American First Lady. This dress and additional garments belonging to Lincoln and other clients such as Nancy Ordway (the wife of the general agent for the postal service in New England during the 1860s)[20] are enormously significant, even without ironclad attribution, because they are rare extant examples of material culture that support archival records such as those collected by the BCDA. Keckley's dresses embody the labor of thousands of Black dressmakers and seamstresses who exist on paper but whose material culture is lost to time or the absences and omissions of the archive.[21] In Keckley's case, records of all kinds paint a rich history of her life. The most important chronicle is her memoir, *Behind the Scenes, or Thirty Years a Slave and Four Years in the White House* (1868), which recounts details that help align her hand with existing Lincoln gowns. For a nineteenth-century Black woman, Keckley was a remarkably visible figure in the Black and mainstream American press; newspaper articles such as an 1862 *New York Evening Post* piece by Mary Clemmer Ames titled "Emancipation in the District—Stories of the Late Slaves" place her at the top of the Washington, D.C., fashion industry during the 1860s.

Fig. 7. Elizabeth Keckley, 1860s

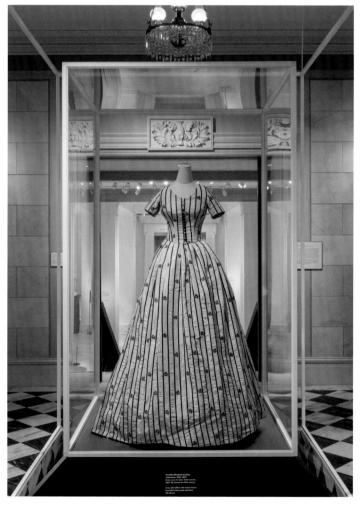

Fig. 8. Installation view from *In America: An Anthology of Fashion*, The Metropolitan Museum of Art, New York, May 7–September 5, 2022. Possibly Elizabeth Keckley (American, 1818–1907). *Dress worn by Mary Todd Lincoln*, 1861; altered late 19th century. Ivory silk taffeta with moiré stripes, brocaded with purple and black silk thread

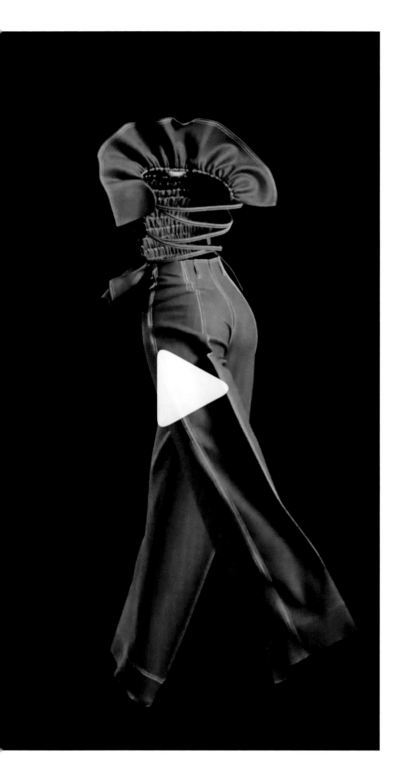

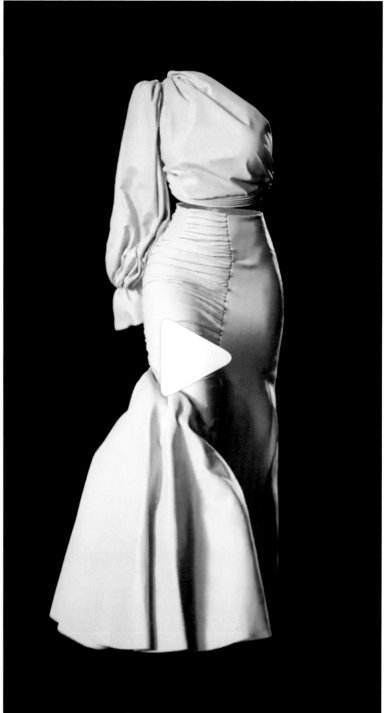

Figs. 9, 10. Stills from Hanifa Instagram fashion show, 2020

Not all designers left such rich clues to their work or created garments deemed prestigious enough to be archived over decades or centuries. Often a connection to elite white clients preserves a Black woman's place in fashion history. This is true of Lowe and Keckley, as well as of Richmond, Virginia, dressmaker Fannie Criss, whose delicate turn-of-the-twentieth-century confections reside in the Valentine, a museum in her hometown. Criss's clients were wealthy white women who were heavily invested in curtailing the ambitions of middle-class Black entrepreneurs such as Criss. As a class, their devotion to historical preservation—which likely prompted their families to donate their Criss gowns to the Valentine—was steeped in the racist Lost Cause mythology that sought to recharacterize slavery as benign and Black people as unfit for citizenship.[22] Ironically, Criss's gowns still exist to showcase her design acumen and technical skill *because* of the preservation interests of this group of privileged white women. Little was written of Criss during her lifetime, a consequence of not only her race but her gender. It is her spectacular material culture that inspires researchers to uncover her story. Criss's influence on American fashion is proven by her prominence in early twentieth-century Richmond, but her full impact is hard to determine. As fashion historian and curator Kristen Stewart notes, Criss's association with actress Gloria Swanson and businesswoman Madam C. J. Walker, figures of national visibility, have been reported but remain unconfirmed.[23]

In answer to the questions, "Who were these Black women fashion designers, and where is their material culture?," this

essay returns to Zelda Wynn Valdes. Her absence and omission from the American fashion historical narrative and from the archive are challenges that scholars have taken up. One of her dresses now in the collection of the Smithsonian National Museum of African American History and Culture—a one-shouldered silk gown beaded with birds of paradise from about 1955 made for Eartha Kitt—was first in the collection of Lois K. Alexander-Lane, who founded the Black Fashion Museum in 1979. Alexander-Lane was an early proponent of affirming the significance of Black women fashion makers in American history and in preserving the work of Black designers in general. Although little of Wynn Valdes's work survives in institutions, her career overlapped with a shift in the way Black people documented and archived themselves. During the nineteenth and twentieth centuries, Black people took control of the "technologies of power" that historically oppressed them.[24] Newspapers, magazines, photographs, films, and, later, television were turned to amplifying, documenting, and celebrating Black cultural producers. Therefore, in the absence of Wynn Valdes's material culture, study of images of her work in Black and mainstream collections can create its own fashion archive, ripe for research. Because she created for Black women entertainers, the Black press abounds with photographs of her designs—and the work of others—that are waiting to be examined.

During the 1960s and 1970s, just when women like Wynn Valdes and Lowe began to elicit recognition on a national scale, the mainstream fashion industry finally began to crack open its doors to Black designers. Yet, overwhelmingly, these designers were men, and again Black women were omitted. In the twenty-first century, Black women are a growing but tiny contingent of the American fashion industry. Few have succeeded in creating enduring brands, and only a small number of their designs are actively collected by museums to preserve their work in the historical fashion narrative. But the technologies of power have again shifted, allowing contemporary Black women fashion makers—in ways comparable to their nineteenth- and twentieth-century counterparts—to build their creative businesses outside the mainstream industry. In May 2020 fledgling designer Anifa Mvuemba, based near Washington, D.C., produced an animated three-dimensional fashion show that she presented on Instagram (figs. 9, 10). During the first few months of the recent global pandemic, Mvuemba's brand Hanifa achieved what so many larger fashion companies could not: a captivating digital fashion experience. Fascinating in the context of this essay, Mvuemba's animated models, walking a digital runway, were absent. The curvaceous contours of their bodies strutted into darkness as the ruched, pleated, and flounced fabric flowed, draped, and pulled taut against their omitted forms. As a Black woman designer without industry connections or access to capital, Mvuemba went unnoticed by the fashion industry until she created a small cabal of invisible women that, ironically, garnered her prominence as an emerging and impactful American designer.[25]

1 Beverly Guy-Sheftall, *Daughters of Sorrow: Attitudes Toward Black Women: 1880–1920* (Brooklyn, N.Y.: Carlson Publishing, 1990), 40–44, 56. Patricia Morton, *Disfigured Images: The Historical Assault on Afro-American Women* (New York: Greenwood Press, 1991), 6–7.

2 The full set of photographs featuring Bryant from May 28, 1953, includes nineteen Kodachrome slides. See Carl Van Vechten Papers Relating to African American Arts and Letters, James Weldon Johnson Collection in the Yale Collection of American Literature, Beinecke Rare Book and Manuscript Library, https://collections.library.yale.edu/catalog/2025715.

3 Nancy Deihl, "Zelda Wynn Valdes: Uptown Modiste," in *The Hidden History of American Fashion: Rediscovering 20th-Century Women Designers* (London: Bloomsbury Academic, 2018). Tanisha Ford, "Overlooked: Zelda Wynn Valdes," *New York Times*, January 9, 2019, https://www.nytimes.com/interactive/2019/obituaries/zelda-wynn-valdes-overlooked.html.

4 David Gonzales, "Matriarch of Dancers Sews Clothing of Delight," *New York Times*, March 23, 1994, B3.

5 "Black Craftspeople Digital Archive Q&A: Part I," National Council on Public History, November 9, 2021, https://ncph.org/history-at-work/black-craftspeople-digital-archive-qa-part-i/.

6 "Hanna–SEA1," Black Craftspeople Digital Archive, accessed February 13, 2023, https://archive.blackcraftspeople.org/items/show/86. "Charlotte–SEA2," Black Craftspeople Digital Archive, accessed February 13, 2023, https://archive.blackcraftspeople.org/items/show/87. Lauren Wicks, "How Tiffany Momon's Deep Dive into Her Family's Genealogy Sparked the Most Comprehensive Archive of Black Craftspeople," *Veranda*, February 4, 2022, https://www.veranda.com/luxury-lifestyle/a38883257/black-craftspeople-digital-archive/.

7 Marisa J. Fuentes, *Dispossessed Lives: Enslaved Women, Violence, and the Archive* (Philadelphia: University of Pennsylvania Press, 2016), 7.

8 Wendy Gamber, "'Reduced to Science': Gender, Technology, and Power in the American Dressmaking Trade, 1860–1910," *Technology and Culture* 36, no. 3 (July 1995): 461–62.

9 "Black Craftspeople Digital Archive Q&A: Part I," *NCPH History@Work* (blog), National Council on Public History, November 9, 2021, https://ncph.org/history-at-work/black-craftspeople-digital-archive-qa-part-i/.

10 Katie Knowles, "The Fabric of Fast Fashion: Enslaved Wearers and Makers as Designers in the American Fashion System," in *Black Designers in American Fashion*, ed. Elizabeth Way (London: Bloomsbury Visual Arts, 2021), 13–14.

11 "Black Craftspeople Digital Archive Q&A: Part I."

12 Alison Moloney, Wanda Lephoto, and Erica de Greef, "Confronting the Absence of Histories, Presence of Traumas and Beauty in Museum Africa, Johannesburg," *Fashion Theory: The Journal of Dress, Body & Culture* 26, no. 4 (March 2022): 553, 545.

13 Michel-Rolph Trouillot, *Silencing the Past: Power and the Production of History* (Boston: Beacon Press, 2015), 26.

14 Trouillot, *Silencing the Past*, 49–58.

15 E. Frances White, *Dark Continent of Our Bodies: Black Feminism and the Politics of Respectability* (Philadelphia: Temple University Press, 2001), 32–35, 46–47.

16 Jonathan Michael Square, "Slavery's Warp, Liberty's Weft: A Look at the Work of Eighteenth- and Nineteenth-Century Enslaved Fashion Makers and Their Legacies," in *Black Designers in American Fashion*, 33.

17 Square, "Slavery's Warp, Liberty's Weft," 37–42.

18 Trouillot, *Silencing the Past*, 26.

19 See Square, "Slavery's Warp, Liberty's Weft."

20 Elizabeth Way, "Elizabeth Keckley and Ann Lowe: Recovering an African American Fashion Legacy that Clothed the American Elite," *Fashion Theory* 19, no. 1 (February 2015): 128.

21 For a study of nineteenth-century Black dressmakers in New York, see Elizabeth Way, "A Matrilineal Thread: Nineteenth- and Early Twentieth-Century Black New York Dressmakers," in *Black Designers in American Fashion*.

22 Kinshasha Holman Conwill and Paul Gardullo, eds., *Make Good the Promises: Reclaiming Reconstruction and Its Legacies* (New York: HarperCollins, 2021), 75, 77.

23 Kristen Stewart, "Dressing Up: The Rise of Fannie Criss," in *Black Designers in American Fashion*, 74, 80, 85.

24 Evelyn Brooks Higginbotham, *Righteous Discontent: The Women's Movement in the Black Baptist Church, 1880–1920* (Cambridge, Mass.: Harvard University Press, 1993), 189.

25 Charlotte Collins, "Anifa Mvuemba Is the Future of Fashion," *InStyle*, November 16, 2021, https://www.instyle.com/fashion/anifa-mvuemba-instyle-award. Dhani Mau, "Hanifa's Anifa Mvuemba Couldn't Get the Fashion Industry's Support. Turns Out She Didn't Need It," *Fashionista*, September 8, 2020, https://fashionista.com/2020/09/anifa-mvuemba-hanifa-clothing-3d-fashion-show.

ANONYMITY

ANONYMITY

YTIMYNONA

ANONYMITY
(ca. 1675–1900)
The Costume Institute Collection

Jessica Regan

The Costume Institute's collection of over 25,000 items of women's dress and accessories includes some 9,000 examples lacking attributions, as their creators are unknown.[1] Such anonymity exists in varying degrees within the department's holdings, which include fashions by individuals who are entirely unidentifiable; garments by known designers or retailers but unknown seamstresses or dressmakers; and pieces by individuals whose names may eventually be traced but whose identities have been obscured by an absence of documentation or by the effects of past inequities. While this group comprises both historical and modern examples, most date prior to the early 1900s, with the largest share belonging to the eighteenth and nineteenth centuries. Throughout those periods, it was common for fashion's creators to go unrecorded; for women's dress, those makers were also typically women, who held the majority of roles as dressmakers, seamstresses, and milliners. The department's early womenswear collection therefore represents the work of myriad female makers who may be collectively acknowledged for their contributions to fashion but who are often obscured as individuals. An overview of these holdings reveals some of the considerations that have shaped collecting in this area and The Costume Institute's approaches to interpreting anonymous objects within its exhibitions. The case studies that follow, which highlight anonymous fashions from the collection, not only reflect the challenges of appreciating the individual skill and artistry of unknown makers but also speak to the value of name recognition itself.

Consisting of approximately ten thousand objects, The Costume Institute's pre-twentieth-century collection encompasses womenswear, menswear, and childrenswear, with a particular strength in women's fashions. Most date to the eighteenth and nineteenth centuries and are examples of European and American fashionable dress. The majority are also anonymous, lacking documentation of the individuals who designed and made them.

Women's fashion from these early periods was essential to The Costume Institute's collecting from its founding, beginning with the department's predecessor, the Museum of Costume Art, established in 1937. Its core collection—at first only a few hundred objects—consisted in large part of women's dress dating to the eighteenth and nineteenth centuries. These original holdings were primarily drawn from the collection first developed by sisters Irene Lewisohn and Alice Lewisohn Crowley as a theatrical wardrobe during their leadership of the Neighborhood Playhouse, a community theater in New York's Lower East Side.[2] The Lewisohns and their Museum of Costume Art cofounders recognized the importance of preserving these objects, which they envisioned as an enduring source of inspiration for contemporary designers and a vital resource for scholars and the general public. When, in 1946, the museum became part of The Metropolitan Museum of Art as The Costume Institute, the collection remained central to the new department's mission, which was described as "a program to emphasize the position of fashion as an art and to aid the creative efforts of American fashion designers and industries."[3]

In The Costume Institute's early years, its collecting of Western historical dress was shaped by a desire to build a time line of fashion, and the department's acquisitions therefore focused on pieces that were typical representatives of their eras. As this area of the collection grew over time, its largely anonymous objects continued to be acquired in a similar manner. While fashions by known designers were often selected as embodiments of the innovations or achievements of particular individuals, unattributed objects were generally chosen as exemplars of their kind in terms of style, technique, or materials, and as reflections of the primary concerns of fashion in their respective periods. Eighteenth-century collecting, for instance, concentrated on examples that conveyed the era's emphasis on fine materials, including skillfully woven textiles and exquisitely wrought embroidery. As nineteenth-century women's fashion was defined by a sequence of rapidly transforming silhouettes, characteristic examples of these changing forms were sought out, along with designs illustrating that century's increased attention to precise tailoring and refined finishing details.

With those considerations in mind, The Costume Institute built an extensive collection of historical dress that represented the evolution of Western fashion from the early eighteenth through the late nineteenth centuries. Strategic purchases from dealers and at auction, as well as fortuitous donations, allowed the department to continue to expand these holdings, often object by object and occasionally through larger groups of acquisitions. The most transformative of these occurred in 2009, when Brooklyn Museum's costume collection was transferred to The Met, enhancing The Costume Institute's early holdings of Western fashion with over two thousand eighteenth- and nineteenth-century garments and accessories, the majority of which were items of women's dress.

Brooklyn Museum made its first significant fashion acquisition in 1926 with a group of late nineteenth- and early twentieth-century designs from the wardrobe of a New York socialite and philanthropist.[4] In subsequent years, the museum formed a collection of eighteenth- and nineteenth-century costume that, without duplicating that of The Met, paralleled it in many ways. Brooklyn's historical collecting was similarly focused on representing key developments in fashionable dress and, like The Costume Institute's, centered on French and American examples.[5] French fashion was a priority for both institutions, reflecting that country's undeniable influence during these periods as well as the perceived supremacy long associated with French design. American dress also constituted a significant portion of these holdings, in large part because many patrons who donated costumes to The Met or to Brooklyn were based in New York and the surrounding region; typically, they gave fashions that had belonged to themselves or their ancestors and had been worn and often made in the United States.

Historical garments, long a collecting priority for The Costume Institute, have likewise been integral to its exhibitions since its inception. In keeping with the department's founding goals, these often anonymous examples have supported the continued exploration of fashion as an art form and furthered the ongoing dialogue between historical and contemporary dress. However, interpretation of unattributed pieces also presents challenges that are distinct from those associated with fashions by known designers—notably, the difficulty of understanding them in relation to their creators. Although these objects may be examined in comparison to others of their kind from the same era and region, or in connection to fashions expressing a common theme, they cannot be considered in the context of a greater body of work by a single person. How typical they may be of an individual's output, and the degree to which they reflect the direction of the maker versus the client, are inherently obscured.

Within Costume Institute exhibitions, these unattributed designs are frequently highlighted to exemplify a particular period and its artistic developments, or to represent a theme that is resonant in fashion across time. Anonymous garments have served to epitomize their eras in exhibitions that focused on a defined period—such as *From Queen to Empress: Victorian Dress, 1837–1877* (December 15, 1988–April 16, 1989) or *Dangerous Liaisons: Fashion and Furniture in the Eighteenth Century* (April 29–September 6, 2004)—as well as in shows exploring a broader time range—such as *Our New Clothes: Acquisitions of the 1990s* (April 6–August 22, 1999), *blog.mode: addressing fashion* (December 18, 2007–April 13, 2008), and *Masterworks: Unpacking Fashion* (November 18, 2016–February 5, 2017), which each highlighted the latest acquisitions made by the department. In the more recent *About Time: Fashion and Duration* (October 29, 2020–February 7, 2021), which traced a disrupted century-and-a-half time line of fashion, anonymous objects similarly represented their own eras while also being placed in conversation with designs from earlier and later periods. These juxtapositions made connections across time and emphasized the continued influence of historical fashion on later generations of designers.

A range of thematic exhibitions have engaged in a similar discourse, beginning with *Infra-Apparel* (April 1–August 8, 1993), which considered fashion's tendency to reveal its inherent, internal structure, and including, more recently, *Camp: Notes on Fashion* (May 9–September 8, 2019), which explored the exuberant and enduring camp aesthetic. These and other thematic shows have featured garments ranging from the eighteenth century to the contemporary, bridging the distance between the historical and the modern and between the obscure maker and the renowned designer.

Although anonymous fashions are not easily discussed in terms of their makers, they do reveal traces of those individuals through the accomplished techniques and distinctive details employed in their creation. The fashions highlighted in the following case studies are not only indicative of their periods but are equally representative of the largely unknown women who created them. These objects reflect the varied levels of anonymity represented throughout the collection, but especially in the department's pre-twentieth-century holdings. They represent the work of entirely unknown creators, a named designer and unknown maker, and a known but uncredited designer. They also illuminate the diverse reasons fashions may join the Museum's collection with nonexistent or incomplete attributions, including the standards of the period in which they were made; hierarchies of the fashion industry, which might promote a named designer but would rarely recognize the seamstresses executing the work; as well as exploitative relationships between designers and more powerful business partners that have rendered the designer anonymous. The entries that follow attest to both the significance of name recognition as well as the ways that makers may be considered—and acknowledged for their skill, knowledge, and expertise—even when their precise identities remain unknown.

1 Thank you to Marci Morimoto, Associate Collections Manager, for researching and sharing The Costume Institute's collection data cited in this entry and those that follow.

2 Harold Koda and Jessica Glasscock, "The Costume Institute at The Metropolitan Museum of Art: An Evolving History," in *Fashion and Museums: Theory and Practice*, ed. Marie Riegels Melchior and Birgitta Svensson (London: Bloomsbury, 2014), 21–22.

3 "Costume Branch for Metropolitan: Museum Adds Institute of Fashion in Step to Stress Style Design as Art," *New York Times*, December 12, 1944, 20.

4 Jan Reeder, *High Style: Masterworks from the Brooklyn Museum Costume Collection at The Metropolitan Museum of Art* (New York: Metropolitan Museum of Art; New Haven, Conn.: Yale University Press, 2010), 9, 33–34.

5 On the overall makeup and history of Brooklyn Museum's costume collection, see Reeder, *High Style*, particularly pp. 13–31, on the historical portion of the collection.

ROBE À LA FRANÇAISE
Revival and Reinvention in Eighteenth-Century Fashion

Jessica Regan

One of the longest-enduring and most iconic forms of eighteenth-century dress, the *robe à la française* remained fundamental to French fashion from the 1730s until the Revolution, continually renewed through variations in silhouette, textiles, and trimmings.[1] This elegant example—dating to the 1770s but composed of fabric produced decades earlier—reflects the evolution of this archetypal style and the eighteenth-century dressmaker's essential ability to transform seemingly outmoded materials into garments that quintessentially belonged to the latest moment in fashion.

Women's dress in eighteenth-century France was the product of a robust network of specialized artisans and tradespeople. These individuals included the designers and weavers responsible for the era's lively textiles, the mercers and drapers who sold those goods, and the dressmakers and *marchandes de modes*—or fashion merchants—who created garments and accessories or furnished their finishing touches. Women were integral to this system as both merchants and makers but most notably as dressmakers. The vast majority left no records of their working practices and today are unidentifiable by name, their artistry revealed only anonymously through surviving fashions.

Dressmakers were responsible for turning a client's recently purchased materials into eye-catching fashions or, often, for revitalizing older textiles by remodeling them into garments that aligned with the spirit of a new era. This example utilizes an ivory silk damask dating to the 1710s that was woven in China for the European market. Representing what twentieth-century historians termed the "bizarre" style for its incorporation of unusual motifs that blended Chinese, Indian,

Persian, and European influences, the silk reflects a trend that faded by the 1720s.[2] However, fine textiles continued to be valued and repurposed as dress styles evolved; monochromatic fabrics in particular retained their appeal for subsequent generations, as their less-prominent imagery integrated more easily into later fashions.[3]

This dress, in which the silk used in the body of the gown also forms its embellishments, was probably made in its entirety by a dressmaker, without the intervention of a *marchande de modes*. Fashion merchants specialized in adornments made of lace, ribbons, and other materials that they also sold, while self-fabric ornamentation typically fell under the dressmaker's purview.[4] The exquisite damask was likely originally used in another garment and later reworked into its current form, as the fabric panels that form the dress are irregular in shape and width. Since these anomalies are obscured by the gown's deep folds, they do not disturb its aesthetic integrity.

The maker has crafted a silhouette and embellishments that fully conform to the prevailing style of the early 1770s, with a wide-hipped skirt and richly textured trimmings. The silk is expertly worked into decorative flounces at the hemline and carefully formed ruching along the center front opening that are graduated in width to complement the gown's swelling silhouette. The dress's most distinctive detail, however, may be its striking silk lining composed of an ivory ground with brilliant green- and raspberry-colored stripes. Nearly hidden and perhaps only discreetly revealed when the wearer was in motion, this vivid textile may also have been previously employed for another use and is here given new life—both functional and alluring.

1 Although by the late 1770s the style was no longer the height of fashion, it remained in use into the 1780s as court dress, largely replacing the *grand habit*. Aileen Ribeiro, *Dress in Eighteenth-Century Europe 1715–1789* (New Haven, Conn.: Yale University Press, 2002), 188, 219.

2 Kristen Stewart, "Dress (*Robe à la française*)," in *Interwoven Globe: The World Textile Trade, 1500–1800*, ed. Amelia Peck (New Haven, Conn.: Yale University Press, 2013), 196. Melinda Watt, "'Whims and Fancies': Europeans Respond to Textiles from the East," in *Interwoven Globe*, 96.

3 The Costume Institute has several other examples of dresses made in the 1770s or 1780s from damasks produced earlier in the century, including 1994.406a–c; 2009.300.731; 2018.110a–c; and 2018.111a, b.

4 This division of labor was codified in revised Parisian guild statutes in 1782, which stipulated that the *marchandes de modes* were only permitted to create dress embellishments of different materials from those used in the dress itself. Clare Haru Crowston, *Fabricating Women: The Seamstresses of Old Regime France, 1675–1791* (Durham, N.C.: Duke University Press, 2001), 67.

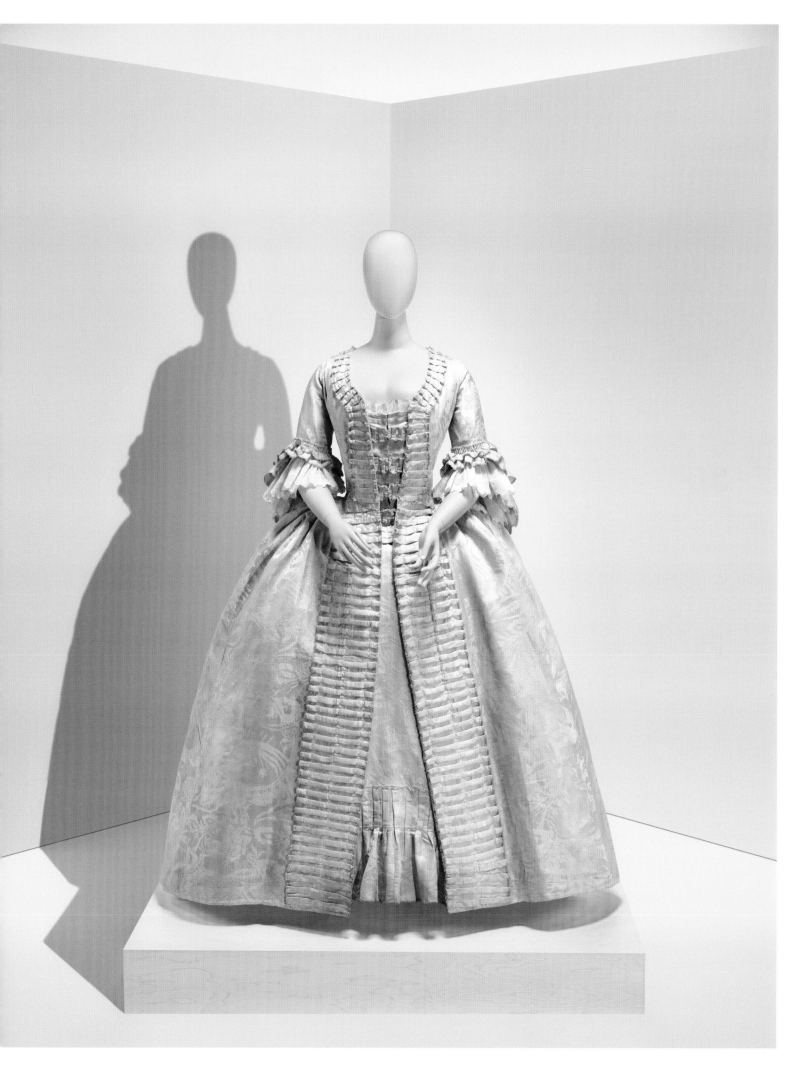

French. *Robe à la française*, ca. 1770; textile 1710–20

AFTERNOON DRESS
Dressmaking in an Age of Transformation

Jessica Regan

The understated design and neat execution of this delicate gown exemplify the style and techniques that defined American dressmaking in the mid-nineteenth century. Typical for the period, the dress does not bear a label identifying its creator, and there is no known documentation illuminating the circumstances of its production in the early 1860s.[1] Although its maker is unknown, the ensemble's finely formed embellishments suggest the work of a proficient dressmaker rather than an amateur home sewer.

Dressmakers working in the nineteenth century responded to constantly changing silhouettes, continuously adapting their techniques to achieve the latest fashionable form. During the 1860s these shifts concentrated on the skirt, a development made possible by the introduction of the cage crinoline in 1856. Composed of thin hoops of pliant steel suspended from cotton tapes, this novel understructure not only provided volume without excessive weight but also allowed for more nuanced changes in shape than the layered petticoats of earlier decades. Vast skirts morphed from a dome-like outline to a more gently graduated form with fullness concentrated at the back. As *Godey's* described the early 1860s silhouette, "hoops . . . still continue ample and of the trailing bell shape, quite small for some distance below the waist and spreading into a wide circumference."[2]

To achieve this new form—narrow at the waist, streamlined over the hips, and expansive at the hemline—dressmakers experimented with various methods, such as combining shaped skirt panels with gores or introducing diverse styles of pleating. Here, the maker utilized selvedge-width panels of silk gauze molded to shape with box pleats at the waist, creating a smooth transition into the hem's broad circumference. The dress's bodice, on the other hand, did not require an innovative approach to compose its foundational structure, which may have been made based on the "pin-to-the-form" technique, a practice commonly in use since the eighteenth century.[3] In this process, the dressmaker determined the contours of pattern pieces by draping fabric directly on the wearer's body, a straightforward way of ensuring that the final garment conformed precisely to her figure.

Fashion guidance of the day suggested that the most appealing and balanced designs dispensed with excessive ornamentation. As the *Lady's Home Magazine* recommended, skirts were best left plain, as trimmings "would spoil the harmony and disguise the beauty" of fine textiles.[4] In this example, the fabric's shimmering effect is enhanced by combining two layers of gauze, in soft pink over white, creating greater luminosity and depth of color.[5] The dress's only adornments are subtle self-fabric embellishments that highlight the fineness of the material, including ruching across the upper bodice and sleeves that yields a series of puffs, or *bouillonnés*. Hand-worked details such as these became increasingly important in fashionable dress with the rise of the sewing machine. Although its invention and proliferation eased certain aspects of garment construction, particularly the stitching of long, straight seams, the sewing machine could not replace hand finishing for the execution of more intricate details, which served as marks of quality and prestige and as signs of an accomplished dressmaker.

1 The dress is believed to have descended in a family based in Salem, Massachusetts, though its precise wearer remains unconfirmed. Provenance information provided by Cora Ginsburg, LLC.
2 "Chitchat upon New York and Philadelphia Fashions, for August," *Godey's*, August 1860, 192.
3 Claudia B. Kidwell, *Cutting a Fashionable Fit: Dressmakers' Systems in the United States* (Washington, D.C.: Smithsonian Institution Press, 1979), 13.
4 "Fashions for February," *Lady's Home Magazine*, February 1860, 125.
5 Thank you to Elizabeth Shaeffer for sharing her observations on the fabric's composition.

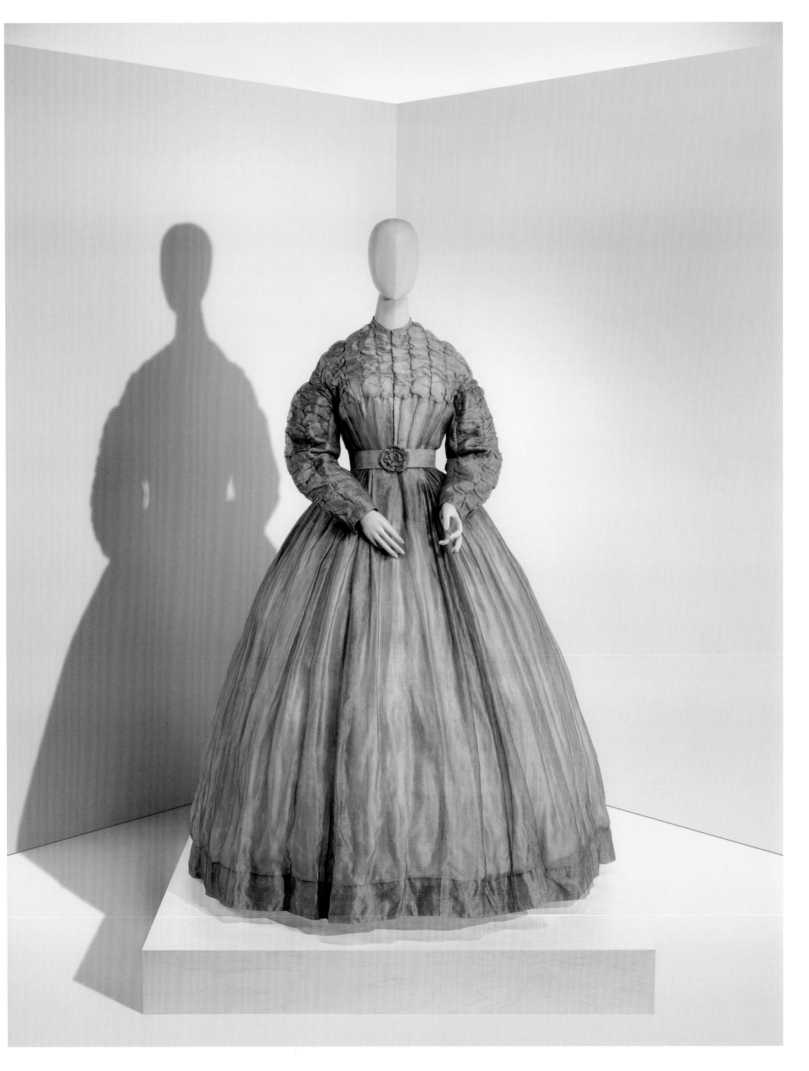

American. *Afternoon dress*, ca. 1861–63. Pink and cream silk gauze

MADAME OLYMPE
The Maker(s) Behind the Modiste

Elizabeth Shaeffer

This striking design of moiré taffeta was made with two bodices: a long-sleeved afternoon style and an alternate for evening with an off-the-shoulder neckline. The interior of the evening bodice bears a gold stamp with the name and business address of Olympe Boisse, known professionally as Madame Olympe, a renowned dressmaker and importer of French fashions based in New Orleans. In the 1860s it was rare for American dressmakers to label their designs. By doing so, Olympe followed the example of Paris-based couturier Charles Frederick Worth, who saw labeling as both a promotional tool and akin to an artist's signature.

Described as a "fashionable modiste," Olympe was a pioneer in establishing Canal Street as a shopping destination.[1] A consummate saleswoman and flatterer of customers,[2] she created confections of fine fabrics that could more than triple in price once lace and ribbons were added.[3] At the time, women's clothing was generally custom made for specific clients, but whether Olympe designed this look herself, copied it in Louisiana from a French model,[4] or imported it from Paris[5] is a matter of speculation. What is more certain is that despite the label bearing her name, the dress would not have been crafted by Olympe's hands,[6] but by a professional seamstress.

Close examination of the ensemble's materials and construction reveals visual traces of the otherwise anonymous maker's process. The seamstress used a lockstitch sewing machine—a revolutionary innovation of the mid-nineteenth century—for many of the seams, allowing her to complete her work significantly more quickly than if she had only sewn by hand.[7] Before being machine sewn, however, seams in the evening bodice were first loosely hand stitched. This method permitted the seamstress to carefully ease the curved edges together, preventing the fabric from puckering and ensuring a tidy fit, which was seen as a reflection of the wearer's good taste and social status.[8] The machined seams used silk for the needle thread and cotton for the bobbin, a technique that was both practical and economical. Lockstitching required at least double the length of thread as hand sewing, and since silk thread was expensive,[9] combining it with cotton reduced costs. Moreover, setting up a machine with both meant that the seamstress would not have to stop her work to rethread with just silk for seams where the thread would be visible or just cotton where it would not. The dual-fiber stitching also blended the flexibility of silk with the strength of cotton, so the seams were neither too weak nor too stiff. Curiously, the silk thread in the day bodice is different from that used in the evening bodice, skirt, and belt, possibly suggesting that the garments were made by different seamstresses or that a seamstress in a busy workroom employed whatever thread was at hand.

Although the actual maker or makers of this dress are unknown, careful study of its assembly provides subtle clues about conscious and perhaps unconscious decisions that factored into its creation. These were influenced not only by the fashionable trends of the day—the silhouette, fabric, and trim that would have been selected by Olympe and her patron—but also by the practicalities of a skilled but unnamed needlewoman.

1 Eliza Ripley, *Social Life in Old New Orleans: Being Recollections of My Girlhood* (New York: D. Appleton, 1912), 58.

2 "Olympe's ways were persuasive beyond resistance. She met her customer at the door with 'Ah, madame'—she had brought from Paris the very bonnet for you! No one had seen it; it was yours! . . . And so Mme. X had her bonnet sent home in a fancy box. . . . And Monsieur X, though he may have called her 'Old Imp,' paid the bill with all the extras of specialty and delivery included, though not itemized." Ripley, *Social Life in Old New Orleans*, 60–61.

3 Olympe Boisse, Wife, Etc., Respondent, v. Lovel Ledoux, Appellant, 2591 (La. 1870).

4 *Patrons modèles*—paper or muslin dress patterns—were sold in France as a way for foreign dressmakers to reproduce the latest Parisian fashions for their clients. Pamela A. Parmal, "La Mode: Paris and the Development of the French Fashion Industry," in *Fashion Show: Paris Style* (Boston: MFA Publications, 2006), 54.

5 Recalling her childhood in Mobile, Alabama, Alva E. Belmont wrote that her mother had clothes from Olympe delivered for herself and her children twice yearly. The clothing's place of manufacture is somewhat nebulous:

she remembered a dress "designed by Olympe" for her mother, but she also states that it was her mother's custom "to order from Paris," though Olympe's business operated out of New Orleans. Alva E. Belmont Memoir, Matilda Young Papers, David M. Rubenstein Rare Book and Manuscript Library, Duke University, Durham, N.C., 30.

6 "She did not—ostensibly, at least—make or even trim *chapeaux*." Ripley, *Social Life in Old New Orleans*, 60.

7 A study published in 1861 found that when sewing fine silk, a lockstitch machine could achieve a staggering 550 stitches per minute versus only 30 by hand. Thomas Prentice Kettell, "Sewing Machines," in *Eighty Years' Progress of the United States: Showing the Various Channels of Industry and Education through which the People of the United States Have Arisen from a British Colony to Their Present National Importance* (New York: L. Stebbins, 1861), 2:427.

8 Cynthia Amnéus, ed., *A Separate Sphere: Dressmakers in Cincinnati's Golden Age, 1877–1922*, exh. cat. (Cincinnati, Ohio: Cincinnati Art Museum; Lubbock: Texas Tech University Press, 2003), 44.

9 Grace Rogers Cooper, *Thirteen-Star Flags: Keys to Identification* (Washington, D.C.: Smithsonian Institution, 1973), 25.

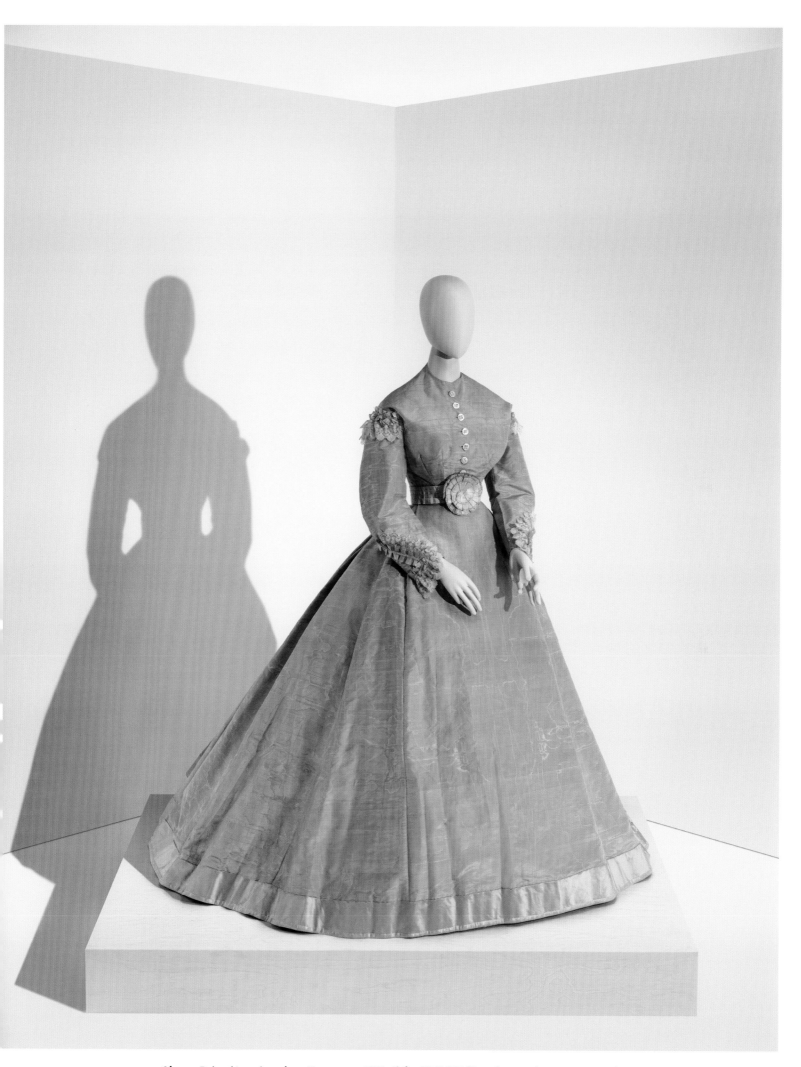

Olympe Boisse (American, born France, ca. 1822–?) for OLYMPE (American, active ca. 1851–1885)
Evening dress, ca. 1865. Pink moiré silk taffeta trimmed with pink silk taffeta, cream silk lace, and pink silk satin with glass beads

ANN LOWE FOR SAKS FIFTH AVENUE
A Label Without a Name

Elizabeth Way

In fashion, one's name on a label is an important and lucrative source of power and prestige. Women designers, and especially women designers of color, must often fight the anonymity of their creative labor, which can too easily be subsumed by a larger, more powerful name. In the case of Ann Lowe, a Black American designer who worked in Montgomery, Alabama, Tampa, Florida, and New York City from the 1910s into the early 1970s, the exquisite details of her material culture—that is, the existing garments she left behind—and her voice in the press combated this invisibility.

The label of this vibrant orange evening dress reads "Saks Fifth Avenue Original Made Exclusively for The Adam Room," the store's made-to-measure salon (fig. 1). Fashion scholar Margaret Powell notes that Lowe—a respected New York couturier known for elite debutante and wedding dresses by the 1950s—was hired as the Adam Room's designer in 1960 or 1961.[1] The high-waisted, A-line silhouette of the orange silk gown aligns with Lowe's time at Saks, yet more concrete evidence of her hand lies in the dress's construction. The seaming with bands of elastic and grosgrain in the bodice's interior and the lace edge finishing are characteristic of Lowe's technique, which was executed to support the wearer and create a smooth, perfect fit without the need for additional undergarments. The structure can be compared to other Lowe dresses that bear her label, authenticating her as the designer of this gown. The self-fabric flowers and leaves that adorn the shoulder straps and low-scooped neckline at the back and that cascade down the rear of the dress are also signatures of Lowe's oeuvre.

Lowe worked in many capacities as a designer, from a live-in dressmaker for a wealthy family to a designer for hire at large manufacturers and as the head of her own ateliers, often partnering with white business managers, investors, or fellow designers. Her position at Saks combined many of these previous roles: she had sole creative authority to work one-on-one with her clients, and her contract stipulated that she buy her own materials and pay her staff while Saks bought her gowns to sell at a markup. Unfortunately, Lowe was not a savvy businesswoman, and this predatory partnership in which Saks accessed her exclusive client network led her to financial ruin. She left Saks by 1962.[2]

Lowe may have been prominent in New York's elite society as a custom fashion designer, and during her years at Saks, her work would have been easily recognized by this circle, but her name was not directly associated with these designs; the labels lacked her moniker. Over the intervening years, her connection to these dresses would have been lost if not for the many press articles in which she recounted the story of her lifework. Lowe only began to appear in the national press during the mid-1960s, toward the end of her career. Championed by her then business partners Benjamin and Ione Stoddard, the owners of the Madeleine Couture fashion house on Madison Avenue, she embarked on a press campaign in which she claimed the credit she deserved, not only for gowns she designed for the Adam Room but for other prominent dresses, including the dress actress Olivia de Havilland wore to the 1947 Academy Awards and Jacqueline Kennedy's 1953 wedding gown.

Fig. 1. *Evening dress* (detail)

1 Margaret Powell, "The Life and Work of Ann Lowe: Rediscovering 'Society's Best-Kept Secret'" (master's thesis, Smithsonian Associates and Corcoran College of Art and Design, 2012), 52.
2 Powell, "The Life and Work of Ann Lowe," 52–55, 60.

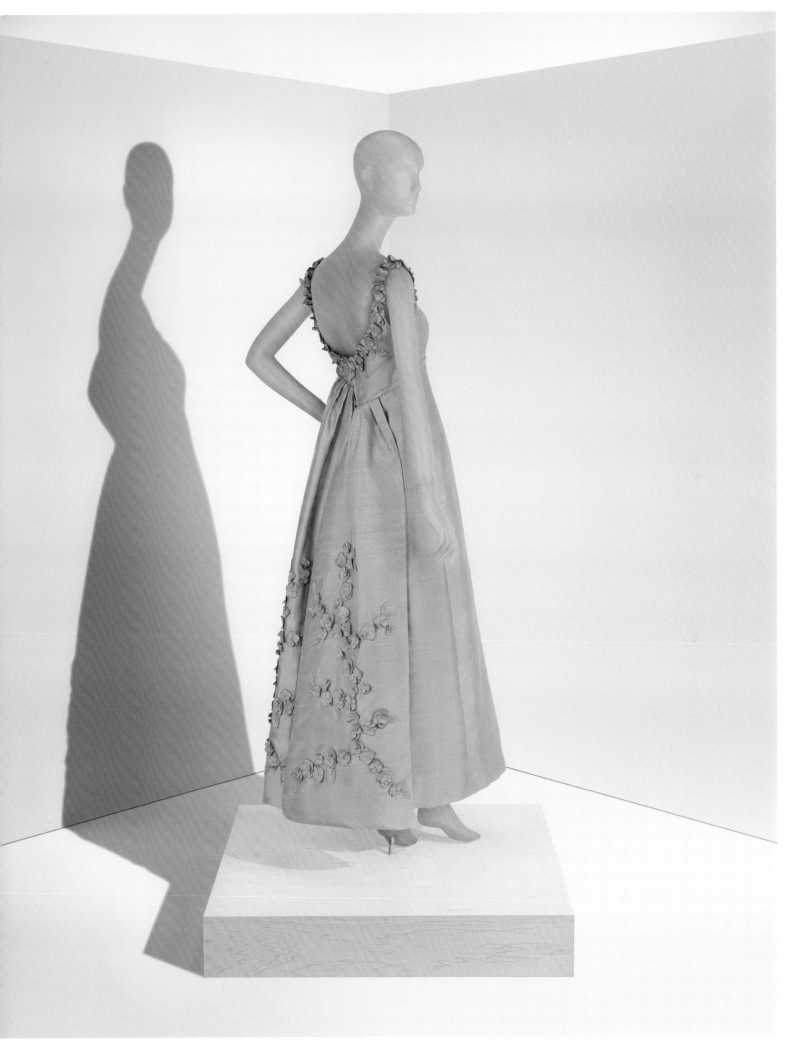

Ann Lowe (American, ca. 1898–1981) for SAKS FIFTH AVENUE (American, founded 1924)
Evening dress, 1960–62. Orange silk shantung appliquéd with self-fabric flowers

VISIBILITY

VISIBILITY

VISIBILITY

VISIBILITY
(ca. 1900–1968)
The Costume Institute Collection

Mellissa Huber

By the first decades of the twentieth century, the known (or named) designer became an increasingly recognizable and prestigious figure due to their centrality in shaping a larger couture house's identity and growing appreciation for the role's artistic merit. This new visibility for makers accompanied ongoing urbanization and job opportunities that paralleled the growth of the media and fashion industry, introducing new frameworks for the contemporaneous consumption and dissemination of dress and its later collecting and interpretation. Unlike with anonymous objects from prior centuries, awareness of the maker fosters opportunities to contextualize both garment and creator within the broader span of a career and furthers our abilities to trace networks of production, purchase, and preservation.

The years between the turn of the century and the end of World War II encapsulate an especially critical era of change in dress and society, bookending a unique moment in which female creatives equaled—and sometimes outnumbered—their male counterparts at fashion houses, many assuming positions of leadership in shaping the direction of modern dress, particularly throughout the interwar period. Given the prevalence of women designers at this time, and our ability to track individual histories more precisely, it is unsurprising that The Costume Institute collection from about 1900 to 1968 contains the richest representation of female designers' work across any given period. Within the holdings of women's main dress, comprising over five thousand garments, 43 percent of the collection was created by female makers or a mixed-gender team.[1] The objects in this section constitute the work of both venerated and forgotten designers, including pieces that have never been shown or published since their acquisition. They reflect the historically Western focus of The Costume Institute's collecting practices and include designs from France, England, America, and Italy, with a bias toward the hegemony of French haute couture and the centrality of Paris as an international fashion destination that is characteristic for the era.

Some of the earliest additions to The Costume Institute's twentieth-century archives predate the formal establishment of the curatorial department and underscore the intended symbiosis between the Museum and the American fashion industry. These acquisitions include the work of makers like Jessie Franklin Turner, who is regarded as among the first Americans to operate in a couture manner. Described in 1933 as "one of the most magical and independent designers in the world,"[2] Turner developed strong working relationships with the Museum of Costume Art, where she served on the board of directors and participated in several early exhibitions, and the Brooklyn Museum, where she met Edward C. Blum and Stewart Culin, who promoted historical and ethnographic source material from institutional collections as inspiration for contemporary design. One such example of this approach includes a dress that Turner created for Elizabeth Goan Crawford,[3] which is woven with bird motifs after a nineteenth-century Indian blouse (p. 124). Similarly, a stylish pajama ensemble that

Tina Leser designed for the New York–based fashion house Edwin H. Foreman, Inc. was inspired by a nineteenth-century East Indian skirt and incorporates a Celanese rayon satin with peacock motifs that was produced by Hafner Associates for The Costume Institute exhibition *From Casablanca to Calcutta: The Arts of North Africa, the Near and Middle East, with Modern Derivations* (January 9–December 15, 1948).

A substantial group of twenty-four dresses came to the Museum in 1946, the year that the rechristened Costume Institute joined The Metropolitan Museum of Art.[4] This gift was orchestrated by Mrs. Harrison Williams (Mona von Bismark, née Strader), Mrs. Ector Munn (Fernanda Wanamaker de Heeren Munn), and Lady Mendl (Elsie de Wolfe) and included the work of many leading French couturiers, such as Alix (Germaine Émilie Krebs, also commonly known as Madame Grès), Elsa Schiaparelli, and Madeleine Vionnet.[5] In practice and in provenance, these dresses follow the convention of focusing on so-called women of style, a popular approach that amplified the often reciprocal relationship of creativity and patronage between designers and their clientele. Culled directly from the wardrobes of society women and custom made to fit their bodies,[6] the donations include fine examples of eveningwear, such as a Chanel dress embroidered with glittering fireworks worn by Countess Madeleine de Montgomery to Lady Mendl's seventy-fifth birthday party in 1939 (p. 109), and a full-skirted gown of smoke silk taffeta modeled by Comtesse Marie-Blanche de Polignac (née Marguerite di Pietro), daughter of Jeanne Lanvin, the dress's creator (pp. 112–13). Donor Elsie de Wolfe was later highlighted in *American Women of Style* (December 13, 1975–August 31, 1976), an exhibition that celebrated fashionable socialites like Millicent Rogers and Rita de Acosta Lydig. The latter's penchant for antique lace had catalyzed her first loan to the Museum of Costume Art for *A Special Exhibition of Costumes, Shoes, and Mantillas Worn by Rita de Acosta Lydig* (March 12–June 29, 1940). Lydig's passion for lace was shared with the design house Callot Soeurs, who created bespoke garments for her from vintage textiles, as exemplified in later gifts to the Brooklyn Museum, including an evening ensemble (p. 99) that featured in the exhibition *American Woman: Fashioning a National Identity* (May 5–August 19, 2010), which explored archetypical feminine styles between 1890 and 1940. Significantly, the broader collection of The Costume Institute reflects an overwhelming bias toward womenswear; approximately 80 percent of the clothing and 81 percent of the accessories held were produced for female consumers. Thus, these types of direct loans and donations between wearer and Museum became increasingly important to building the collection and lending a new form of visibility to maker and patron alike through the act of preservation and display.

Larger donations from a wardrobe often enable the acquisition of exceptional garments that may otherwise be overlooked as solitary objects. Such is the case with a sumptuous velvet cape and pleated dress of gold lamé created by the French couturier Marcelle Chapsal (p. 110) that came to The Met in 1953 with a group of forty-one pieces from Thelma Chrysler Foy. Chapsal launched her business during a difficult moment in war-suppressed France and never achieved the same degree of recognition as her mentor, Madeleine Vionnet, though she would have been well known to haute couture clients like Foy, whose recognized taste and social standing no doubt eased the accession of the ensemble. The French house of Mad Carpentier, a joint venture of two other ex-Vionnet staff, Madeleine Maltezos and Suzie Carpentier, produced a vivid blue-green and navy evening dress that was initially cataloged as American (p. 118), an unsurprising mistake given that Mad Carpentier was often assumed by the press to be a single person. The gown has not been exhibited since its donation by Eleanora Eaton Brooks in 1975.

While examples of eveningwear are prevalent, the collection also contains daywear that dually documents fashion trends and the increasing liberation of women's daily lives. For example, a chic rendition of the little black dress from Premet's autumn/winter 1929–30 collection (p. 106), gifted by the American journalist Mary Van Rensselaer Thayer, descends from *la garçonne* model introduced by Madame Charlotte in 1923. The garment's longevity as a coveted style subject to subtle updates across the decade can be attributed in part to Madame Charlotte's keen understanding of women's needs. A group of Chanel ensembles that was purchased at auction, more recently revealed as from the estate of Ofelia Fabiani, includes a black and white day suit (p. 107) that conveys a similar blend of ease and elegance. Many such gifts reflect loyalties between designer and client, as demonstrated through Diana S. Field's cache of garments by the iconoclastic designer Elizabeth Hawes (p. 119) and pioneering American businesswoman Margaret Rudkin's collection of Valentina.

Although gifts of twentieth-century dress have become less frequent with the passage of time, those that emerge today are all the more remarkable. Rare objects designed by Madame Lefranc for Premet (p. 98) and by the houses of Madeleine & Madeleine (p. 100), Augustabernard (p. 116), and Maggy Rouff (pp. 120–21) from a recent promised gift of fashion collector Sandy Schreier[7] have substantially enhanced The Costume Institute's representation of female designers from the period. While industry conditions shaped the contemporaneous elevation and documentation of the work of many leading female designers, an examination of our collecting practices and strengths reveals how many women who were dressed by these designers have also contributed to the representation of women's work within the Museum. The garments that follow embody the technical and aesthetic innovations that occurred in dress during the first decades of the twentieth century and perpetuate forms of visibility for maker and wearer in tandem, chronicling the ways in which women have contributed to fashion as creators, consumers, and philanthropists.

1 The category of "main dress" for women includes forms of outerwear, such as dresses and coats, and excludes accessories, undergarments, and clothing for men and children.
2 "The Dressmakers of the U.S.," *Fortune*, December 1933, 141.
3 Elizabeth Goan Crawford was a respected fashion historian who wrote for *Women's Wear Daily* for over thirty-six years. She was a member of the governing board of the Brooklyn Museum, an honorary advisor to its former Design Lab, and was married to M. D. C. Crawford. Many objects that were donated to the Brooklyn Museum from the Crawford collection were gifted by her and her sister, Adelaide Goan.
4 Despite its geographic move to the Museum in 1946, The Costume Institute was not formally recognized as a curatorial department until 1956.
5 See Andrew Bolton, "Le Colis de Trianon-Versailles and *Paris Openings*," Heilbrunn Timeline of Art History, The Metropolitan Museum of Art, October 2004, https://www.metmuseum.org/toah/hd/psop/hd_psop.htm.
6 Increasingly, contemporary fashion that is procured directly from the design house often comes in a runway sample size and, at times, may even be fabricated to fit a fashion mannequin without the expectation of ever being dressed on a living body.
7 Sandy Schreier is remarkable for her prescient involvement in fashion collecting, as she recognized the value of historical dress from an early moment and never wore the garments in her collection to ensure their preservation.

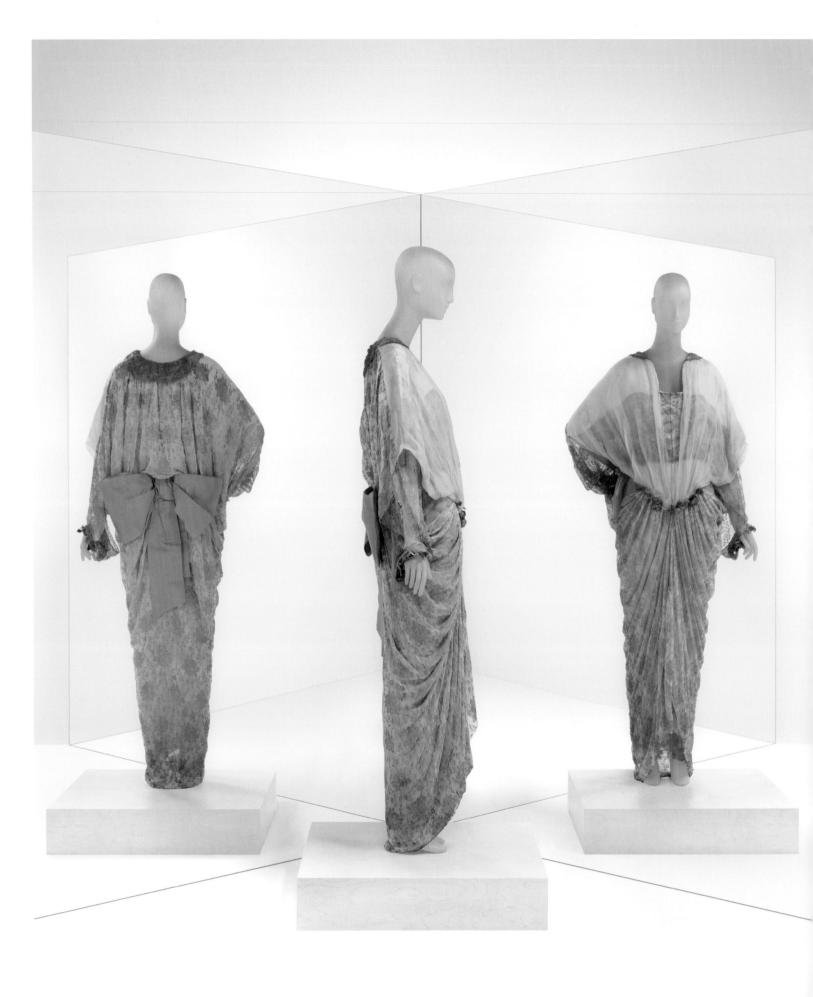

Probably *Madame Lefranc* (French, 1878–1914) for PREMET (French, ca. 1911–1932)
Tea gown, ca. 1913. Ivory and gold silk-metal jacquard chiffon, pale pink chiffon, and gold metal lace trimmed with gold lamé flowers and bow of blue silk faille

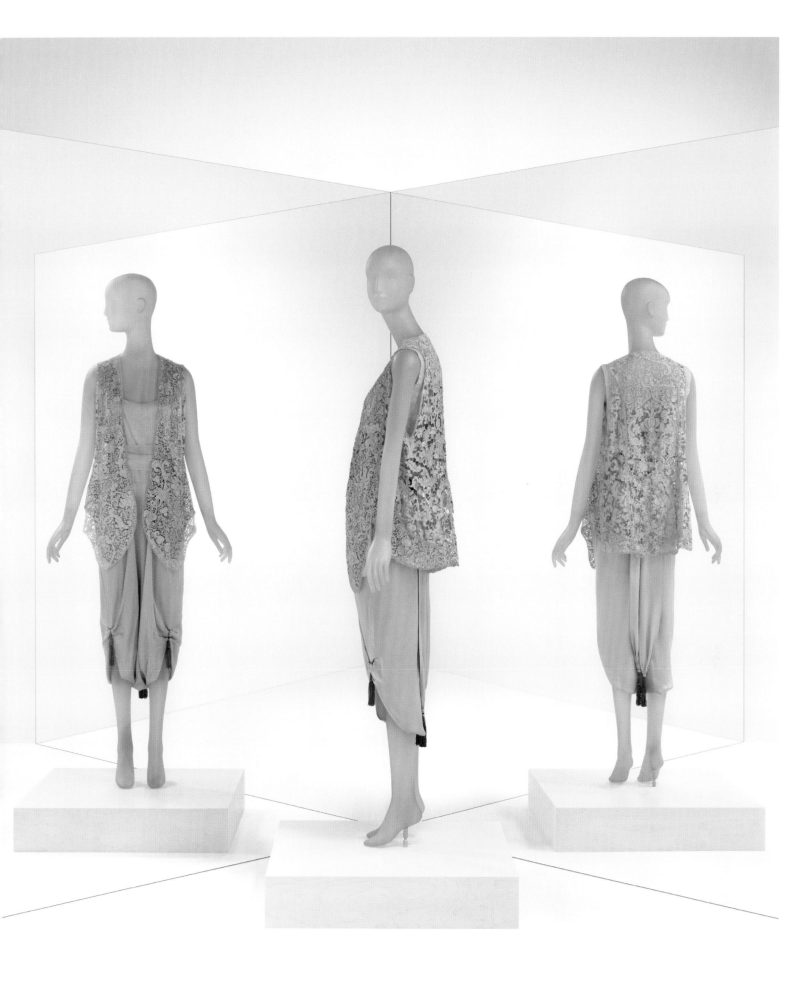

Marie Callot Gerber (French, 1857–1927) for CALLOT SOEURS (French, 1895–1937)
Evening ensemble, ca. 1910. Vest of ivory linen Venetian-type lace; bifurcated underdress of ivory silk charmeuse and georgette

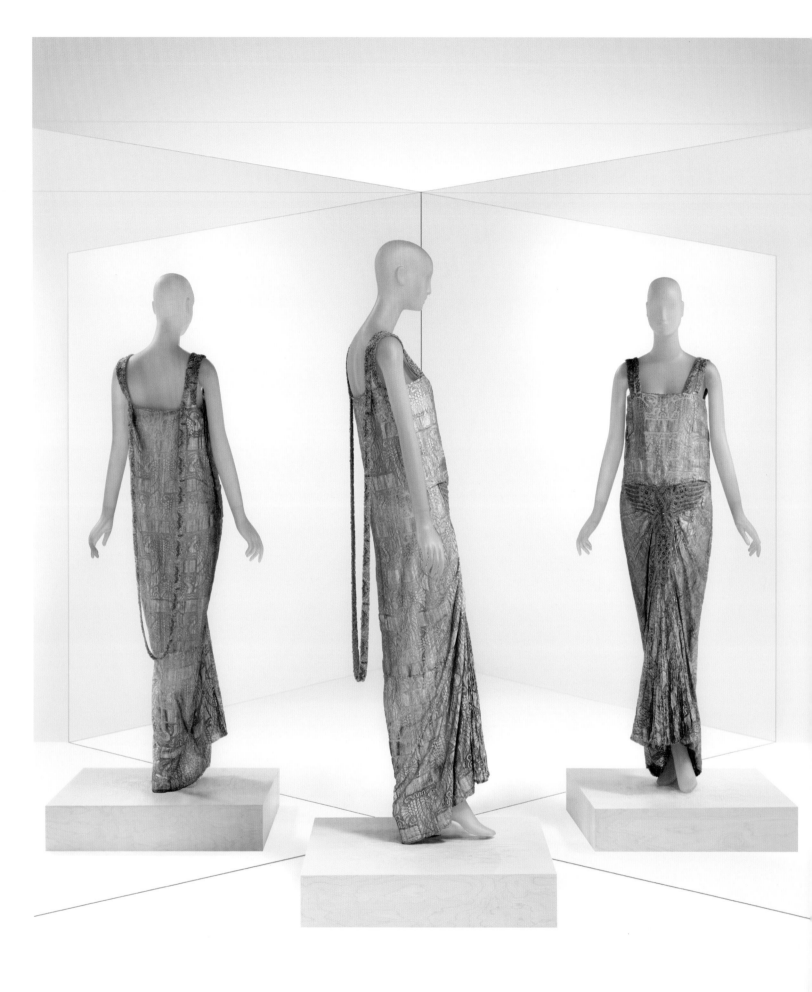

Probably *Madeleine Lepeyre* (French, ?) and *Madame Madeleine* (French, ?) for MADELEINE & MADELEINE (French, 1919–1924/26)
Evening dress, ca. 1923. Pink silk crepe de chine and red cotton and gold silk and metal lace, embroidered with pink, silver,
and blue-green bugle beads and pink and blue-green synthetic stones

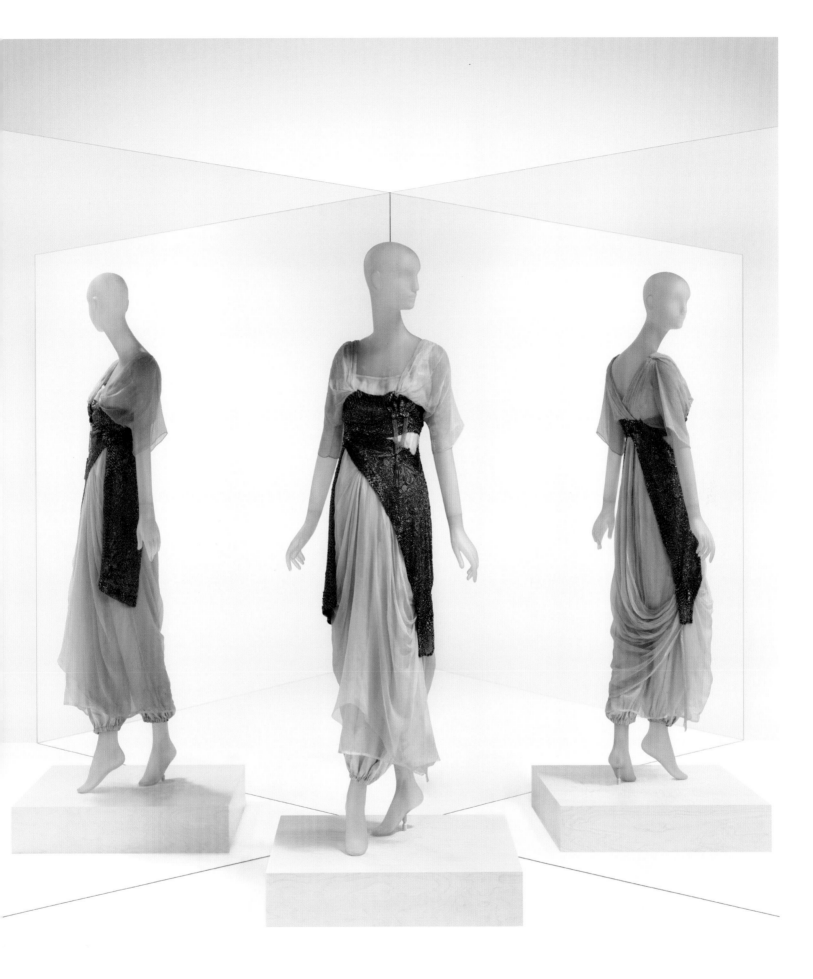

Marie Angenard (French, 1859–1942) for JEANNE HALLÉE (French, 1870–1924)
Jupe culotte evening ensemble, 1911–12. Pink silk chiffon and satin and dark blue silk net, embroidered with blue and silver bugle beads and silver metal thread

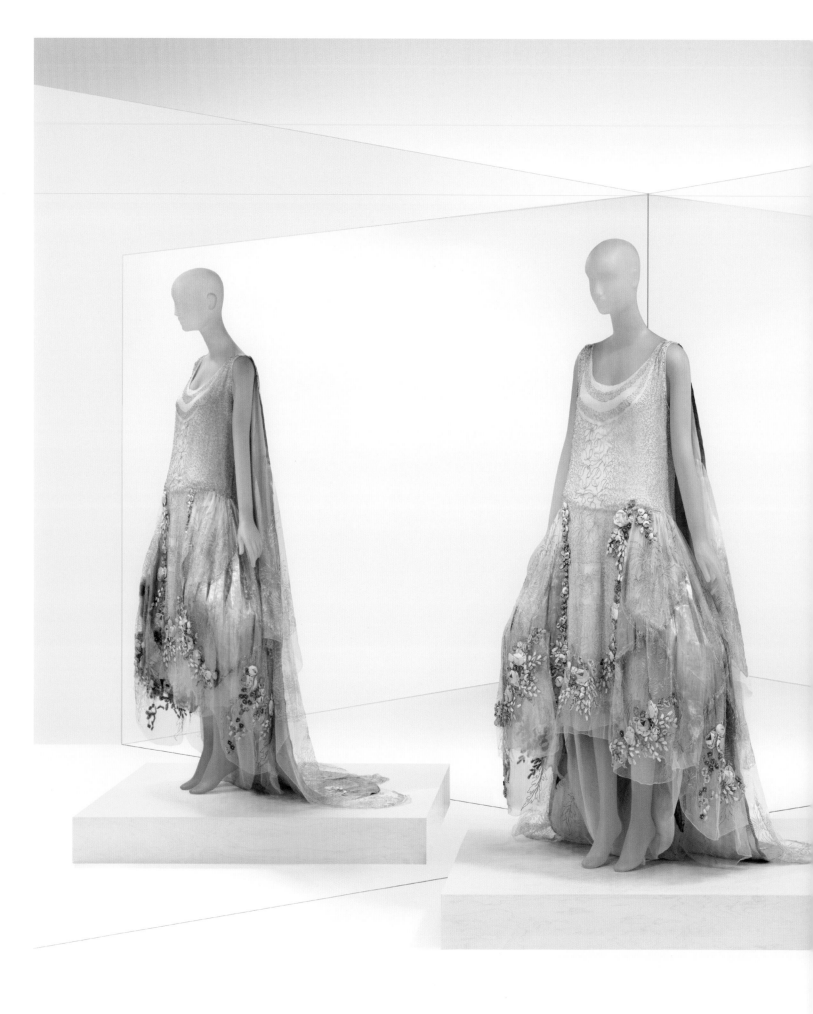

Sylvie Boué de Montegut (French, 1872–1953) and *Jeanne d'Etreillis* (French, 1876–1957) for BOUÉ SOEURS (French, 1897–1957)
Court presentation ensemble, 1928. Pink silk chiffon and ivory tulle embroidered with silver cord, silver-blue silk and metal lamé, and polychrome silk flowers and floss

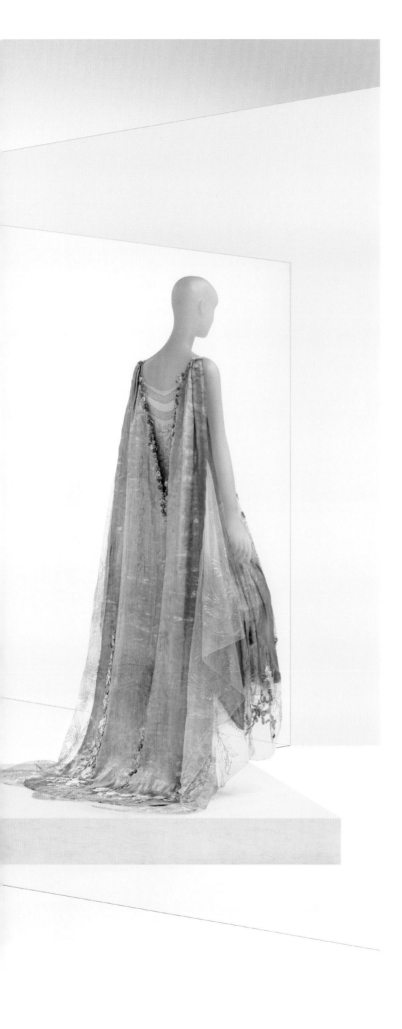

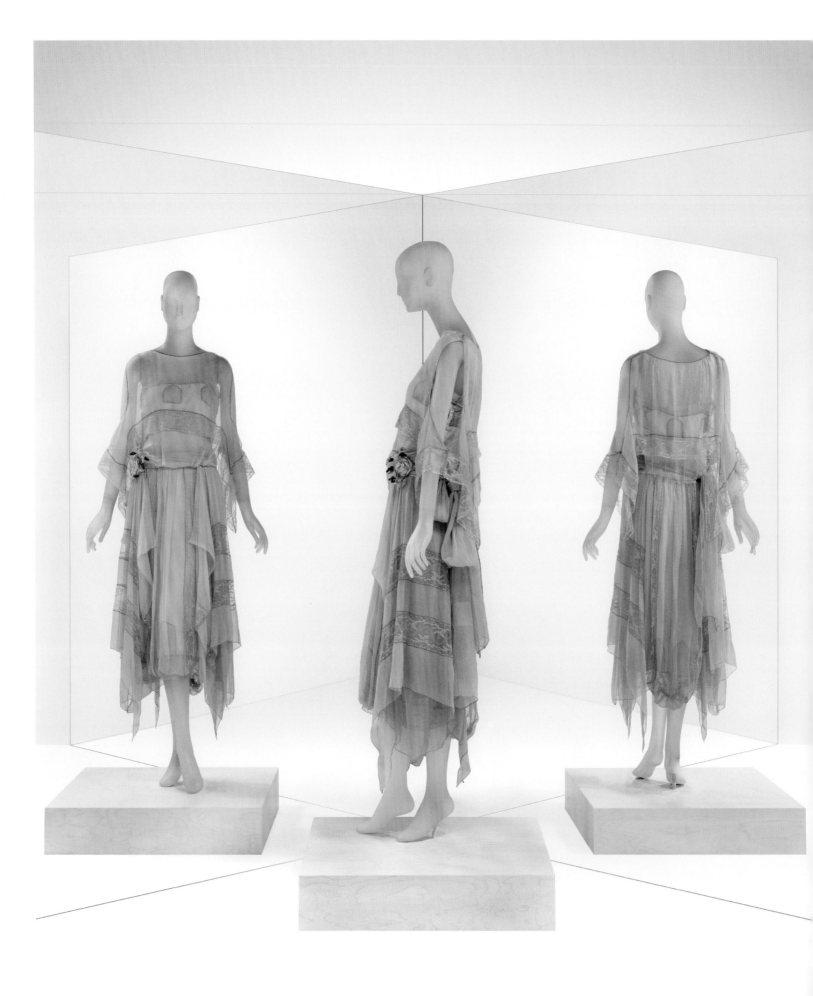

Lucy Christiana Duff-Gordon (British, 1863–1935) for LUCILE LTD., NEW YORK (American, 1910–1932; founded London, 1904)

Evening dress, 1922. Beige silk chiffon and lace with polychrome silk flowers

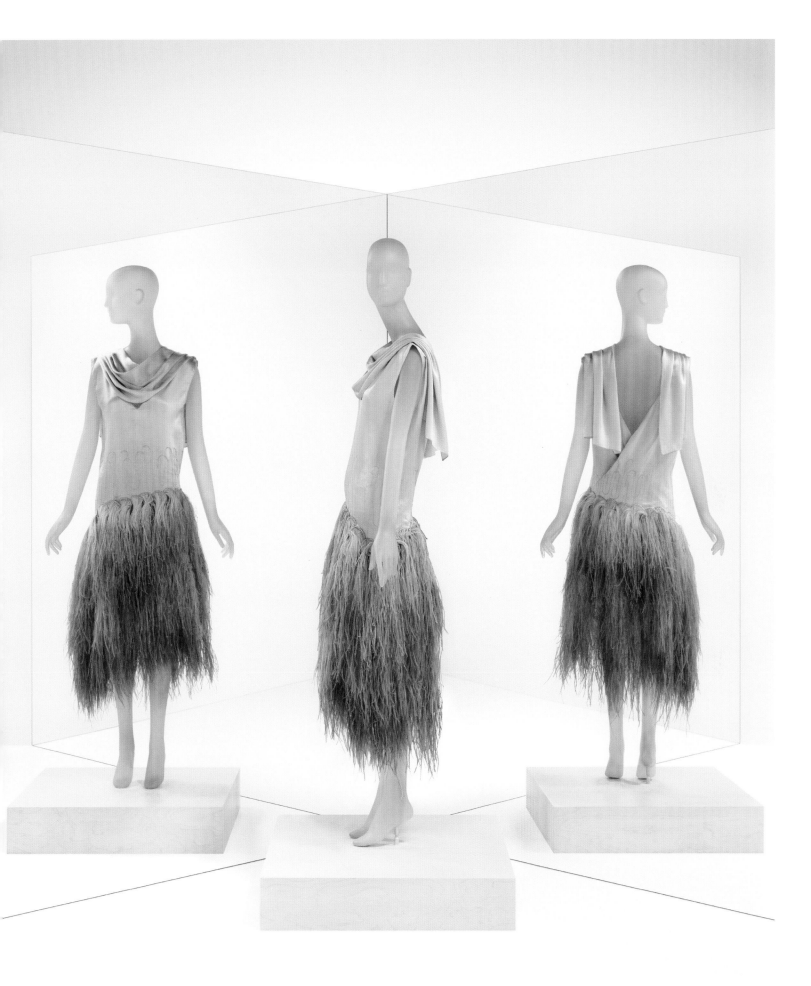

Marie-Louise Boulanger (French, 1878–1958) for LOUISEBOULANGER (French, 1923–1939)
Evening dress, 1928. Beige silk satin embroidered with natural straw, and panels of beige silk tulle embroidered with ombré-dyed beige and pink knotted ostrich plumes 105

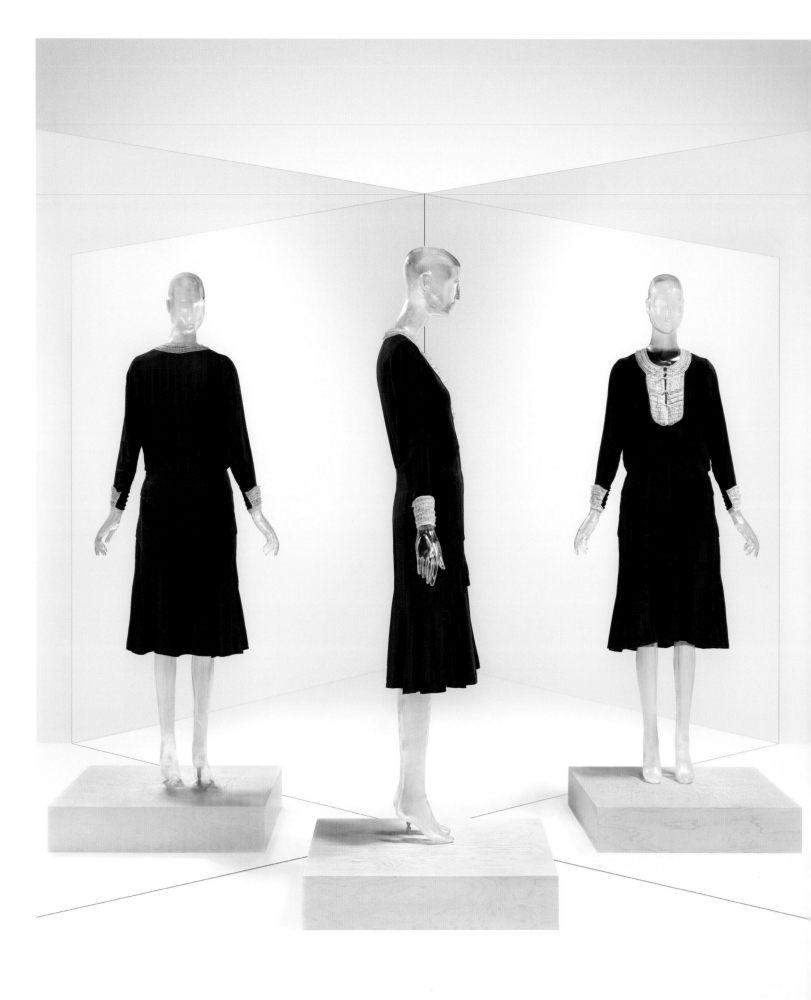

Probably *Charlotte Révyl* (French, ?–1947) for PREMET (French, ca. 1911–1932)
Dress, autumn/winter 1929–30. Black silk crepe de chine with collar, dickey, and cuffs of ivory cotton and silk tulle

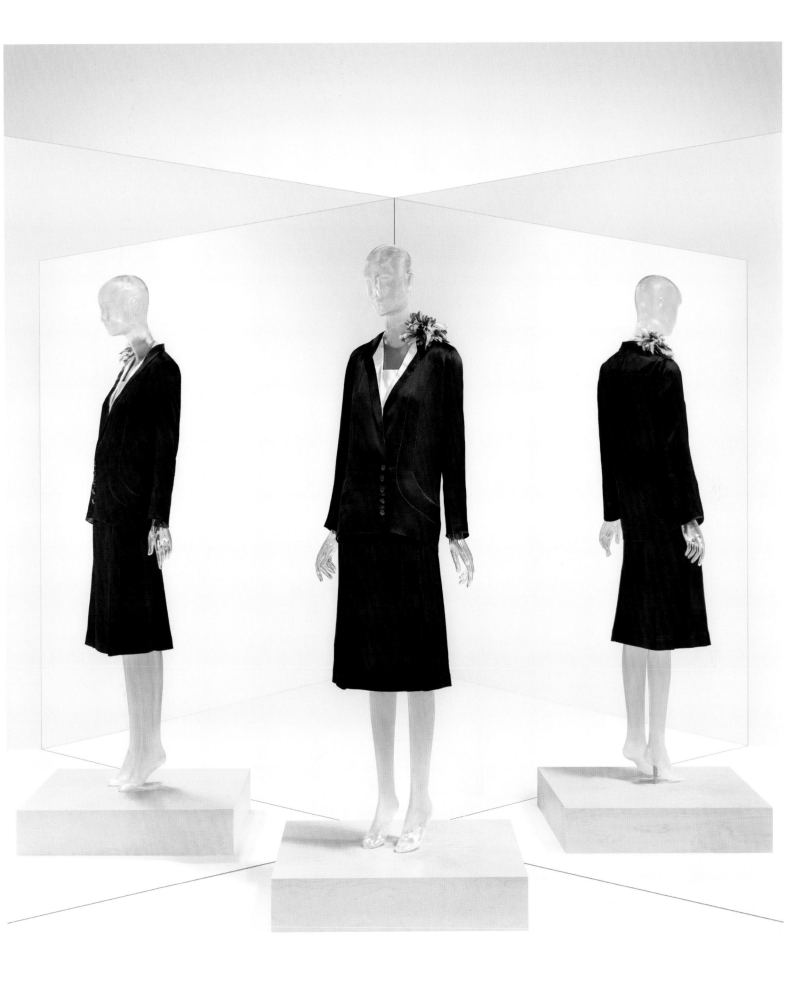

Gabrielle Chanel (French, 1883–1971) for CHANEL (French, founded 1910)
Suit, ca. 1927. Jacket, blouse, and skirt of black and ivory silk charmeuse with chrysanthemum appliqué of black and white silk chiffon

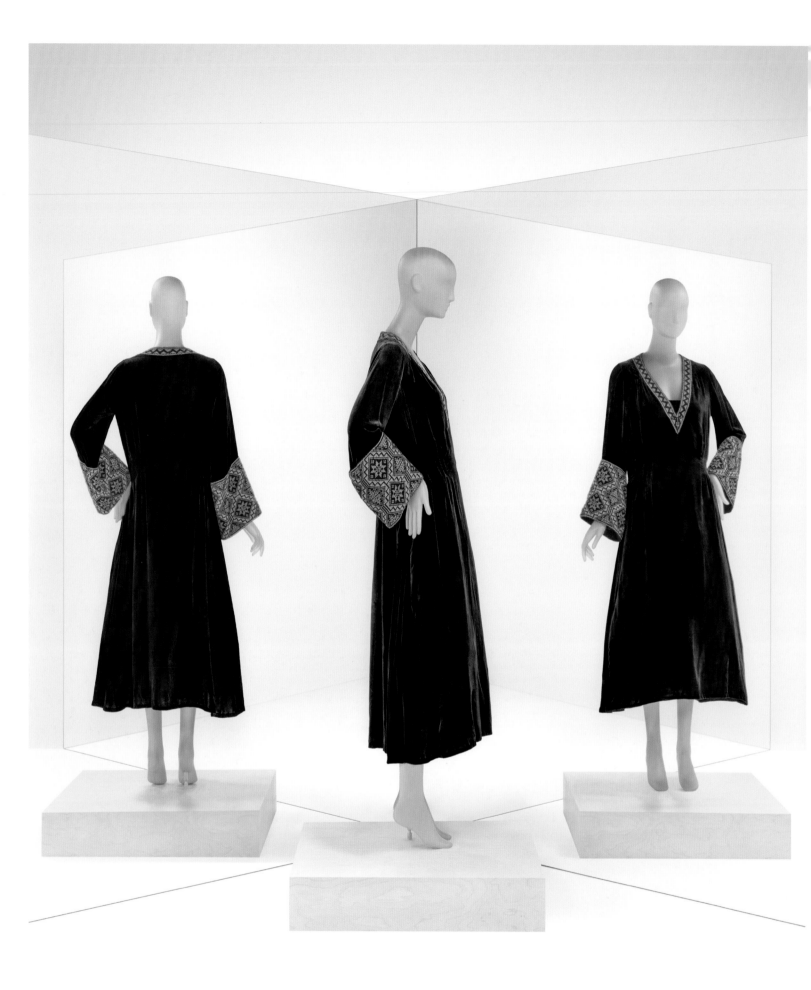

Sonia Levienne (Russian, ?) and possibly *Valentina Schlée* (Ukrainian, born Russian Empire, 1899–1989)
for CHEZ SONIA (American, active 1928–ca. 1938)
Evening dress, ca. 1928. Black silk velvet embroidered with gold and bronze metal thread

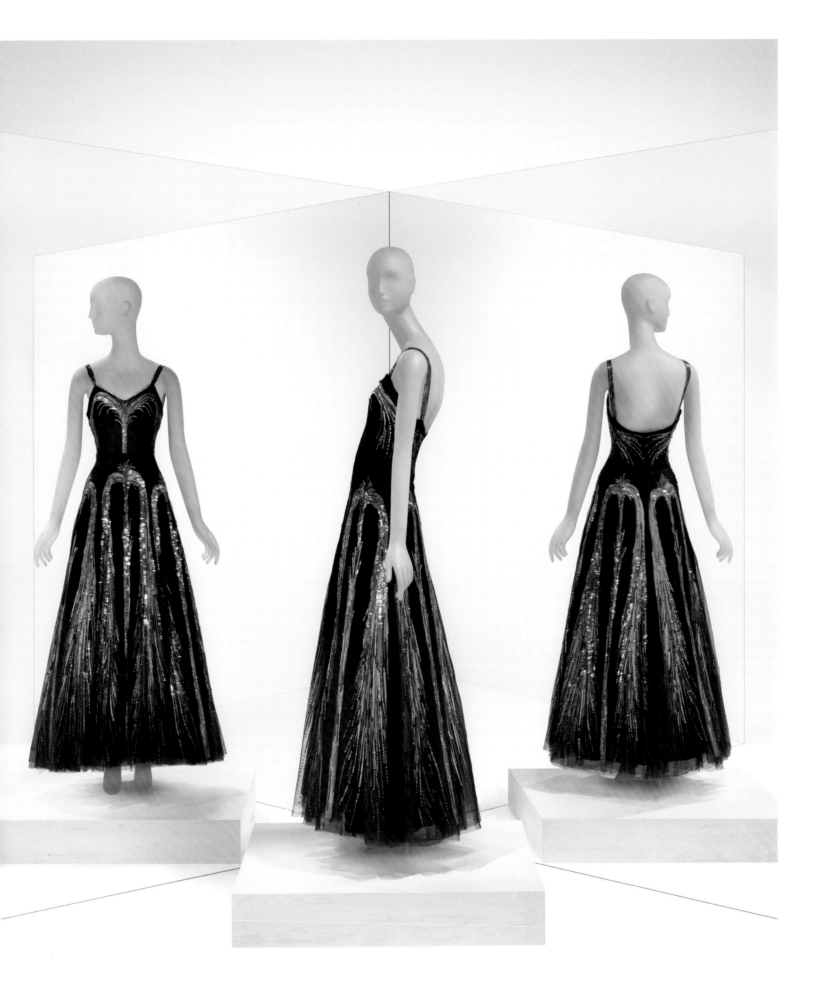

Gabrielle Chanel (French, 1883–1971) for CHANEL (French, founded 1910)
Evening dress, autumn/winter 1938–39. Black silk tulle embroidered with red, pink, gold, and silver sequin fireworks

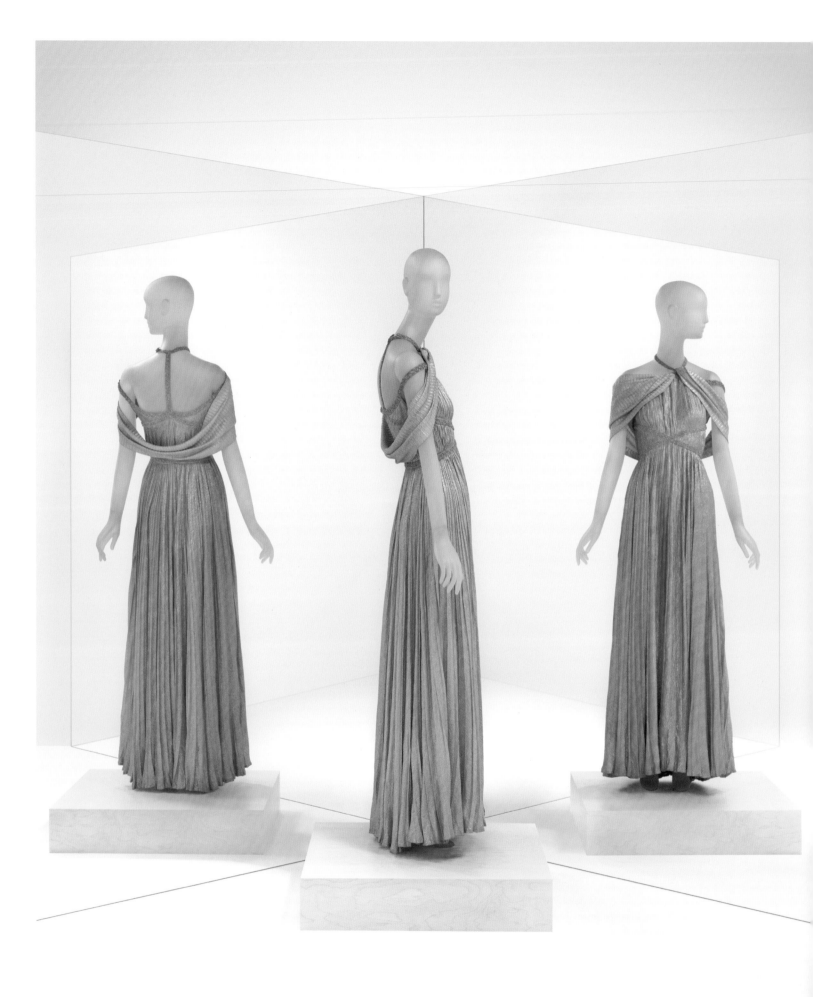

Marcelle Chapsal (French, 1891–1990) for MARCELLE CHAUMONT (French, 1940–1953)
Evening dress, autumn/winter 1948–49. Pleated gold lamé embroidered with gold metal and silk braid and beads

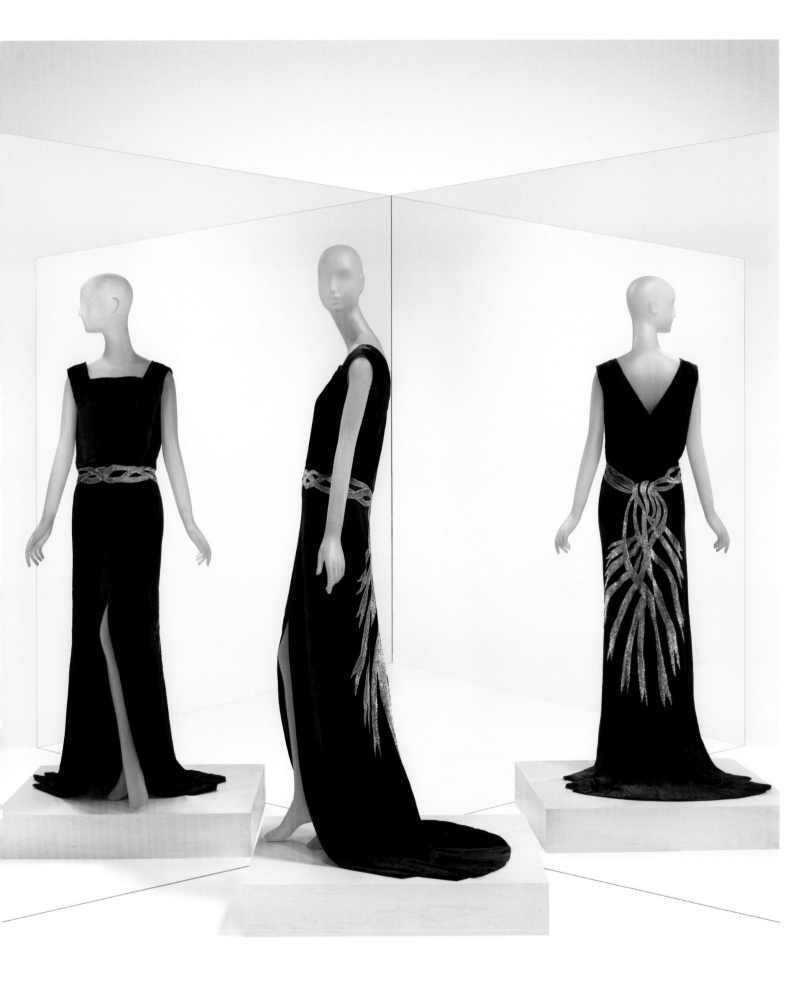

Madeleine Vionnet (French, 1876–1975) for VIONNET (French, 1912–1914; 1918–1939)
Evening dress, autumn/winter 1924–25. Dark brown silk velvet embroidered with a trompe l'oeil ribbon belt of gold metal thread and sequins

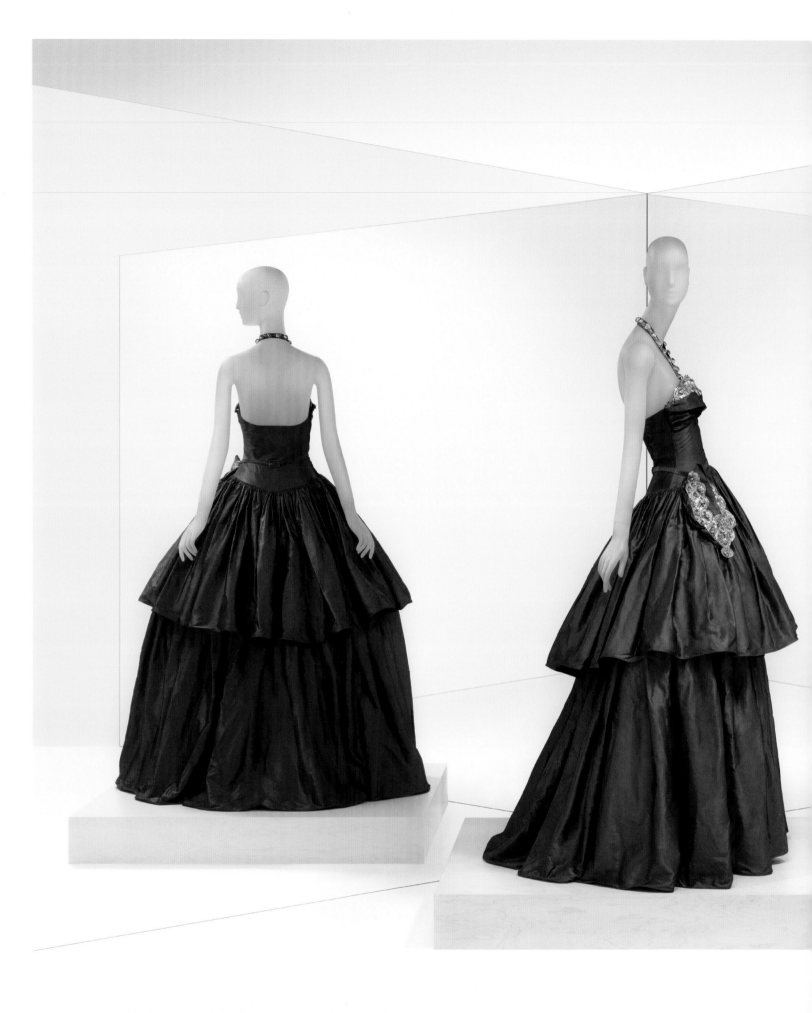

Jeanne Lanvin (French, 1867–1946) for LANVIN (French, founded 1889)
"Cyclone" evening dress, 1939. Gray silk taffeta embroidered with gold and coral sequins and beads

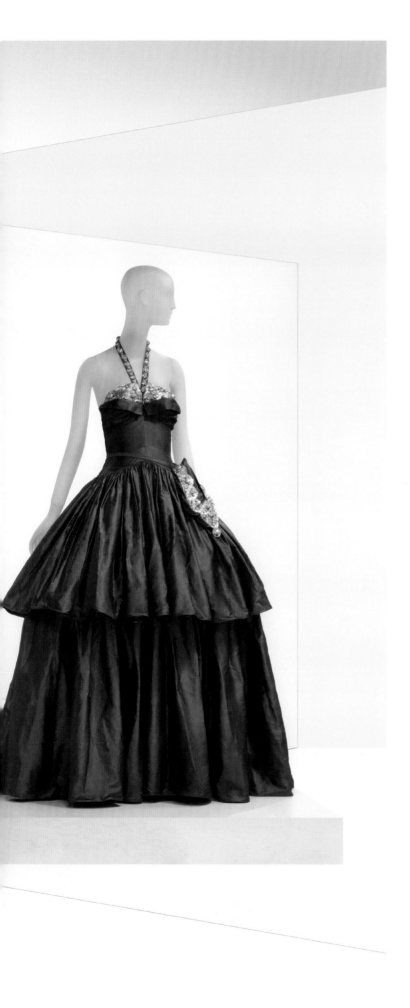

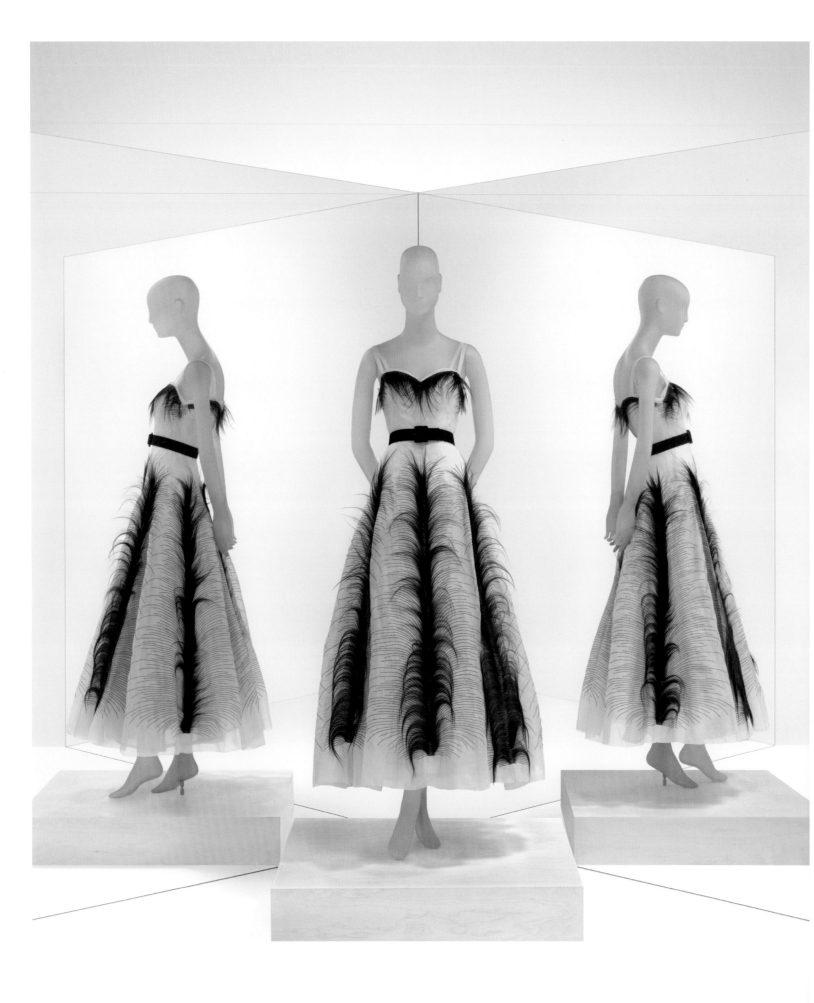

Ana de Pombo (Spanish, 1900–1985) for PAQUIN (French, 1891–1956)
Evening dress, 1938. Ivory silk organza trimmed with black colobus-monkey fur

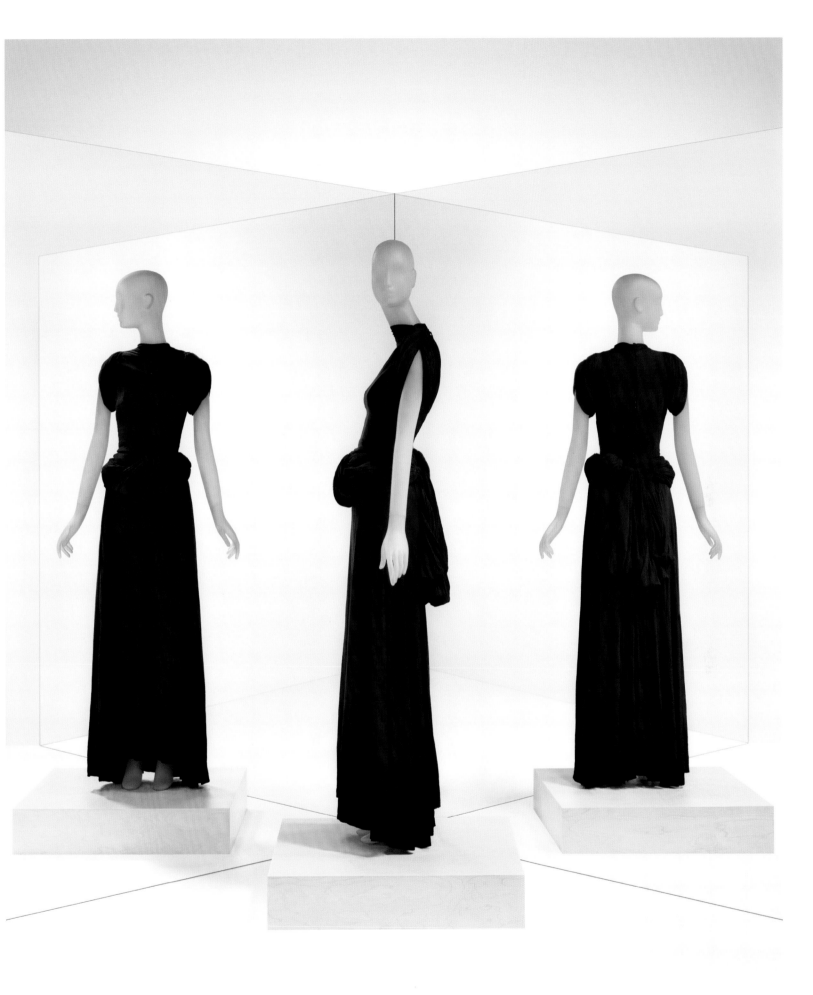

Madame Grès (*Germaine Émilie Krebs*) (French, 1903–1993) for ALIX (French, 1934–1942)
Evening dress, ca. 1936. Black silk jersey

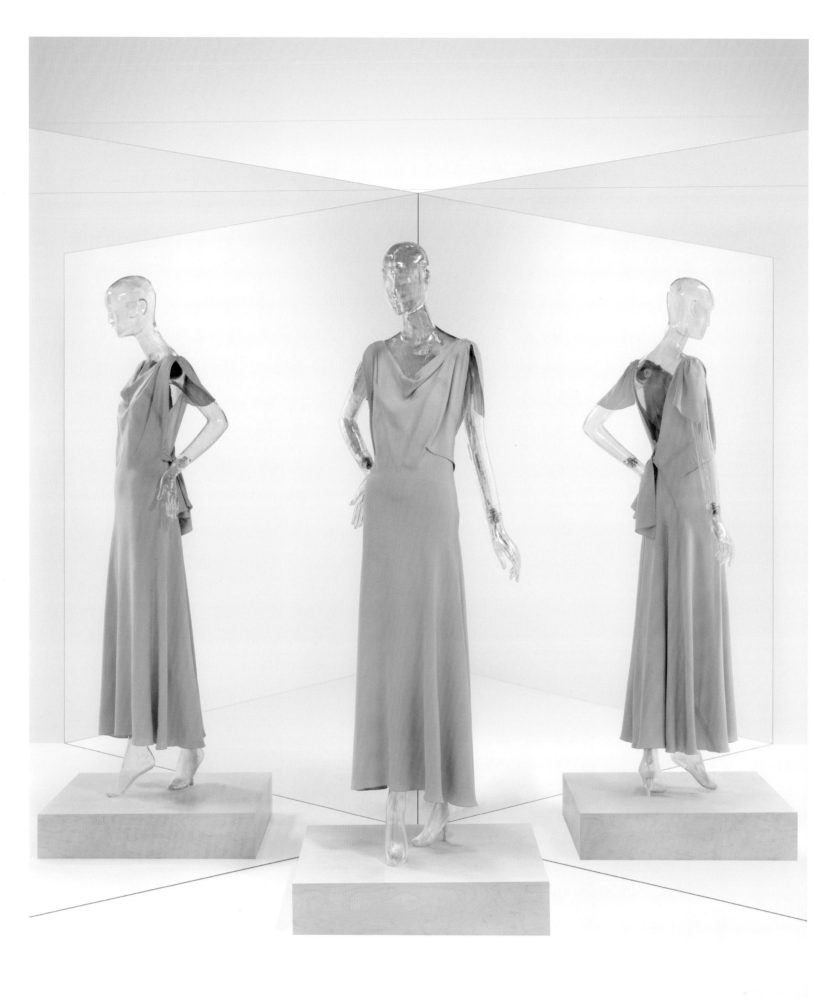

Augusta Bernard (French, 1886–1946) for AUGUSTABERNARD (French, 1923–1934)
Dress, ca. 1932. Pale pink silk crepe de chine

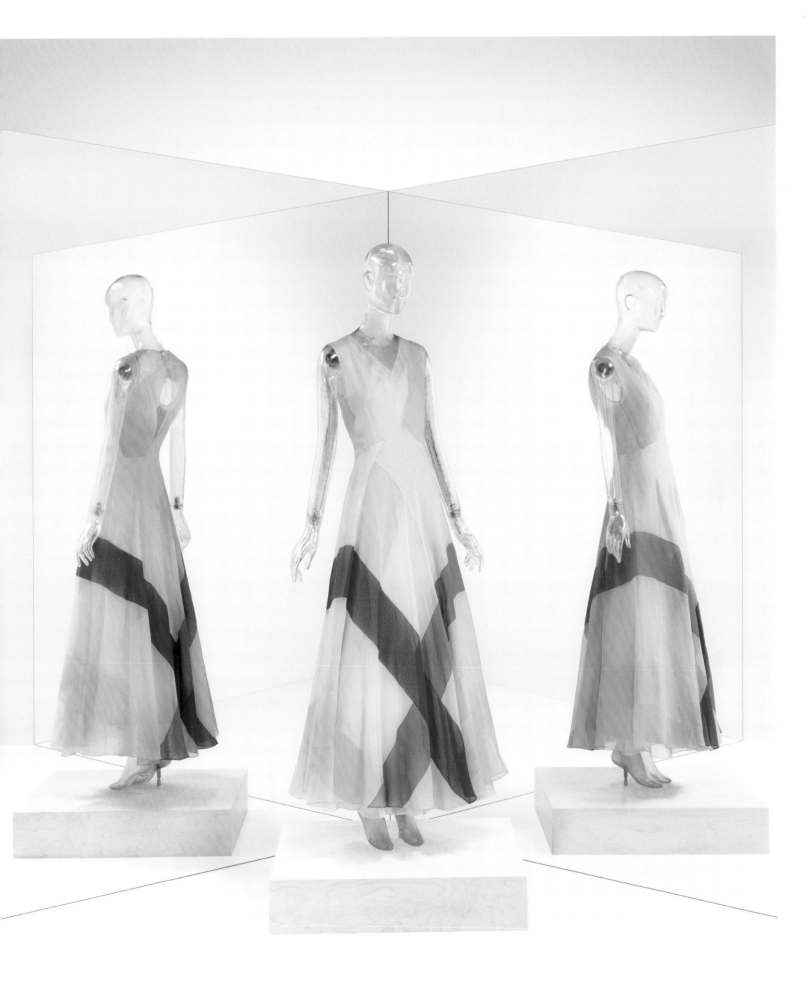

Maria "Nina" Ricci (Italian, 1883–1970) for NINA RICCI (French, founded 1932)
Evening dress, spring/summer 1937. Ivory, red, blue, pink, and green silk chiffon and ivory satin-backed crepe

117

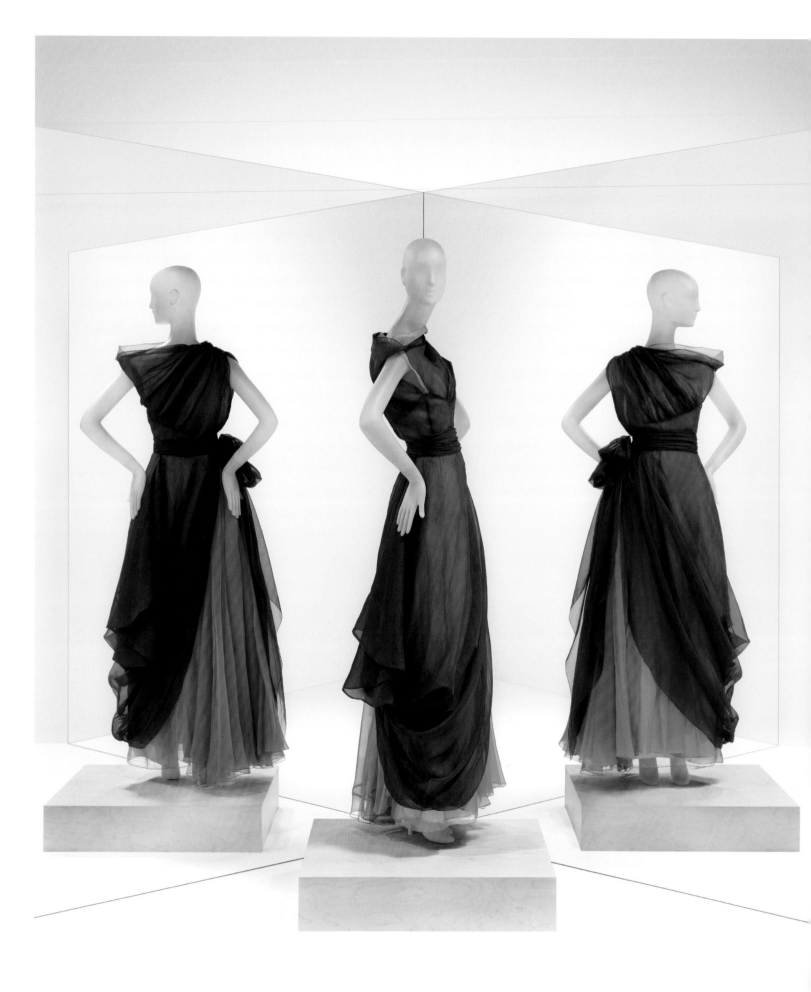

Madeleine Maltezos (French, 1900–1985) and *Suzie Carpentier* (*Adèle Clerisse*) (French, 1892–?) for MAD CARPENTIER (French, 1939–1957)

Evening dress, late 1940s. Blue-green and navy silk organdy

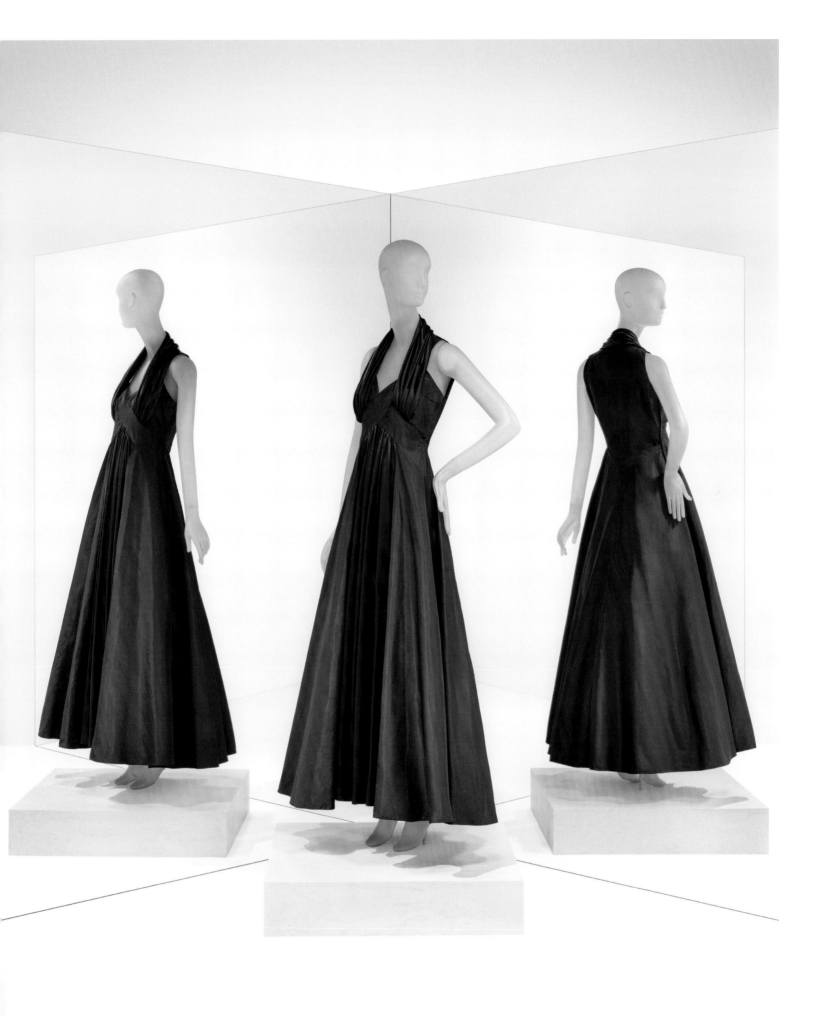

Elizabeth Hawes (American, 1903–1971) for HAWES INCORPORATED (American, 1928–1940; 1947–1948)
"The Styx" dress, autumn/winter 1936–37. Blue-green *changeante* silk taffeta and green silk satin

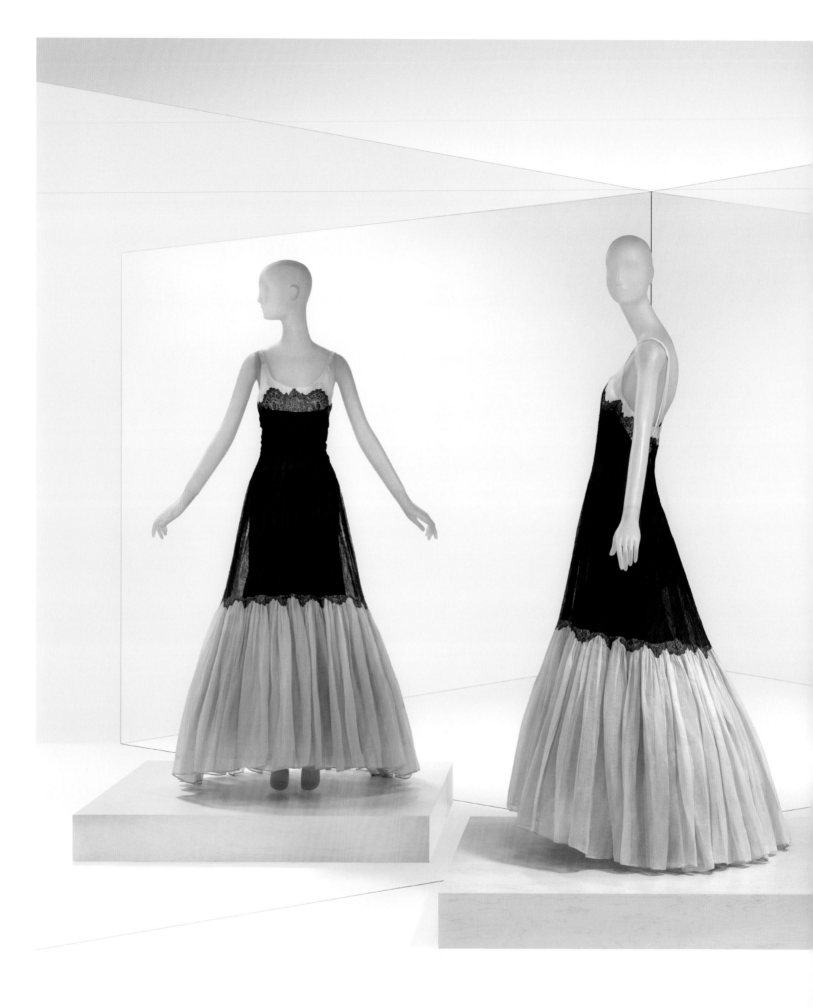

Maggy Besançon de Wagner (Belgian, 1896–1971) for MAGGY ROUFF (French, 1927–1979)
Evening dress, ca. 1936. Pale blue-green cotton organdy and black cotton lace

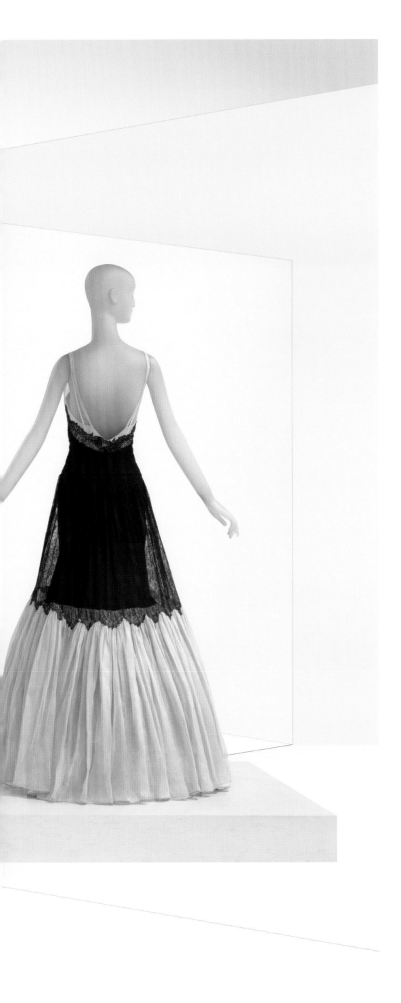

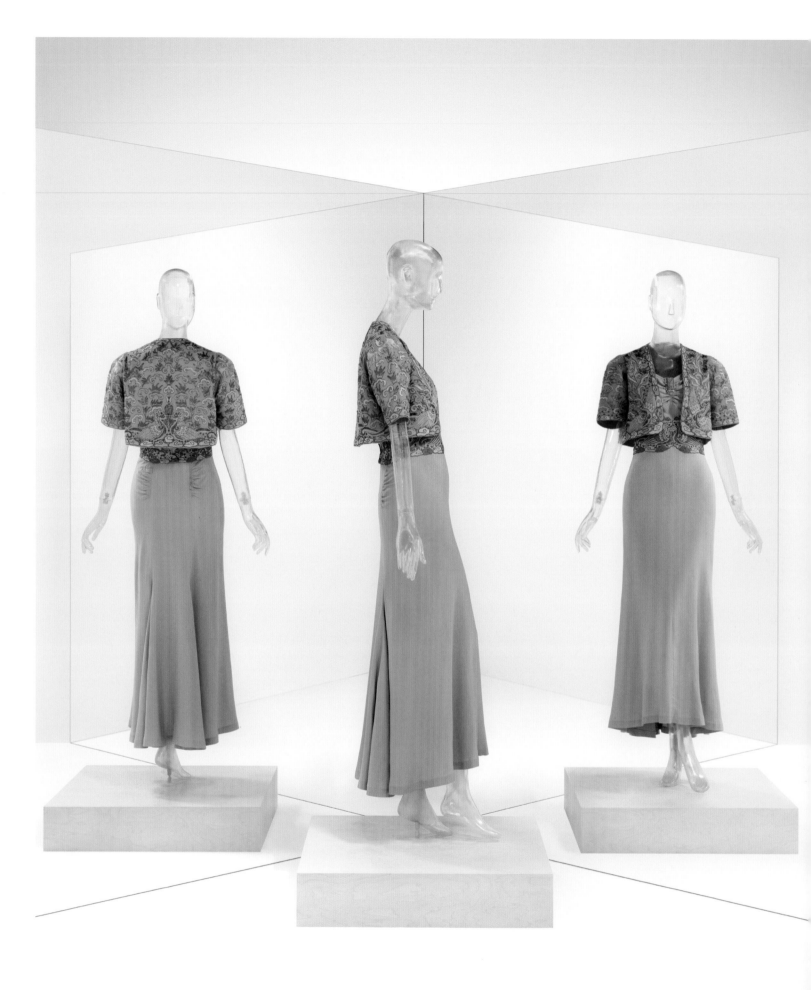

Jeanne Havet (French, ca. 1860–1948) for AGNÈS-DRECOLL (French, 1931–1963)
Evening ensemble, ca. 1932. Dress of pale green wool crepe embroidered with pale blue and cream silk and gold metal thread; dress clip of silver metal, coral, and clear gemstones; bolero of orange silk crepe embroidered with pale blue and cream silk and gold metal thread

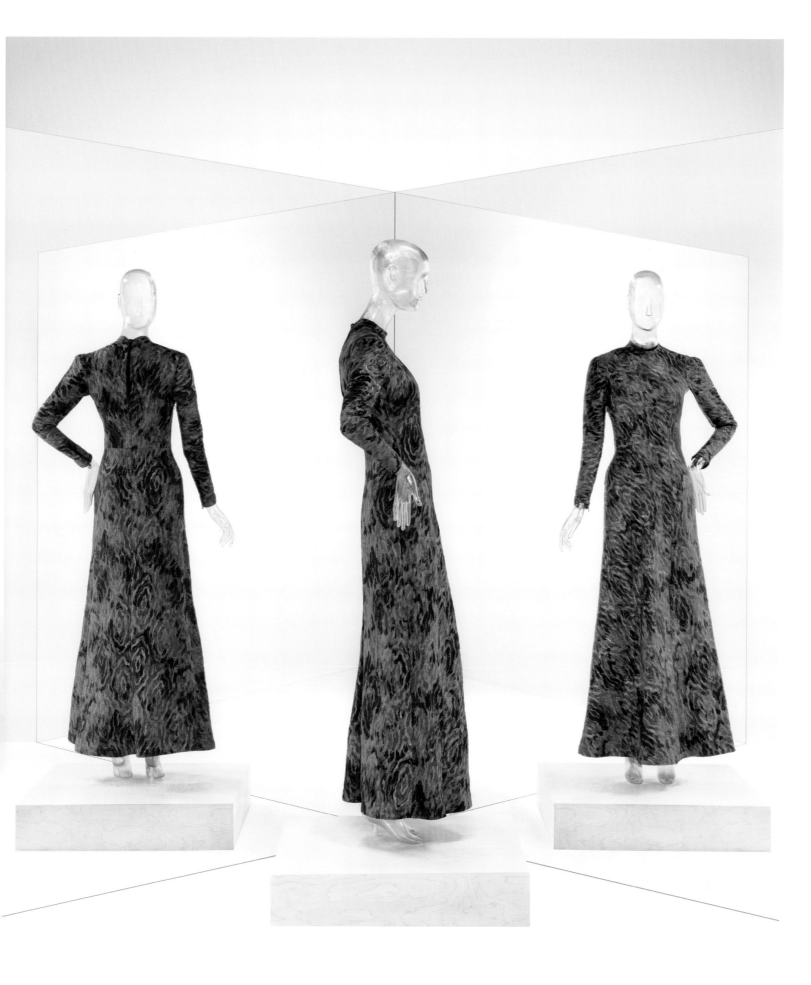

Elsa Schiaparelli (Italian, 1890–1973) for SCHIAPARELLI (French, 1927–1954)
Evening dress, autumn/winter 1937–38. Green silk faille brocaded with black, green, and iridescent gold metallic thread in a wood-grain pattern with black metal zippers 123

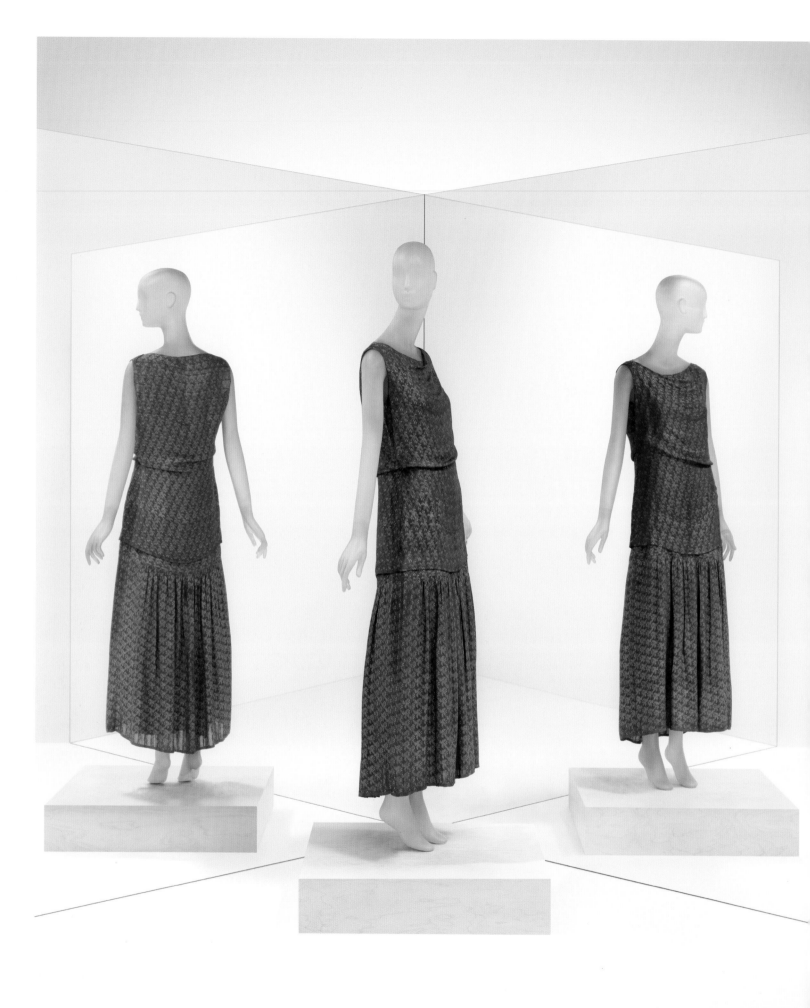

Jessie Franklin Turner (American, 1881–1956) for JESSIE FRANKLIN TURNER (American, 1923–1943)
Evening dress, ca. 1920. Brown silk chiffon brocaded with bird motifs in gold metal thread and white and orange silk

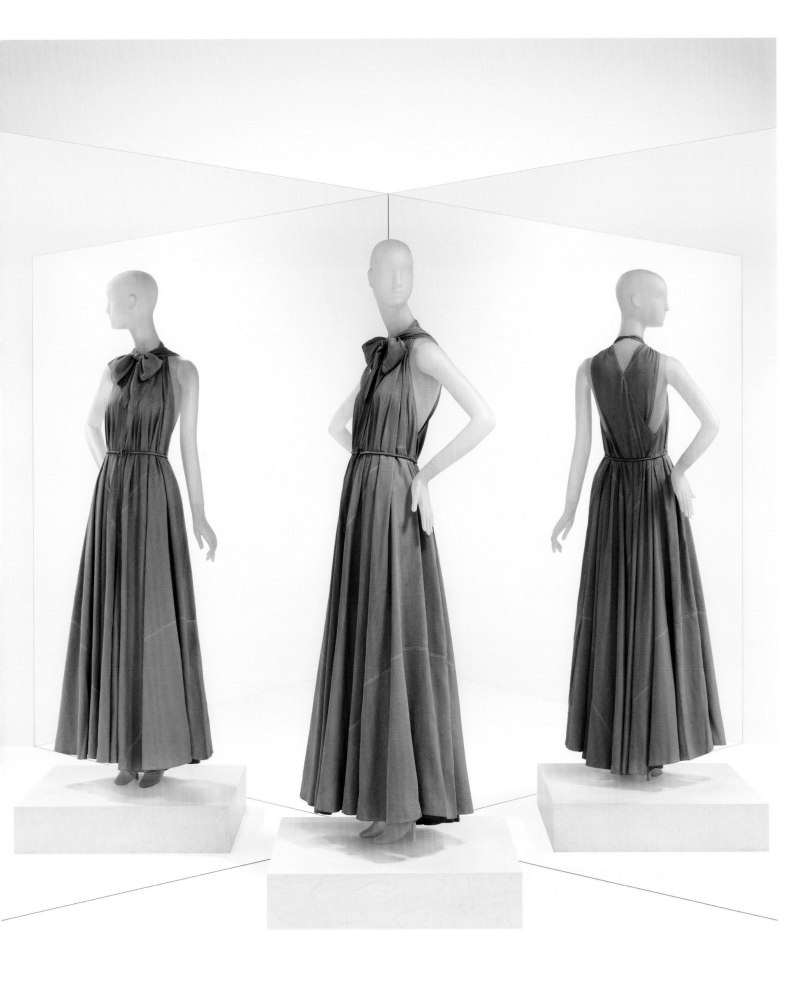

Claire McCardell (American, 1905–1958) for CLAIRE McCARDELL/TOWNLEY FROCKS (American, 1929–1938; 1940–ca. 1968)
"Future" dress, 1945. Brown silk shantung

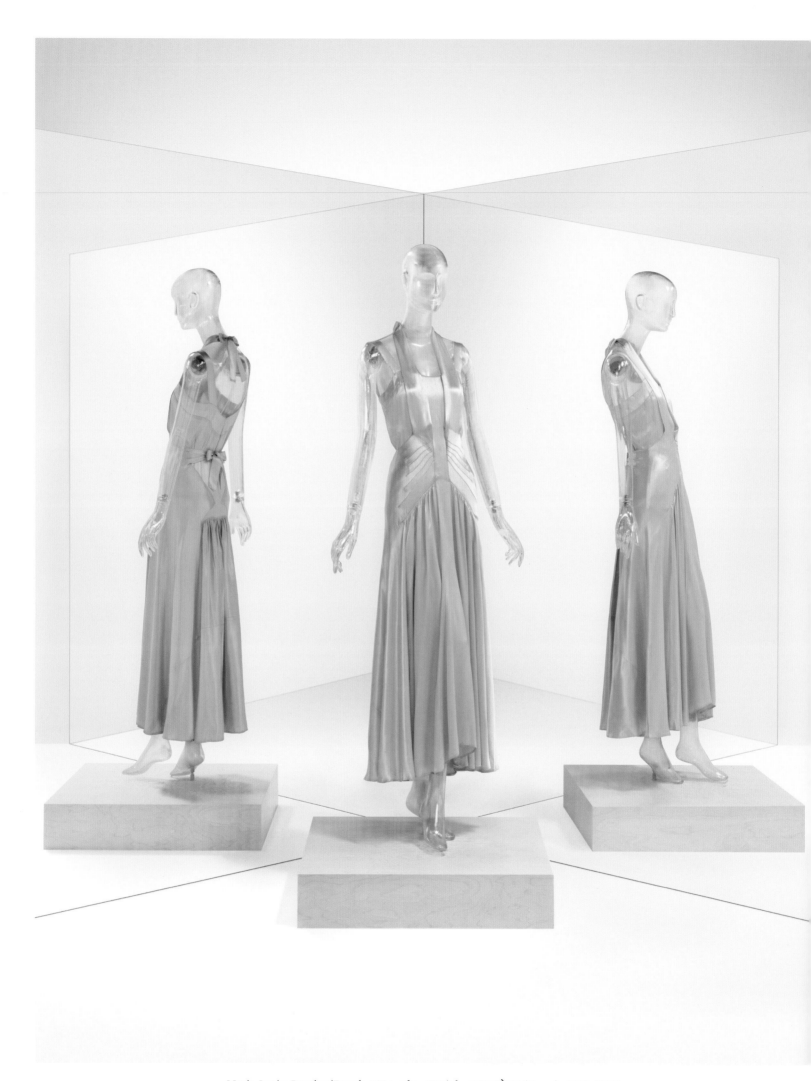

Marie-Louise Bruyère (French, 1884–after 1959) for BRUYÈRE (French, 1928–1959)
Evening dress, 1931–32. Ivory and pale pink satin rayon

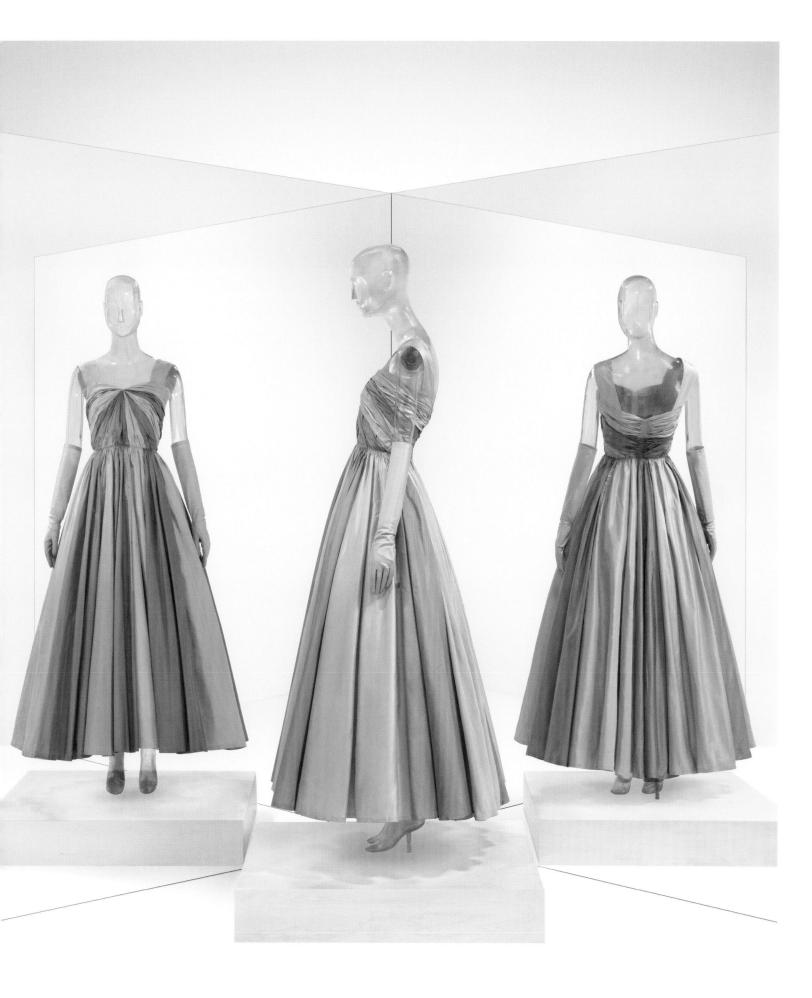

Marie-Louise Bruyère (French, 1884–after 1959) for BRUYÈRE (French, 1928–1959)
Evening ensemble, ca. 1952. Dress of pink and green striped silk taffeta; gloves of pink silk taffeta

127

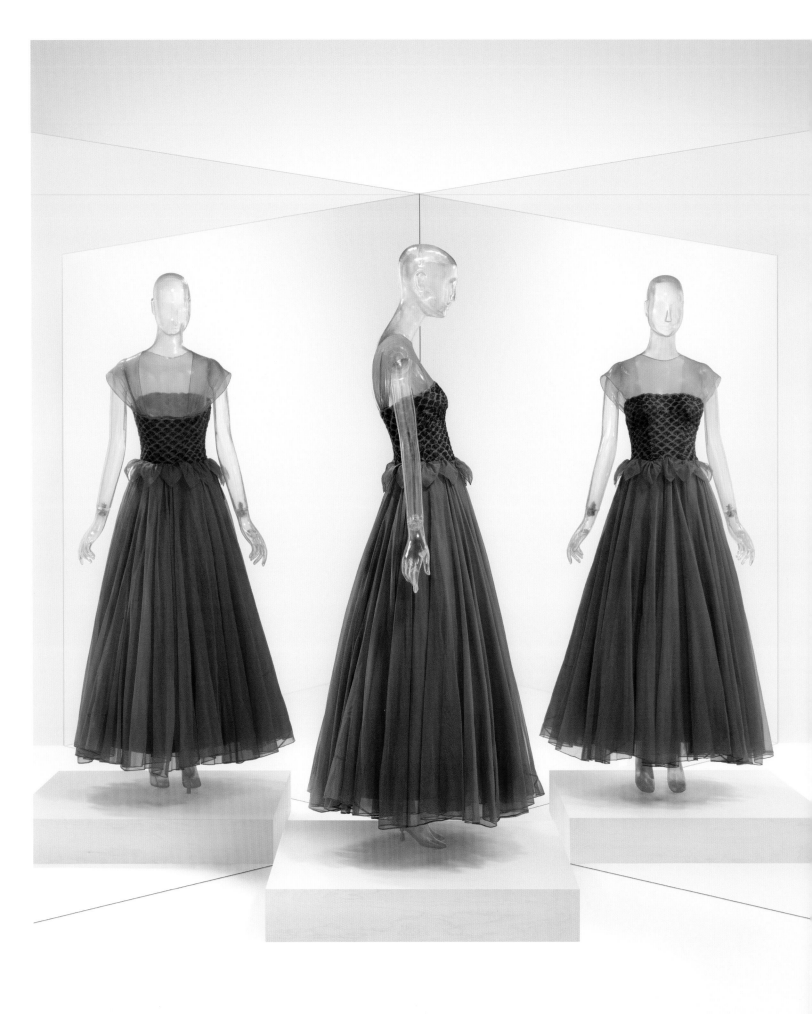

Probably *Pauline (Potter) de Rothschild* (American, 1908–1976) for HATTIE CARNEGIE (American, 1918–1965)

Evening dress, ca. 1949. Brown silk marquisette embroidered with shell motifs of silver bugle beads

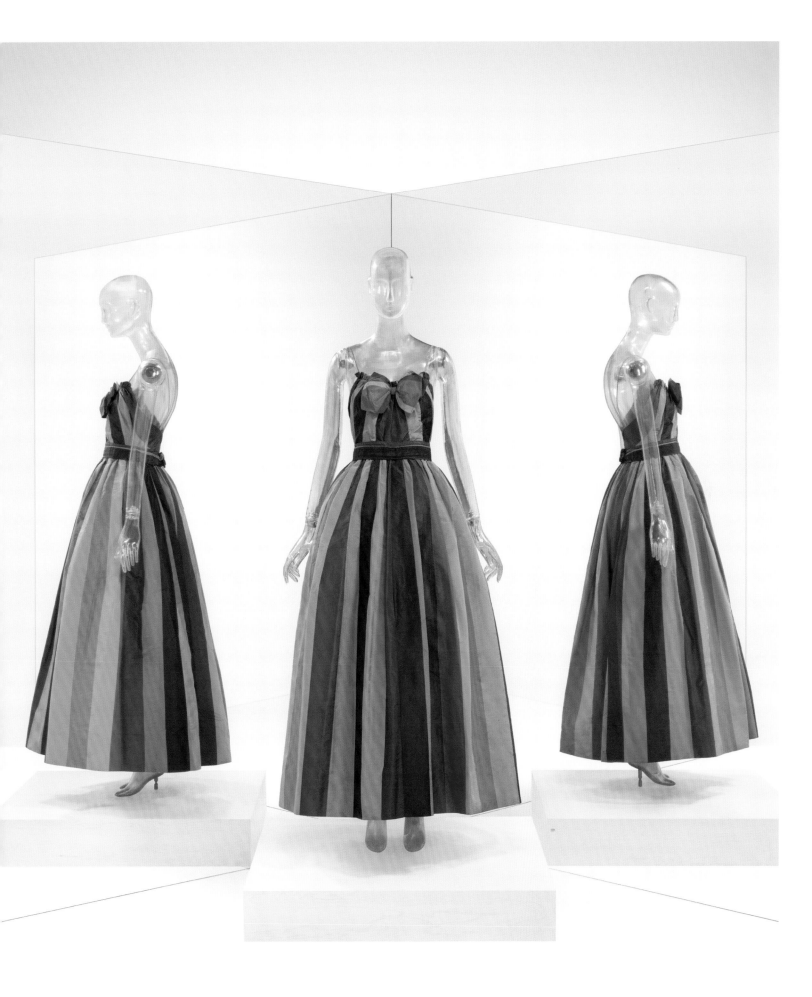

Probably *Pauline (Potter) de Rothschild* (American, 1908–1976) for HATTIE CARNEGIE (American, 1918–1965)
Evening dress, 1940–59. Polychrome striped *changeante* silk taffeta

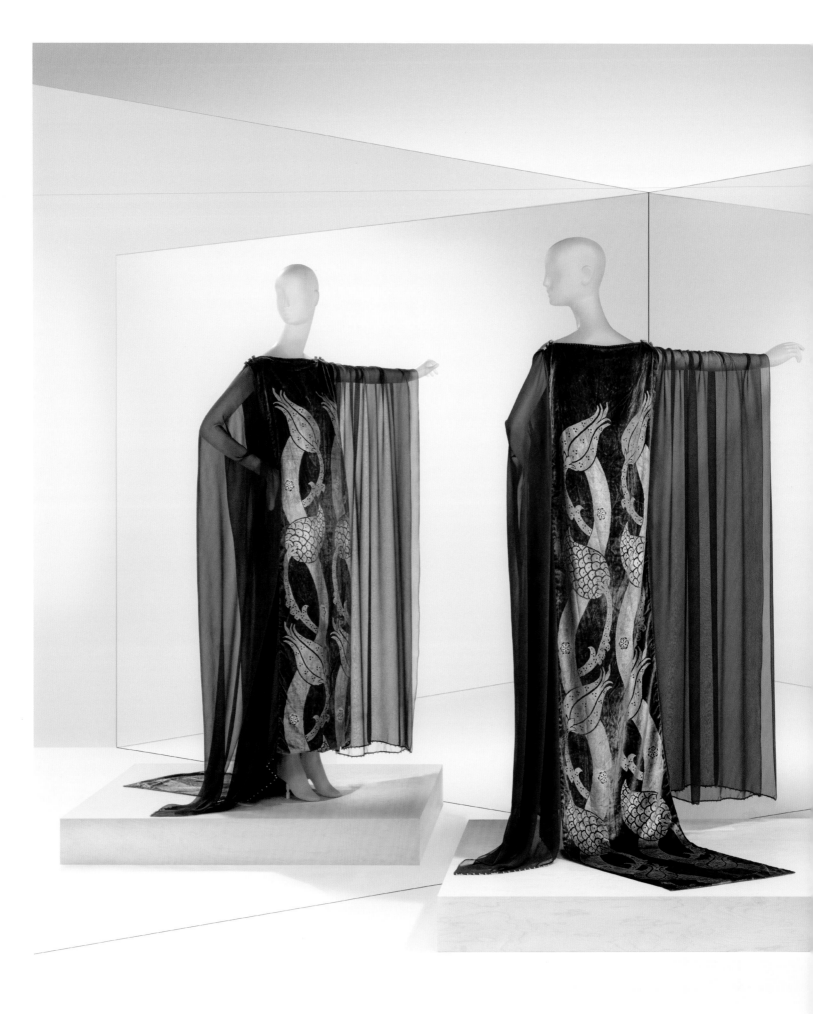

Maria Monaci Gallenga (Italian, 1880–1944) for GALLENGA (Italian, 1918–1974)
"Theodosia" tea gown, ca. 1925. Purple silk velvet printed with silver and gold metallic powder pigment;
replica sleeves of purple silk crinkle chiffon embroidered with glass beads

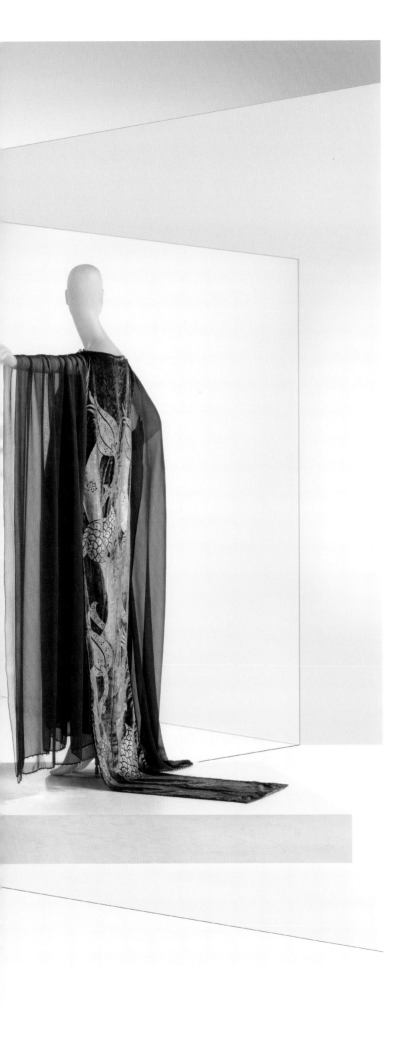

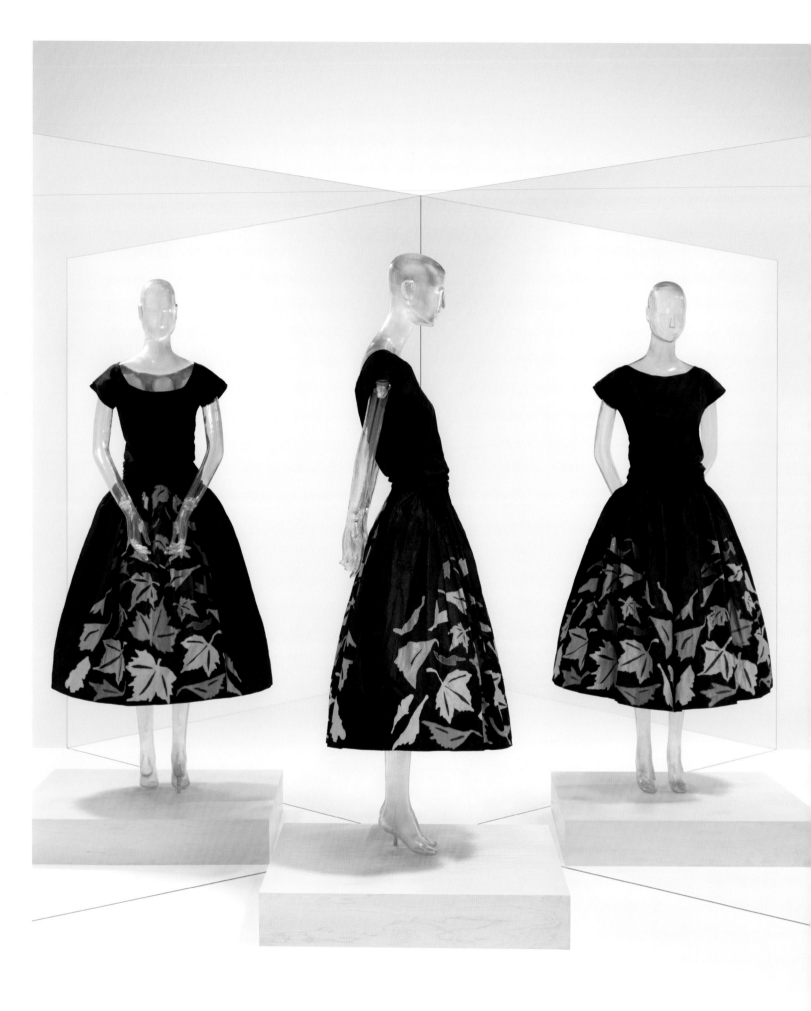

Marie Cuttoli (French, 1879–1973) for MYRBOR (French, 1922–1936)
Evening dress, 1924. Black silk taffeta embroidered with polychrome silk taffeta leaf motifs

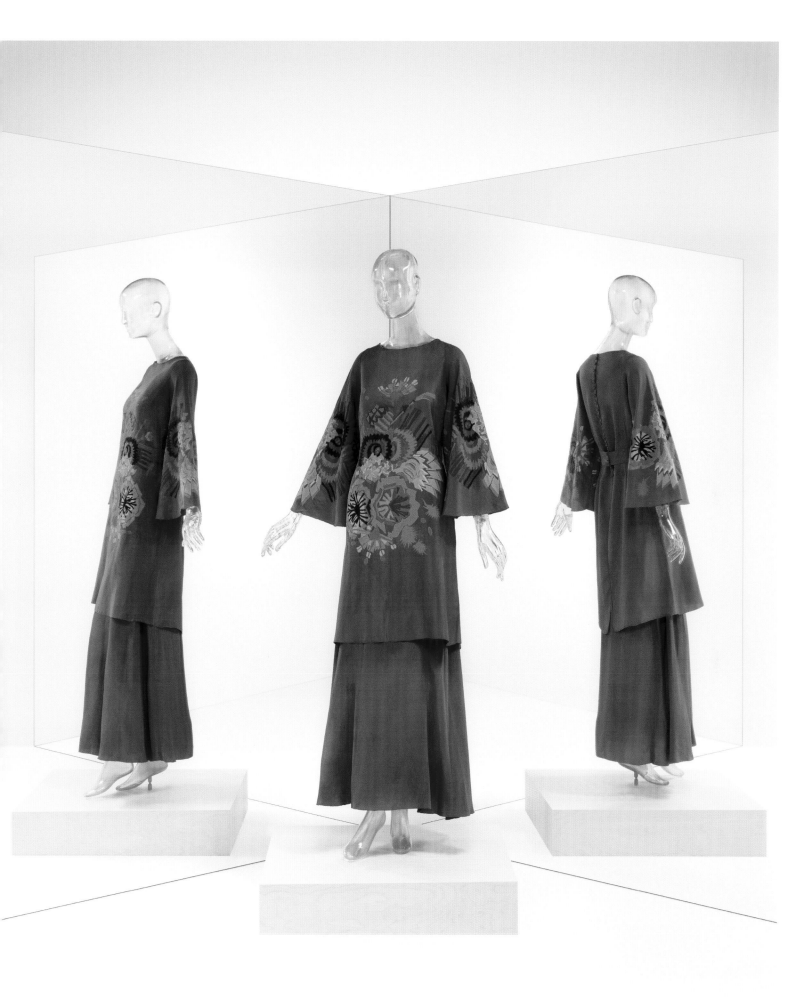

Sarah Lipska (Polish, 1882–1973) for SARAH LIPSKA (French, late 1920s–1939)
Dress, ca. 1928. Red silk crepe with floral appliqué of polychrome silk crepe

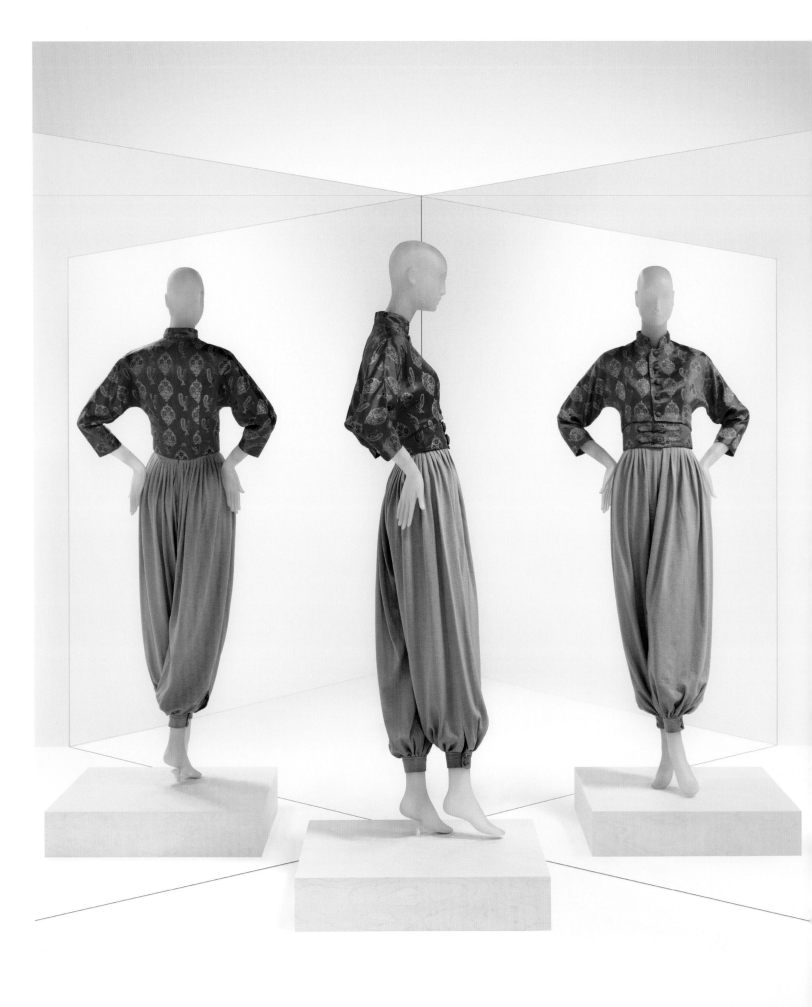

Tina Leser (American, 1910–1986) for EDWIN H. FOREMAN, INC. (American)
Lounging pajamas, 1948. Jumpsuit of gray wool jersey; bolero and belt of red rayon satin jacquard embroidered with polychrome peacock and floral motifs

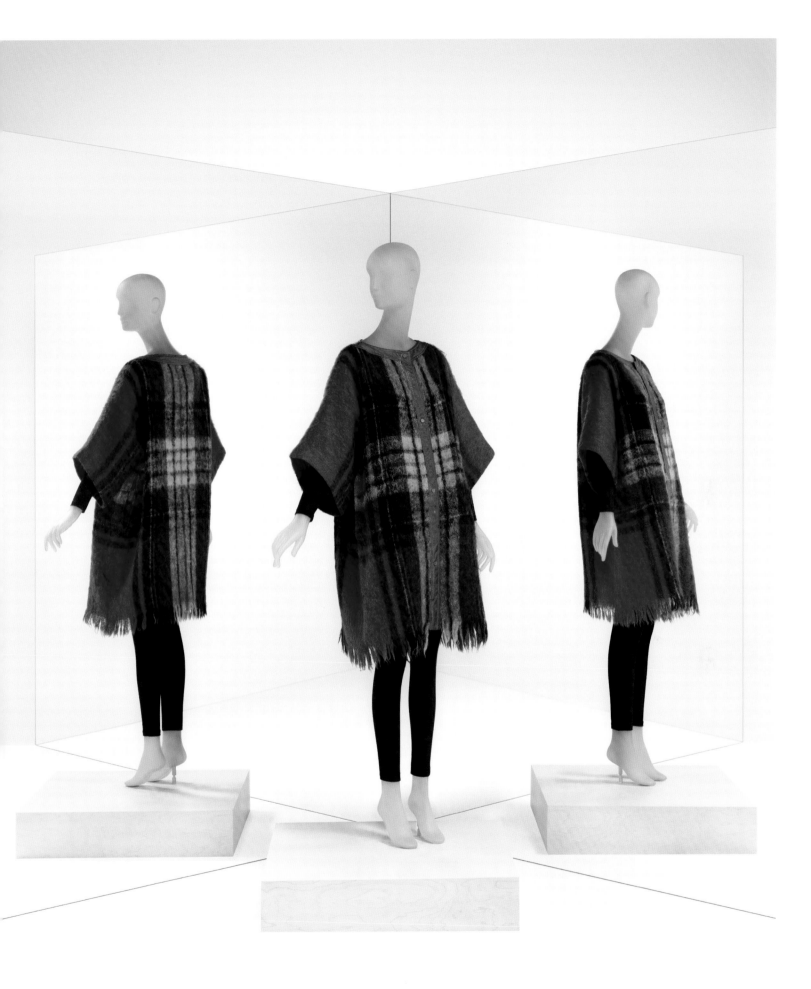

Bonnie Cashin (American, 1908–2000) for BONNIE CASHIN DESIGNS (American, 1952–1985)
Coat, 1958. Red, black, and white plaid mohair knit and red leather

AGENCY

AGENCY

AGENCY
(1968–PRESENT)
The Costume Institute Collection

Amanda Garfinkel

The Costume Institute's contemporary womenswear collection from 1968 to the present represents a period of sweeping change in fashion led by a shift in authority from haute couture to ready-to-wear. The boutique revolution of the 1960s democratized fashion by appealing to a younger generation of women who rejected the formality and expense of custom-made clothing in favor of the ease, accessibility, and affordability of ready-made garments. The boutique model presented an opportunity for female designers to bypass the manufacturers and department stores that dominated the industry in the 1950s and create fashions under their own names, selling to and interacting with their customers in cultivated environments of their own making. The demand for ready-to-wear fashions grew in the 1970s and 1980s as women joined the workforce in greater numbers. Female makers responded to the resulting need for versatility in dress with designs that reflected the changing circumstances and complexities of women's lives. Since the 1990s, a period when individuality and eccentricity were increasingly celebrated in fashion, female designers have advocated for a reconsideration of the feminine ideal.

The collection from 1968 onward consists of approximately 8,500 objects encompassing womenswear, menswear, childrenswear, and accessories, with a particular focus on women's dress from Europe, Asia, and the United States. Of the approximately 4,000 examples of women's main dress fashions in the collection, about 25 percent, or one-quarter, is attributed to female makers. Many of these garments created by women designers reveal expressions of female agency in alignment with the department's mission, first established in 1971, to emphasize fashion's relevance to contemporary life.[1]

The broad representation of female designers of the 1960s and 1970s in the collection is due in part to the creativity and foresight of female makers and their supporters and attests to the bold and independent spirit of the period. Diana Vreeland, former editor in chief of *Vogue* magazine and fashion editor at *Harper's Bazaar*, was appointed special consultant to the department in 1972. Along with colleagues Stella Blum and Jean Druesedow, Vreeland was instrumental in the acquisition of countercultural fashions and initiated a collecting campaign, drawing from her relationships with established haute couture houses and clients, as well as designers and buyers of boutique and ready-to-wear fashions, that increased annual donations by the hundreds. While the steadfast generosity of museum donors including Jayne Wrightsman, Pauline de Rothschild, and Bernice Chrysler Garbisch continued to bolster the department's couture holdings, the team targeted contemporary works by emerging designers that reflected the rapid cultural changes and artistic developments of the period. Vreeland solicited the donation of two works by and from British designer Zandra Rhodes from her first collection in 1968 (p. 143). A significant gift from Jane Holzer, dubbed *New York* magazine's "Girl of the Year" in 1964, included examples by boutique designers Betsey Johnson for Paraphernalia (p. 142), Thea Porter, and Alice Pollack for Quorum. In 1979 actress Lauren Bacall donated a group of

more than one hundred pieces from the period including designs by the French *créatrices*, or ready-to-wear designers, Sonia Rykiel (p. 147) and Jean Muir. Additional acquisitions made directly from designers Bonnie Cashin, Norma Kamali, and Hanae Mori (p. 149) and donations of work by Mary Quant, Barbara Hulanicki for Biba (p. 144), and Diane von Furstenberg demonstrated the growing influence of the female perspective on everyday fashion.

Exhibition development became an important driver of acquisitions in the 1980s. The department presented *The World of Balenciaga*, its first exhibition focusing on the achievements of a single designer, in 1973 (March 23–June 30). It presented its first monographic exhibition on a living designer, *Yves Saint Laurent: 25 Years of Design*, in 1983–84 (December 14–September 2), and its first on a female designer, *Madame Grès*, in 1994 (September 13–November 27). The Grès exhibition consisted of thirty-four examples from the department's existing collection supplemented by purchases and over thirty loans—later donations—from dedicated collectors. Grès, whose career in Paris spanned the 1930s through the late 1980s, is the most well-represented female designer in the department's contemporary collection. The archive of over three hundred garments—all variations on her classical- and Eastern-inspired designs made by manipulating fabric directly on the body—demonstrates the artistry and consistency of her vision. Her broad influence extended to the work of Japanese designer Rei Kawakubo, who presented her first collection in Paris in 1981 with avant-garde designs that redefined notions of fashionability; she became the subject of the department's next monographic exhibition dedicated to a female maker, *Rei Kawakubo/Comme des Garçons: Art of the In-Between* (May 4–September 4, 2017). Kawakubo is the third most represented female designer in the collection and, like Grès, has established a successful and enduring career without yielding to fashionable trends and conventions. Intergenerational dialogue between female designers across time inspired the department's 2012 exhibition, *Impossible Conversations: Schiaparelli and Prada* (May 10–August 19), which drew parallels between the work of Italian designers Elsa Schiaparelli and Miuccia Prada, both known for their works confronting norms of taste, beauty, and femininity in fashion. Exhibitions like these foster long-term relationships with designers and cultivate opportunities to expand the collection. Kawakubo (p. 158) and Prada (p. 159) made significant gifts to the department in the years following their exhibitions, greatly enhancing our holdings of their work.

Thematic exhibitions since the 1990s have concentrated on key developments in fashion with a particular focus on its ability to reflect changing mores and ideals. The exhibitions *Infra-Apparel* (April 1–August 8, 1993), *Bare Witness* (April 2–August 8, 1996), and *Extreme Beauty: The Body Transformed* (December 6, 2001–March 3, 2002) responded to fashion's relationship to the female body. In the 1960s and 1970s, ready-to-wear introduced standardized sizing to a generation of women accustomed to the rigid structure and idealized proportions of custom-made garments. As the dictates of fashion and the conventions of propriety and modesty relaxed over time, makers and wearers subverted notions of the feminine ideal by experimenting with the exposure of the body and its silhouette. Acquisitions displayed in the exhibitions by Grès, Vivienne Westwood (p. 151) (the second most represented female designer in the contemporary collection, many pieces created in collaboration with her former business and romantic partner Malcolm McLaren), and Kawakubo promoted a sense of bodily agency and encouraged women to use fashion as a medium of self-expression and determination. The exhibition *Manus x Machina: Fashion in the Age of Technology* (May 5–September 5, 2016), which explored the effects of technological advancements on design, prompted the acquisition of five works by Iris van Herpen. Her cross-disciplinary collaborations with artists, architects, scientists, and engineers produce designs that suggest the phenomenal evolution of the female body.

Assessments of the department's holdings for exhibitions often reveal gaps in the archive. A review of acquisitions made in the 1990s for the exhibition *Our New Clothes: Acquisitions of the 1990s* (April 6–August 22, 1999) prompted the donation of six works by and from Ann Demeulemeester (p. 155), a designer previously unrepresented in the collection. An early proponent of deconstruction, Demeulemeester introduced silhouettes inspired in part by the sober forms and colors of menswear. Her work offered women an alternative to the often superficial and erotically charged expressions of femininity advanced by the industry. Although Costume Institute exhibitions traditionally focus on womenswear, *Bravehearts: Men in Skirts* (November 4, 2003–February 8, 2004) and *Camp: Notes on Fashion* (May 9–September 8, 2019) explored expressions of gender fluidity in dress and led to acquisitions of representative works by Anna Sui as well as JiSun Park and KyuYong Shin of Blindness.

The Costume Institute's recent exhibitions *About Time: Fashion and Duration* (October 29, 2020–February 7, 2021) and the two-part show *In America* (September 18, 2021–September 5, 2022) presented sweeping time lines and histories of fashion from the nineteenth century to the present. The planning of both revealed weaknesses in the department's holdings of 1970s and 1980s ready-to-wear, subsequently filled by acquisitions that reflected the simplicity, practicality, and adaptability of women's dress during those decades. The most significant was a donation from Donna Karan consisting of eleven components of her "Seven Easy Pieces" collection, a modular system of dress that suited the lifestyle of modern women during the period. *In America* included galleries highlighting the work of emerging designers prioritizing contemporary issues related to community, representation, and sustainability. Acquired works from the exhibition by rising female designers including Hillary Taymour of Collina Strada (p. 172) and Jamie Okuma (p. 169) promoted the conscious creation of fashion and represented a legacy of empowerment through practice established by their predecessors.

Solicited and unsolicited donations from women working in the fashion industry who had special access to makers and knowledge of fashion's artistic significance constitute a large share of the contemporary collection. Model Alva Chinn, retailer and designer Stella Ishii, designer Patricia Pastor, personal assistant Faye Robson, collector Sandy Schreier, studio manager Minori Shironishi, studio liaison Nancy Talcott, and journalists Rosamond Bernier, Holly Brubach, Amy Fine Collins, Mary Ann Crenshaw, and Amy Spindler, among others, dedicated their careers to expanding the discourse of fashion. They redoubled their commitment to the discipline by ensuring the preservation of their collections as a record of their contributions to the field and the achievements of the designers they admired.

The fashions highlighted in the following plates represent the work of female designers during a period of accelerated change and increased opportunity in the fashion industry. Boutique culture expanded female makers' access to creative and economic agency, while the emergence of ready-to-wear introduced a system of design in accord with women's evolving lifestyles and increasing independence. The artistic achievements of female makers, including their reconsiderations of the figure and reinterpretations of the feminine ideal, became an increasing focus of fashion design and scholarship. Works by female designers that foreground broad and diverse expressions of identity and experience, ethical modes of production, and creative collaboration remain a priority in the ongoing development of the contemporary collection.

1 Harold Koda and Jessica Glasscock, "The Costume Institute at the Metropolitan Museum of Art: An Evolving History," in *Fashion and Museums: Theory and Practice*, ed. Marie Riegels Melchior and Birgitta Svensson (London: Bloomsbury, 2014).

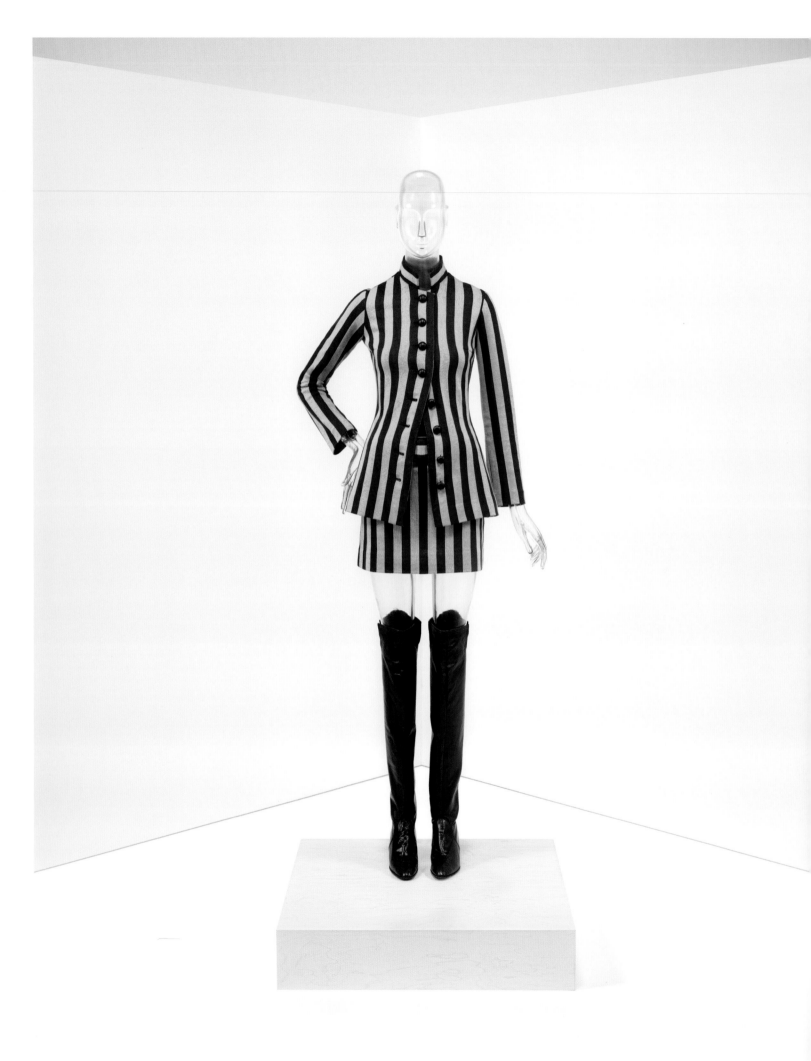

Betsey Johnson (American, born 1942) for PARAPHERNALIA (American, 1965–late 1970s)
Ensemble, 1966. Skirt suit of yellow and dark brown striped cotton knit

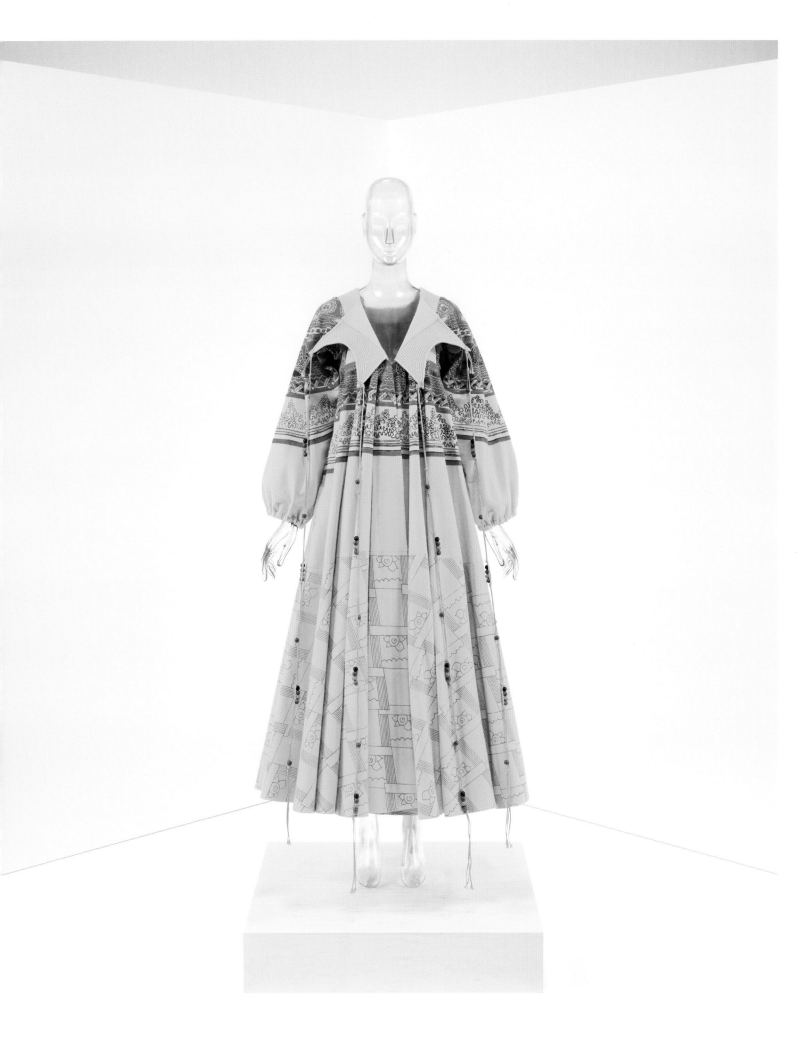

Zandra Rhodes (British, born 1940) for ZANDRA RHODES (British, founded 1969)
Coat, 1968–69. Yellow wool felt, screen printed with "The Knitted Circle" and "Diamonds and Roses" patterns in black and red

143

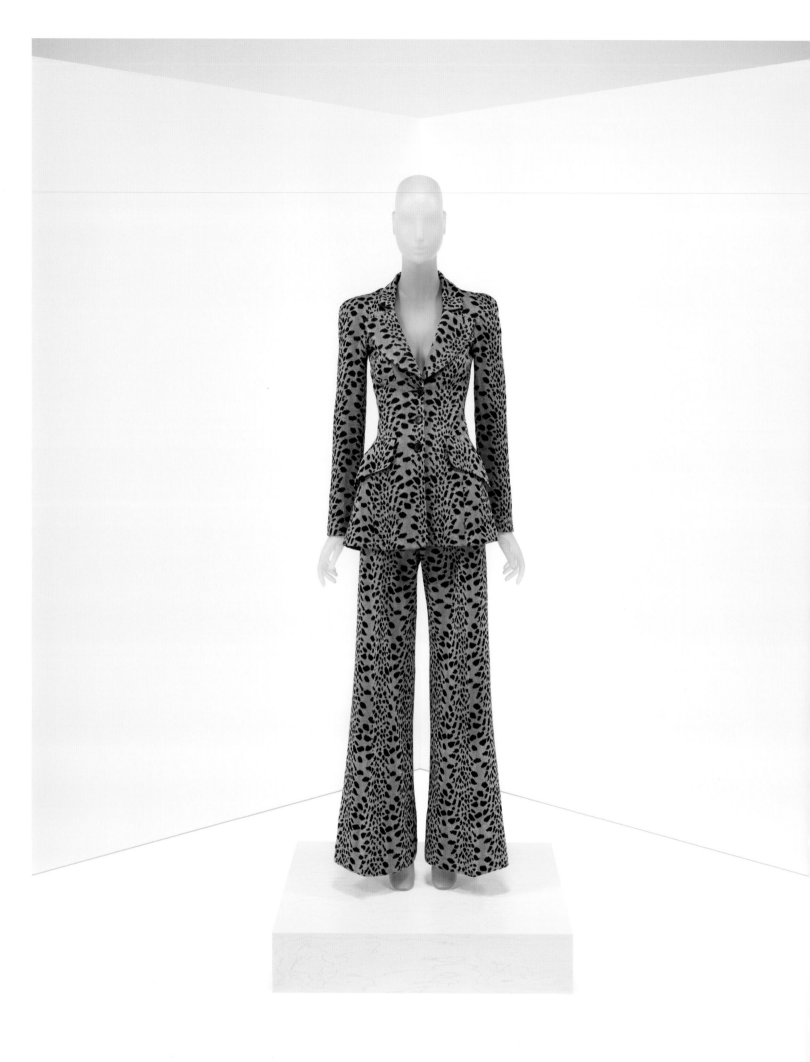

Barbara Hulanicki (Polish, born 1936) for BIBA (British, 1963–1975)
Suit, ca. 1972. Brown and black polyester and gold metal knit jacquard with leopard-print motifs

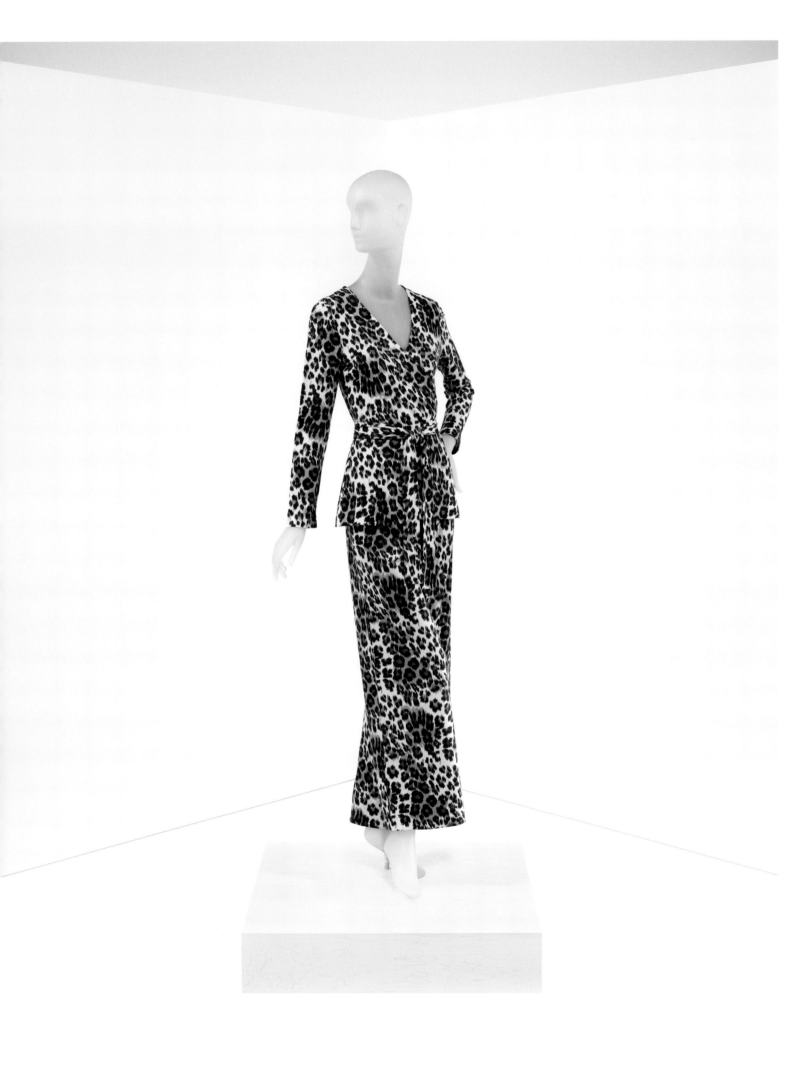

Diane von Furstenberg (American, born Belgium, 1946) for DIANE VON FURSTENBERG (American, founded 1972)
Ensemble, ca. 1970–79. Blouse and pants of brown, white, and black leopard-print cotton-rayon knit

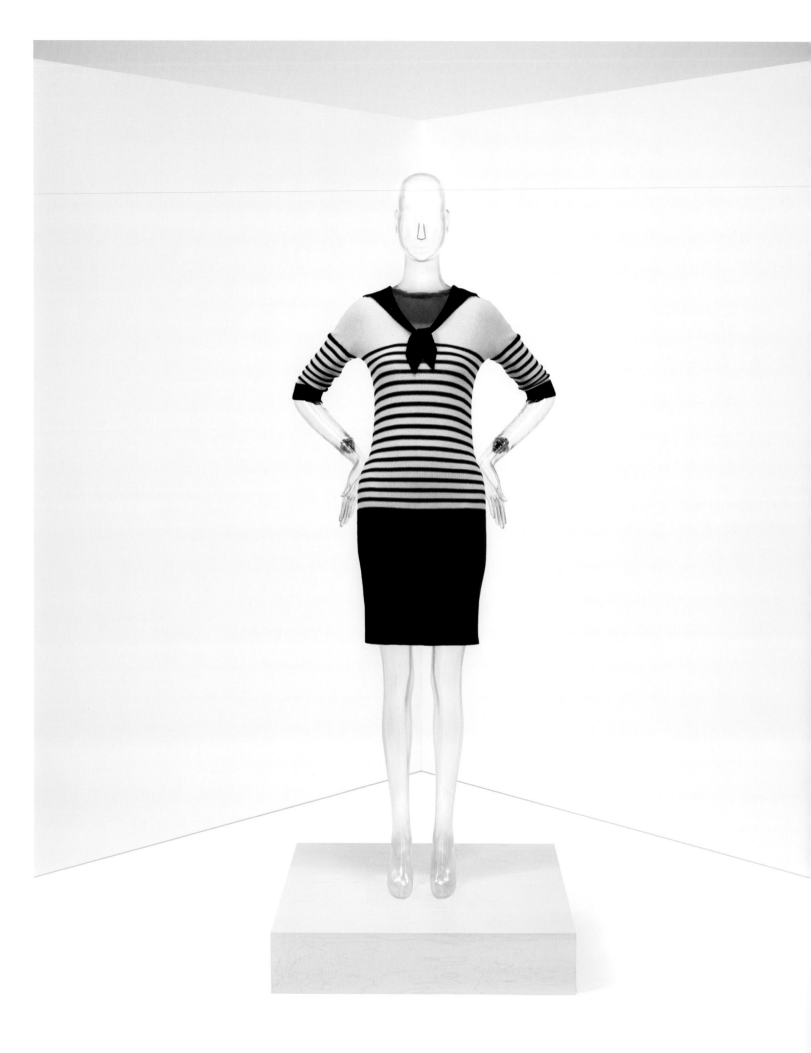

Sonia Rykiel (French, 1930–2016) for SONIA BY SONIA RYKIEL (French, 1999–2016)
Dress, spring/summer 2010. Black and white striped cotton knit

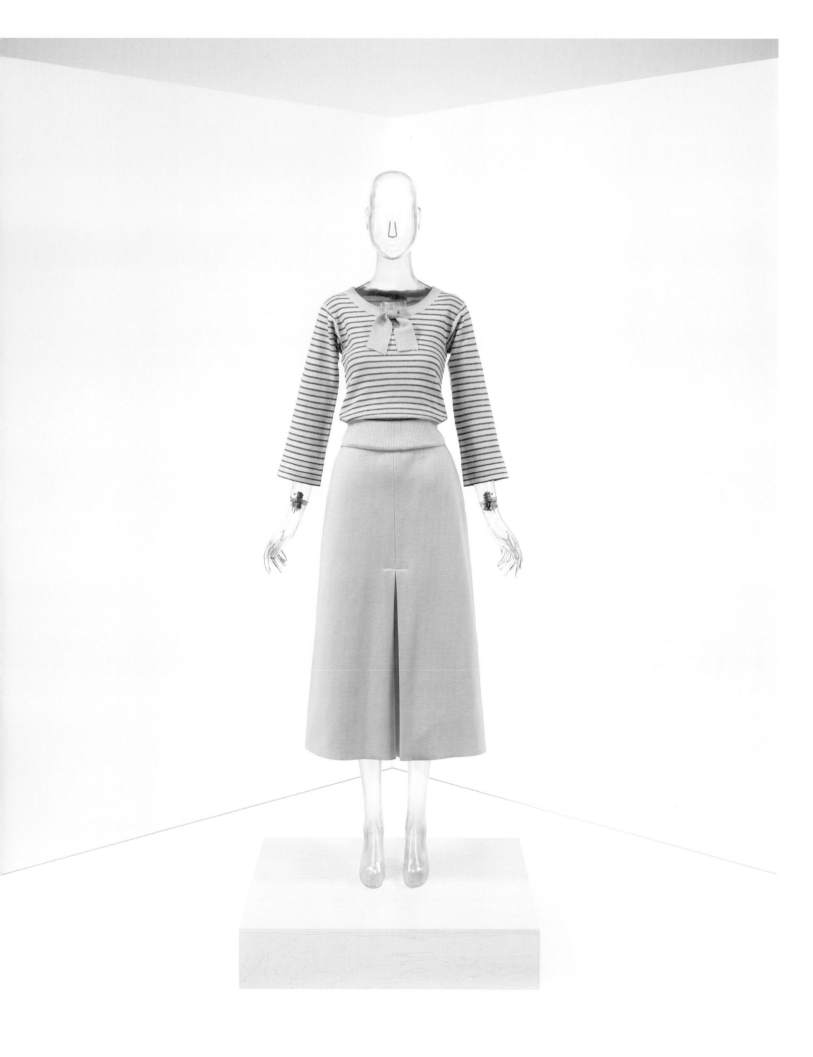

Sonia Rykiel (French, 1930–2016) for SONIA RYKIEL (French, 1968–2019; 2021–present)
Ensemble, 1974–76. Sweater of light pink, red, and white striped wool knit; skirt of light pink wool knit

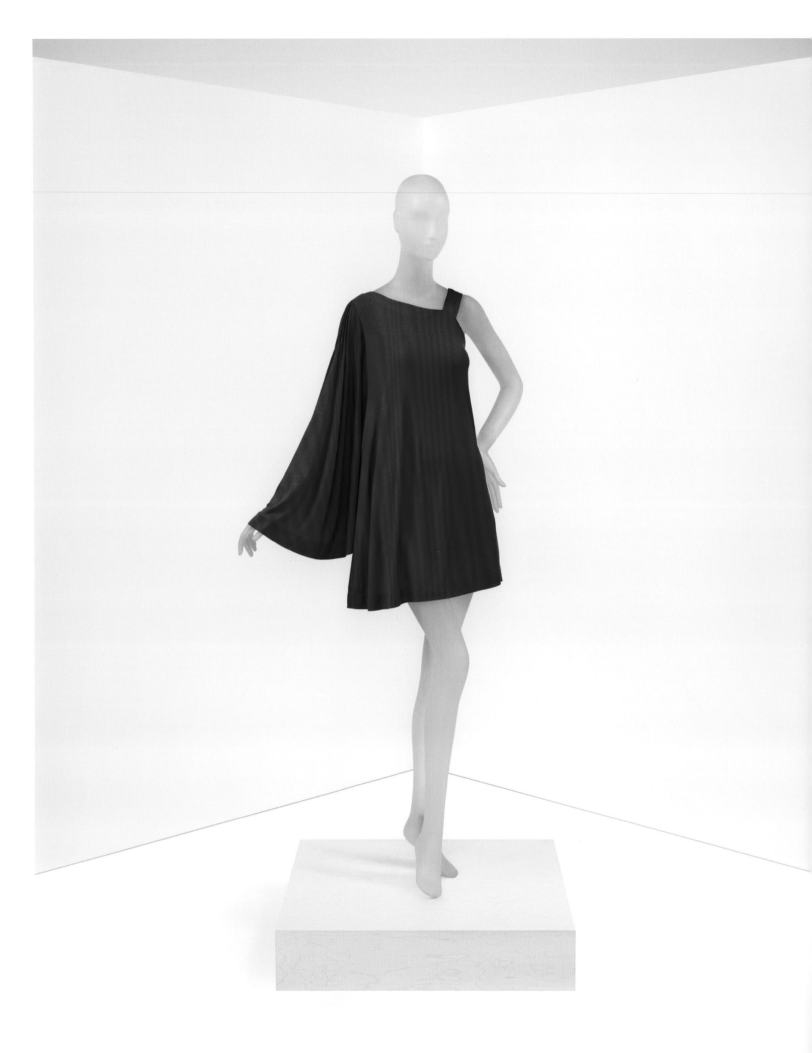

Jean Muir (British, 1928–1995) for JEAN MUIR (British, 1966–2007)
Dress, 1980s. Red rayon jersey

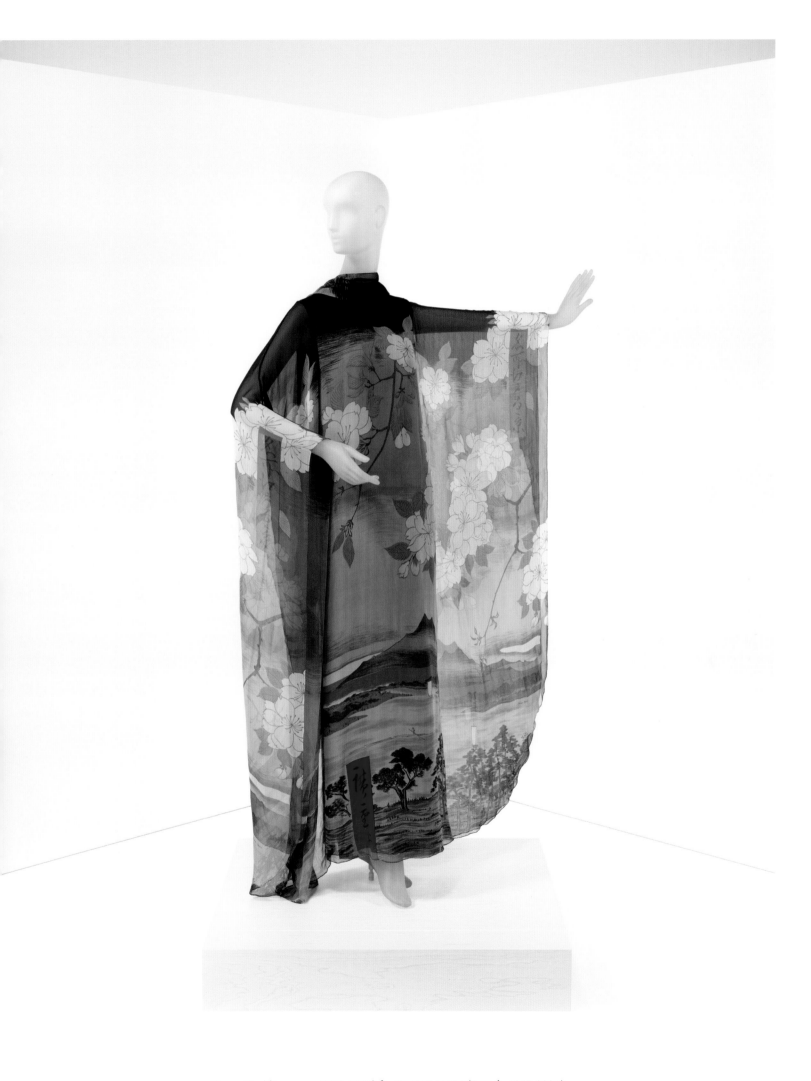

Hanae Mori (Japanese, 1926–2022) for HANAE MORI (French, 1977–2004)
Evening dress, autumn/winter 1974–75. Polychrome printed silk chiffon with Japanese-landscape and cherry-blossom motifs

149

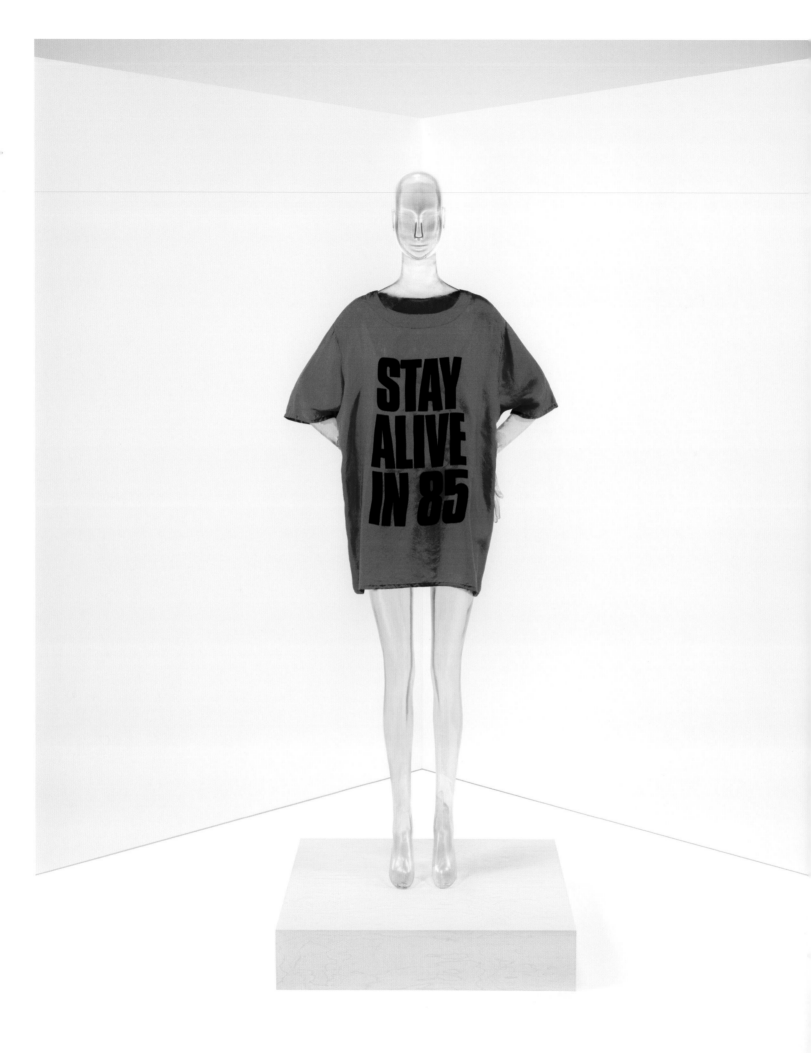

Katharine Hamnett (British, born 1947) for KATHARINE HAMNETT LONDON (British, founded 1979)
"Stay Alive in 85" T-shirt, 1985. Red silk plain weave printed with black text

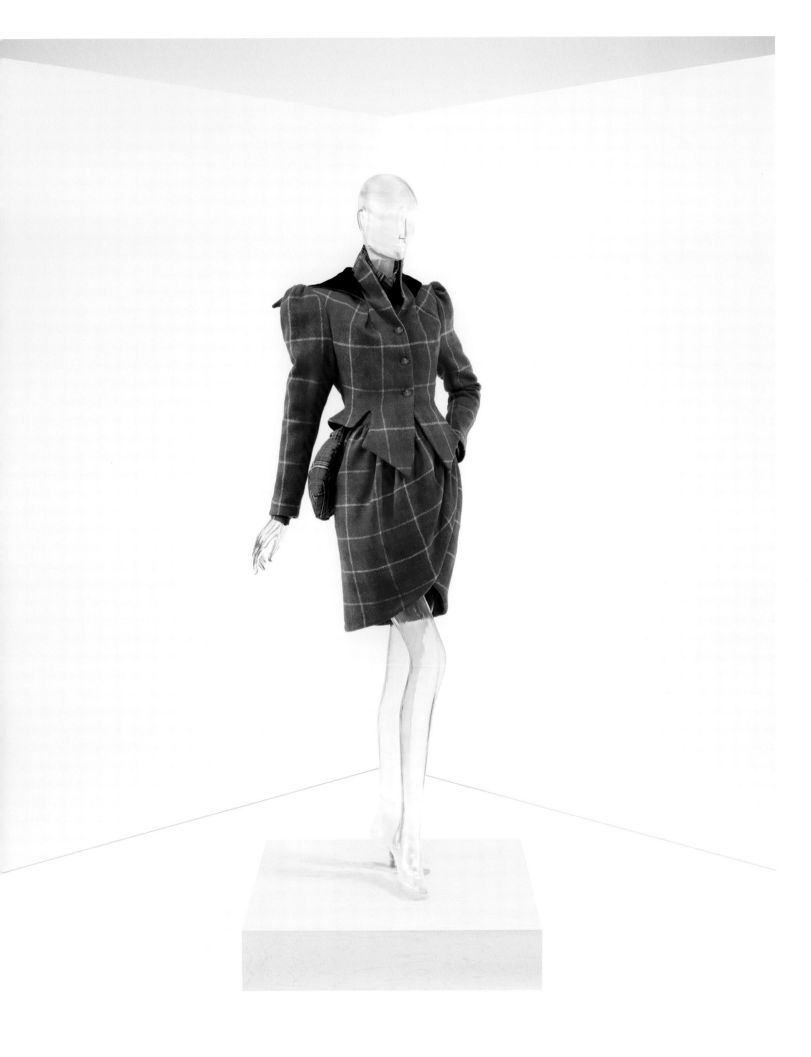

Vivienne Westwood (British, 1941–2022) for VIVIENNE WESTWOOD (British, founded 1971)
"On Liberty" suit, autumn/winter 1994–95. Jacket and skirt of red, yellow, and white wool-cotton windowpane-plaid twill, trimmed with black cotton velvet; dress and bustle of red, yellow, white, blue, and black cotton tartan

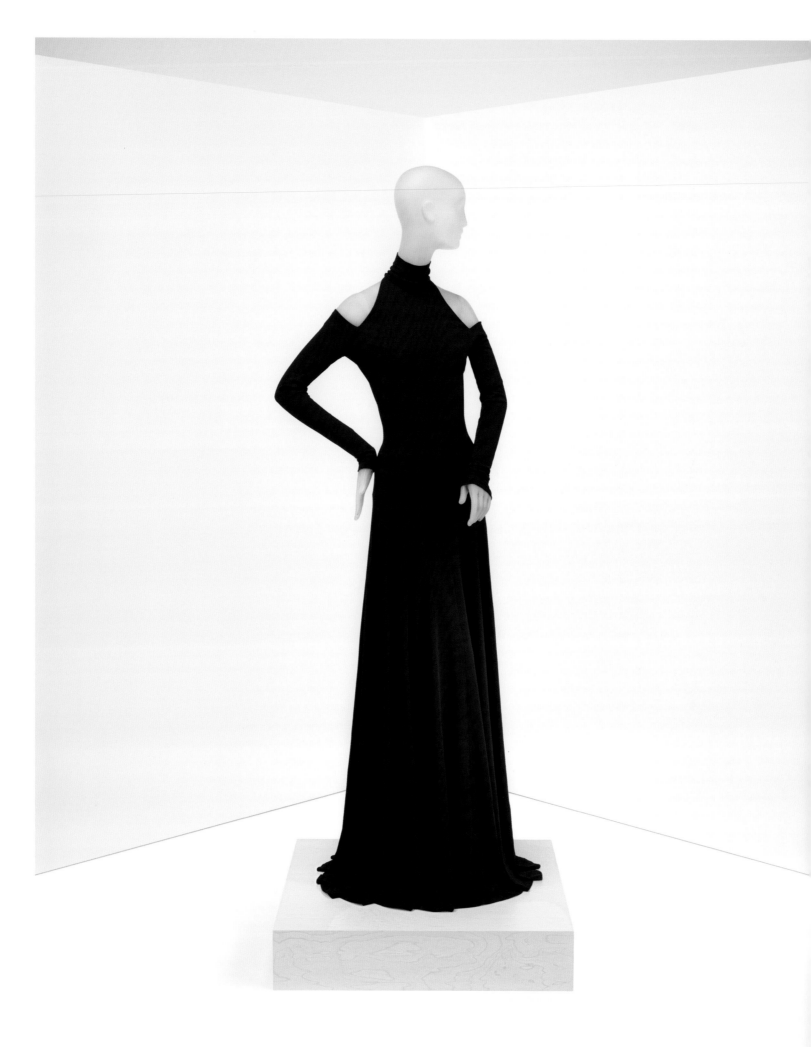

Donna Karan (American, born 1948) for DONNA KARAN NEW YORK (American, founded 1985)
Evening ensemble, autumn/winter 1992–93. Black silk matte jersey

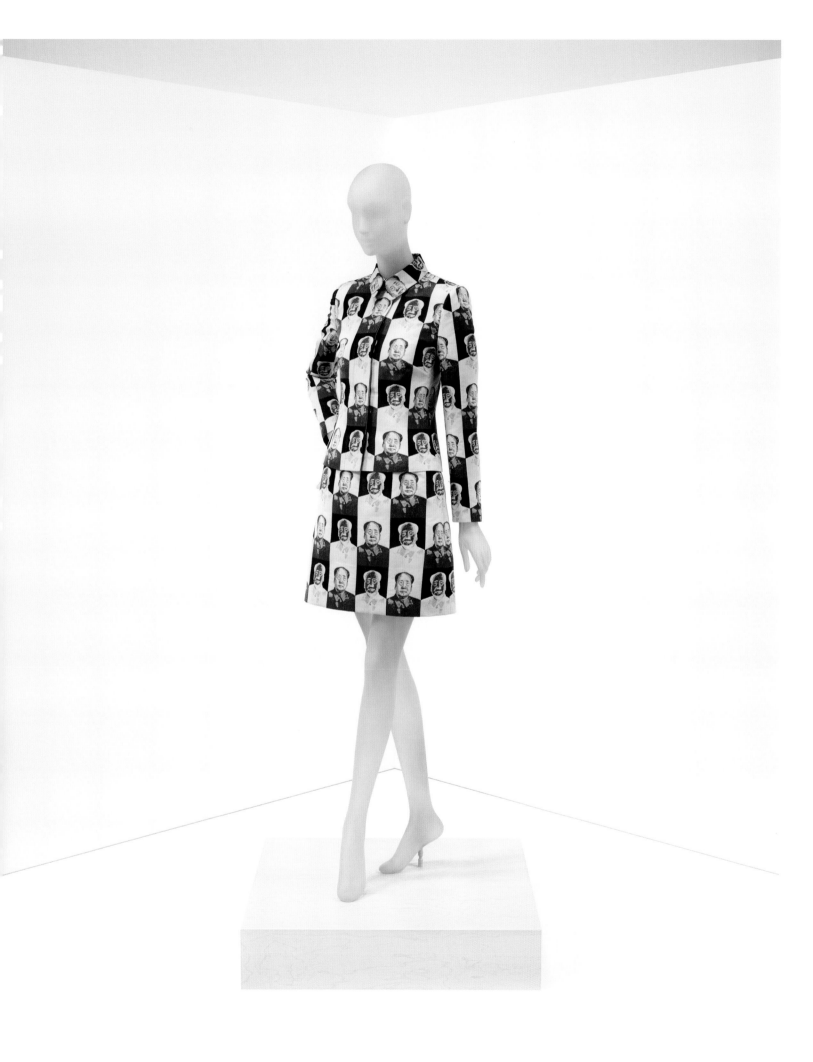

Vivienne Tam (American, born China, 1957) for VIVIENNE TAM (American, founded 1982)
"Mao" suit, spring/summer 1995; edition 2015. Black and white polyester jacquard woven with positive and negative images of Mao Zedong

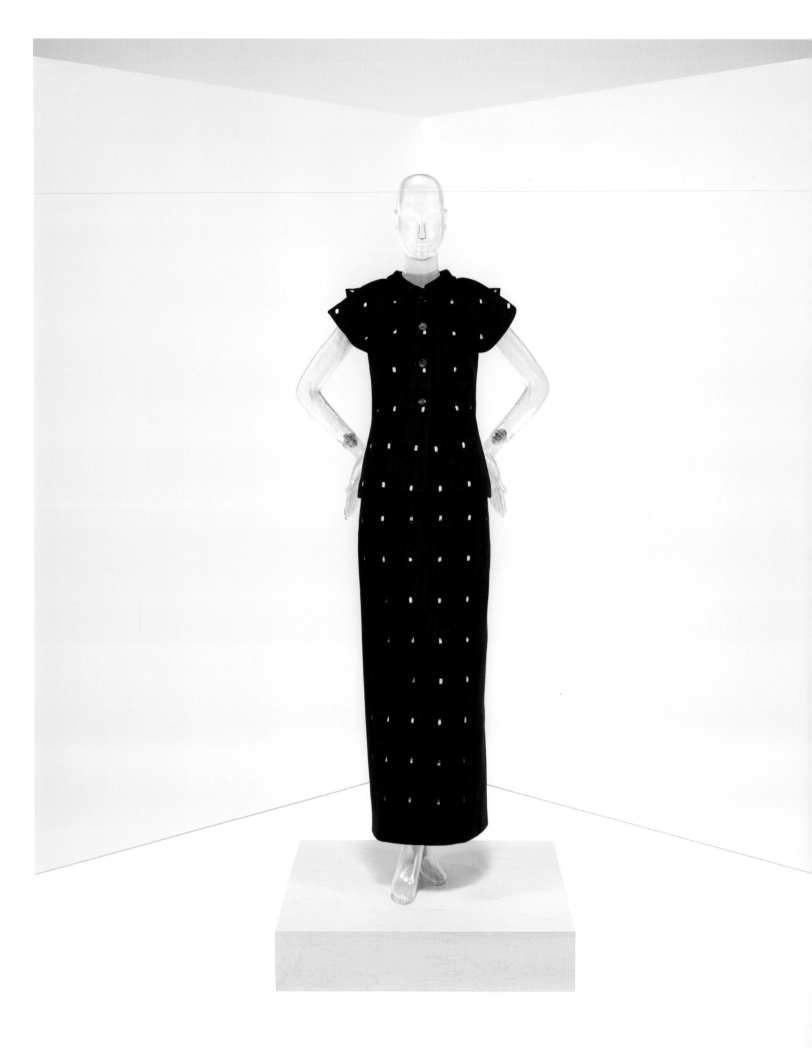

Jil Sander (German, born 1943) for JIL SANDER (Italian, founded Germany, 1968)
Suit, autumn/winter 1998–99. Black wool twill underlaid with white cotton plain weave

Ann Demeulemeester (Belgian, born 1959) for ANN DEMEULEMEESTER (Belgian, founded 1985)
Suit, spring/summer 1997. Jacket and pants of black synthetic twill; shirt of lavender and dark gray synthetic piqué; undershirt of white rayon jersey

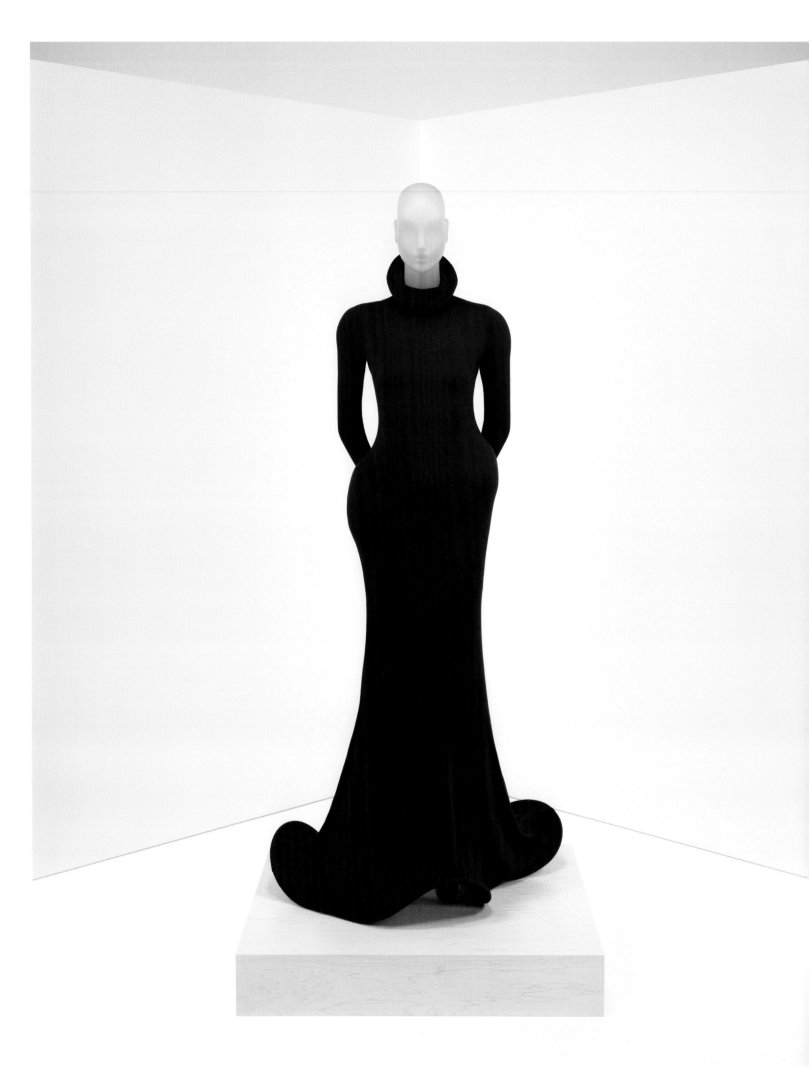

Georgina Godley (British, born 1955) for GEORGINA GODLEY (British, 1985–1999)
Dress, autumn/winter 1986–87; edition 2019. Dress of black viscose jersey; underdress of black cotton-Lycra jersey
padded with synthetic foam, batting, and cotton domette

Rei Kawakubo (Japanese, born 1942) for COMME DES GARÇONS (Japanese, founded 1969)
Dress, spring/summer 1997. Dress of black and white synthetic gingham plain weave, with nylon, polyurethane, and down padding

Rei Kawakubo (Japanese, born 1942) for COMME DES GARÇONS (Japanese, founded 1969)
Ensemble, autumn/winter 1982–83. Sweater of black wool knit; skirt of black cotton plain weave
and black polyester batting; T-shirt of white cotton jersey

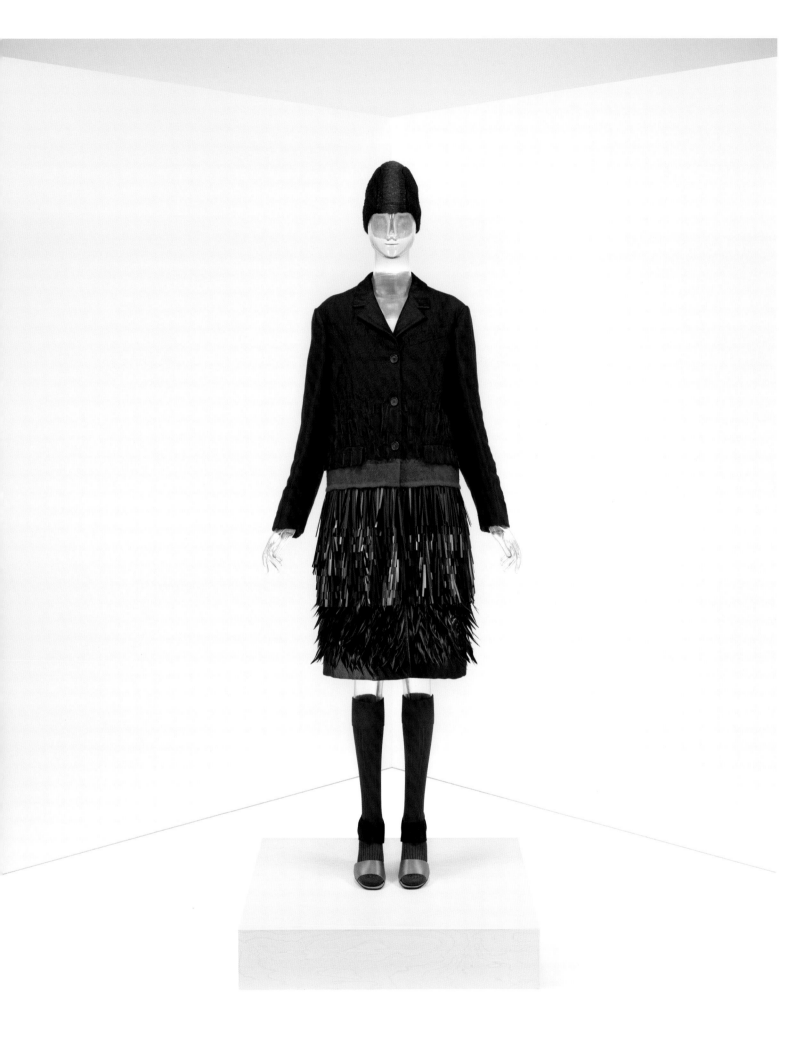

Miuccia Prada (Italian, born 1949) for PRADA (Italian, founded 1913)
Ensemble, autumn/winter 2007–8. Coat of black silk-linen-synthetic gabardine novelty weave with green felted wool embroidered with
black feathers and black rectangular sequins; skirt of black silk gabardine embroidered with black rectangular sequins

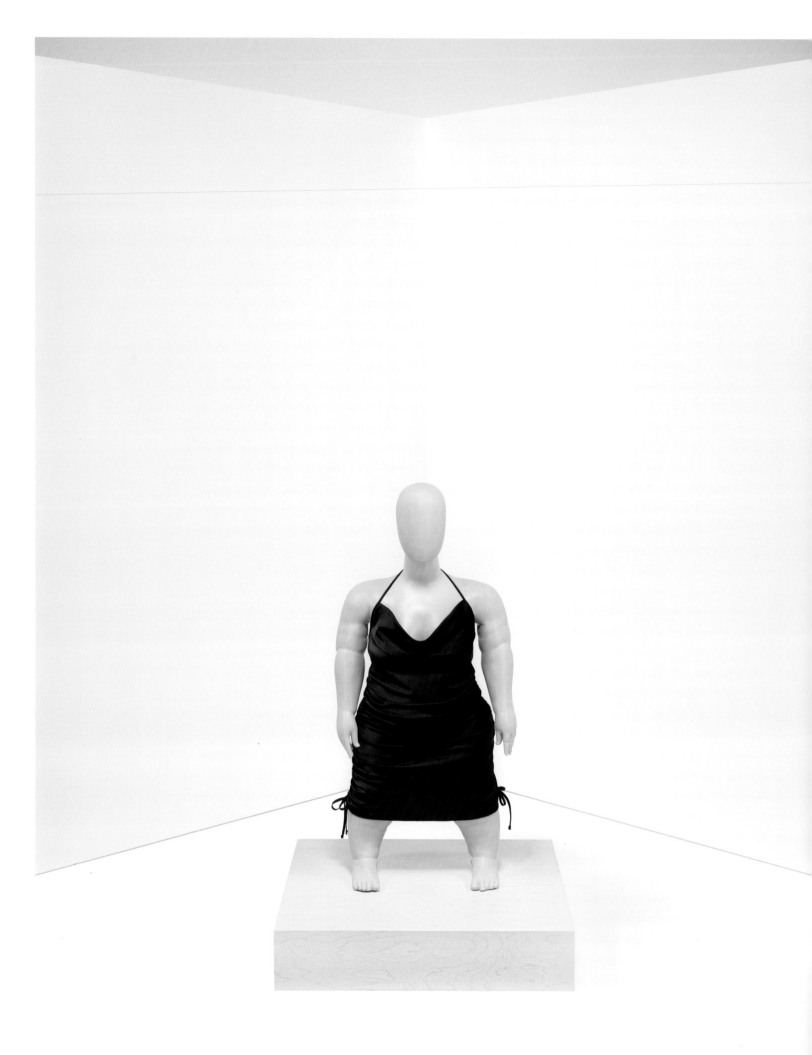

Jasmin Søe (Danish, born 1991) for CUSTOMIETY (Danish, founded 2021)
"Going Out" dress, 2021. Black polyester satin

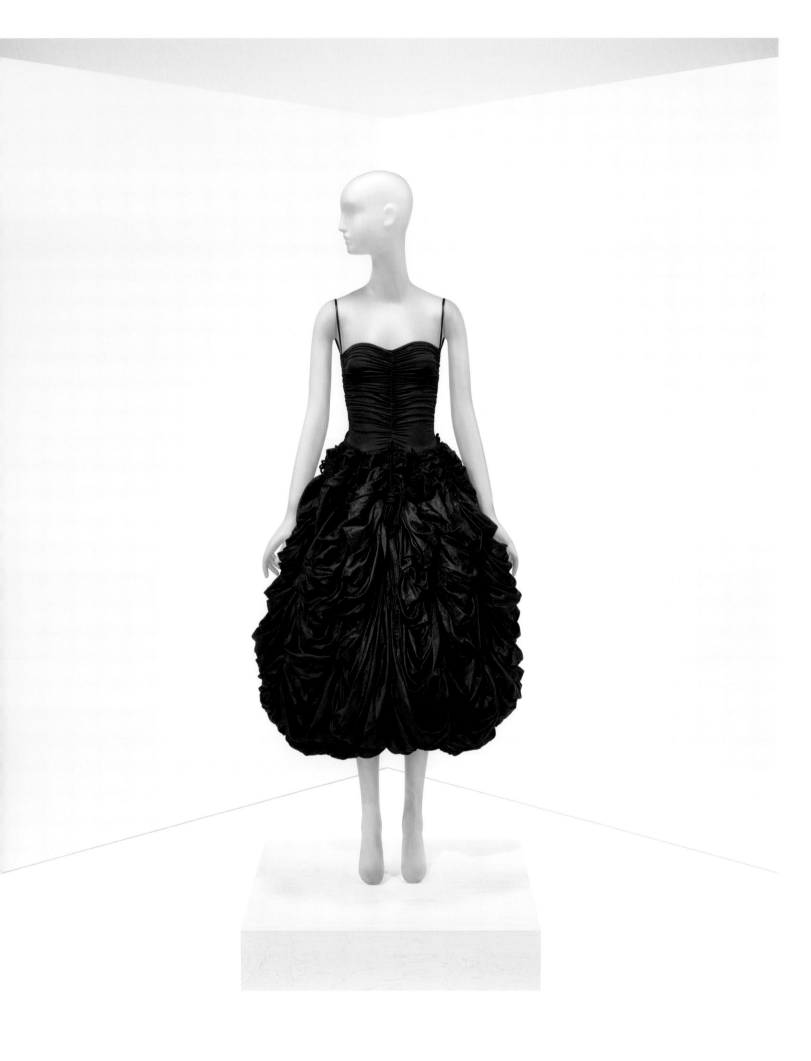

Norma Kamali (American, born 1945) for OMO NORMA KAMALI (American, founded 1977)
Evening dress, 1978. Black nylon ripstop

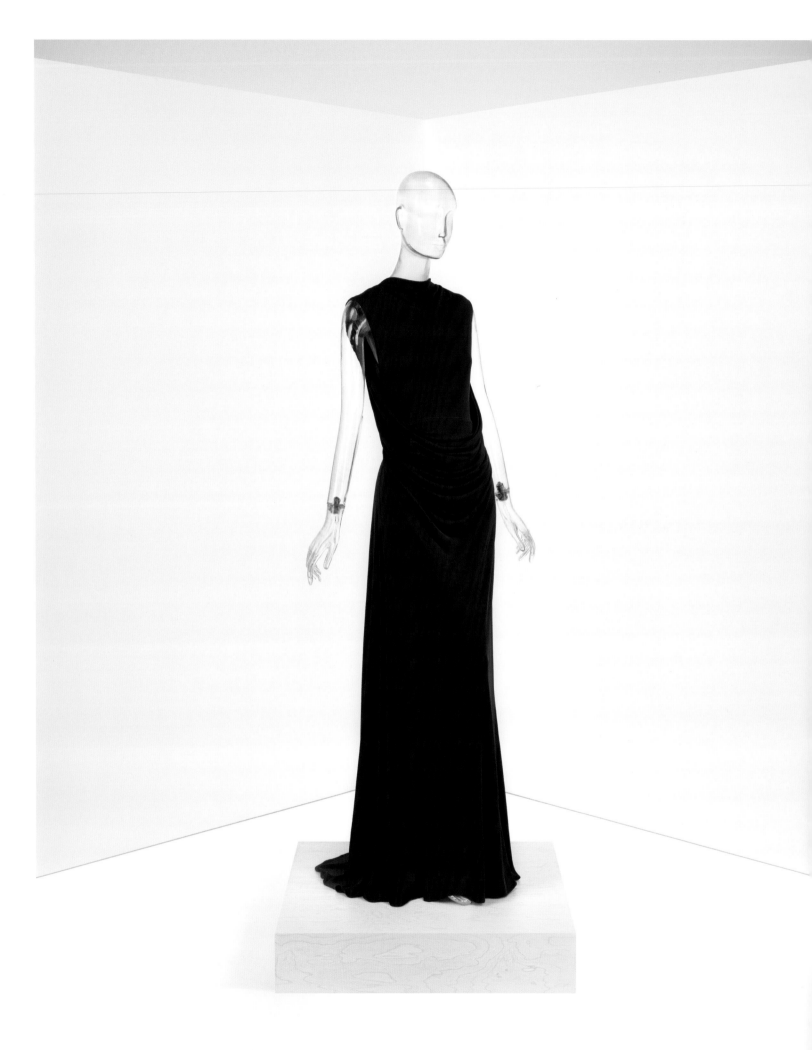

Isabel Toledo (American, born Cuba, 1961–2019) for ISABEL TOLEDO (American, 1985–2019)
"Kangaroo" dress, spring/summer 1993. Black rayon jersey

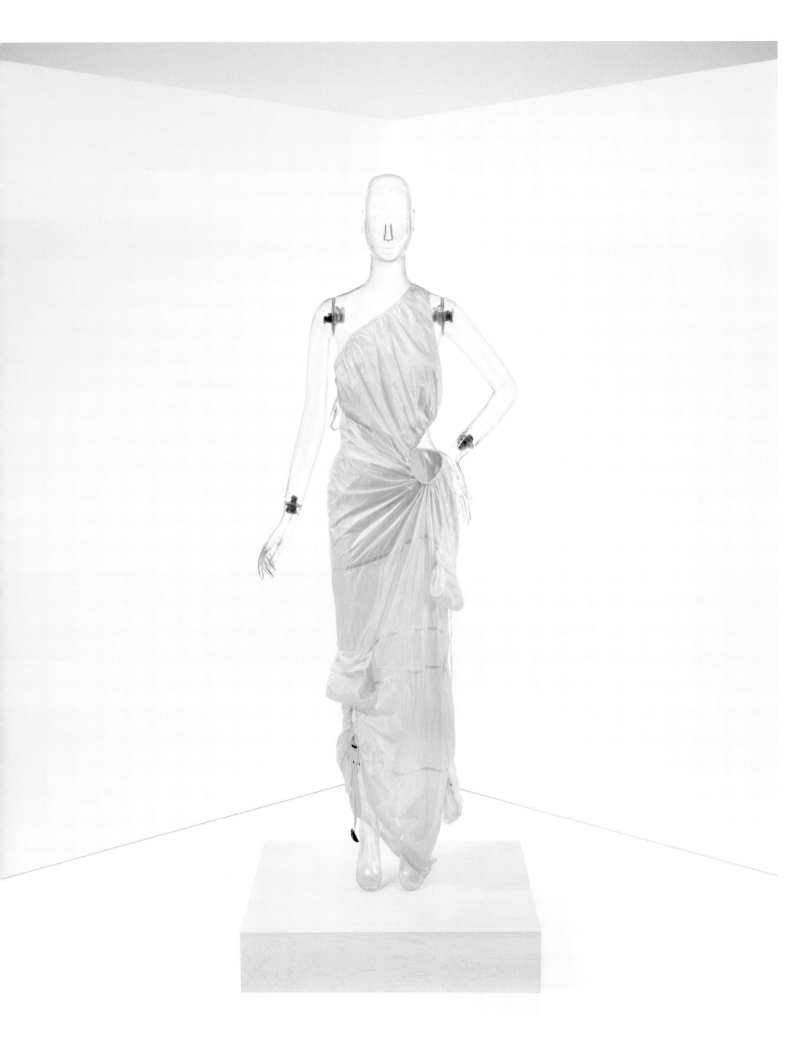

Pia Davis (American, born 1989) and *Autumn Randolph* (American, born 1988) for NO SESSO (American, founded 2015)
"One Titty Dress (OTD)," autumn/winter 2022–23. Dress of white nylon with silver metal hardware

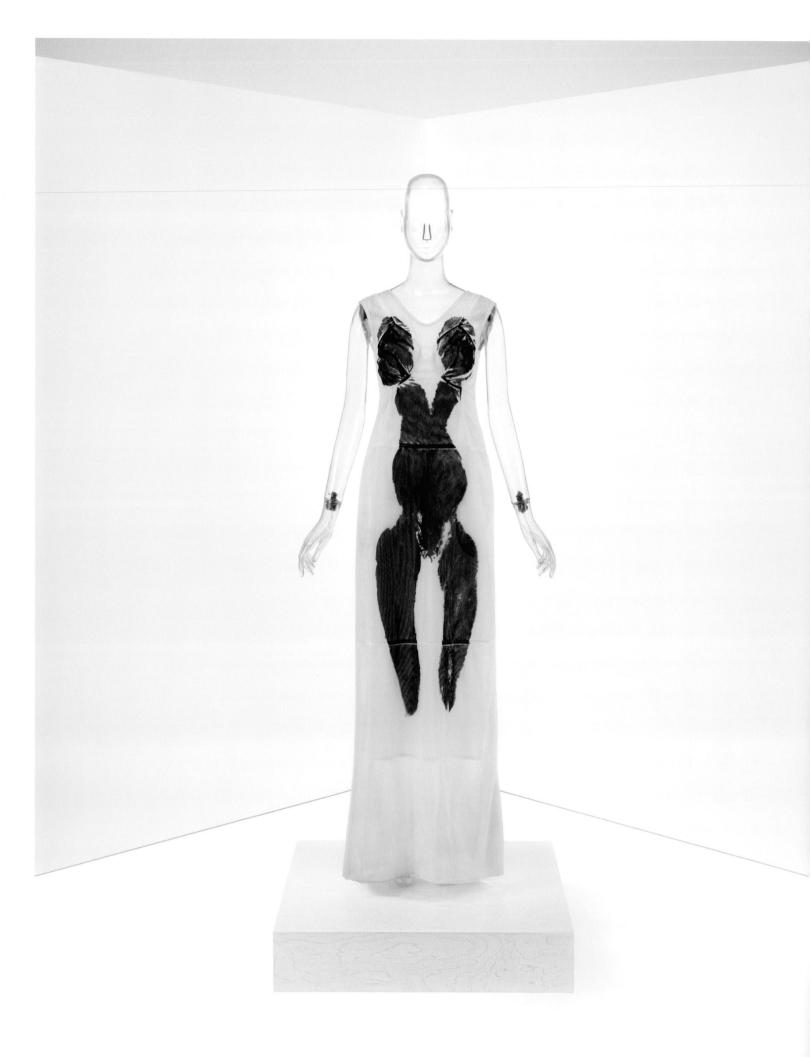

Phoebe Philo (British, born 1973) for CÉLINE (French, founded 1945)
"Céline-Yves Klein" dress, spring/summer 2017. White double stretch polyamide fishnet with body print in "Klein blue" pigment

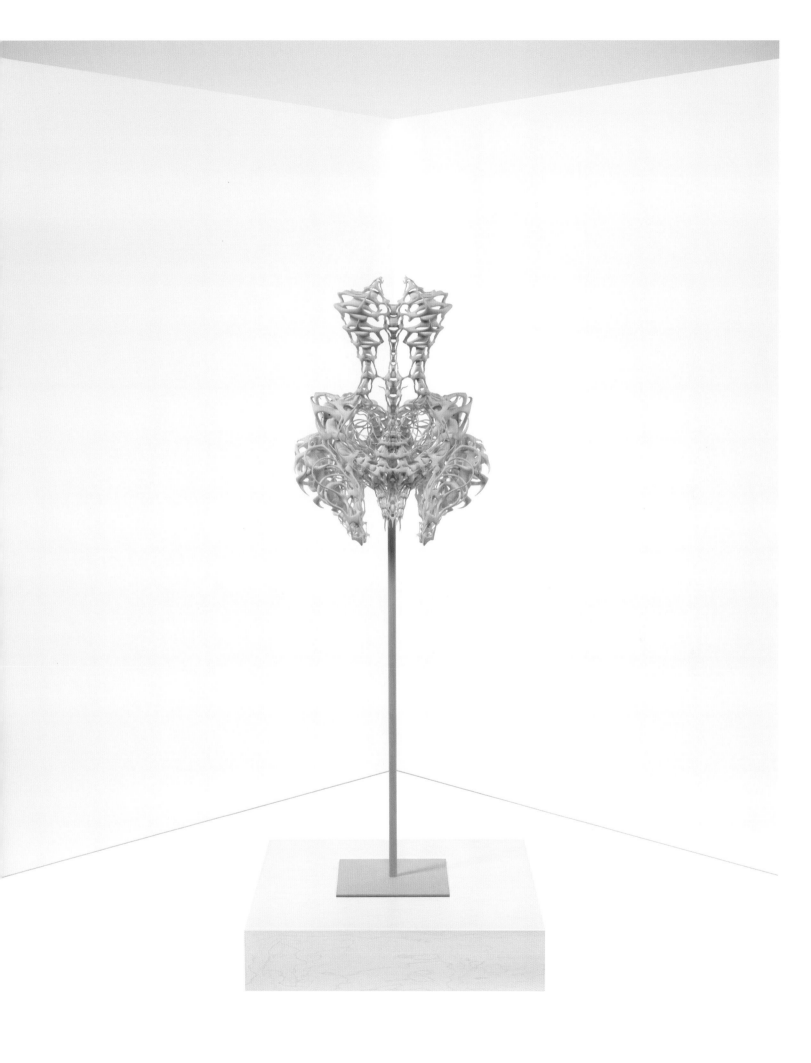

Iris van Herpen (Dutch, born 1984) for IRIS VAN HERPEN (Dutch, founded 2007)
Ensemble, autumn/winter 2011–12. Skeleton dress of white polyamide 3D printed by Materialise

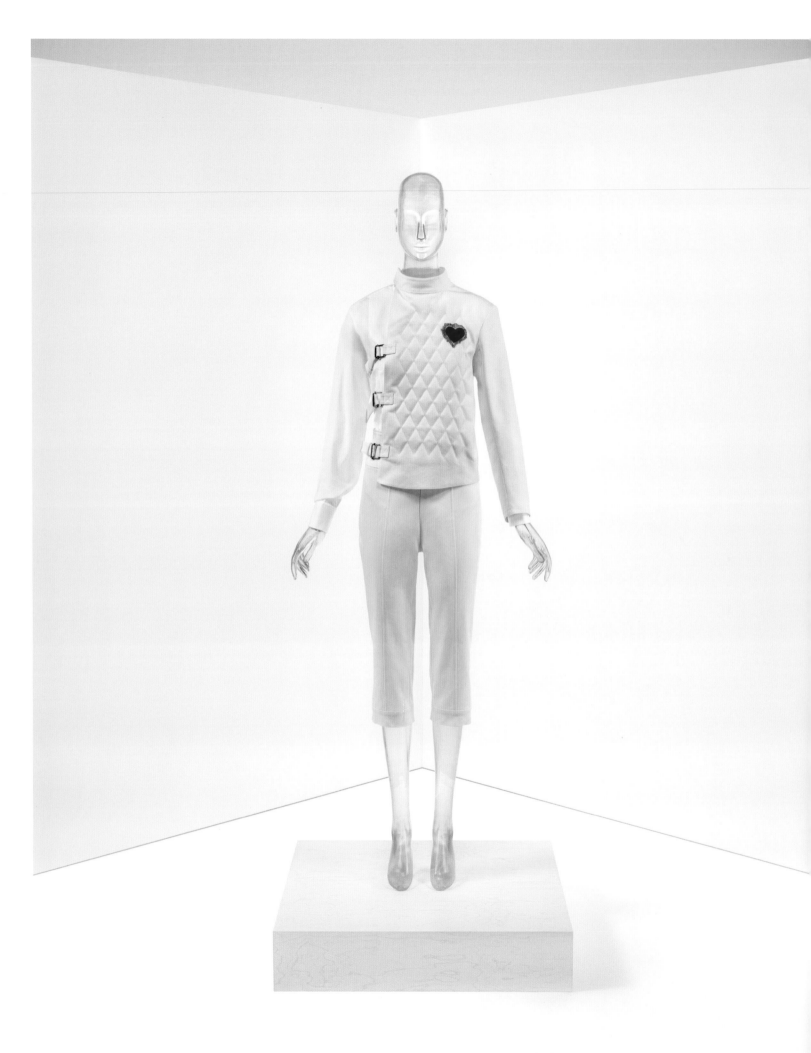

Maria Grazia Chiuri (Italian, born 1964) for DIOR (French, founded 1947)
Ensemble, spring/summer 2017; edition 2020. Jacket of white cotton canvas with matelassé quilting embroidered with a heart motif
in red silk and glass seed beads; shirt of white cotton plain weave and piqué; knickers of white cotton canvas

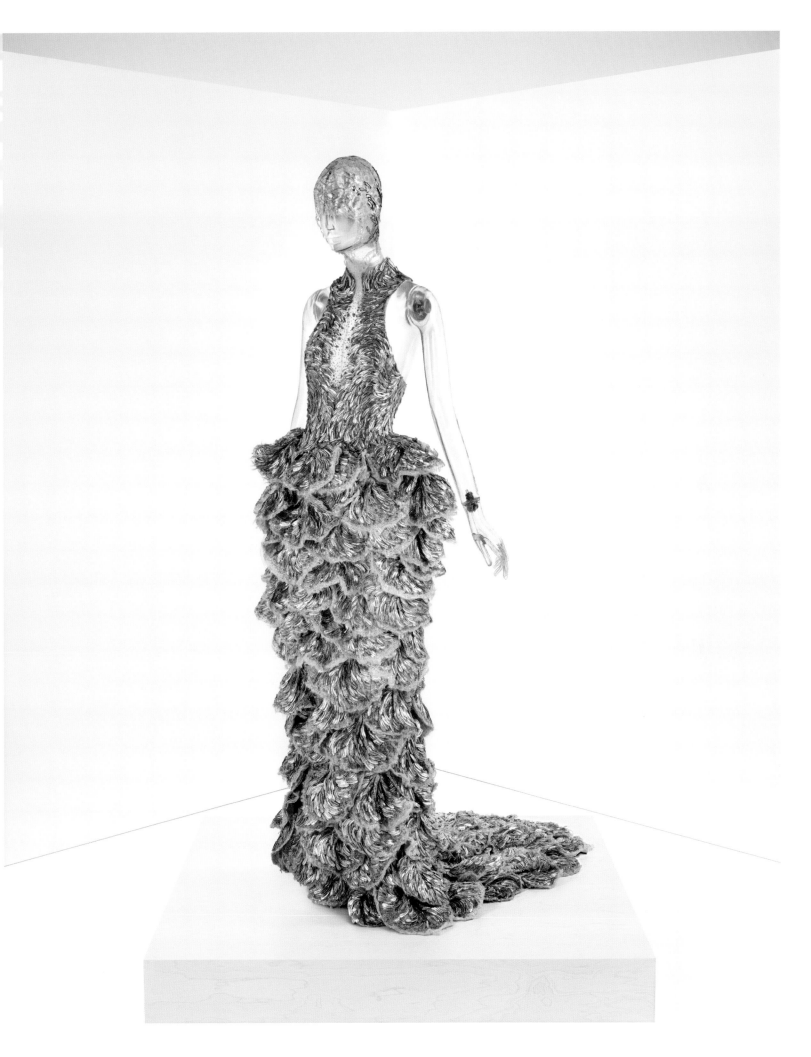

Sarah Burton (British, born 1974) for ALEXANDER MCQUEEN (British, founded 1992)
Ensemble, spring/summer 2012. Dress of white silk organza and nude silk mesh embroidered with silver glass beads, clear glass crystals, and silver metal feather-shaped paillettes; headpiece of silver synthetic Chantilly lace embroidered with silver metal feather-shaped sequins and silver and gray glass beads

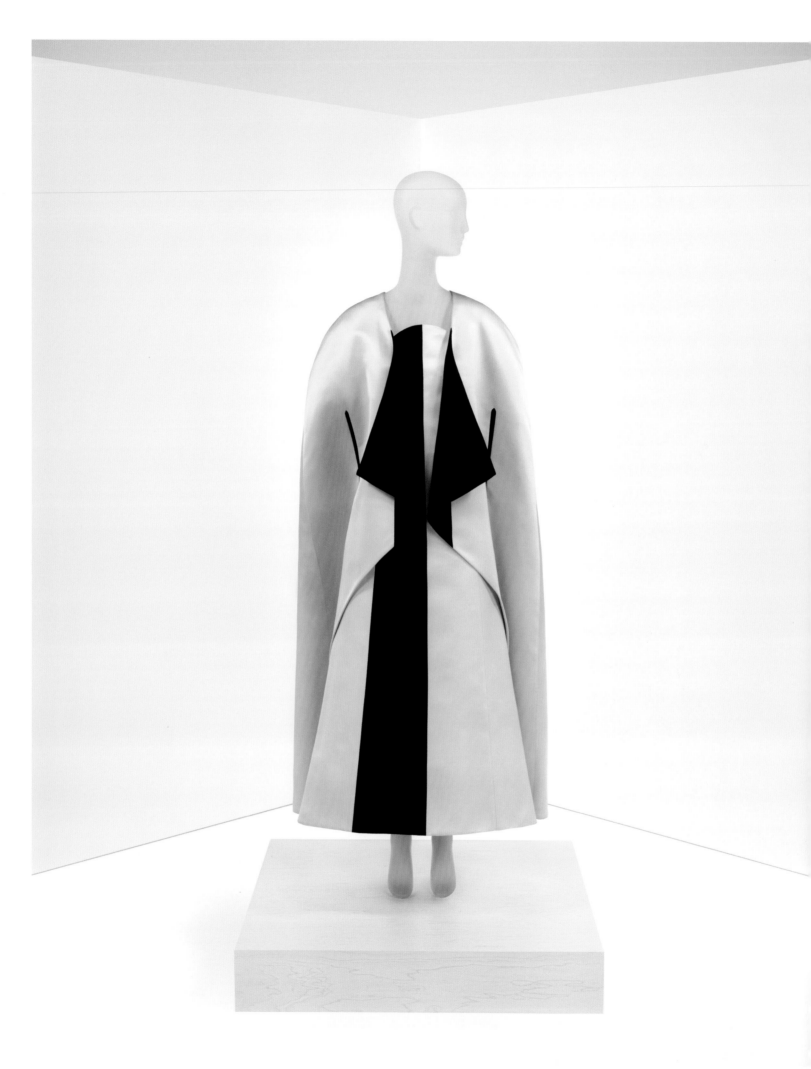

Yeohlee Teng (American, born Malaysia, 1951) for YEOHLEE (American, founded 1981)
Cape and evening dress, autumn/winter 1993–94; spring/summer 1992. Black and ivory double-faced silk satin

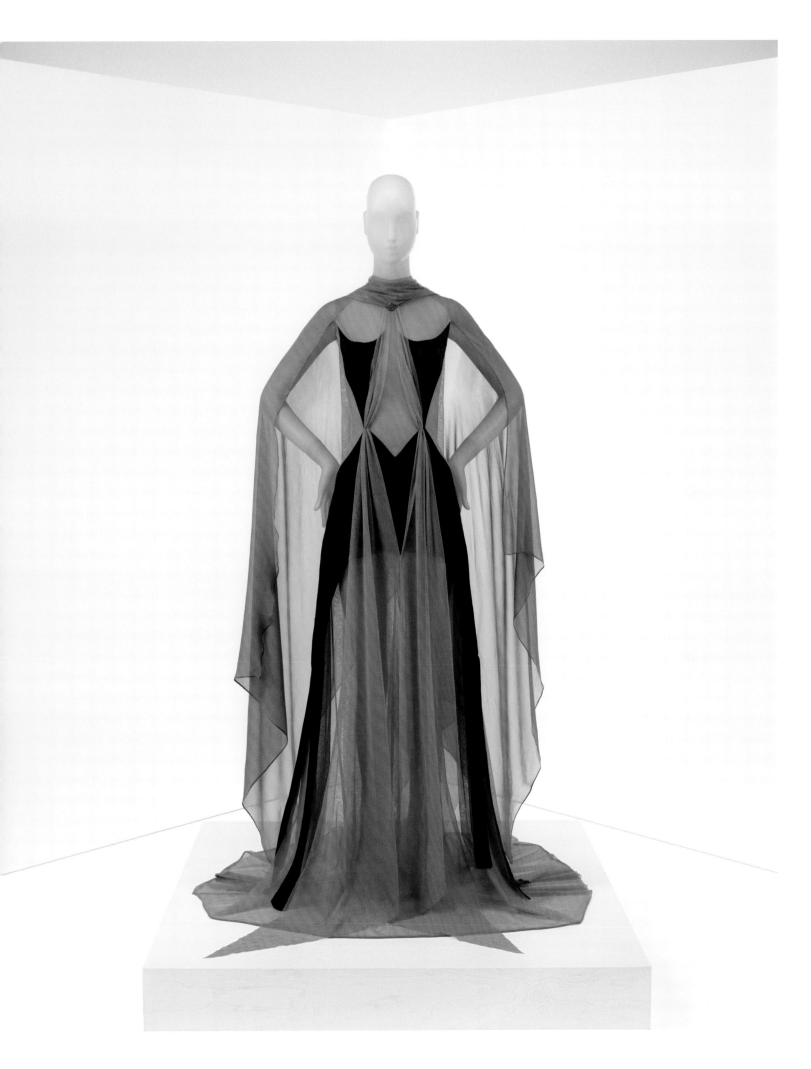

Jamie Okuma (enrolled member of the La Jolla Band of Mission Indians,
Shoshone-Bannock, Wailaki, Luiseño, and Okinawan, born 1977)
"Parfleche" dress, 2021. Black silk satin and nude synthetic net with antique cut-steel button

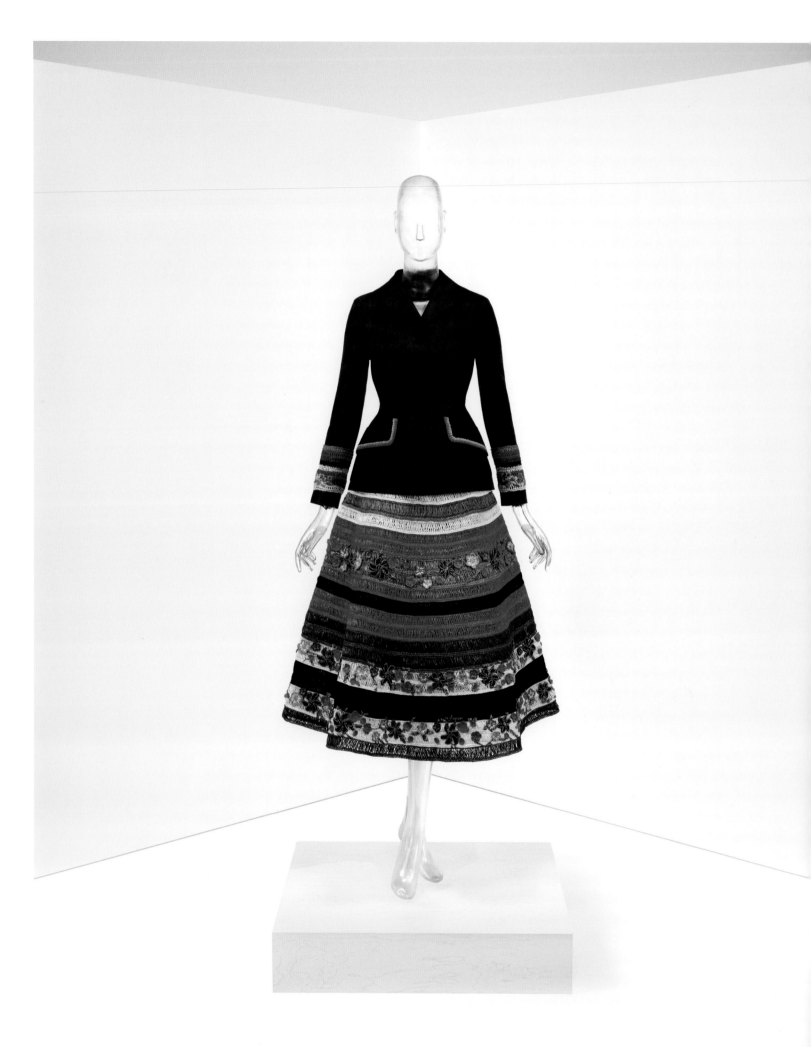

Maria Grazia Chiuri (Italian, born 1964) and *Grace Wales Bonner* (British, born 1992) for DIOR (French, founded 1947)
Ensemble, cruise 2020; edition 2022. Jacket of black silk shantung crocheted with red, white, and green viscose;
skirt of red, white, green, and black striped raffia embroidered with flowers

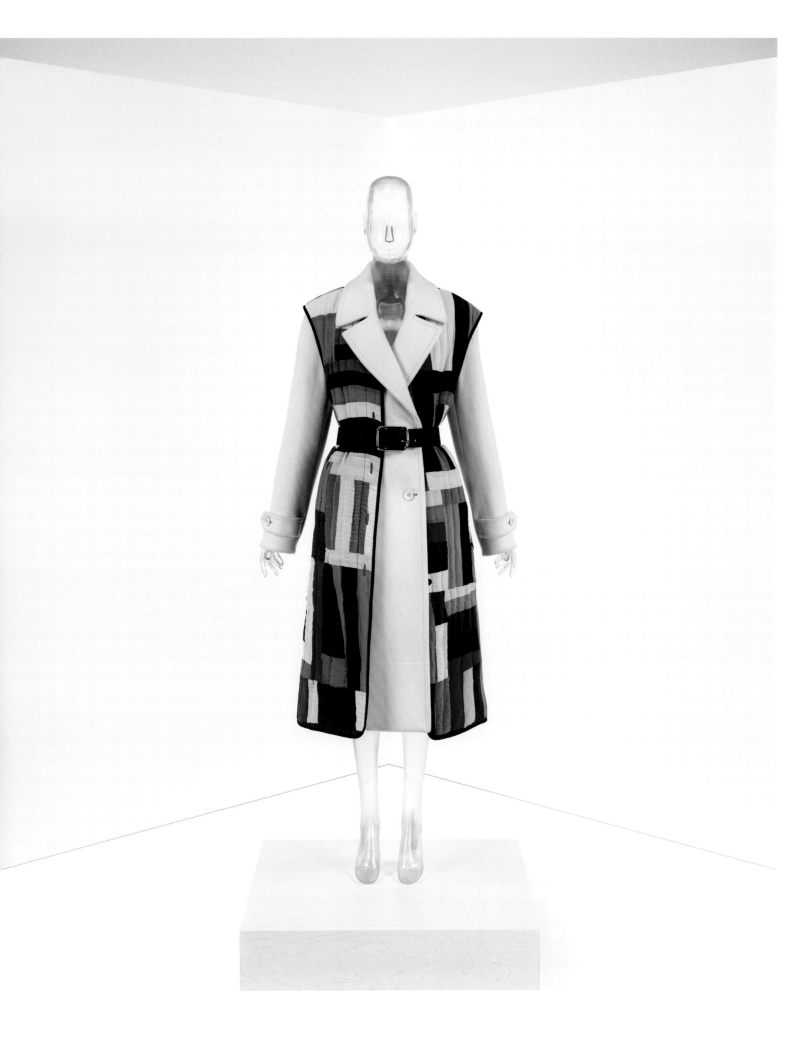

Gabriela Hearst (Uruguayan, born 1976) for CHLOÉ (French, founded 1952)
Ensemble, autumn/winter 2022–23. Coat of ivory brushed wool-polyamide; vest of polychrome quilted silk crepe remnants;
belt of black leather with brass metal buckle

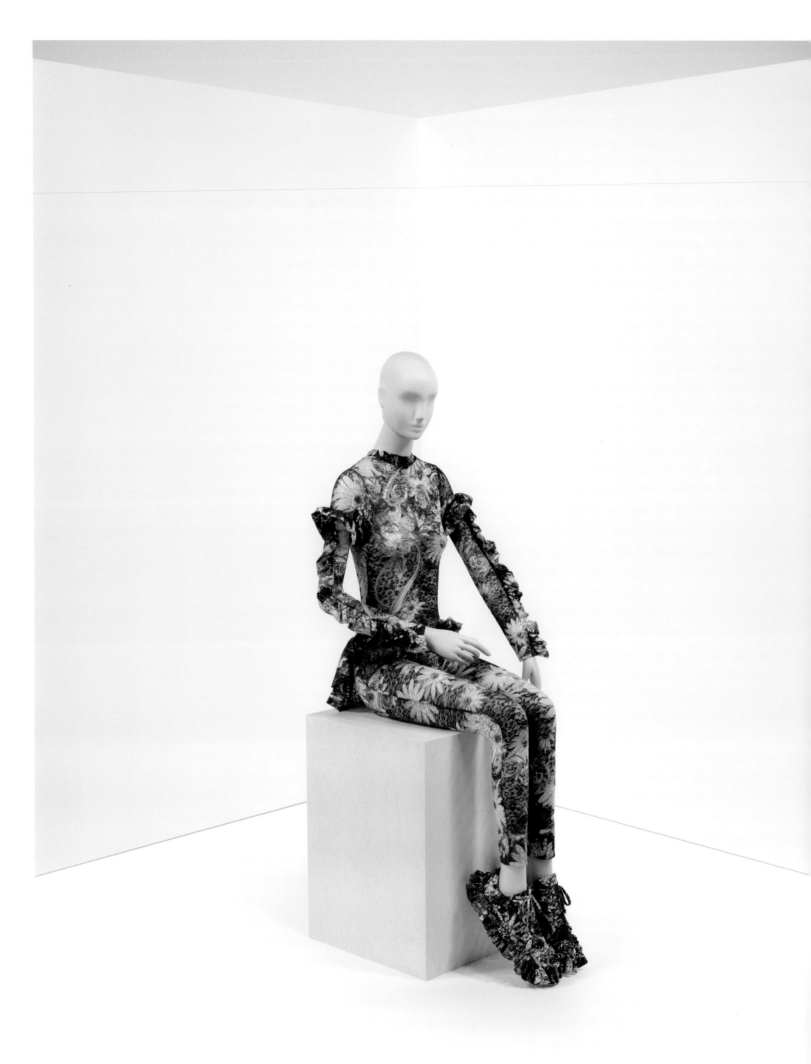

Hillary Taymour (American, born 1987) for COLLINA STRADA (American, founded 2008)
Ensemble, autumn/winter 2021–22. Bodysuit of polychrome printed deadstock lace with motifs by Charlie Engman for Collina Strada;
Reebok sneakers with laces and appliqué of polychrome printed deadstock lace with motifs by Charlie Engman for Collina Strada

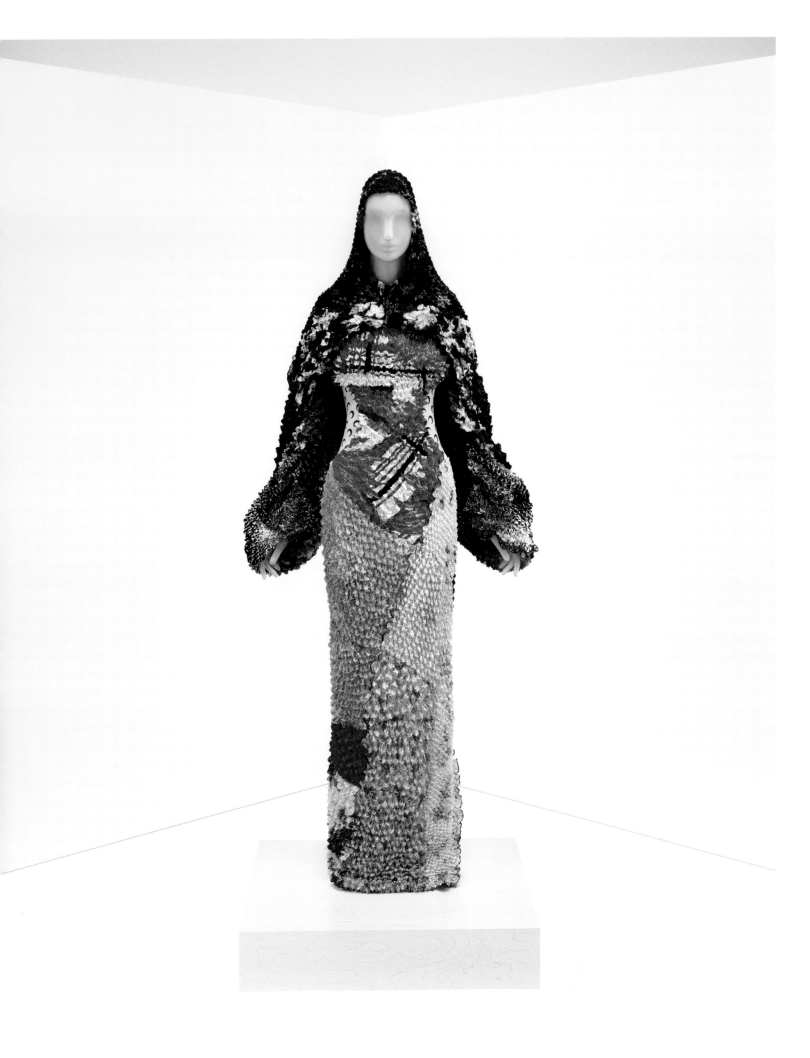

Marine Serre (French, born 1991) for MARINE SERRE (French, founded 2018)
Dress, spring/summer 2022. Polychrome printed polyester-elastane and recycled polychrome printed polyester-elastane

ABSENCE/
OMISSION

ABSENCE/
OMISSION

ABSENCE/OMISSION
The Costume Institute Collection

Amanda Garfinkel and Mellissa Huber

Absence is intrinsic to the collection and study of fashion, whether the voids or omissions are intentional and result from carefully defined parameters; circumstantial and proscribed by fixed or fluctuating limitations; aspirational to stake room for future growth; or revealed through critical assessment and the passage of time. The condition of absence is also due to the challenging and costly nature of displaying and caring for clothing and accessories that are designed to be dressed on a figure.[1] Given the inextricable connection between the corporeal and sartorial object, every clothing collection is thus incomplete, comprised of inert and retired garments that emphasize the absence that occurs when the tie between body and dress has been severed.[2] This dilemma, central to exhibiting fashion, introduces interpretive and display challenges that must reconcile the object's condition with the maker's intent and the actual, imagined, or intended wearer. In the museum, the individual object constitutes part of a larger whole, extending beyond its relationship with the body to broader connections, including its initial presentation on the runway, its maker and production histories, and its social and physical trajectories. Collection objects are subject to continuous assessment and critique, as they represent institutional ambitions, while new scholarship, changing mores, and cultural shifts foster forms of understanding and awareness that may have been less perceptible to previous custodians. Time works both for and against the historian, providing the magnanimous wisdom of hindsight while obscuring perspective in the moment. This is especially true when it comes to fashion, which is ephemeral in both practice and material.

While a museum archive is presumably immune to the subjective passions of what Werner Muensterberger might refer to as an individual's "collecting sentiments,"[3] comprising the distinctive experiences, impulses, and tastes of a single person, a purely objective institutional remove is also an impossibility. A collection consists of a series of decisions made by a variety of stakeholders over time. Every choice introduces another amid intervening pragmatic limitations such as life span and use of a garment, the prioritization or selection of rare pieces over others, and criteria like provenance or availability. With clothing, the decisions multiply following the point of acquisition: How should the object be stored? In what manner or context will the garment be displayed? What elements of the item or maker will be the focus of interpretation? How does the object enhance, supplement, or promote discourse in the context of the museum's current holdings? Most often, it is the formal and exceptional that survives, reflecting elite methods of production and consumption that are typically prized for their craftsmanship and "wonder" over notions of "resonance."[4] The history of The Costume Institute thus reflects the choices and influence of its founders and a long succession of curators, conservators, archivists, librarians, artists, designers, scholars, philanthropists, interns, and volunteers who have all contributed to shaping its exhibitions and holdings.

The Costume Institute's current strategy for acquiring contemporary fashion aligns with the Museum's mission to reflect change in society through the interpretation and presentation of its collections.[5] From the 1970s to the end of the twentieth century, the practice of collecting contemporary fashion was not immediate but based in part on the assessment of a design's lasting significance over time.[6] As a result, collecting opportunities were missed or lost and the resulting gaps in the collection filled retroactively. The pace and scope of fashion in the twenty-first century—guided by individual expression and cultural identity rather than dominant styles—have increased and diversified as the industry expands globally. While contemporary acquisitions continue to be evaluated on their artistic and technical merits, they are now made in time and concentrate on themes like sustainability, collaboration, representation, and inclusivity—values unacknowledged or antithetical to those of earlier periods in fashion history. These ethical considerations reflect the collective and individual concerns of the Museum's international audience, along with the shifting nature and emphasis of the fashion industry itself, and have become fundamental to the acquisition of contemporary dress.

In recent years, demographic assessments of Western fashion collections have revealed a consistent lack of diversity and have prompted efforts to rebalance the representation of works by women designers and designers of color.[7] An ongoing review of The Costume Institute's holdings reveals a similar imbalance. Approximately half of the thirty thousand works in the archive are unattributed or unidentified; most are from the eighteenth and nineteenth centuries. As Jessica Regan explains in her essay (pp. 15–24), it was common for fashions made by women prior to the twentieth century to remain unattributed due to a lack of documentation, the rarity of extant garments, and inequities in the fashion system. For women designers of color, gaps in the archive are even greater, and as Elizabeth Way acknowledges in her analysis (pp. 69–78), their contributions have often been intentionally obscured or overlooked. The rise and the promotion of the named designer in the late nineteenth and early twentieth century led to improved recordkeeping and documentation. Of the collection's identified works, 30 percent are attributed to women designers—the largest share active in the first half of the twentieth century, a unique period of increased visibility and influence—yet only 9 percent of the objects credited to women represent the work of female designers of color. The relative few women designers represented in the collection since the mid-twentieth century may, in part, be attributed to the dominance of the male designer in modern and contemporary fashion and the focus on work by established couturiers among donors. Although a review of acquisitions made in recent years shows a steady increase in representation, a significant imbalance remains, resulting in the omission from the archive of the contributions and perspectives of women and other marginalized communities. The absence of extant objects and other forms of material culture and documentation can impede attempts to correct historical oversight and bias. Despite these obstacles, the awareness of gaps in the collection stimulates inquiry and encourages new, thoughtful approaches to collecting, interpretation, and display.

The objects in this section demonstrate types of absences that occur within museum collections and the canon of fashion history. Their significance is often multifaceted, expressing notions of agency and visibility while simultaneously underscoring—and sometimes addressing—instances of historical omission. They reflect the cultural influences, social, political, and industrial inequities, and aesthetic conventions that have shaped fashion over time. Specifically, they underscore the contributions of women designers obscured by

the mythology of the sole creative genius; the limited rights and legal protections historically unavailable to women; and the persistent exclusion of bodies deemed incompatible with traditional standards of the feminine ideal. The final object demonstrates the inspiring, ingenious, and determined efforts of contemporary designers to subvert the fashion system and shape their own narratives: Anifa Mvuemba's "Pink Label Congo" collection, which debuted over social media during the height of the COVID-19 pandemic, reflects the fascinating potential of fashion to communicate complex ideas, along with its power to initiate change.

1 This cost is financial, relative to storage space, materials, and well-regulated environmental conditions, as well as time-based, requiring the dedicated expertise of collections specialists and conservators to properly monitor and treat objects that begin to deteriorate almost from the moment of completion. For an example of some of the challenges that fashion objects can introduce, see Glenn Petersen and Sarah Scaturro, "Inherent Vice," in *Charles James: Beyond Fashion*, ed. Harold Koda and Jan Glier Reeder, exh. cat. (New York: Metropolitan Museum of Art, 2014), 233–49. Regarding the sometimes invisible labor of conservation work, see Sarah Scaturro, "Confronting Fashion's Death Drive: Conservation, Ghost Labor, and the Material Turn within Fashion Curation," in *Fashion Curating: Critical Practice in the Museum and Beyond*, ed. Annamari Vänskä and Hazel Clark (New York: Bloomsbury, 2018), 21–38.
2 As Alexandra Warwick and Dani Cavallaro have pointed out, even the relationship between garment and the dressed body can be seen as an "interplay of presence and absence." *Fashioning the Frame: Boundaries, Dress and the Body* (Oxford: Berg, 1998), xxii.
3 Werner Muensterberger, *Collecting: An Unruly Passion* (Princeton, N.J.: Princeton University Press, 2014), 7.
4 Stephen Greenblatt, "Resonance and Wonder," in *Exhibiting Cultures: The Poetics and Politics of Museum Display*, ed. Ivan Karp and Steven Lavine (Washington, D.C.: Smithsonian Institution Press, 1991), 42–56.
5 Dan Weiss and Max Hollein, *A Plan for The Met 2022–2027* (New York: Metropolitan Museum of Art, 2022).
6 Harold Koda and Jan Glier Reeder, interview by Hazel Clark, January 26, 2012, cited in Cheryl Buckley and Hazel Clark, "In Search of the Everyday: Museums, Collections, and Representations of Fashion in London and New York," in *Fashion Studies: Research Methods, Sites and Practices*, ed. Heike Jenss (London: Bloomsbury, 2016), 25–41.
7 For recent studies on representation within the fashion industry, see McKinsey & Company, *Shattering the Glass Runway*, September 2018, https://www.mckinsey.com/~/media /McKinsey/Industries/Retail/Our%20Insights/Shattering%20the%20glass%20runway /Shattering-the-glass-runway.pdf; and Ralph Lauren Corp. and Parity.org, *Unlocking Gender Parity in Fashion: A Roadmap Exploring Gender and Race in the Fashion Industry*, October 2020, https://www.parity.org/fashion/.

THE "DELPHOS" GOWN
A History Hidden in Plain Sight

Mellissa Huber

An elegant tube of gleaming silk that softly clings to the figure, the "Delphos" gown, with its distinctive pleats, at once reveals and obfuscates the body beneath. The inherent contradiction in these abilities characterizes the nature of the garment itself: timeless, yet modern; fashionable and nonconformist; easy to wear, but challenging to maintain; and simply constructed through complex fabrication techniques. While countless publications, exhibitions, and collections document the cultural impact of the dress—a style produced regularly from 1909 to 1952 that frequently lingered in wardrobes for decades beyond—the gown's true inventor has largely remained absent from the historical record, though she has been present all along.

When the artist and designer Mariano Fortuny opened his Venetian textile workshop at the Palazzo Pasaro degli Orfei in 1906, his partner, Henriette Nigrin, was by his side. Together they developed their first garment: the undulating, body-enveloping "Knossos" scarf. Similar to the "Knossos," which drew inspiration from ancient dress like the Indian sari or the Greek himation, their subsequent design, the "Delphos," also considered historical source material. A prototype with a variety of permutations, the dress defied time yet was in tune with the zeitgeist. Breaking with the heavily corseted structure characteristic of contemporaneous women's clothing, the "Delphos" recalled the draped and pleated textiles of classical Greece yet rearticulated the reference through a modern lens. The garment was initially adopted by an artistic clientele that included performers like Lyda Borelli, Isadora Duncan, Eleonora Duse, and Ruth St. Denis, growing in popularity over the following decades to become possibly the most famous creation associated with Mariano Fortuny.

The "Delphos" was produced with fine imported textiles made from Japanese silk tussah, a soft, raw yarn with a delicate sheen and a propensity to wrinkle. To achieve the gown's sophisticated coloration, the Fortuny workshop dyed the fabric utilizing natural pigments that were built up over multiple baths to create depth and luminosity, eschewing the uniformity of artificial dyes. This dress, one of many examples of the style in The Costume Institute collection, comprises four panels of vertically seamed pleated silk taffeta. Like other extant pieces, the neckline and sleeves contain a corded drawstring that offered the wearer customization. Murano glass beads punctuate the sides of the bodice, gently anchoring the pleated fabric around the figure while also providing a decorative flourish.

The pleating process for the "Delphos" was proprietary. The gowns came coiled and stored in small circular boxes and had to be returned to Fortuny to have their folds refurbished if they flattened during use. One associated patent for a fabric pleating system filed with the Parisian Office national de la propriété industrielle in 1909 provides an initial clue that Mariano Fortuny was not the sole creator of the dress. Although the document cites him as the owner, it also includes his handwritten note that credits Nigrin as the inventor, claiming expediency as the reason for this official misattribution.[1]

Nigrin has frequently been categorized as Fortuny's assistant, muse, and partner, and as a skilled seamstress who was "extraordinarily good with her hands,"[2] but not until very recently has she been more publicly acknowledged in her creative role. Although the couple designed and experimented together, Nigrin oversaw the clothing and textile workshops where the most luxurious Fortuny silk and velvet garments were produced.

Following her husband's death in 1949, she sold the brand to Elsie McNeill,[3] an American interior designer with whom the couple had collaborated on their expansion into the U.S. market. Nigrin's attachment to the "Delphos" is ultimately revealed in her private correspondence to McNeill. While other activities of the house could continue, she halted production of the gown, sharing that as "these garments are of my own creation, even more than many others, I desire that no-one else take them over, and thus to the sale of the Delphos we must apply the words *the end*."[4] Over seventy years later, the iconic gown continues to inspire generations of designers and remains a coveted object sought by collectors and institutions. As scholars continue to look closer at Nigrin's contributions and work to reinsert her name into the historical record, perhaps the story has yet to reach its conclusion.

1 My sincere thanks to Cristina Maria Da Roit at the Palazzo Fortuny for her generosity in sharing her research records. The full note on the patent reads: "Ce brevet est de la propriété de Madame Henriette Brassart qui est l'inventeur. J'ai pris ce brevet en mon nom pour l'urgence du depot." Mémoire descriptive, Office national de la propriété industrielle de Paris, June 10, 1909, Biblioteca Nazionale Marciana, Venice, Fondo Mariutti Fortuny, inv. M.8.1.5. For more on Henriette Nigrin, see Daniela Ferretti and Cristina Da Roit, eds., *Henriette Fortuny: Portrait of a Muse*, exh. cat. (Venice: Fondazione Musei Civici di Venezia, 2016).

2 Guillermo de Osma, *Mariano Fortuny: His Life and Work* (New York: Rizzoli, 1980), 102.

3 Later Countess Lee Gozzi.

4 Henriette Nigrin to Elsie McNeill, n.d., Biblioteca Nazionale Marciana, Venice, Fondo Mariutti Fortuny, inv. M.1.10.32. Cited in Claudio Franzini, "Henriette and Mariano: The Imprints of the Iconauts," in Ferretti and Da Roit, *Henriette Fortuny*, 90.

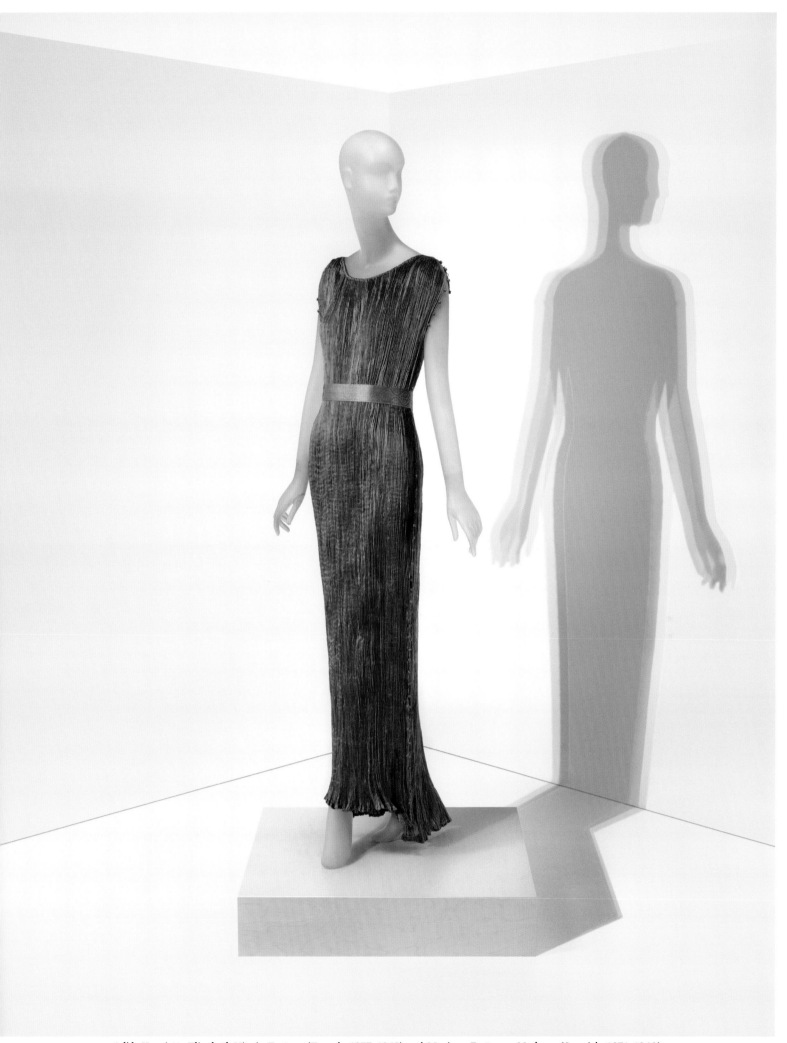

Adèle Henriette Elisabeth Nigrin Fortuny (French, 1877–1965) and *Mariano Fortuny y Madrazo* (Spanish, 1871–1949)
for FORTUNY (Italian, founded 1906)
"Delphos" gown, ca. 1932. Blue-green pleated silk taffeta with belt of green silk plain weave printed with gold metallic pigment

ESTER MANAS
Democratizing Size

Karen Van Godtsenhoven

The plus-size female body has been largely absent from modern fashion history, which has preferred a young, thin, able-bodied, white, and cisgender female figure. Since the late twentieth century, various designers have deconstructed different elements of this beauty ideal, but it is only in the twenty-first century that we see a conscious evolution toward a more inclusive and diverse image on and off the catwalk.

Ester Manas is one of the designers pushing the envelope, "making clothes to welcome everyone."[1] Her all-embracing approach to sizing and body type is an inherent part of her design process, which results in garments with a generous and sensual architecture for different figures, such as this asymmetric stretch dress that clings to the body yet allows for movement. The Neobaroque garment features ruching and cutouts that both veil and reveal the curvaceous body beneath. Some areas—namely, the arms, midriff, and legs—are left only half covered between folds of the fabric in an apparent game of hide-and-seek with the viewer's gaze.

Manas's research involves spending time with women of all shapes and sizes to understand what works on an intellectual level and then to try it out on a technical level. She sees friends and models as her codesigners and also uses her own body as a trial site for her garments: "I'm big, and always I fit on myself first. . . . A lot of brands have a curvy girl on the catwalk now—but the reality is, you cannot find a good size in the store afterwards. . . . I try to give the dream a reality."[2] Her body politics are well received, as the plus-size figure becomes a more frequent sight at fashion week. Manas explained that after having had few model options in autumn 2022 and

spring 2023, "[t]his season when we went back [to the casting agency], we had choice!"[3]

On top of this collaborative, embodied, and inclusive approach to designing fashion, Manas also strives toward sustainability by limiting use of virgin fabrics, as she did in this dress. She trawls through warehouses and factories to source her materials, resulting in 80 percent deadstock or upcycled textiles in every collection. Moreover, she endeavors to empower not only the wearer but also the garment maker, often working with Brussels-based confection atelier Mulieris (Latin for "of the woman"), which serves as a social and professional reintegration program for people in precarious circumstances.

Manas, who designs her label in collaboration with her partner in life and business, Balthazar Delepierre, graduated from the fashion department of the Brussels art school of La Cambre in 2017 with her plus-size collection "Big Again," which won the Galeries Lafayette prize at the Hyères International Festival of Fashion, Photography, and Fashion Accessories in 2018. The collection told the history of "a woman. Of the woman. Of all women, but mostly those who have been forgotten in the ranks of fashion's threadlike canvases. . . . With 'Big Again,' I work[ed] on the skin: that of women with generous curves, which, the more they are dressed, the more they reveal themselves. But also the skin, like leather, like armor to face the world."[4] This fusion of skin with fabric on a plus-size body gives new impetus to the notion of the fold in fashion, as seen in this dress: here, the rising and falling folds of the garment's cascading fabric meld with the flesh in an infinite unison and mutual becoming as a plea against unnecessary modesty for larger bodies.

1 Ester Manas in Sarah Mower, "Ester Manas: Fall 2022 Ready-to-Wear," *Vogue*, March 5, 2022, https://www.vogue.com/fashion-shows/fall-2022-ready-to-wear/ester-manas.
2 Manas in Mower, "Ester Manas."
3 Mower, "Ester Manas."
4 My translation of Ester Manas in Julie Nysten, "Show17 La Cambre mode(s). Étoile de Bazar. Ester Manas," *Bazar*, May 2, 2017, https://www.bazarmagazin.com/hits/show17-la-cambre -mode-etoile-de-bazar-ester-manas#.ZCROiS-QlpQ.

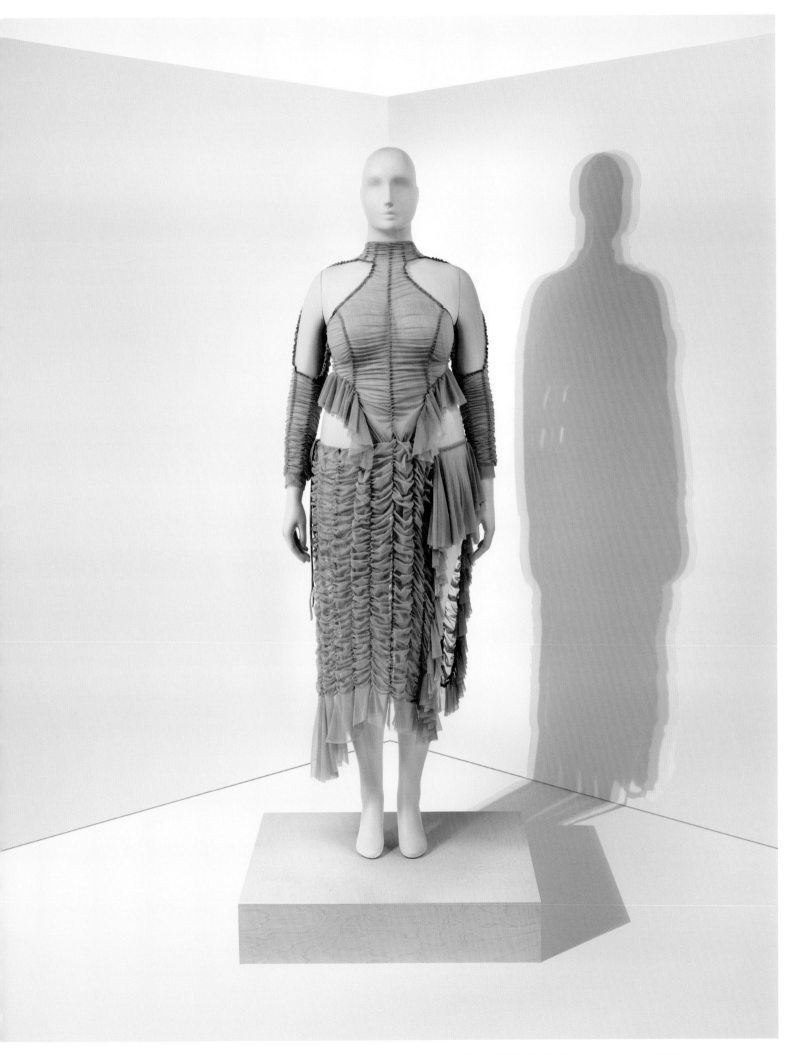

Ester Manas (French, born 1992) and *Balthazar Delepierre* (Belgian, born 1993) for ESTER MANAS (Belgian, founded 2019)
Dress, spring/summer 2022. Green polyester–elastane mesh

SIMONE ROCHA
Addressing the Maternal Body

Karen Van Godtsenhoven

An affiliative thread runs through Simone Rocha's fashion career, as she grew up surrounded by the fabrics of her father, Chinese Irish designer John Rocha. Her ethereal creations contain an outspoken feminine imaginary and sensibility, fusing romantic details with darker, gothic undertones. This spring/summer 2022 ensemble, the second look from her ten-year-anniversary collection, draws inspiration from the beauty and contradictions inherent in motherhood, as influenced by the birth of Rocha's second child. Here, she addresses the morphologically dubious maternal body—pregnant and postpartum—historically absent from catwalks and fashion weeks.[1]

In this collection, Rocha's tender garments feature details like veils, mother-of-pearl beading, and christening-gown sleeves that allude to traditionally Catholic rites of passage such as baptism, communion, and marriage, as well as motherhood. The gentle volumes of this ensemble accommodate an expectant mother's changing body. Decorative breast pockets beset with silver pearl beads recall the structure of a nursing bra, the outline of which is integrated into a corsage made of bedding brocade, and when dressed on the runway, the garment was accessorized with a pearl necklace of porcelain baby teeth—"found things & foundlings . . . baby teeth & lack of sleep," as stated in the show notes. The billowing sleeves resemble those of a nightgown, linking the ensemble to the privacy of the bedroom or nursery, whereas the floral embroidery and tulle refer to baptismal, communion, and wedding gowns, more public rites of transition. By fusing nightgowns with bedding, Rocha expresses the "out-of-control body dislocation that going through the whole [birth] process causes" and alludes to the "spooky, deranged insomnia"[2] that often accompanies motherhood. Her fascination with the work of Louise Bourgeois, whose own childhood and maternal trauma are woven into her soft, embroidered fabric works and large, looming metal *Maman* sculptures, inspired Rocha to express elements from her personal life in her work: "I loved the fact that the subject matter was so personal and how she reflected her life in her art in such a transparent way. . . . [M]aking art was a form of therapy for her."[3] The darker undercurrent of these emotions and unconscious processes is illustrated by the gothic sensibility Rocha's designs evoke. Like Bourgeois, Rocha lifts the taboo placed on the maternal body and brings it into the realm of fashion as a symbolic and creative motif.

1 Rocha had embraced a similar theme in her autumn/winter 2016–17 collection, which coincided with the birth of her first child.
2 Sarah Mower, "Simone Rocha: Spring 2022 Ready-to-Wear," *Vogue*, September 20, 2021, https://www.vogue.com/fashion-shows/spring-2022-ready-to-wear/simone-rocha.
3 Simone Rocha, "Simone Rocha's Ode to the Great Louise Bourgeois," *ES Magazine*, February 4, 2022, https://www.standard.co.uk/esmagazine/simone-rocha-louise-bourgeois-designer-b980568.html.

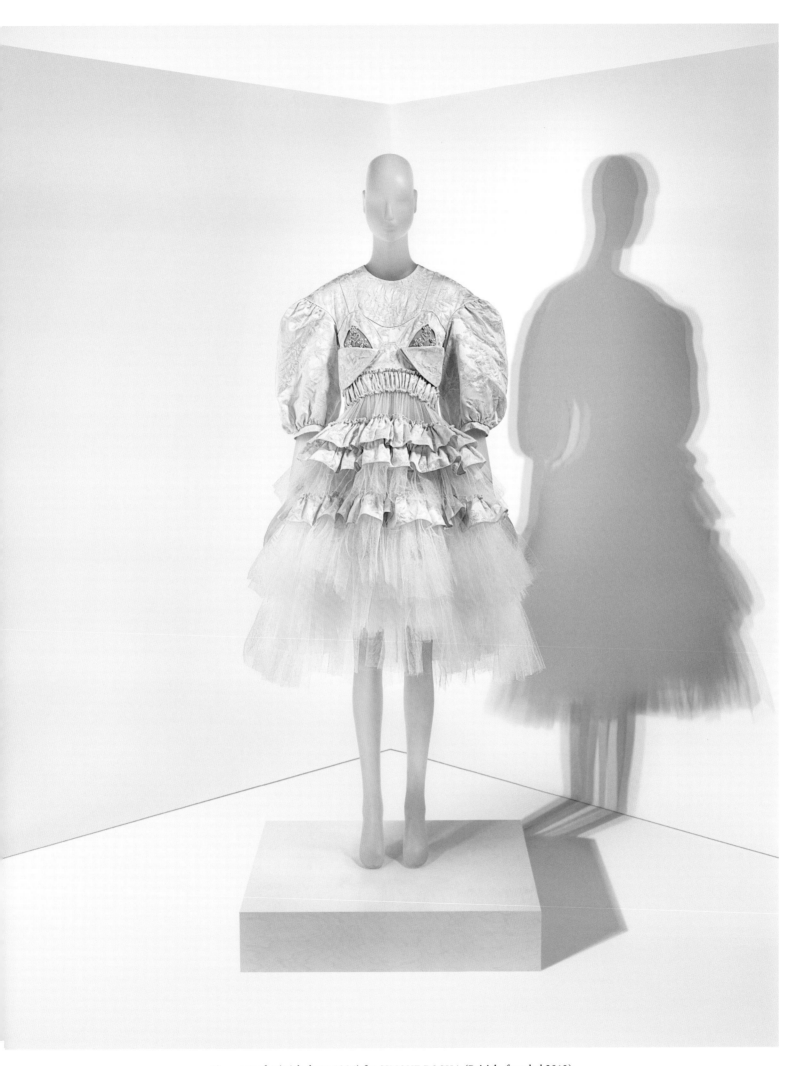

Simone Rocha (Irish, born 1986) for SIMONE ROCHA (British, founded 2010)
Ensemble, spring/summer 2022. White silk brocade and white nylon tulle embroidered with pearls

HANIFA'S "KINSHASA" DRESS
Color, Culture, and the Politics of Representation

Elizabeth Way

Anifa Mvuemba paid tribute to her Congolese roots with the "Kinshasa" dress, the first piece in Hanifa's influential 3D-animated "Pink Label Congo" capsule collection. The stunning fashion show omitted models, only drawing more attention to the inclusively embodied designs that sashayed across over 150,000 Instagram feeds. The idea of countering omissions is both deeply embedded and multilayered in the "Kinshasa" dress. Named after the capital of Democratic Republic of the Congo, the garment incorporates the red, blue, and yellow of the Congolese flag. In a short film and interview that preceded the collection presentation, Mvuemba discussed how a lack of awareness of the Congolese culture and situation has made the country and its people invisible in the international consciousness, even as 60 to 70 percent of Earth's supply of coltan—a vital ore in the manufacture of electronics—makes the world dependent on the nation's mining industry. Mvuemba shed light on the contrast between the country's beautiful natural resources and the horrific plight of child mining laborers. Viewers followed an animated YouTube search of "Democratic Republic of the Congo," underscoring the designer's commitment to encouraging her audience to research and understand issues of Congolese labor abuse and violence.

Yet Mvuemba's film also highlighted her pride in her Congolese heritage. Inspired by the stories of Congolese women's strength and perseverance, as related by her mother, the collection emphasizes "the beauty of Congo [that] is often untapped and overlooked."[1] The decision to center her collection on her background was well thought through; wary of the fashion industry's tendency to pigeonhole Black and African designers, she waited for the right time to bring this part of her identity as a designer to the fore.[2] Focusing on the intentional details of her designs, Mvuemba noted in the film, "If you're African then you know about . . . African seamstresses and how . . . detail . . . and color [are] so important. . . . I really wanted to make sure that I used that in this collection, just to give tribute to all the African seamstresses out there, not just Congo specifically."[3]

In the "Kinshasa" dress's national colors, red signifies pain, suffering, and blood, blue represents peace, and yellow symbolizes hope. It can be no coincidence that, from the front, the dress looks to be completely red. As movement is introduced, flashes of yellow show at the skirt's hem at the sides, and only from the back—a vantage point often omitted from fashion exhibitions—can the interplay of the three colors be seen. The backless cut makes the body of the wearer an integral part of the powerful design, and in the months after the Instagram presentation, the bodies of intergenerational Black American women stood in for the invisible model to make the "Kinshasa" dress an icon of the Hanifa brand. Actress and beauty entrepreneur Tracee Ellis Ross wore it in an August 2020 editorial shoot for Elle.com and actress Zendaya donned it on the cover of *InStyle* in September 2020. Both women specifically chose the dress to represent their allegiance to Black fashion creators and their often invisible impact.

1 Hanifa (@hanifaoffical), Instagram video, May 23, 2020, https://www.instagram.com/tv
 /CAhDULhAFvG/?hl=en.
2 Devine Blacksher, "The Designer Who Sent Ghost Models Down the Runway: Anifa Mvuemba
 Always Does Things Her Own Way," *The Cut*, September 14, 2020, https://www.thecut.com
 /2020/09/hanifa-designer-anifa-mvuemba-on-her-pink-label-congo-show.html.
3 Hanifa (@hanifaoffical), Instagram video.

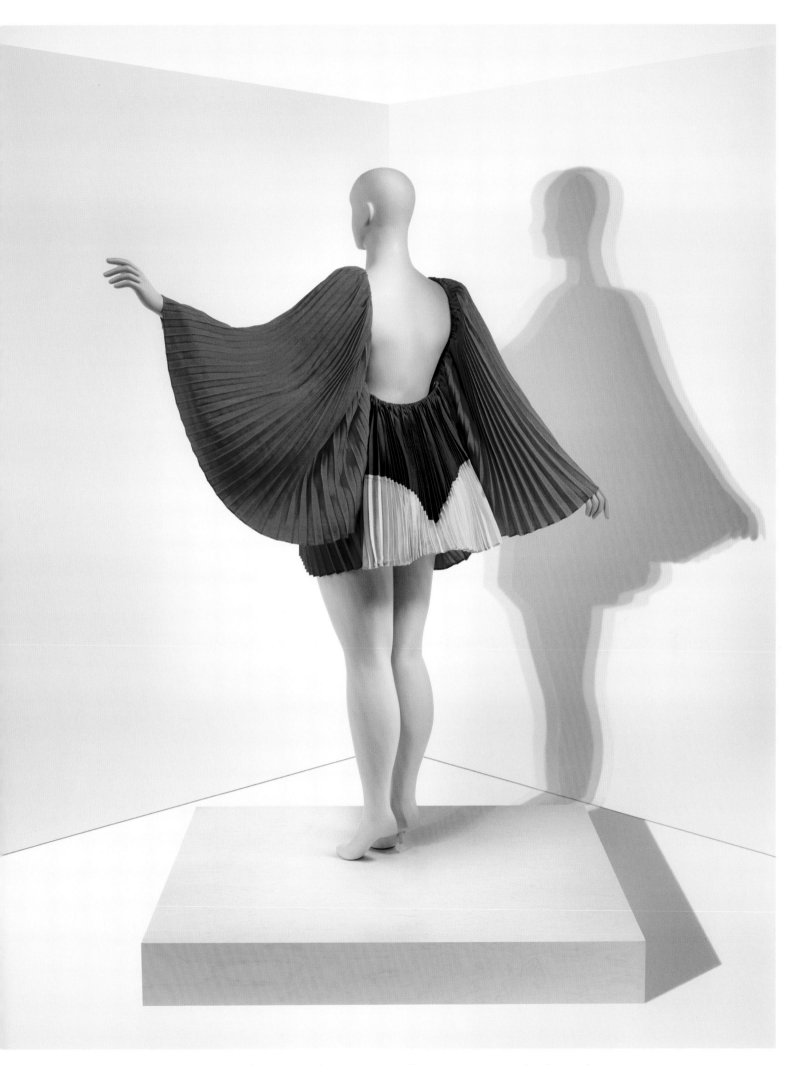

Anifa Mvuemba (American, born Kenya, 1990) for HANIFA (American, founded 2012)
"Kinshasa" dress, autumn/winter 2020–21 "Pink Label Congo." Red, blue, and yellow pleated polyester suiting

187

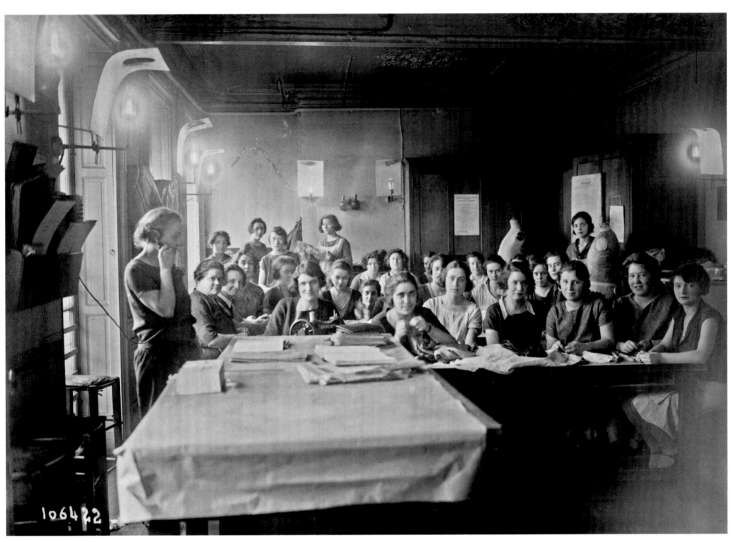

Seamstresses in the Paquin workrooms, 1926

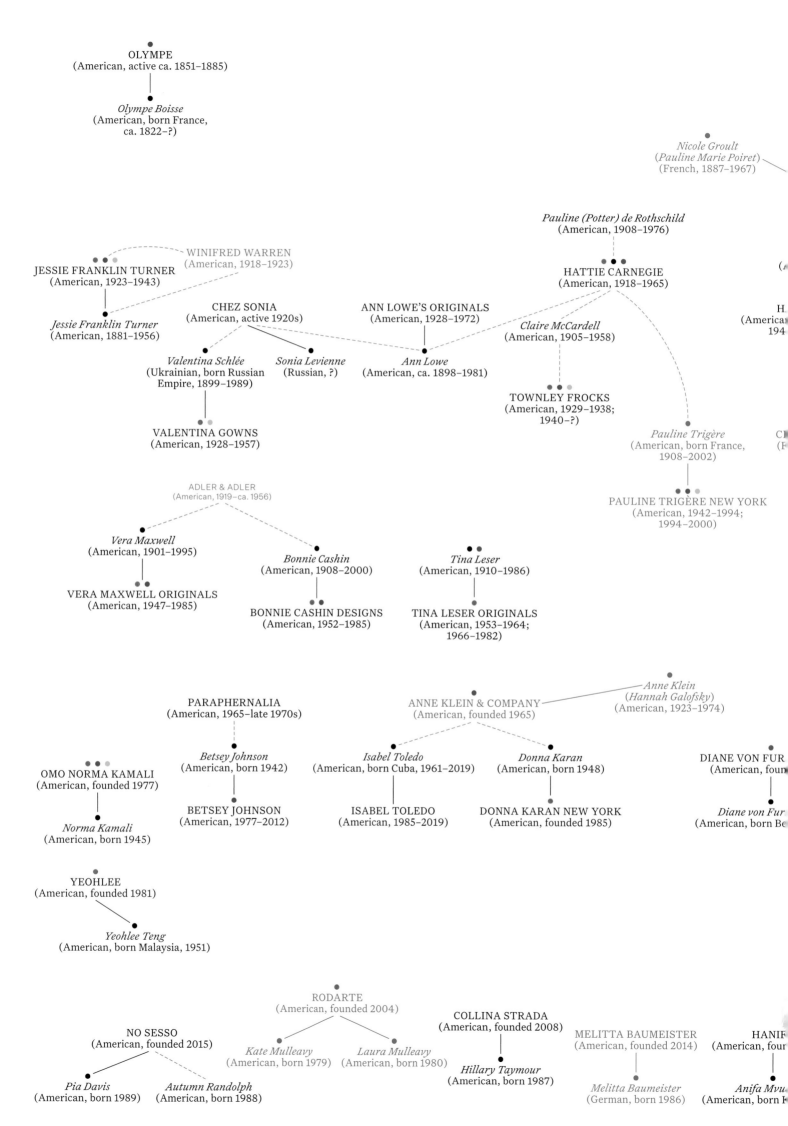

OLYMPE
(American, active ca. 1851–1885)

Olympe Boisse
(American, born France,
ca. 1822–?)

Nicole Groult
(*Pauline Marie Poiret*)
(French, 1887–1967)

Pauline (Potter) de Rothschild
(American, 1908–1976)

WINIFRED WARREN
(American, 1918–1923)

JESSIE FRANKLIN TURNER
(American, 1923–1943)

HATTIE CARNEGIE
(American, 1918–1965)

H.
(America
194

Jessie Franklin Turner
(American, 1881–1956)

CHEZ SONIA
(American, active 1920s)

ANN LOWE'S ORIGINALS
(American, 1928–1972)

Claire McCardell
(American, 1905–1958)

Valentina Schlée
(Ukrainian, born Russian
Empire, 1899–1989)

Sonia Levienne
(Russian, ?)

Ann Lowe
(American, ca. 1898–1981)

TOWNLEY FROCKS
(American, 1929–1938;
1940–?)

Pauline Trigère
(American, born France,
1908–2002)

C
(F

VALENTINA GOWNS
(American, 1928–1957)

PAULINE TRIGÈRE NEW YORK
(American, 1942–1994;
1994–2000)

ADLER & ADLER
(American, 1919–ca. 1956)

Vera Maxwell
(American, 1901–1995)

Bonnie Cashin
(American, 1908–2000)

Tina Leser
(American, 1910–1986)

VERA MAXWELL ORIGINALS
(American, 1947–1985)

BONNIE CASHIN DESIGNS
(American, 1952–1985)

TINA LESER ORIGINALS
(American, 1953–1964;
1966–1982)

Anne Klein
(*Hannah Galofsky*)
(American, 1923–1974)

PARAPHERNALIA
(American, 1965–late 1970s)

ANNE KLEIN & COMPANY
(American, founded 1965)

Betsey Johnson
(American, born 1942)

Isabel Toledo
(American, born Cuba, 1961–2019)

Donna Karan
(American, born 1948)

DIANE VON FUR
(American, foun

OMO NORMA KAMALI
(American, founded 1977)

BETSEY JOHNSON
(American, 1977–2012)

ISABEL TOLEDO
(American, 1985–2019)

DONNA KARAN NEW YORK
(American, founded 1985)

Diane von Fur
(American, born Be

Norma Kamali
(American, born 1945)

YEOHLEE
(American, founded 1981)

Yeohlee Teng
(American, born Malaysia, 1951)

RODARTE
(American, founded 2004)

COLLINA STRADA
(American, founded 2008)

MELITTA BAUMEISTER
(American, founded 2014)

HANIF
(American, four

NO SESSO
(American, founded 2015)

Kate Mulleavy
(American, born 1979)

Laura Mulleavy
(American, born 1980)

Hillary Taymour
(American, born 1987)

Pia Davis
(American, born 1989)

Autumn Randolph
(American, born 1988)

Melitta Baumeister
(German, born 1986)

Anifa Mvu
(American, born H

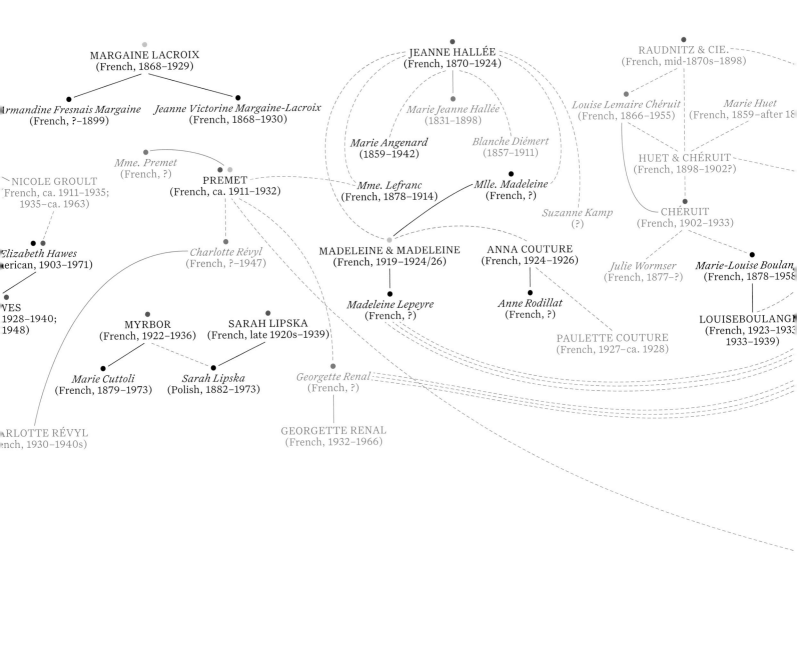

MARGAINE LACROIX
(French, 1868–1929)

rmandine Fresnais Margaine
(French, ?–1899)

Jeanne Victorine Margaine-Lacroix
(French, 1868–1930)

Mme. Premet
(French, ?)

PREMET
(French, ca. 1911–1932)

NICOLE GROULT
French, ca. 1911–1935;
1935–ca. 1963)

Elizabeth Hawes
erican, 1903–1971)

VES
1928–1940;
1948)

Charlotte Révyl
(French, ?–1947)

MYRBOR
(French, 1922–1936)

SARAH LIPSKA
(French, late 1920s–1939)

Marie Cuttoli
(French, 1879–1973)

Sarah Lipska
(Polish, 1882–1973)

RLOTTE RÉVYL
nch, 1930–1940s)

Georgette Renal
(French, ?)

GEORGETTE RENAL
(French, 1932–1966)

JEANNE HALLÉE
(French, 1870–1924)

Marie Jeanne Hallée
(1831–1898)

Marie Angenard
(1859–1942)

Blanche Diémert
(1857–1911)

Mme. Lefranc
(French, 1878–1914)

Mlle. Madeleine
(French, ?)

Suzanne Kamp
(?)

MADELEINE & MADELEINE
(French, 1919–1924/26)

ANNA COUTURE
(French, 1924–1926)

Madeleine Lepeyre
(French, ?)

Anne Rodillat
(French, ?)

PAULETTE COUTURE
(French, 1927–ca. 1928)

RAUDNITZ & CIE.
(French, mid-1870s–1898)

Louise Lemaire Chéruit
(French, 1866–1955)

Marie Huet
(French, 1859–after 18

HUET & CHÉRUIT
(French, 1898–1902?)

CHÉRUIT
(French, 1902–1933)

Julie Wormser
(French, 1877–?)

Marie-Louise Boulan
(French, 1878–1958

LOUISEBOULANG
(French, 1923–193
1933–1939)

TENBERG
ed 1972)

enberg
gium, 1946)

VIVIENNE TAM
(American, founded 1982)

Vivienne Tam
(American, born China, 1957)

A
ded 2012)

mba
enya, 1990)

JAMIE OKUMA
(American, founded 2012)

Jamie Okuma
(enrolled member of the La Jolla Band of
Mission Indians, Shoshone-Bannock, Wailaki,
Luiseño, and Okinawan, born 1977)

GENEALOGY OF WOMEN DESIGNERS

This genealogical chart traces just a few of the connections between women makers featured in this publication, reflecting the mentorship, business associations, and friendships that were forged across careers. While some of the designers included have been extensively documented, others are less remembered today. Research into these houses is ongoing, building upon the curiosity and perseverance of other scholars, and—we hope—inspiring continued inquiry into the lives and creative achievements of those for whom there remain questions and voids.

As an inherently collective endeavor, fashion represents the contributions of numerous roles, all of them essential throughout the process of creation and production. While it would be impossible for any diagram to contain the full scope and dynamism of the industry, with some exceptions, this didactic primarily focuses on the known designers and the associated houses that they worked for. Despite these caveats, and within the bounds of this limited purview, the plurality of this genealogy and the connective thread that runs between houses illustrate ways in which new generations of creators have built upon the legacies of their predecessors, as they forge new lines and associations of their own.

Fashion houses are arranged within the graphic following a geographical and chronological configuration, with designers placed above or below their associated houses. The chart begins with those working in America, followed by makers in France, Japan, England, Italy, Belgium, The Netherlands, and Denmark. Given the collection-based nature of this book and The Costume Institute's ongoing assessment of our holdings, there are also notations that highlight a selection of important relationships within our departmental history, considering the collection, its advocates, and key milestones as an additional layer in relation to the representation of women designers within the fashion canon.

Régina Callot Tennyson-Chantrell
(French, 1861–?)

séphine Callot Crimont
(French, 1866–1897)

Marthe Callot Bertrand
(French, 1859–1920)

Jeanne Lanvin
(French, 1867–1946)

Jeanne Paquin
(French, 1869–1936)

CALLOT SOEURS
(French, active 1895–1937)

LANVIN
(French, founded 1889)

PAQUIN
(French, 1891–1956)

Marie Callot Gerber
(French, 1857–1927)

Marie-Louise Bruyère
(French, 1884–after 1959)

AGNÈS
(French, 1906–1931)

Alice Bernard
(French, ?)

Mme. Claire
(?)

Marie-Blanche de Polignac
(French, 1897–1958)

Madeleine Vionnet
(French, 1876–1975)

ALICE BERNARD
(French, ca. 1918–ca. 1930)

Madeleine Wallis
(?)

VIONNET
(French, 1912–1914;
1918–1939)

Marcelle Chapsal
(French, 1891–1990)

Madeleine Maltezos
(French, 1900–1985)

Suzie Carpentier
(Adèle Clerisse)
(French, 1892–?)

AUGUSTABERNARD — — — Key Workroom Staff — — — SCHIAPARELLI
(French, 1923–1934) (French, 1927–1954)

BRUYÈRE
(French, 1928–1959)

Ana de Pombo
(Spanish, 1900–1985)

AGNÈS-DREC
(French, 1931–1

Augusta Bernard
(French, 1886–1946)

Elsa Schiaparelli
(Italian, 1890–1973)

MARCELLE CHAUMONT
(French, 1940–1953)

MAD CARPENTIER
(French, 1939–1957)

BIANCA MOSCA
(British, 1940–1950)

Bettina Bergery
(French, ca. 1860–1948)

Jeanne Have
(French, ca. 1860–

Mughette Buhler
(French, ?)

Bianca Mosca
(Bianca Lea Rosa Mottironi)
(Italian, ?–1950)

CÉLINE
(French, founded 1945)

DIOR
(French, founded by
Christian Dior, 1947)

CHLOÉ
(French, founded 1952)

Rei Kawakubo
(Japanese, born 1942,

Gaby Aghion
(French, 1921–2014)

Sonia Rykiel
(French, 1930–2016)

Maria Grazia Chiuri
(Italian, born 1964)

SONIA RYKIEL
(French, 1968–2019;
2021–present)

SONIA BY SONIA RYKIEL
(French, 1999–2016)

Grace Wales
(British, bor

HANAE MORI
(French, 1977–2004)

Phoebe Philo
(British, born 1973)

Hanae Mori
(Japanese, 1926–2022)

Gabriela Hearst
(Uruguayan, born 1976)

MARINE SERRE
(French, founded 2018)

Marine Serre
(French, born 1991)

BOUÉ SOEURS
(French, 1897–1957)

Sylvie Boué de Montegut
(French, 1872–1953)

Jeanne d'Etreillis
(French, 1876–1957)

LUCILE LTD., NEW YORK
(American, 1910–1932;
founded London, 1904)

Lucy Christiana Duff-Gordon
(British, 1863–1935)

FORTUNY
(Italian, founded 1906)

Mariano Fortuny y Madrazo
(Spanish, 1871–1949)

*Adèle Henriette Elisabeth
Nigrin Fortuny*
(French, 1877–1965)

DRECOLL
(French/British, 1902–1931)

Maggy Besançon de Wagner
(Belgian, 1896–1971)

CHANEL
(French, founded 1910)

Gabrielle Chanel
(French, 1883–1971)

PRADA
(Italian, founded 1913)

Miuccia Prada
(Italian, born 1949)

GALLENGA
(Italian, 1918–1974)

Maria Monaci Gallenga
(Italian, 1880–1944)

Anne-Marie Besançon de Wagner
(?)

MAGGY ROUFF
(French, 1927–1979)

ALIX BARTON
(French, 1933–1934)

Madame Grès
(*Germaine Émilie Krebs*)
(French, 1903–1993)

Julie Barton
(?)

NINA RICCI
(French, founded 1932)

Maria "Nina" Ricci
(Italian, 1883–1970)

ALIX
(French, 1934–1942)

GRÈS
(French, 1942–1988)

Barbara Hulanicki
(Polish, born 1936)

Jean Muir
(British, 1928–1995)

Zandra Rhodes
(British, born 1940)

Jil Sander
(German, born 1943)

COMME DES GARÇONS
(Japanese, founded 1969)

BIBA
(British, 1963–1975)

JEAN MUIR
(British, 1966–2007)

ZANDRA RHODES
(British, founded 1969)

JIL SANDER
(Italian, founded Germany, 1968)

VIVIENNE WESTWOOD
(British, founded 1971)

KATHARINE HAMNETT LONDON
(British, founded 1979)

Ann Demeulemeester
(Belgian, born 1959)

Vivienne Westwood
(British, 1941–2022)

GEORGINA GODLEY
(British, 1985–1999)

Katharine Hamnett
(British, born 1947)

ANN DEMEULEMEESTER
(Belgian, founded 1985)

Bonner
(1992)

ALEXANDER McQUEEN
(British, founded by
Alexander McQueen, 1992)

Georgina Godley
(British, born 1955)

STELLA McCARTNEY
(British, founded 2001)

Sarah Burton
(British, born 1974)

Stella McCartney
(British, born 1971)

WALES BONNER
(British, founded 2014)

SIMONE ROCHA
(British, founded 2010)

IRIS VAN HERPEN
(Dutch, founded 2007)

Iris van Herpen
(Dutch, born 1984)

ESTER MANAS
(Belgian, founded 2019)

CUSTOMIETY
(Danish, founded 2021)

Simone Rocha
(Irish, born 1986)

Ester Manas
(French, born 1992)

Balthazar Delepierre
(Belgian, born 1993)

Jasmin Søe
(Danish, born 1991)

KEY

MAKER-BASED INFORMATION

●——— Founding designer or eponymous house
- - - - - - - Designer movements between houses
- - - - - - - House movements through merger or reorganization
NAME Male designer/house founded by male designer

COLLECTION-BASED INFORMATION

<u>NAME</u> Past subject of monographic or dual exhibition
● Designer represented in The Costume Institute collection by direct donation
● Designer represented in the Brooklyn Museum costume collection gift
● Designer represented in the Sandy Schreier promised gift
● Cited or connected but not represented in publication checklist

CHECKLIST

Works in the Collection of The Metropolitan Museum of Art
(unless noted otherwise)

ANONYMITY

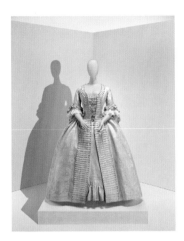
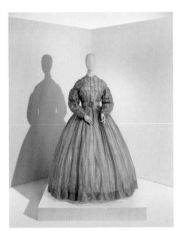
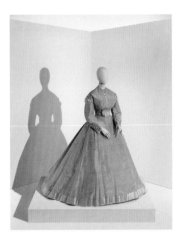
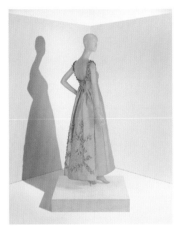

French
Robe à la française, ca. 1770; textile
1710–20
Ivory silk damask
Costume Institute Benefit Fund, 1999
(1999.41a, b)
p. 85

American
Afternoon dress, ca. 1861–63
Pink and cream silk gauze
Purchase, Irene Lewisohn Trust Gift, 2022
(2022.257a, b)
p. 87

Olympe Boisse (American, born France,
ca. 1822–?) for OLYMPE
(American, active ca. 1851–1885)
Evening dress, ca. 1865
Pink moiré silk taffeta trimmed with pink
silk taffeta, cream silk lace, and pink silk
satin with glass beads
Brooklyn Museum Costume Collection
at The Metropolitan Museum of Art,
Gift of the Brooklyn Museum, 2009;
Gift of Mrs. H. E. Rifflard, 1932
(2009.300.3009a, c–d)
p. 89

Ann Lowe (American, ca. 1898–1981)
for SAKS FIFTH AVENUE
(American, founded 1924)
Evening dress, 1960–62
Orange silk shantung appliquéd with
self-fabric flowers
Gift of Mrs. Carll Tucker Jr., 1979
(1979.260.2)
p. 91

VISIBILITY

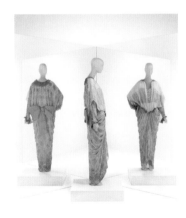
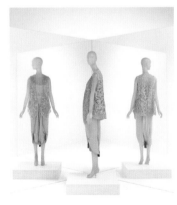
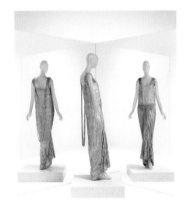
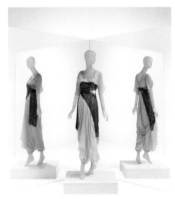

Probably *Madame Lefranc*
(French, 1878–1914)
for PREMET (French, ca. 1911–1932)
Tea gown, ca. 1913
Ivory and gold silk-metal jacquard chiffon,
pale pink chiffon, and gold metal lace
trimmed with gold lamé flowers and bow
of blue silk faille
Promised Gift of Sandy Schreier
(L.2019.43.48)
p. 98

Marie Callot Gerber (French, 1857–1927)
for CALLOT SOEURS
(French, 1895–1937)
Evening ensemble, ca. 1910
Vest of ivory linen Venetian-type lace;
bifurcated underdress of ivory silk
charmeuse and georgette
Brooklyn Museum Costume Collection
at The Metropolitan Museum of Art,
Gift of the Brooklyn Museum, 2009;
Gift of Mercedes de Acosta, 1954
(2009.300.1201, 2009.300.1197a, b)
p. 99

Probably *Madeleine Lepeyre* (French, ?)
and *Madame Madeleine* (French, ?)
for MADELEINE & MADELEINE
(French, 1919–1924/26)
Evening dress, ca. 1923
Pink silk crepe de chine and red cotton and
gold silk and metal lace, embroidered with
pink, silver, and blue-green bugle beads
and pink and blue-green synthetic stones
Promised Gift of Sandy Schreier
(L.2018.61.45)
p. 100

Marie Angenard (French, 1859–1942) for
JEANNE HALLÉE (French, 1870–1924)
Jupe culotte evening ensemble, 1911–12
Pink silk chiffon and satin and dark blue
silk net, embroidered with blue and silver
bugle beads and silver metal thread
Isabel Shults Fund, 1981 (1981.328.3)
p. 101

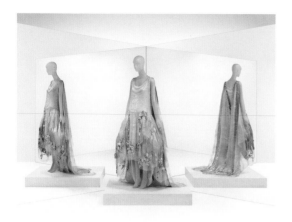
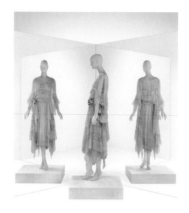
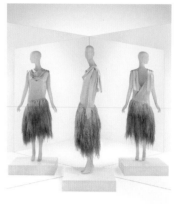

Sylvie Boué de Montegut (French, 1872–1953)
and *Jeanne d'Etreillis* (French, 1876–1957)
for BOUÉ SOEURS (French, 1897–1957)
Court presentation ensemble, 1928
Dress and train of pink silk chiffon and ivory tulle embroidered
with silver cord in a foliate and vermicelli pattern, with insets
of silver-blue silk and metal lamé with picot edging, appliquéd
with blue silk ribbon and polychrome silk flowers and floss
Gift of Mrs. George Henry O'Neil, 1968 (C.I.68.48a–c)
pp. 102–3

Lucy Christiana Duff-Gordon
(British, 1863–1935) for LUCILE LTD.,
NEW YORK (American, 1910–1932;
founded London, 1904)
Evening dress, 1922
Beige silk chiffon and lace with polychrome
silk flowers
Gift of the Staten Island Institute of Arts &
Sciences, pursuant to the instructions of
Mr. and Mrs. Elisha Dyer, 1976 (1976.217.6)
p. 104

Marie-Louise Boulanger (French,
1878–1958) for LOUISEBOULANGER
(French, 1923–1939)
Evening dress, 1928
Beige silk satin embroidered with natural
straw, and panels of beige silk tulle
embroidered with ombré-dyed beige and
pink knotted ostrich plumes
Gift of Mrs. Wolcott Blair, 1973 (1973.6a, b)
p. 105

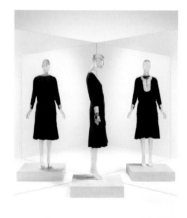
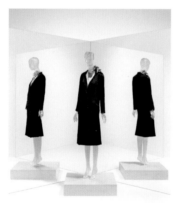
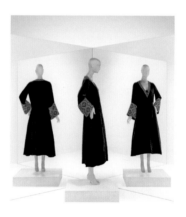
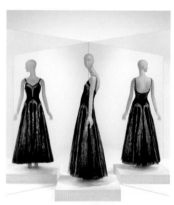

Probably *Charlotte Révyl*
(French, ?–1947)
for PREMET (French, ca. 1911–1932)
Dress, autumn/winter 1929–30
Black silk crepe de chine with collar, dickey,
and cuffs of ivory cotton and silk tulle
Gift of Mary Van Rensselaer Thayer, 1978
(1978.367.5)
p. 106

Gabrielle Chanel (French, 1883–1971)
for CHANEL (French, founded 1910)
Suit, ca. 1927
Jacket, blouse, and skirt of black and
ivory silk charmeuse with chrysanthemum
appliqué of black and white silk chiffon
Purchase, The New York Historical Society,
by exchange, 1984 (1984.29a–c)
p. 107

Sonia Levienne (Russian, ?) and
possibly *Valentina Schlée* (Ukrainian,
born Russian Empire, 1899–1989)
for CHEZ SONIA (American, active
1928–ca. 1938)
Evening dress, ca. 1928
Black silk velvet embroidered with gold
and bronze metal thread
Brooklyn Museum Costume Collection
at The Metropolitan Museum of Art,
Gift of the Brooklyn Museum, 2009;
Gift of the estate of Margaret Rudkin, 1967
(2009.300.2123)
p. 108

Gabrielle Chanel (French, 1883–1971)
for CHANEL (French, founded 1910)
Evening dress, autumn/winter 1938–39
Black silk tulle embroidered with red,
pink, gold, and silver sequin fireworks
Gift of Mrs. Harrison Williams, Lady Mendl,
and Mrs. Ector Munn, 1946 (C.I.46.4.7a–c)
p. 109

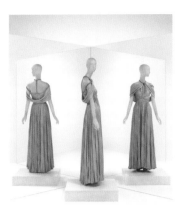
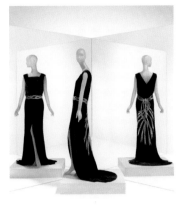
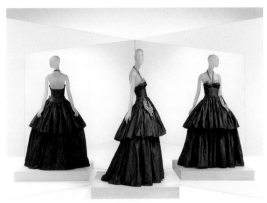

Marcelle Chapsal (French, 1891–1990)
for MARCELLE CHAUMONT
(French, 1940–1953)
Evening dress, autumn/winter 1948–49
Pleated gold lamé embroidered with
gold metal and silk braid and beads
Gift of Mrs. Byron C. Foy, 1953
(C.I.53.40.4a–c)
p. 110

Madeleine Vionnet (French, 1876–1975)
for VIONNET (French, 1912–1914;
1918–1939)
Evening dress, autumn/winter 1924–25
Dark brown silk velvet embroidered with
a trompe l'oeil ribbon belt of gold metal
thread and sequins
Gift of Amy Newman, in honor of Harold
Koda, 2017 (2017.314)
p. 111

Jeanne Lanvin (French, 1867–1946)
for LANVIN (French, founded 1889)
"Cyclone" evening dress, 1939
Gray silk taffeta embroidered with gold and coral sequins and beads
Gift of Mrs. Harrison Williams, Lady Mendl, and Mrs. Ector Munn,
1946 (C.I.46.4.18a, b)
pp. 112–13

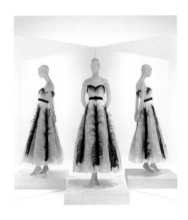
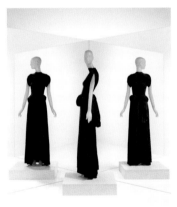
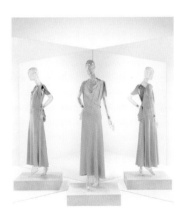
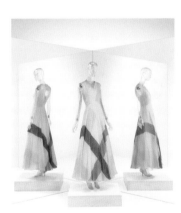

Ana de Pombo (Spanish, 1900–1985)
for PAQUIN (French, 1891–1956)
Evening dress, 1938
Ivory silk organza trimmed with black
colobus-monkey fur
Gift of Mrs. John Chambers Hughes, 1958
(C.I.58.34.20a, b)
p. 114

Madame Grès (*Germaine Émilie Krebs*)
(French, 1903–1993)
for ALIX (French, 1934–1942)
Evening dress, ca. 1936
Black silk jersey
Purchase, Friends of The Costume Institute
Gifts, 2020 (2020.57)
p. 115

Augusta Bernard (French, 1886–1946)
for AUGUSTABERNARD
(French, 1923–1934)
Dress, ca. 1932
Pale pink silk crepe de chine
Promised Gift of Sandy Schreier
(L.2019.43.28)
p. 116

Maria "Nina" Ricci (Italian, 1883–1970)
for NINA RICCI (French, founded 1932)
Evening dress, spring/summer 1937
Ivory, red, blue, pink, and green silk chiffon
and ivory satin-backed crepe
Gift of Mrs. Stephen M. Kellen, 1987
(1987.270.1a, b)
p. 117

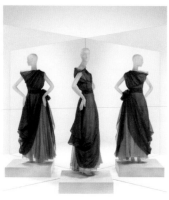
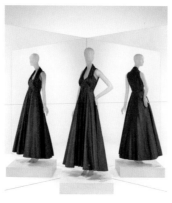
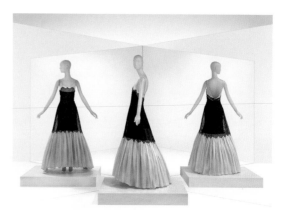

Madeleine Maltezos (French, 1900–1985)
and *Suzie Carpentier* (*Adèle Clerisse*)
(French, 1892–?) for MAD CARPENTIER
(French, 1939–1957)
Evening dress, late 1940s
Blue-green and navy silk organdy
Gift of Eleanora Eaton Brooks, 1975
(1975.139.3a–e)
p. 118

Elizabeth Hawes (American, 1903–1971)
for HAWES INCORPORATED
(American, 1928–1940; 1947–1948)
"The Styx" dress, autumn/winter 1936–37
Blue-green *changeante* silk taffeta and
green silk satin
Brooklyn Museum Costume Collection
at The Metropolitan Museum of Art,
Gift of the Brooklyn Museum, 2009;
Gift of Diana S. Field, 1963
(2009.300.869a)
p. 119

Maggy Besançon de Wagner (Belgian, 1896–1971)
for MAGGY ROUFF (French, 1927–1979)
Evening dress, ca. 1936
Pale blue-green cotton organdy and black cotton lace
Promised Gift of Sandy Schreier (L.2019.43.52a, b)
pp. 120–21

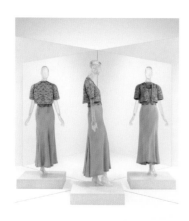
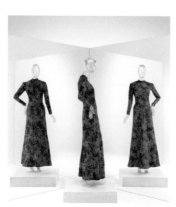
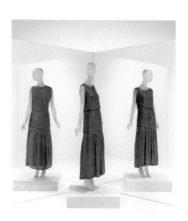
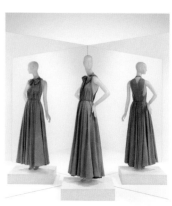

Jeanne Havet (French, ca. 1860–1948)
for AGNÈS-DRECOLL
(French, 1931–1963)
Evening ensemble, ca. 1932
Dress of pale green wool crepe embroidered
with pale blue and cream silk and gold metal
thread; dress clip of silver metal, coral, and
clear gemstones; bolero of orange silk crepe
embroidered with pale blue and cream silk
and gold metal thread
Gift of Miss Julia P. Wightman, 1990
(1990.104.11a–c)
p. 122

Elsa Schiaparelli (Italian, 1890–1973)
for SCHIAPARELLI (French, 1927–1954)
Evening dress, autumn/winter 1937–38
Green silk faille brocaded with black, green,
and iridescent gold metallic thread in a
wood-grain pattern with black metal zippers
Isabel Shults Fund, 2007 (2007.18)
p. 123

Jessie Franklin Turner
(American, 1881–1956)
for JESSIE FRANKLIN TURNER
(American, 1923–1943)
Evening dress, ca. 1920
Brown silk chiffon brocaded with bird
motifs in gold metal thread and white
and orange silk
Brooklyn Museum Costume Collection
at The Metropolitan Museum of Art,
Gift of the Brooklyn Museum, 2009;
Gift of Adelaide Goan, 1964
(2009.300.336a, b)
p. 124

Claire McCardell (American, 1905–1958)
for CLAIRE McCARDELL/
TOWNLEY FROCKS
(American, 1929–1938; 1940–ca. 1968)
"Future" dress, 1945
Brown silk shantung
Brooklyn Museum Costume Collection
at The Metropolitan Museum of Art,
Gift of the Brooklyn Museum, 2009;
Gift of Claire McCardell, 1956
(2009.300.2445)
p. 125

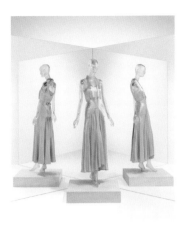 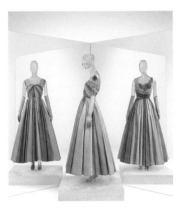 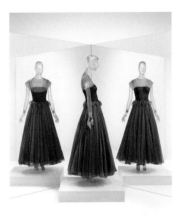 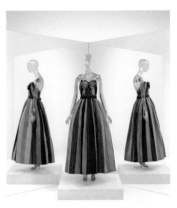

Marie-Louise Bruyère
(French, 1884–after 1959)
for BRUYÈRE (French, 1928–1959)
Evening dress, 1931–32
Ivory and pale pink satin rayon
Gift of Mrs. William Dubilier, 1964
(C.I.64.46.10)
p. 126

Marie-Louise Bruyère
(French, 1884–after 1959)
for BRUYÈRE (French, 1928–1959)
Evening ensemble, ca. 1952
Dress of pink and green striped silk taffeta;
gloves of pink silk taffeta
Purchase, Friends of The Costume Institute
Gifts, 2022 (2022.379a–c)
p. 127

Probably *Pauline (Potter) de Rothschild*
(American, 1908–1976) for HATTIE
CARNEGIE (American, 1918–1965)
Evening dress, ca. 1949
Brown silk marquisette embroidered with
shell motifs of silver bugle beads
Brooklyn Museum Costume Collection
at The Metropolitan Museum of Art,
Gift of the Brooklyn Museum, 2009;
Gift of Mrs. Leon A. Mnuchin, 1961
(2009.300.302)
p. 128

Probably *Pauline (Potter) de Rothschild*
(American, 1908–1976) for HATTIE
CARNEGIE (American, 1918–1965)
Evening dress, 1940–59
Polychrome striped *changeante* silk taffeta
Gift of Jean Stralem, 1993 (1993.463.3)
p. 129

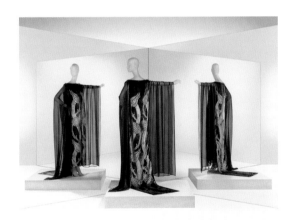 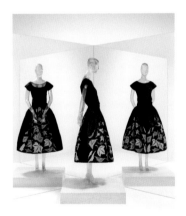 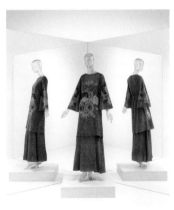

Maria Monaci Gallenga (Italian, 1880–1944)
for GALLENGA (Italian, 1918–1974)
"Theodosia" tea gown, ca. 1925
Purple silk velvet printed with silver and gold metallic powder
pigment; replica sleeves of purple silk crinkle chiffon embroidered
with glass beads
Gift of Mrs. Francis Coleman and Mrs. Charles H. Erhart Jr., 1975
(1975.383.3)
pp. 130–31

Marie Cuttoli (French, 1879–1973)
for MYRBOR (French, 1922–1936)
Evening dress, 1924
Black silk taffeta embroidered with
polychrome silk taffeta leaf motifs
Brooklyn Museum Costume Collection at
The Metropolitan Museum of Art,
Gift of the Brooklyn Museum, 2009;
Gift of Mrs. V. D. Crisp, 1963
(2009.300.3248)
p. 132

Sarah Lipska (Polish, 1882–1973)
for SARAH LIPSKA
(French, late 1920s–1939)
Dress, ca. 1928
Red silk crepe with floral appliqué of
polychrome silk crepe
Gift of Louis Rorimer, 1938 (C.I.38.2.18a, b)
p. 133

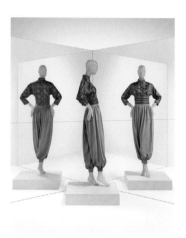

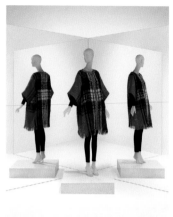

Tina Leser (American, 1910–1986)
for EDWIN H. FOREMAN, INC.
(American)
Lounging pajamas, 1948
Jumpsuit of gray wool jersey; bolero and
belt of red rayon satin jacquard embroidered
with polychrome peacock and floral motifs
Gift of Mr. Edwin H. Foreman, 1949
(C.I.49.20.1a–c)
p. 134

Bonnie Cashin (American, 1908–2000)
for BONNIE CASHIN DESIGNS
(American, 1952–1985)
Coat, 1958
Red, black, and white plaid mohair knit
and red leather
Gift of Louise Nevelson, 1978 (1978.390)
p. 135

AGENCY

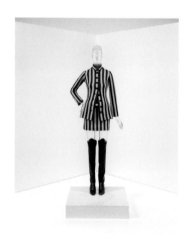

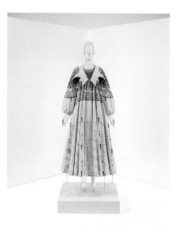

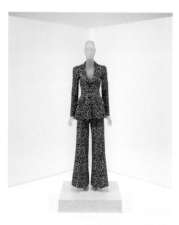

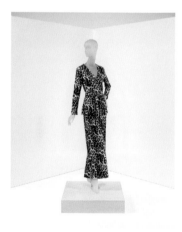

Betsey Johnson (American, born 1942)
for PARAPHERNALIA
(American, 1965–late 1970s)
Ensemble, 1966
Skirt suit of yellow and dark brown striped
cotton knit
Gift of Jane Holzer, 1974 (1974.384.37a–d)

worn with

André Perugia (French, 1893–1977)
for CHARLES JOURDAN
(French, founded 1919)
Boots, ca. 1968
Brown leather
Gift of Jane Holzer, 1977 (1977.115.29a, b)
p. 142

Zandra Rhodes (British, born 1940)
for ZANDRA RHODES
(British, founded 1969)
Coat, 1968–69
Yellow wool felt, screen printed with
"The Knitted Circle" and "Diamonds and
Roses" patterns in black and red
Gift of Zandra Rhodes, 1973 (1973.60.2)
p. 143

Barbara Hulanicki (Polish, born 1936)
for BIBA (British, 1963–1975)
Suit, ca. 1972
Brown and black polyester and gold metal
knit jacquard with leopard-print motifs
Gift of the Estate of Luciana Martinez de la
Rosa, 1997 (1997.59.7a, b)
p. 144

Diane von Furstenberg
(American, born Belgium, 1946)
for DIANE VON FURSTENBERG
(American, founded 1972)
Ensemble, ca. 1970–79
Blouse and pants of brown, white, and
black leopard-print cotton-rayon knit
Gift of Blanche Perris Kahn, 1999
(1999.378a, b)
p. 145

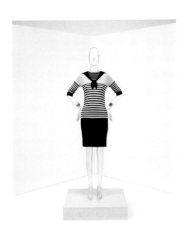
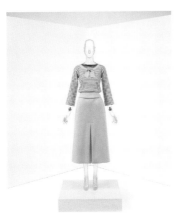
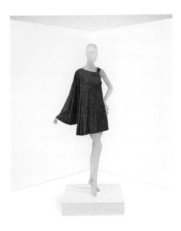
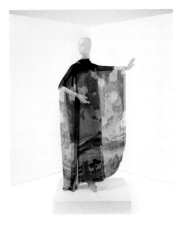

Sonia Rykiel (French, 1930–2016)
for SONIA BY SONIA RYKIEL
(French, 1999–2016)
Dress, spring/summer 2010
Black and white striped cotton knit
Gift of Mellissa Huber, 2023 (2023.231.1)
p. 146

Sonia Rykiel (French, 1930–2016)
for SONIA RYKIEL (French, 1968–2019;
2021–present)
Ensemble, 1974–76
Sweater of light pink, red, and white striped
wool knit; skirt of light pink wool knit
Gift of Lauren Bacall, 1979 (1979.324.6a, b)
p. 147

Jean Muir (British, 1928–1995)
for JEAN MUIR (British, 1966–2007)
Dress, 1980s
Red rayon jersey
Promised Gift of Sandy Schreier
(L.2019.43.42)
p. 148

Hanae Mori (Japanese, 1926–2022)
for HANAE MORI (French, 1977–2004)
Evening dress, autumn/winter 1974–75
Polychrome printed silk chiffon with
Japanese-landscape and cherry-blossom
motifs
Gift of Madame Hanae Mori, 1975
(1975.86.3a, b)
p. 149

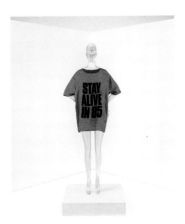
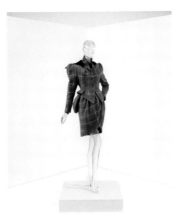
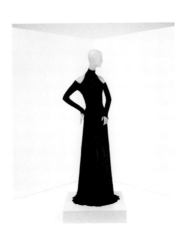
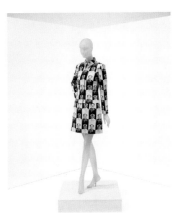

Katharine Hamnett (British, born 1947)
for KATHARINE HAMNETT LONDON
(British, founded 1979)
"Stay Alive in 85" T-shirt, 1985
Red silk plain weave printed with black text
Promised Gift of Sandy Schreier
(L.2019.43.16)
p. 150

Vivienne Westwood (British, 1941–2022)
for VIVIENNE WESTWOOD
(British, founded 1971)
"On Liberty" suit, autumn/winter 1994–95
Jacket and skirt of red, yellow, and white
wool-cotton windowpane-plaid twill,
trimmed with black cotton velvet; dress
and bustle of red, yellow, white, blue, and
black cotton tartan
Gift of Vivienne Westwood, 1995
(1995.213a–c, h)
p. 151

Donna Karan (American, born 1948)
for DONNA KARAN NEW YORK
(American, founded 1985)
Evening ensemble, autumn/winter 1992–93
Black silk matte jersey
Gift of The Donna Karan Company, 1997
(1997.459a)
p. 152

Vivienne Tam (American,
born China, 1957) for VIVIENNE TAM
(American, founded 1982)
"Mao" suit, spring/summer 1995; edition
2015
Black and white polyester jacquard
woven with positive and negative images
of Mao Zedong
Gift of Vivienne Tam, 2022 (2022.448a, b)
p. 153

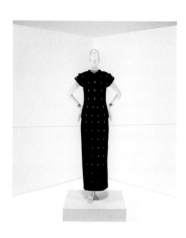

Jil Sander (German, born 1943)
for JIL SANDER (Italian, founded
Germany, 1968)
Suit, autumn/winter 1998–99
Black wool twill underlaid with white cotton
plain weave
Gift of Mrs. Michael Lewis, 2001
(2001.786a, b)
p. 154

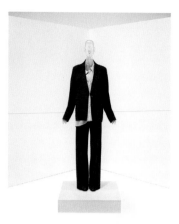

Ann Demeulemeester (Belgian, born 1959)
for ANN DEMEULEMEESTER
(Belgian, founded 1985)
Suit, spring/summer 1997
Jacket and pants of black synthetic twill;
shirt of lavender and dark gray synthetic
piqué; undershirt of white rayon jersey
Gift of Ann Demeulemeester, 1998
(1998.513.4a–d)
p. 155

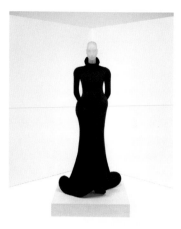

Georgina Godley (British, born 1955)
for GEORGINA GODLEY (British,
1985–1999)
Dress, autumn/winter 1986–87; edition 2019
Dress of black viscose jersey; underdress
of black cotton-Lycra jersey padded with
synthetic foam, batting, and cotton domette
Purchase, Friends of The Costume Institute
Gifts, 2019 (2019.433a, b)
p. 156

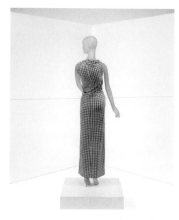

Rei Kawakubo (Japanese, born 1942)
for COMME DES GARÇONS (Japanese,
founded 1969)
Dress, spring/summer 1997
Dress of black and white synthetic gingham
plain weave, with nylon, polyurethane, and
down padding
Gift of Barneys New York, 1998
(1998.516.1a, b)
p. 157

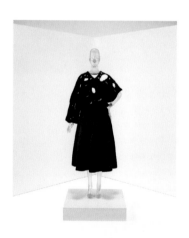

Rei Kawakubo (Japanese, born 1942)
for COMME DES GARÇONS
(Japanese, founded 1969)
Ensemble, autumn/winter 1982–83
Sweater of black wool knit; skirt of black
cotton plain weave and black polyester
batting; T-shirt of white cotton jersey
Gift of COMME des GARÇONS, 2020
(2020.243.7a–c)
p. 158

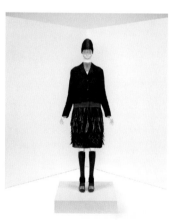

Miuccia Prada (Italian, born 1949)
for PRADA (Italian, founded 1913)
Ensemble, autumn/winter 2007–8
Coat of black silk-linen-synthetic
gabardine novelty weave with green felted
wool embroidered with black feathers and
black rectangular sequins; skirt of black
silk gabardine embroidered with black
rectangular sequins
Gift of PRADA, in honor of Harold Koda,
2016 (2016.636a–g)
p. 159

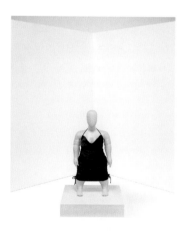

Jasmin Søe (Danish, born 1991) for
CUSTOMIETY (Danish, founded 2021)
"Going Out" dress, 2021
Black polyester satin
Gift of Mellissa Huber, 2023 (2023.231.2)
p. 160

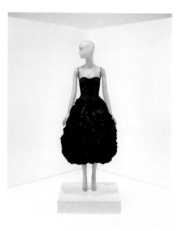

Norma Kamali (American, born 1945)
for OMO NORMA KAMALI
(American, founded 1977)
Evening dress, 1978
Black nylon ripstop
Gift of Anne Byrne, 1980 (1980.336.3)
p. 161

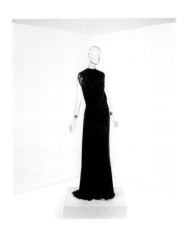

Isabel Toledo (American, born Cuba, 1961–2019) for ISABEL TOLEDO (American, 1985–2019)
"Kangaroo" dress, spring/summer 1993
Black rayon jersey
Purchase, Friends of The Costume Institute Gifts, 2023 (2023.73)
p. 162

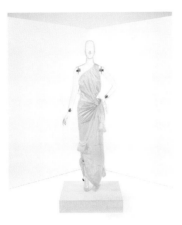

Pia Davis (American, born 1989) and *Autumn Randolph* (American, born 1988) for NO SESSO (American, founded 2015)
"One Titty Dress (OTD)," autumn/winter 2022–23
Dress of white nylon with silver metal hardware
Purchase, Millia Davenport and Zipporah Fleisher Fund, 2023 (2023.145)
p. 163

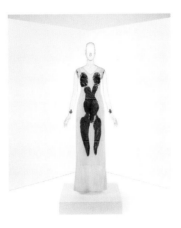

Phoebe Philo (British, born 1973) for CÉLINE (French, founded 1945)
"Céline-Yves Klein" dress, spring/summer 2017
White double stretch polyamide fishnet with body print in "Klein blue" pigment
Gift of Céline, 2023 (2023.371a, b)
p. 164

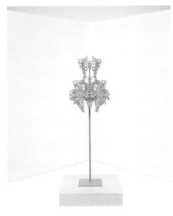

Iris van Herpen (Dutch, born 1984) for IRIS VAN HERPEN (Dutch, founded 2007)
Ensemble, autumn/winter 2011–12
Skeleton dress of white polyamide 3D printed by Materialise
Purchase, Friends of The Costume Institute Gifts, 2012 (2012.560a, b)
p. 165

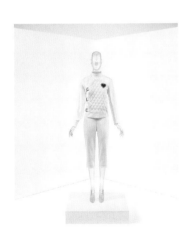

Maria Grazia Chiuri (Italian, born 1964) for DIOR (French, founded 1947)
Ensemble, spring/summer 2017; edition 2020
Jacket of white cotton canvas with matelassé quilting embroidered with a heart motif in red silk and glass seed beads; shirt of white cotton plain weave and piqué; knickers of white cotton canvas
Gift of Christian Dior Couture, in celebration of the Museum's 150th Anniversary, 2021 (2021.68.2a–c)
p. 166

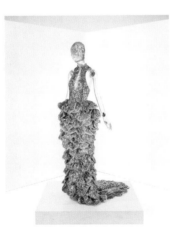

Sarah Burton (British, born 1974) for ALEXANDER MCQUEEN (British, founded 1992)
Ensemble, spring/summer 2012
Dress of white silk organza and nude silk mesh embroidered with silver glass beads, clear glass crystals, and silver metal feather-shaped paillettes; headpiece of silver synthetic Chantilly lace embroidered with silver metal feather-shaped sequins and silver and gray glass beads
Gift of Alexander McQueen, 2017 (2017.199a–e)
p. 167

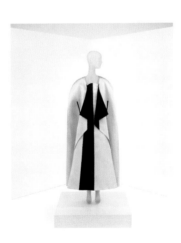

Yeohlee Teng (American, born Malaysia, 1951) for YEOHLEE (American, founded 1981)
Cape and evening dress, autumn/winter 1993–94; spring/summer 1992
Black and ivory double-faced silk satin
Gift of Yeohlee Teng, 1995 (1995.72.7; 1995.72.1)
p. 168

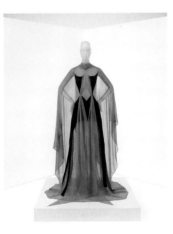

Jamie Okuma (enrolled member of the La Jolla Band of Mission Indians, Shoshone-Bannock, Wailaki, Luiseño, and Okinawan, born 1977)
"Parfleche" dress, 2021
Black silk satin and nude synthetic net with antique cut-steel button
Purchase, Friends of The Costume Institute Gifts, 2023 (2023.366)
p. 169

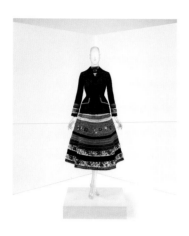

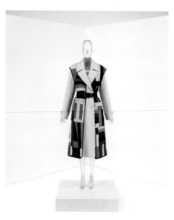

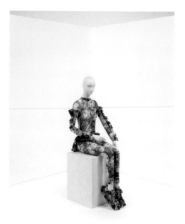

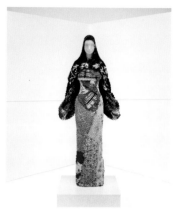

Maria Grazia Chiuri (Italian, born 1964)
and *Grace Wales Bonner* (British, born
1992) for DIOR (French, founded 1947)
Ensemble, cruise 2020; edition 2022
Jacket of black silk shantung crocheted
with red, white, and green viscose; skirt of
red, white, green, and black striped raffia
embroidered with flowers
Gift of Christian Dior Couture, 2023
(2023.368a, b)
p. 170

Gabriela Hearst (Uruguayan, born 1976)
for CHLOÉ (French, founded 1952)
Ensemble, autumn/winter 2022–23
Coat of ivory brushed wool-polyamide;
vest of polychrome quilted silk crepe
remnants; belt of black leather with brass
metal buckle
Courtesy Chloé
p. 171

Members of the Gee's Bend Quilting
Collective who collaborated on this
garment include: Loretta Pettway Bennett,
Marlene Bennett Jones, Lue Ida McCloud,
Doris Mosely, Cassandra Pettway,
Caster Pettway, Emma Mooney Pettway,
Kristin Pettway, Mary Margaret Pettway,
Stella Mae Pettway, Veronica Saulsberry,
Pleasant Scott, Andrea Pettway Williams,
and Sharon Williams

Hillary Taymour (American, born 1987)
for COLLINA STRADA
(American, founded 2008)
Ensemble, autumn/winter 2021–22
Bodysuit of polychrome printed deadstock
lace with motifs by Charlie Engman for
Collina Strada; Reebok sneakers with
laces and appliqué of polychrome printed
deadstock lace with motifs by Charlie
Engman for Collina Strada
Purchase, Gould Family Foundation, 2023
(2023.246a–c)
p. 172

Marine Serre (French, born 1991) for
MARINE SERRE (French, founded 2018)
Dress, spring/summer 2022
Polychrome printed polyester-elastane
and recycled polychrome printed
polyester-elastane
Purchase, The Gould Family Foundation,
in memory of Jo Copeland, 2023
(2023.395a)
p. 173

ABSENCE/OMISSION

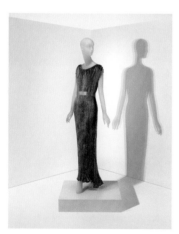

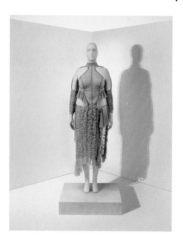

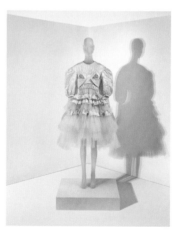

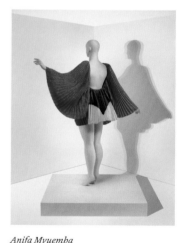

Adèle Henriette Elisabeth Nigrin Fortuny
(French, 1877–1965) and *Mariano
Fortuny y Madrazo* (Spanish, 1871–1949)
for FORTUNY (Italian, founded 1906)
"Delphos" gown, ca. 1932
Blue-green pleated silk taffeta with belt
of green silk plain weave printed with
gold metallic pigment
Gift of Robert Rubin, in memory of Doris
Rubin, 2011 (2011.443.1a, b)
p. 181

Ester Manas (French, born 1992)
and *Balthazar Delepierre* (Belgian,
born 1993) for ESTER MANAS
(Belgian, founded 2019)
Dress, spring/summer 2022
Green polyester-elastane mesh
Purchase, Millia Davenport and Zipporah
Fleisher Fund, 2023 (2023.50)
p. 183

Simone Rocha (Irish, born 1986) for
SIMONE ROCHA (British, founded 2010)
Ensemble, spring/summer 2022
White silk brocade and white nylon tulle
embroidered with pearls
Gift of Simone Rocha, 2023 (2023.118.1a)
p. 185

Anifa Mvuemba
(American, born Kenya, 1990)
for HANIFA (American, founded 2012)
"Kinshasa" dress, autumn/winter 2020–21
"Pink Label Congo"
Red, blue, and yellow pleated polyester
suiting
Purchase, Millia Davenport and Zipporah
Fleisher Fund, 2023 (2023.250)
p. 187

SELECTED BIBLIOGRAPHY

Amnéus, Cynthia, ed. *A Separate Sphere: Dressmakers in Cincinnati's Golden Age, 1877–1922*. Exh. cat. Cincinnati, Ohio: Cincinnati Art Museum; Lubbock: Texas Tech University Press, 2003.

Ballard, Bettina. *In My Fashion*. New York: David McKay, 1960.

Bass-Krueger, Maude. "Sonia Rykiel (1930–2016), a Fashion Revolutionary." Hypotheses, August 25, 2016. https://histoiredemode.hypotheses .org/3722.

Bass-Krueger, Maude, and Sophie Kurkdjian. *French Fashion, Women & the First World War*. Exh. cat. New York: Bard Graduate Center, 2019.

Beauvoir, Simone de. *The Second Sex*. Translated by H. M. Parshley. Harmondsworth, U.K.: Penguin Books, 1974.

Benstock, Shari, and Suzanne Ferriss. *On Fashion*. New Brunswick, N.J.: Rutgers University Press, 1994.

Berch, Bettina. *Radical by Design: The Life and Style of Elizabeth Hawes*. New York: E. P. Dutton, 1988.

Bertin, Célia. *Paris à la Mode*. New York: Harper, 1957.

Besançon de Wagner, Maggy, and André Dignimont. *Ce que j'ai vu en chiffonnant la clientèle*. Paris: Librairie des Champs-Élysées, 1938.

Besançon de Wagner, Maggy, and Léon Benigni. *La Philosophie de l'élégance*. Paris: Éditions littéraires de France, 1945.

Blum, Dilys. *Shocking!: The Art and Fashion of Elsa Schiaparelli*. Exh. cat. Philadelphia: Philadelphia Museum of Art, 2003.

Braidotti, Rosi. *Nomadic Subjects: Embodiment and Sexual Difference in Contemporary Feminist Theory*. New York: Columbia University Press, 1994.

Buckley, Cheryl, and Hilary Fawcett. *Fashioning the Feminine: Representation and Women's Fashion from the Fin de Siecle to the Present*. London: I. B. Tauris, 2002.

Butler, Judith. *Gender Trouble: Feminism and the Subversion of Identity*. New York: Routledge, 1990.

Chadwick, Whitney, and Tirza True Latimer. *The Modern Woman Revisited: Paris between the Wars*. New Brunswick, N.J.: Rutgers University Press, 2003.

Chantrell, Lydie. *Les Moires 1895– 1920: Mesdames Callot Soeurs*. Paris: Groupement économique "France-Gutenberg," 1978.

Chapsal, Madeleine. *Madeleine Vionnet, ma mère et moi. L'éblouissement de la haute couture*. Paris: Éditions J'ai Lu, 2011.

Chase, Edna Woolman, and Ilka Chase. *Always in Vogue*. Garden City, N.Y.: Doubleday, 1954.

Cixous, Hélène. "The Laugh of the Medusa." Translated by Keith Cohen and Paula Cohen. *Signs* 1, no. 4 (Summer 1976): 875–93.

Collins, Charlotte. "Anifa Mvuemba Is the Future of Fashion." *InStyle*, November 16, 2021. https://www .instyle.com/fashion/anifa-mvuemba -instyle-award.

Conor, Liz. *The Spectacular Modern Woman: Feminine Visibility in the 1920s*. Bloomington: Indiana University Press, 2004.

Conwill, Kinshasha Holman, and Paul Gardullo, eds. *Make Good the Promises: Reclaiming Reconstruction and Its Legacies*. New York: HarperCollins, 2021.

Crawford, M. D. C. *The Ways of Fashion*. New York: G. P. Putnam, 1941.

Crowston, Clare Haru. *Fabricating Women: The Seamstresses of Old Regime France, 1675–1791*. Durham, N.C.: Duke University Press, 2001.

D'Eaubonne, Françoise. *Le Féminisme ou la mort*. Paris: Pierre Horay, 1974.

Deihl, Nancy, ed. *The Hidden History of American Fashion: Rediscovering 20th-Century Women Designers*. London: Bloomsbury Academic, 2018.

Deleuze, Gilles, and Félix Guattari. *A Thousand Plateaus: Capitalism and Schizophrenia*. Vol. 2, translated by Brian Massumi. Minneapolis: University of Minnesota Press, 1987.

Delpierre, Madeleine. *La Mode et ses métiers: Du XVIIIᵉ siècle à nos jours*. Exh. cat. Paris: Le Musée, 1981.

Denning, Michael. *The Cultural Front: The Laboring of American Culture in the Twentieth Century*. London: Verso Press, 1997.

Entwistle, Joanne. *The Fashioned Body: Fashion, Dress, and Modern Social Theory*. 2nd ed. Cambridge: Polity Press, 2015.

Epstein, Beryl Williams. *Fashion Is Our Business*. Philadelphia: J. B. Lippincott, 1945.

Ettinger, Bracha L. "Copoiesis." *Ephemera* 5(X), no. 4 (December 2005): 703–4.

Evans, Caroline. *The Mechanical Smile: Modernism and the First Fashion Shows in France and America 1900–1929*. New Haven, Conn.: Yale University Press, 2013.

Evans, Caroline, and Minna Thornton. "Fashion, Representation, Femininity." *Feminist Review*, no. 38 (Summer 1991): 48–66.

Ferretti, Daniela, and Cristina Da Roit, eds. *Henriette Fortuny: Portrait of a Muse*. Exh. cat. Venice: Fondazione Musei Civici di Venezia, 2016.

Fisher, Fiona, ed. *Performance, Fashion and the Modern Interior: From the Victorians to Today*. London: Berg, 2011.

Font, Lourdes M. "International Couture: The Opportunities and Challenges of Expansion, 1880–1920." *Business History* 54, no. 1 (2012): 30–47.

Ford, Tanisha C. "Overlooked: Zelda Wynn Valdes." *New York Times*, January 9, 2019. https://www.nytimes.com /interactive/2019/obituaries/zelda -wynn-valdes-overlooked.html.

Friedan, Betty. *The Feminine Mystique*. New York: W. W. Norton, 2013.

Fuentes, Marisa J. *Dispossessed Lives: Enslaved Women, Violence, and the Archive*. Philadelphia: University of Pennsylvania Press, 2016.

Fukai, Akiko. "Japonism in Fashion." In *Japonism in Fashion*. Exh. cat. Kyoto: Kyoto Costume Institute, 1994. chrome-extension:// efaidnbmnnnibpcajpcglclefindmkaj /https://www.kci.or.jp/en/research /dresstudy/pdf/e_Fukai_Japonism_in _Fashion.pdf.

Gamber, Wendy. *The Female Economy: The Millinery and Dressmaking Trades, 1860–1930*. Urbana: University of Illinois Press, 1997.

———. "'Reduced to Science': Gender, Technology, and Power in the American Dressmaking Trade, 1860–1910," *Technology and Culture* 36, no. 3 (July 1995): 455–82.

Garnier, Guillaume. *Paris-Couture- Années Trente*. Exh. cat. Paris: Le Musée, 1987.

Gonzales, David. "Matriarch of Dancers Sews Clothing of Delight." *New York Times*, March 23, 1994, B3.

Green, Nancy L. *Ready-to-Wear and Ready-to-Work: A Century of Industry and Immigrants in Paris and New York*. Durham, N.C.: Duke University Press, 1997.

Grossiord, Sophie. *Roman d'une garde-robe: Le chic d'une parisienne de la belle époque aux années 30*. Exh. cat. Paris: Paris Musées, les musées de la mode de la Ville de Paris, 2013.

Guy-Sheftall, Beverly. *Daughters of Sorrow: Attitudes Toward Black Women: 1880–1920*. Brooklyn, N.Y.: Carlson, 1990.

Hawes, Elizabeth. *Fashion Is Spinach*. New York: Random House, 1938.

———. *It's Still Spinach*. Boston: Little, Brown, 1954.

———. "The Woman Problem." *Antioch Review* 5, no. 1 (Spring 1945): 46–55.

———. *Why Women Cry; or, Wenches with Wrenches*. New York: Reynal & Hitchcock, 1943.

Hawes, Elizabeth, and James Thurber. *Men Can Take It*. New York: Random House, 1941.

Higginbotham, Evelyn Brooks. *Righteous Discontent: The Women's Movement in the Black Baptist Church, 1880–1920*. Cambridge, Mass.: Harvard University Press, 1993.

Hohé, Madelief, Georgette Koning, and Eve Demoen. *Femmes Fatales: Sterke Vrouwen in de Mode = Strong Women in Fashion*. Exh. cat. Zwolle, Netherlands: Waanders Uitgevers, 2018.

Irigaray, Luce. *This Sex which Is Not One*. Translated by Catherine Porter with Carolyn Burke. Ithaca, N.Y.: Cornell University Press, 1985.

Kirke, Betty. *Madeleine Vionnet*. San Francisco: Chronicle Books, 2012.

Koda, Harold, Richard Martin, and Laura Sinderbrand. *Three Women: Madeleine Vionnet, Claire McCardell, and Rei Kawakubo*. Exh. cat. New York: Fashion Institute of Technology, 1987.

Kurkdjian, Sophie, and Sandrine Teinturier. *Au coeur des maisons de couture: une histoire sociale des ouvrières de la mode (1880–1950)*. Paris: Éditions de l'atelier, 2021.

Lambert, Eleanor. *World of Fashion: People, Places, Resources*. New York: R. R. Bowker, 1976.

Laughlin, Kathleen A., Julie Gallagher, Dorothy Sue Cobble, Eileen Boris, Premiila Nadasen, Stephanie Gilmore, and Leandra Zarnow. "Is It Time to Jump Ship? Historians Rethink the Waves Metaphor." *Feminist Formations* 22, no. 1 (Spring 2010): 76–135.

Librairie Diktats. *Sous la coupe des femmes: Figures féminines de la mode, de Rose Bertin à Rei Kawakubo*. Paris: Diktats, 2013.

Loos, Adolf. "Ornement et crime." *Les Cahiers d'aujourd'hui*, no. 5 (June 1913).

Major, John S., Yeohlee Teng, and Paola Antonelli. *Yeohlee: Work*. Mulgrave, Australia: Peleus Press, 2003.

Martin, Richard. *American Ingenuity: Sportswear, 1930s–1970s*. Exh. cat. New York: Metropolitan Museum of Art, 1998.

Masiola Rosini, Rosanna, and Sabrina Cittadini. *The Golden Dawn of Italian Fashion: A Cross-Cultural Perspective on Maria Monaci Gallenga*. Newcastle upon Tyne, U.K.: Cambridge Scholars, 2020.

Mau, Dhani. "Hanifa's Anufa Mvuemba Couldn't Get the Fashion Industry's Support. Turns Out She Didn't Need It." *Fashionista*, September 8, 2020. https://fashionista.com/2020/09 /anifa-mvuemba-hanifa-clothing-3d -fashion-show.

Menkes, Suzy. "Hanae Mori: The Iron Butterfly." In *Hanae Mori Style*, edited by Yasuko Suita, 12–13. Tokyo: Kodansha International, 2001.

Merceron, Dean Lester, Alber Elbaz, Harold Koda, Ian Luna, Mandy DeLucia, Mark Melnick, and Eugene Lee. *Lanvin*. New York: Rizzoli, 2016.

Milbank, Caroline Rennolds. *Couture: The Great Designers*. New York: Stewart, Tabori & Chang, 1985.

———. *New York Fashion: The Evolution of American Style*. New York: Harry N. Abrams, 1989.

Moloney, Alison, Wanda Lephoto, and Erica de Greef. "Confronting the Absence of Histories, Presence of Traumas and Beauty in Museum Africa, Johannesburg." *Fashion Theory: The Journal of Dress, Body & Culture* 26, no. 4 (March 2022): 545–54.

Montégut, Phillippe. "Boué Soeurs: The First Haute-Couture Establishment in America." *Dress* 15, no. 1 (1989): 79–86.

Mori, Hanae. *Fasshon: Chō ha Kokkyō o Koeru*. Tokyo: Iwanami Shoten, 1993.

———. *Goodbye Butterfly*. Tokyo: Bungei Shunjū, 2010.

Morton, Patricia. *Disfigured Images: The Historical Assault on Afro-American Women*. New York: Greenwood Press, 1991.

National Council on Public History. "Black Craftspeople Digital Archive Q&A: Part I." November 9, 2021. https://ncph.org/history-at-work /black-craftspeople-digital-archive -qa-part-i/.

O'Conner, Callie. "Jeanne Hallée 1870–1924: 'One of the Best of the Early Houses.'" Master's thesis, Fashion Institute of Technology, 2020.

Papalas, Marylaura. "Avant-Garde Cuts: Schiaparelli and the Construction of a Surrealist Femininity." *Fashion Theory: The Journal of Dress, Body & Culture* 20, no. 5 (2016): 503–22.

Parkins, Ilya, and Elizabeth M. Sheehan, eds. *Cultures of Femininity in Modern Fashion*. Durham: University of New Hampshire Press, 2011.

Parkins, Ilya, and Maryanne Dever, eds. *Fashion: New Feminist Essays*. London: Routledge, Taylor & Francis Group, 2020.

Picken, Mary Brooks, and Dora Loues Miller. *Dressmakers of France: The Who, How, and Why of the French Couture*. New York: Harper, 1956.

Pombo, Ana de. *Mi Última Condena: Autobiografía*. Madrid: Taurus, 1971.

Pouillard, Véronique. *Paris to New York: The Transatlantic Fashion Industry in the Twentieth Century*. Cambridge, Mass.: Harvard University Press, 2021.

Pouillard, Véronique, and Waleria Dorogova. "Couture Ltd: French Fashion's Debut in London's West End." *Business History* 64, no. 3 (2020): 1–23.

Reeder, Jan Glier. *High Style: Masterworks from the Brooklyn Museum Costume Collection at The Metropolitan Museum of Art*. Exh. cat. New York: Metropolitan Museum of Art; New Haven, Conn.: Yale University Press, 2010.

———. "The Touch of Paquin, 1891–1920." Master's thesis, Fashion Institute of Technology, 1990.

Regan, Jessica, and Mellissa Huber. *In Pursuit of Fashion: The Sandy Schreier Collection*. Exh. cat. New York: Metropolitan Museum of Art, 2019.

Ricoeur, Paul. "Mimesis and Representation." *Annals of Scholarship: Metastudies of the Humanities and Social Sciences* 2, no. 3 (1981): 15–16.

Roberts, Mary Louise. *Civilization without Sexes: Reconstructing Gender in Postwar France, 1917–1927*. Chicago: University of Chicago Press, 1994.

Robinson, Hilary. *Reading Art, Reading Irigaray: The Politics of Art by Women*. London: I. B. Tauris, 2006.

Roger-Milès, Léon. *Les Créateurs de la mode: Dessins et documents de Jungbluth*. Paris: Eggimann, 1910.

Romano, Alexis. *Prêt-á-Porter, Paris and Women: A Cultural Study of French Readymade Fashion, 1945–68*. London: Bloomsbury Visual Arts, 2022.

Rykiel, Sonia. *Dictionnaire déglingué*. Paris: Flammarion, 2011.

Sano, Ayaka. "Overcoming the Oriental Past: Hanae Mori's American Dream, 1965–1976." Master's thesis, New York University, 2020.

Schiaparelli, Elsa. *Shocking Life: The Autobiography of Elsa Schiaparelli*. London: V&A Publications, 2007.

Seely, Stephen D. "How Do You Dress a Body without Organs? Affective Fashion and Nonhuman Becoming." *WSQ: Women's Studies Quarterly* 41, no. 1/2 (Spring/Summer 2012): 247–65.

Sirop, Dominique. *Paquin: Une rétrospective de 60 ans de haute couture*. Exh. cat. Lyon: Musée historique des tissus, 1989.

Slinkard, Petra, ed. *The Women Who Revolutionized Fashion: 250 Years of Design*. Exh. cat. Salem, Mass.: Peabody Essex Museum; New York: Rizzoli Electa, 2020.

Smelik, Anneke. "Fashioning the Fold: Multiple Becomings in Fashion." In *This Deleuzian Century: Art, Activism, Life*, edited by Rosi Braidotti and Rick Dolphijn, 37–56. Leiden, Netherlands: Brill Ropodi, 2014.

Steele, Valerie. *Paris Fashion: A Cultural History*. Rev. ed. London: Bloomsbury USA, 2020.

———. *Women of Fashion: Twentieth-Century Designers*. New York: Rizzoli International, 1991.

Steele, Valerie, and Patricia Mears. *Isabel Toledo: Fashion from the Inside Out*. New Haven, Conn.: Yale University Press, 2009.

Strassel, Annemarie. "Designing Women: Feminist Methodologies in American Fashion." *WSQ: Women's Studies Quarterly* 41, no. 1/2 (Spring/Summer 2012): 35–59.

———. "Redressing Women: Feminism in Fashion and the Creation of American Style, 1930–1960." PhD diss., Yale University, 2008.

Tam, Vivienne. *China Chic*. New York: HarperCollins, 2005.

Tilburg, Patricia A. *Working Girls: Sex, Taste and Reform in the Parisian Garment Trades, 1880–1919*. Oxford: Oxford University Press, 2019.

Toledo, Isabel. *The Roots of Style: Weaving Together Life, Love & Fashion*. New York: New American Library, 2012.

Trouillot, Michel-Rolph. *Silencing the Past: Power and the Production of History*. Boston: Beacon Press, 2015.

Veillon, Dominique. *Fashion under the Occupation*. Oxford: Berg, 2002.

Vinken, Barbara. *Fashion Zeitgeist: Trends and Cycles in the Fashion System*. London: Berg, 2020.

Way, Elizabeth, ed. *Ann Lowe: American Couturier*. Exh. cat. New York: Rizzoli Electa, 2023.

———, ed. *Black Designers in American Fashion*. London: Bloomsbury Visual Arts, 2021.

———. "Elizabeth Keckley and Ann Lowe: Recovering an African American Fashion Legacy that Clothed the American Elite." *Fashion Theory: The Journal of Dress, Body & Culture* 19, no. 1 (2015): 115–41.

White, E. Frances. *Dark Continent of Our Bodies: Black Feminism and the Politics of Respectability*. Philadelphia: Temple University Press, 2001.

Wicks, Lauren. "How Tiffany Momon's Deep Dive into Her Family's Genealogy Sparked the Most Comprehensive Archive of Black Craftspeople." *Veranda*, February 4, 2022. https://www.veranda.com /luxury-lifestyle/a38883257/black -craftspeople-digital-archive/.

Wilson, Elizabeth. *Adorned in Dreams: Fashion and Modernity*. New ed. London: Bloomsbury Visual Arts, 2020.

ACKNOWLEDGMENTS

We are grateful to the many people who provided generous support for the exhibition *Women Dressing Women* and this associated publication. In particular, we are fortunate to have had the encouragement of Max Hollein, Marina Kellen French Director and CEO of The Metropolitan Museum of Art; Jameson Kelleher, Chief Operating Officer; Quincy Houghton, Deputy Director for Exhibitions; Andrea Bayer, Deputy Director for Collections and Administration; Whitney W. Donhauser, Deputy Director and Chief Advancement Officer; Inka Drögemüller, Deputy Director for Digital, Education, Publications, Imaging, Library, and Live Arts; Lavita McMath Turner, Chief Diversity Officer; and Anna Wintour, Met Trustee, Global Editorial Director, *Vogue*, and Chief Content Officer, Condé Nast. Extraordinary thanks to Andrew Bolton, Wendy Yu Curator in Charge of The Costume Institute, for his advocacy and invaluable guidance on this project. We offer our special gratitude to Morgan Stanley for their generous support of the show and this catalogue. The company's early enthusiasm for the guiding themes of this project was deeply heartening, and we celebrate the firm's first major sponsorship of The Costume Institute.

We greatly appreciate the inspiring contributions and collaboration of our fellow essayists Jessica Regan and Elizabeth Way and their essential roles in helping to shape this book. The Publications and Editorial Department of The Met, under the direction of Mark Polizzotti, Publisher and Editor in Chief, is responsible for realizing the Museum's publications. We especially wish to thank Gwen Roginsky for the characteristic dedication and skill she brought to the oversight of this publication, along with an incredible team that includes editorial manager Elizabeth Levy and editor Jane Takac Panza; production managers Nerissa Dominguez Vales and Sue Medlicott; image rights administrator Anne Levine; and project coordinator Rachel High. We thank Laura Genninger as well as Nick Thompson at Studio 191 for the creativity and thoughtfulness of the beautiful design and art direction of this book. Sincerest thanks to Anna-Marie Kellen for her unwavering enthusiasm and commitment to the project, resulting in extraordinary photographs that were splendidly retouched by Jessica Ng. Special thanks to Eric Wei, Sharon Ou, and their colleagues at Artron Art Printing for their expertise. It was a pleasure and an honor to realize the publication with this phenomenal group.

It is an incredible privilege to work with the exceptionally talented and dedicated staff of The Costume Institute. Tremendous thanks to Alyssa Hollander and Laura Scognamiglio for their help in the organization and realization of this project. We thank Alexandra Fizer and Mika Kiyono for their advice and enthusiasm in sharing this exhibition with our audiences. Stephanie Kramer, Julie Tran Lê, and Kai Toussaint Marcel have provided much-appreciated support and research assistance. Our gratitude to Rebecca Perry for her expert facilitation of the new acquisitions that entered our collection as part of this project. We especially wish to thank Melina Plottu, who oversaw the conservation program for this publication and exhibition with great skill and creativity alongside our colleagues Christopher Mazza, who took point on conserving garments for the exhibition installation; Glenn O. Petersen who provided infinitely capable support in regard to challenging treatments and mounts; and Elizabeth Shaeffer, who authored an illuminating text on the dressmaker Madame Olympe. As always, our installation manager Joyce Fung brought the garments to life through her exquisite and sensitive dressing of objects for both photography and exhibition and through the development of mannequins that were installed with the skillful assistance of Hector Serna. Shelly Tarter and her colleagues in Collections, including Bethany Gingrich and Tracy Yoshimura, graciously facilitated many object viewings, providing access to our permanent collection and helping to unearth object histories both old and new. We would particularly like to thank Marci Morimoto for her attentive and careful review and analysis of our departmental collecting data. Our deep gratitude goes to Amanda Garfinkel for her insightful feedback, encouragement, and perceptive text contributions.

Tremendous thanks to our amazing colleagues at The Metropolitan Museum of Art: Tom Scally, Buildings General Manager; Taylor Miller, Buildings Manager for Exhibitions; Alicia Cheng, Head of Design, and Maanik Singh Chauhan, Christopher DiPietro, Chelsea Garunay, Maru Pérez, Sarah Pulvirenti, and Alexandre Viault of the Design Department; Gillian Fruh, Senior Manager of Exhibitions; Douglas Hegley, Chief Digital Officer, and Christopher Alessandrini, Melissa Bell, Paul Caro, Ann Collins, and Kate Farrell of the Digital Department; Meryl Cohen, Chief Registrar, and Becky Bacheller of the Registrar's Office; Stephen A. Manzi, Kate Thompson, and John L. Wielk in Development; and Kayla Elam of the Publications and Editorial Department.

We would also like to thank Aurola Alfaro; Young Bae; Ann M. Bailis; Peter Berson; Monika Bincsik, Diane and Arthur Abbey Associate Curator for Japanese Decorative Arts, Department of Asian Art; Eric Breitung; Jennifer Brown; Federico Caro; Caroline Chang; Kimberly Chey; Jennie Choi; Skyla Choi; Marie Clapot; Clint Ross Coller; Sharon H. Cott;

Francesca D'Alessio; Cristina Del Valle; Elizabeth De Mase; Kate Dobie; Michael Doscher; Izabella Dudek; Jourdan Ferguson; William Scott Geffert; Nora Gorman; Leanne Graeff; Deborah Gul Haffner; Jason Herrick; Heidi Holder, Frederick P. and Sandra P. Rose Chair of Education; Lela Jenkins; Elena Kanagy-Loux; Meghan Kase; Amy Lamberti; Claire Lanier; Marco Leona, David H. Koch Scientist in Charge, Department of Scientific Research; Lewis Levesque; Matthew Lytle; Victoria Martinez; Rebecca McGinnis, Mary Jaharis Senior Managing Educator, Accessibility, Education Department; Sua Mendez; Grace Mennell; John Meroney; Darcy-Tell Morales; Rebecca Noonan Murray; Amy Nelson; Maria Nicolino; Sarah M. Parke; Morgan Pearce; Sarah Pecaut; Elizabeth Perkins; Mario Piccolino; Lisa Pilosi, Sherman Fairchild Conservator in Charge, Department of Objects Conservation; Adriana Rizzo; Josephine Rodriguez; Leslye Saenz; Frederick J. Sager; Rebecca Schear; Gretchen Scott; Marianna Siciliano; Jamie Song; Soo Hee H. Song; Yu Tang; Mabel Taylor; Limor Tomer, Lulu C. and Anthony W. Wang General Manager of Live Arts; Kate Truisi; Kristen Vanderziel; Kenneth Weine; Anna Yanofsky; Anna Zepp; Philip Zolit; and Margaret Zyro.

We would like to express our sincere appreciation to past and present docents, interns, volunteers, and fellows of The Costume Institute who contributed to this project, including docents Sarah Baird, Peri Clark, Ronnie Grosbard, Francesca Gysling, Ruth Henderson, Dorann Jacobowitz, Betsy Kahan, Linda Kastan, Susan Klein, Mary Massa, Charles Mayer, Ginny Poleman, Eleanore Schloss, and Charles Sroufe; interns Izabel Cockrum, Emily Elizabeth Lance, Abigail Lenhard, Nathalia Moran, Nathalie Silva, Talia Spielholz, and Lauren Vaccaro; and fellows Kris Cnossen, Lilien Lisbeth Feledy, Alexis Romano, and Jonathan Michael Square.

We are grateful for the ongoing support of the Friends of The Costume Institute, chaired by Wendi Murdoch and cochaired by Eva Chen, Sylvana Ward Durrett, and Mark Guiducci, and are thrilled to feature many important female designers in this publication on account of the excellent eye and generous promised gift of renowned fashion collector Sandy Schreier. Sincerest thanks also to Lizzie and Jonathan Tisch as well as Wendy Yu for their ongoing support of the department. As ever, our appreciation goes to Condé Nast for its longtime support of The Costume Institute's exhibitions.

For their assistance with research, thanks to our wonderful colleagues at the American University of Paris (Sophie Kurkdjian); Costume Museum of Canada (Andrea Brown, Helen Leeds); Diktats (Antoine Bucher, Nicolas Montagne); FIT Special Collections and College Archives (April Calahan, Samantha Levin, Karen Trivette); Fondation Cartier (Chris Dercon); Fortuny (Mickey Riad, Alberto Torsello, Carla Turrin); Fortuny Museum (Cristina Da Roit); Galleria Nazionale d'Arte Moderna e Contemporanea (Clementina Conte, Gabriella Tarquini); Ghent University (Maude Bass-Krueger); The Hinton Group (Nate Hinton, Vickee Yang); Japan Society (Ayaka Sano Iida); Jil Sander (Sandra Purificato); Marine Serre (Andrea Gaggio Avellan, Jessica Boukris, Alice Poubelle); MoMu (Birgit Ansoms); Murphy Library Special Collections/ARC Archives, University of Wisconsin–La Crosse (Laura M. Godden); Musée des Arts Décoratifs (Emmanuelle Blandinières Beuvin, Myriam Teissier); The Museum at FIT (Callie O'Conner); Museum of Fine Arts Boston (Emily Stoehrer); Palais Galliera (Sylvie Roy); Parsons School of Design (Ulrich Lehmann); Patrimoine Lanvin (Laure Harivel); Purple PR (Cathy Lee); Sonia Rykiel (Lola Dussart, Yumiko Hayashi, Roland Herlory, Pauline Varoquier); Tilting the Lens (Áine Aherne, Emma Shaw); and Tirelli Trappetti Costumi (Daniela Bartoli, Laura Nobile, Alessia Zucca). We are grateful to Virginia Barbato; Lauren Bierly; Nadia Blumenfeld-Charbit; Lucas Cohen; Comme des Garçons (Emma Doherty); Community New York (Richie Keo); DK Display (Neal Rosenberg); Waleria Dorogova; Michael Downer; France Display Corp. (Lisa Cipriano); Frank Glover Productions (Margaret Karmilowicz); Jessica Glasscock; Adam Hayes; Benjamin Klemes; Mr. and Mrs. Michael Lewis; Jacqueline Novak; Briana Parker; Ilya Parkins; Emmanuelle Polle; Proportion London (Natalie Beazley); Michelle Ralph-Fortón; Sarah Scaturro; Jessica M. Sewell; Dan Thawley; and Window France (Nora Abdelli, Kiki Frisbie, Jean Marc Mesguich).

For their contributing roles in remaking an ensemble for this exhibition and our permanent collection, special thanks to Gabriela Hearst, Catherine Lebrun, and Geraldine-Julie Sommier at Chloé, and to the skilled artisans of the Gee's Bend Quilting Collective, particularly Loretta Pettway Bennett, Marlene Bennett Jones, Lue Ida McCloud, Doris Mosely, Cassandra Pettway, Caster Pettway, Emma Mooney Pettway, Kristin Pettway, Mary Margaret Pettway, Stella Mae Pettway, Veronica Saulsberry, Pleasant Scott, Andrea Pettway Williams, and Sharon Williams. We extend our appreciation and admiration to Sinéad Burke; Linda and Bob Cutler; Nancy Deihl; Anne Teresa De Keersmaeker; Balthazar Delepierre; Ann Demeulemeester; Maria Echeverri; Deborah and Martin Huber; Mary Jane Kennedy; Caitlin Keogh; Harold Koda; Rachel Lifter; Ester Manas; Mascha Mareen; Anifa Mvuemba; Jamie Okuma; Aaron Rose Philip; Jan Reeder; Simone Rocha; Jil Sander; Collier Schorr; Petra Slinkard; Jasmin Søe; Carla Sozzani; Ruby Sky Stiler; Hillary Taymour; Sofia Thompson; Ruben Toledo; Kathleen Turner; Diane von Furstenberg; and especially David Kennedy Cutler as well as Hans, Simone, and Theodore Caarls.

This book is dedicated to all of the women makers—anonymous and acclaimed—for their immeasurable contributions to the field of fashion.

MELLISSA HUBER
Associate Curator, The Costume Institute

KAREN VAN GODTSENHOVEN
Independent Curator

CREDITS

Back cover: The Metropolitan Museum of Art, New York, Brooklyn Museum Costume Collection at The Metropolitan Museum of Art, Gift of the Brooklyn Museum, 2009; Gift of Claire McCardell, 1956 (2009.300.2445); p. 6: Bibliothèque Forney, Paris; p. 8: Fonds Roger Viollet, Bibliothèque historique de la ville de Paris; p. 190: Bibliothèque nationale de France, Paris, département Estampes et photographie, EI-13 (1284)

ARTISTRY AND ANONYMITY
Defining WOMEN'S ROLE *in* WOMEN'S FASHION
(ca. 1675–1900)

Fig. 1: Bibliothèque nationale de France, Paris, département Estampes et photographie, OA-52-PET FOL; fig. 2: Bibliothèque nationale de France, Paris, département Estampes et photographie, OA-63-PET FOL; fig. 3: Bibliothèque nationale de France, Paris, département Estampes et photographie, OA-62-PET FOL; fig 4: Bibliothèque nationale de France, Paris, département Estampes et photographie, RES-926 (7); fig. 5: The Metropolitan Museum of Art, New York, The Irene Lewisohn Costume Reference Library at The Costume Institute. Gift of Woodman Thompson; fig. 6: From *La Mode illustrée*, November 19, 1882, p. 373. The Irene Lewisohn Costume Reference Library at The Costume Institute

A CONSTELLATION OF COMETS AND SHOOTING STARS
New VISIBILITY *for* WOMEN *in* FASHION
(ca. 1900–1968)

Fig. 1: From *Vogue Paris*, April 1, 1940, p. 28. Bibliothèque nationale de France, Paris, département Littérature et art, FOL-V-5554 (BIS); fig. 2: *L'Illustration*, Paris; fig. 3: From *Les Créateurs de la mode*, Eggimann, Paris, 1910, p. 67; fig. 4: From Vogue, November 1, 1926; fig. 5: Patrimoine Lanvin; fig. 6: Paris, musée des Arts décoratifs; fig. 8: From *Les Modes*, May 1907, p. 23. Bibliothèque nationale de France, département Sciences et techniques, FOL-V-4312; fig. 9: George Hoyningen-Huene Estate Archives; fig. 10: From Vogue Paris, July 1, 1926, p. XXVII (Germaine Lecomte) and From *Vogue Paris*, August 1, 1924, p. XI (Louiseboulanger); fig. 11: From *Vogue Paris*, October 1, 1924, p. 18. Bibliothèque nationale de France, département Littérature et art, FOL-V-5554 (BIS); fig. 12: From *Vogue Paris*, June 1, 1925, p. 19. Bibliothèque nationale de France, département Littérature et art, FOL-V-5554 (BIS); fig. 13: From *Vogue Paris*, April 1, 1926; fig. 14: Photography Collection, New York Public Library, inv. 87PH048.1599; fig. 15: From *Vogue*, December 15, 1927; fig. 16: From *Vogue*, September 15, 1948, p. 135; fig. 17: From *Vogue*, July 15, 1931; fig. 18: From *Harper's Bazaar*, July 1940, p. 44; fig.20: Fashion Institute of Technology | SUNY, Gladys Marcus Library Special Collections and College Archives; fig. 21: From *Vogue*, April 1, 1950, pp. 116–17

ABSENCE/OMISSION
BLACK AMERICAN WOMEN FASHION MAKERS

Figs. 2, 3: Carl Van Vechten Papers Relating to African American Arts and Letters. James Weldon Johnson Collection in the Yale Collection of American Literature, Beinecke Rare Book and Manuscript Library of Yale University; fig. 4: The Metropolitan Museum of Art, New York, Gift of Lucy Curley Joyce Brennen, 1979 (1979.144); fig. 5: The Metropolitan Museum of Art, New York, Gift of Mrs. K. Fenton Trimingham Jr., 1975 (1975.349a, b); fig. 7: From the Lincoln Financial Foundation Collection; fig. 8: National Museum of American History, Smithsonian Institution, Washington, D.C.; figs. 9, 10: Hanifa, Designer Anifa Mvuemba

PHOTO CREDITS

Alamy Stock Photo: p. 35 (right); Liz Allison Photography: p. 65; Avalon.Red: p. 52 (left); Cecil Beaton, *Vogue* © Condé Nast, April 1, 1950: p. 44 (top and bottom); Photos: Beinecke Rare Book and Manuscript Library of Yale University: p. 72; Photo by Bettmann Archive / Getty Images: p. 75; © The Estate of Erwin Blumenfeld 2023: front cover; Photo Kennedi Carter: p. 60; Clifford Coffin, *Vogue* © Condé Nast, September 15, 1948: p. 40; © Kevin Davies: p. 57; Photo by Michel Dufour / WireImage: p. 61; Photo Charlie Engman: p. 64; Courtesy of the Fashion Institute of Technology | SUNY, Gladys Marcus Library Special Collections and College Archives: p. 43 (right); Hanifa, Designer Anifa Mvuemba. Permission granted: p. 77; © George Hoyningen-Huene Estate Archives: figs. 9, 17; Courtesy Jil Sander: p. 56 (right); © Succession Yves Klein c/o Artists Rights Society (ARS), New York / ADAGP, Paris 2023: p. 164; © François Kollar / Bibliothèque Forney / Roger-Viollet: p. 6; Photographed by Jill Krementz: p. 51; Kyodo / Kyodo News Images: p. 55; Martha Holmes / Shutterstock.com: p. 43 (right); Peter Lindbergh (courtesy Peter Lindbergh Foundation, Paris): p. 56 (left); © Boris Lipnitzki / BHVP / Roger-Viollet: p. 8; © Inès Manai / Courtesy of Dior: p. 66; Craig McDean / Art + Commerce: p. 49; ILVY NJIOKIKTJIEN / *The New York Times* / Redux: p. 63; PA Images / Alamy Stock Photo: p. 53; © Paris, Les Arts décoratifs: p. 32; Gordon Parks / The LIFE Picture Collection / Shutterstock: p. 71; Courtesy Patrimoine Lanvin: p. 31 (right); Douglas Pollard, *Vogue* © Condé Nast, December 15, 1927: p. 38 (bottom); Vittoriano Rastelli / Corbis via Getty Images: p. 54; Norman Jean Roy / Trunk Archive: p. 59; © Sonia Rykiel: p. 50; Charles Sheeler, *Vogue* © Condé Nast, November 1, 1926: p. 31 (left); Edward Steichen, *Vogue* © Condé Nast, July 15, 1931, © 2023 The Estate of Edward Steichen / Artists Rights Society (ARS), New York: p. 42 (left); Photographer TANUMA Takeyoshi's Office: p. 10; © Van Vechten Trust: p. 72; HARLEY WEIR / ART PARTNER: p. 52 (right)

This catalogue is published in conjunction with *Women Dressing Women*,
on view at The Metropolitan Museum of Art, New York,
from December 4, 2023, through March 3, 2024.

The exhibition and catalogue are made possible by Morgan Stanley.

Morgan Stanley

Published by The Metropolitan Museum of Art, New York
Mark Polizzotti, Publisher and Editor in Chief
Peter Antony, Associate Publisher for Production
Michael Sittenfeld, Associate Publisher for Editorial

Publication Management by Gwen Roginsky
Project Coordination and Marketing by Rachel High
Editorial Management by Elizabeth Levy
Edited by Jane Takac Panza
Art direction and book design by Laura Genninger, STUDIO 191,
with Nick Thompson
Production by Nerissa Dominguez Vales and Sue Medlicott,
The Production Department

New Photography by Anna-Marie Kellen
Image Production by Jesse Ng
Image Acquisition and Rights by Anne Levine

Typeset in Untitled Sans and Untitled Serif
Separations by Altaimage, London/New York
Printed and bound by Artron Art Printing (HK) Limited, Shenzhen, China

Front cover: Claire McCardell wearing her "Future" dress design, 1945.
Photographed by Erwin Blumenfeld. © The Estate of Erwin Blumenfeld 2023
Back cover: *"Future" dress*, 1945, p. 125

Additional photography credits: p. 211
First printing

The Metropolitan Museum of Art
1000 Fifth Avenue
New York, New York 10028
metmuseum.org

Distributed by
Yale University Press, New Haven and London
yalebooks.com/art
yalebooks.co.uk

Cataloguing-in-Publication Data is available from the Library of Congress.
ISBN 978-1-58839-720-1